icons of the desert

Early
Aboriginal
Paintings
from
Papunya

icons of the desert

Early
Aboriginal
Paintings
from
Papunya

ROGER BENJAMIN

FRED MYERS
VIVIEN JOHNSON
R. G. KIMBER
HETTI PERKINS

Edited by Roger Benjamin with Andrew C. Weislogel

HERBERT F. JOHNSON MUSEUM OF ART • CORNELL UNIVERSITY

This catalogue accompanies an exhibition organized by the Herbert F. Johnson Museum of Art at Cornell University, curated by Roger Benjamin and coordinated by Andrew C. Weislogel, associate curator and master teacher at the Johnson Museum.

The exhibition was presented at:

Herbert F. Johnson Museum of Art
Cornell University
Ithaca, New York
January 10 – April 5, 2009

Fowler Museum of Cultural History
University of California
Los Angeles
May 3 – August 2, 2009

Grey Art Gallery
New York University
New York
September 1 – December 5, 2009

COVER: Shorty Lungkarta Tjungurrayi,
Mystery Sand Mosaic (detail, see cat. 41)

FRONTISPIECE: Johnny Warangkula Tjupurrula,
Water Dreaming at Kalipinypa, (detail, see cat. 27)

FRONT ENDPAPER: Aerial photo of Papunya, 1972,
© Michael Jensen

Library of Congress Control Number:
2008943908
ISBN-13: 978-1-934260-06-7
ISBN-10: 1-934260-06-1

Australian edition
Library of Congress Control Number:
2008943908
ISBN-13: 978-1-934260-07-4
ISBN-10: 1-934260-07-X

Published by:
Herbert F. Johnson Museum of Art
Cornell University
Ithaca, New York 14853
www.museum.cornell.edu

Distributed by:
Cornell University Press
Ithaca, New York 14850
www.cornellpress.cornell.edu

Aboriginal and Torres Strait Islander people are respectfully advised that photographs of deceased persons, as well as images of their work, appear in this book, and that this may cause distress.

contents

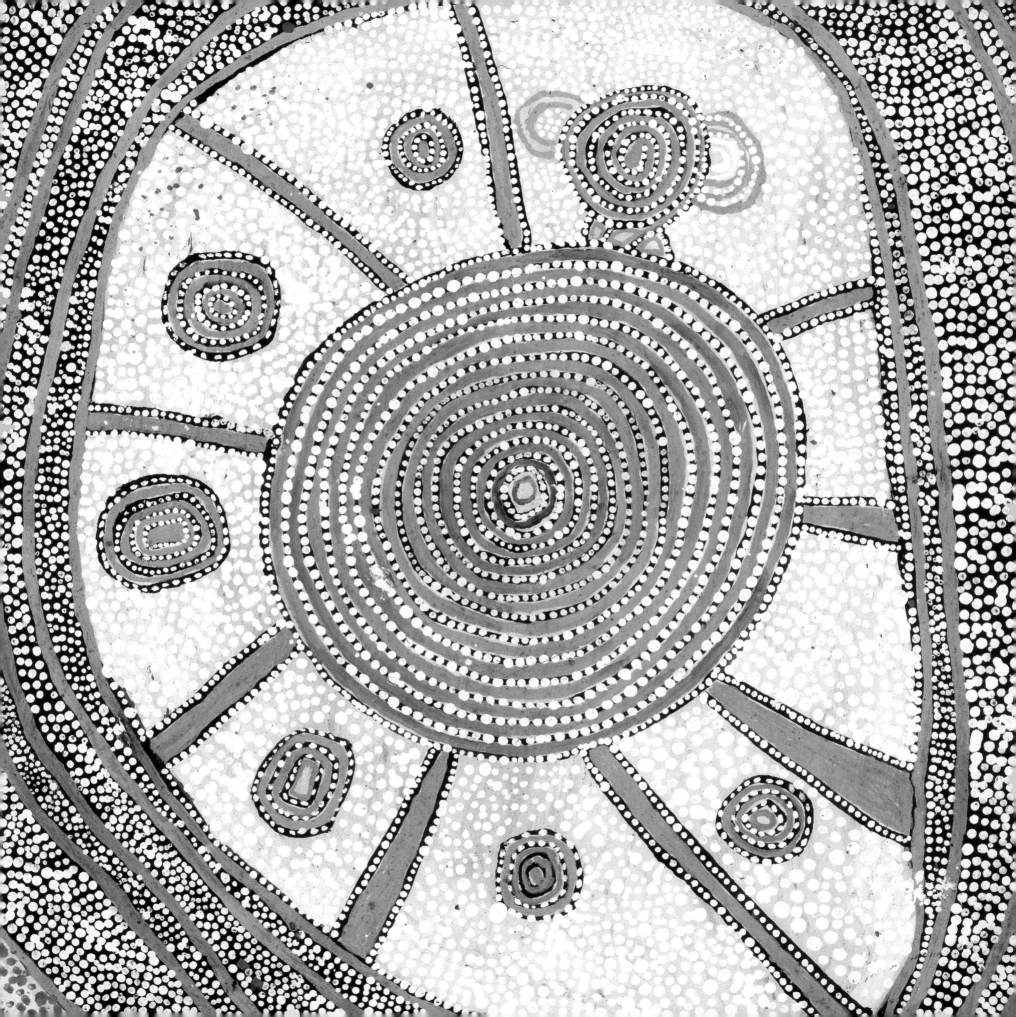

foreword

It is fair to say that we carry the collecting gene. Surely, without this dominant trait, our lives would have evolved differently—perhaps dramatically so. For over forty years, we have studied, traveled, met exceptional people, and developed our collections. Initially, we collected American folk sculpture, and then, for the last fifteen years, Australian indigenous paintings and, more recently, paintings and drawings by a small number of outsider artists. If there is a common thread that ties our collecting activities, it is that few of the artists whose work we admire have formal academic art training—our acquisitions were driven simply by the response of eye, heart, and mind to each piece.

Our acquaintance with Australian indigenous painting began with a visit to the Museums and Art Galleries of the Northern Territory in Darwin in 1994. We followed up this first spark of interest with a trip to Papunya Tula Artists in Alice Springs. We loved every painting we saw, a sure sign that we needed education. Taking a cue from lessons learned about provenance, rarity, and originality while forming our collection of folk art, we sought some organizing principle on which to base our Australian paintings collection, and decided to focus primarily on early boards painted by the original artists working at Papunya, also considering examples of later work from the best of these artists. Having made this decision, we sought out expertise and were fortunate to receive guidance from Melbourne-based Irene Sutton of Sutton Art Gallery and Tim Klingender of Sotheby's Australia. Their knowledge, judgment, and integrity were essential to the development of this collection.

As we look at these early boards, we imagine the hands of the artists themselves handling these works. Their authenticity, originality, and mystery touches us. These artists were not just producing art to make a living, nor were they influenced by the art market fashion of their day; they were moved instead by a compelling need for creative expression. These paintings spring not just from the hand but from the soul. And while we cannot ultimately understand the messages embedded in these paintings, their spirituality is evident and commands respect.

The three facets of our collecting philosophy have always been connoisseurship, scholarship, and education—we seek to bring together the finest examples available, to support original research to advance understanding of this art and the artists' culture, and finally, to promote education by sharing the works with the public. We hope this exhibition and its catalogue will serve as the ultimate expressions of our philosophy. We are grateful to Frank Robinson and Andy Weislogel of the Johnson Museum and guest curator Roger Benjamin of the University of Sydney for partnering with us to bring this exhibition to fruition.

JOHN AND BARBARA WILKERSON

◀ Shorty Lungkarta Tjungurrayi, *Classic Pintupi Water Dreaming* (detail, see cat. 25)

acknowledgments

The collaborative and international nature of this exhibition project is indicated by the great numbers of colleagues and friends, both old and new, whose contributions we celebrate here. First, we thank the artists represented in this book, and their families and communities, for the unique and truly staggering contribution to the art world stemming from their seminal exchange of ideas with Geoffrey Bardon at Papunya beginning in 1971: Anatjari Tjakamarra, Billy Stockman Tjapaltjarri, Charlie Tarawa Tjungurrayi, Clifford Possum Tjapaltjarri, Freddy West Tjakamarra, George Tjangala, John Kipara Tjakamarra, Johnny Scobie Tjapanangka, Johnny Warangkula Tjupurrula, Kaapa Mbitjana Tjampitjinpa, Kingsley Tjungurrayi, Long Jack Phillipus Tjakamarra, Mick Namararri Tjapaltjarri, Old Walter Tjampitjinpa, Shorty Lungkarta Tjungurrayi, Tim Leura Tjapaltjarri, Tim Payungka Tjapangarti, Tommy Lowry Tjapaltjarri, Turkey Tolson Tjupurrula, Uta Uta Tjangala, Willy Tjungurrayi, Yala Yala Gibbs Tjungurrayi, and Yumpuluru Tjungurrayi.

A dedicated team of scholars has delved into these works and their makers' stories so that readers and exhibition visitors may benefit. First among these is Roger Benjamin of the University of Sydney, guest curator for the project and the main author and editor of this book. He has maintained a vision for the project throughout, never losing sight of the whole in a vast desert of detail, and his expert blending of rigorous scholarship with a teacher's passion for the subject have been a model for us all. In addition, Roger has been a key partner in promoting the exhibition to ensure the exposure these works truly merit, working with us to help secure the other exhibition venues, and serving as the project's chief ambassador on both continents.

We are grateful to Fred Myers of New York University for lending us both the immediacy of his memories and the subtlety of his reflections on his time in the field and in friendship with important figures from the Papunya movement, as well as for his invaluable expertise at many critical junctures of the process, during which he served as the project's conscience and our chief sounding board. We are honored to have the participation of Vivien Johnson of the University of New South Wales, the preeminent biographer of the pantheon of Papunya artists, who points out the cultural diversity among the original Papunya artists and, in particular, Charlie Tarawa Tjungurrayi's nuanced role as liaison between the painters and the outside world. Likewise, we are delighted that Hetti Perkins of the Art Gallery of New South Wales has graced us with an eloquent and stirring introduction to the book, and we appreciate her help and friendship all along the way.

We owe a special debt of gratitude to R. G. (Dick) Kimber, a legend from the early Papunya days and a man of many talents; Dick's surpassing knowledge of and friendship with the Aboriginal community have resulted in a fascinating interview in this book. Even more fundamentally, Dick was responsible for initiating the respectful dialogue with the community on which this project is based. We naturally also wish to thank those Aboriginal people—many of them artists in their own right—who took the time to speak with Dick, and whose wishes have given the exhibition its compass: Dinny Nolan Tjampitjinpa, brother of Kaapa Tjampitjinpa; Kaapa's son, Keith Kaapa Tjangala; his niece, Doreen Nangala; Emma Nangala, daughter of Old Walter Tjampitjinpa; Nebo Tjampitjinpa Maxwell, Brenda Napaltjarri, Pamela Napaltjarri, and Maria Nampitjinpa, son and daughters of George Tjangala; Michael Nelson Tjakamarra; Murphy Roberts; and Kevin Wirri.

In the project's early days, research and curatorial assistant Clare Lewis spent many hours tracking down much of the catalogue information about each work that appears in this volume. Sarah Tutton, our Australian project manager, has admirably juggled the variety of tasks we have asked of her, from preparing education materials and a film series to accompany the exhibition to organizing two important trips—first for the exhibition team to the Western

Desert in July 2007, and second for Papunya Tula Artists painters and staff to Ithaca for our programming here at the Johnson. Sarah has also diligently assembled the many permissions and photo credits for the book. For assistance with these images, we also wish to thank Dorn Bardon; Anthony Wallis of the Aboriginal Artists Agency, Sydney; Margaret Levi and Robert Kaplan of Seattle; Philip Brackenreg of Legend Press; and Tim Klingender and Francesca Cavazzini of Sotheby's Australia.

Paul Sweeney and his team at Papunya Tula Artists, especially Sarita Quinliven and Luke Scholes, have played a crucial role in the success of this exhibition. The standing of PTA in the local Aboriginal communities has ensured that our project was well received, and Paul has facilitated our requests in a number of areas. PTA field officers Bryony Nicholson, Vanessa Patterson, and Tim Dilworth helped us experience first-hand how current artists live and work in Kintore and Kiwirrkura, and introduced us to the astonishing beauty and isolation of the desert from which these works spring. We are also grateful to Melbourne gallerist Irene Sutton, who has been a friend and guiding force for the collectors—and to this project—for many years.

It is wonderful to have the opportunity again to thank the hardworking and professional team at the Johnson Museum. Liz Emrich, exhibitions coordinator, assisted ably in a host of ways; registrar Matt Conway oversaw transportation of the works with his usual mastery and attention to detail; preparators Wil Millard, George Cannon, and David Ryan carried out the installation with consummate care and sensitivity. Cathy Klimaszewski, associate director and Harriett Ames Charitable Trust Curator of Education, and her fine staff—Hannah Dunn Ryan, Carol Hockett, Mariel Gonzalez, and Elizabeth Saggese—have adeptly handled the considerable task of translating this utterly new and multifaceted material for our public. Deputy Director Peter Gould has managed the resources for the project, and accounts manager Brenda Stocum has overseen the flow of receipts and payments moving between Ithaca and Sydney, Melbourne, and Alice Springs. Like the paintings themselves, this book is intended to stand the test of time; publicity and publications coordinator Andrea Potochniak has worked inventively and tirelessly to ensure the best chance at this, and Ithaca-based designer Mo Viele has given us a beautiful visual forum in which to experience the paintings and commentary. We are grateful to photographer Tony De Camillo for his superb photography of the collection, and to the Johnson's own Julie Magura for providing many of the other photographs in the book, including the original painting diagrams. Finally, I wish to thank Frank Robinson, the Richard J. Schwartz Director, for his unflagging energy and sound advice as the project passed through its many stages. This kind of support is the best gift a curator can wish for.

Of course, neither exhibition nor catalogue would have come to pass without the vision and dedication of John and Barbara Wilkerson. They have built a truly significant collection, one that crystallizes this pivotal moment in art and cultural history as few collections can. Of equal importance, however, is their initiative to share these works with the public in this meaningful way. We are grateful for the financial support of their Actus Foundation, which has permitted us to pursue the project in uncommon breadth and depth. And we are grateful for John and Barbara's generosity of spirit, patience, good humor, and steadfast friendship, which have seen us through the twists and turns in this fascinating journey with its wealth of opportunities for learning, personal growth, and sheer enjoyment.

ANDREW C. WEISLOGEL
Associate Curator/Master Teacher

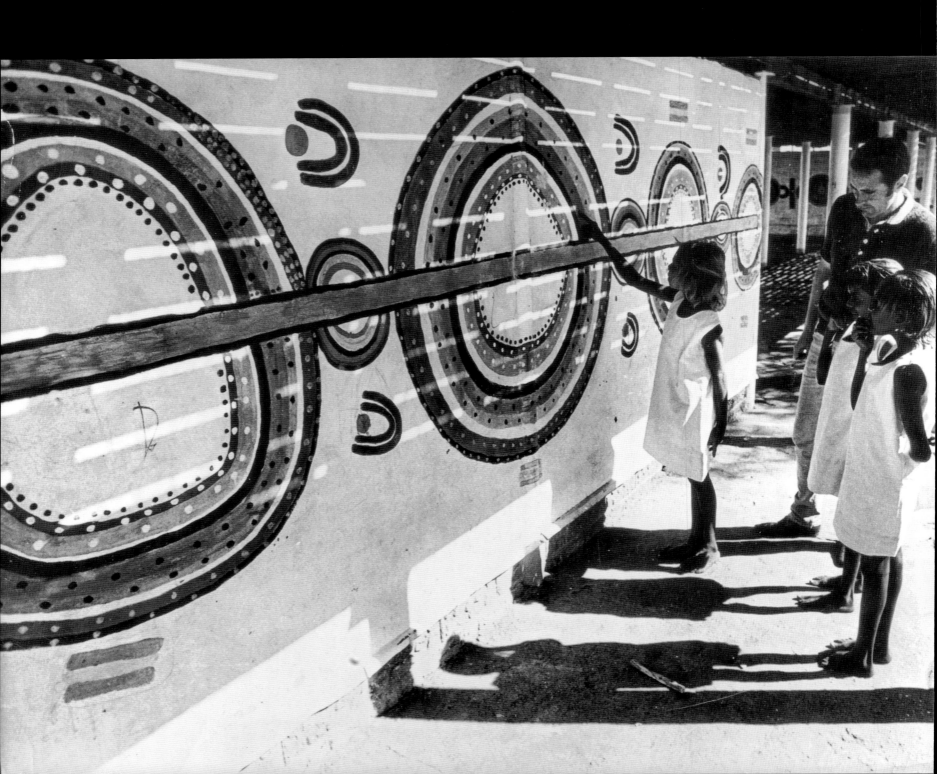

HETTI PERKINS

◄ Honey Ant Mural,
Papunya Special School,
ca. July 14, 1972

Three primary school
girls in uniform with an
unidentified teacher;
the girl at left touches
the painting as if to tell
a part of the Honey Ant
Dreaming that is proper
to Papunya settlement.

In my professional life as a curator of Aboriginal art, I have had the privilege over the years of meeting many artists, and visiting their country and the art centers that support them. As a child in the mid–1970s I traveled with my father, the public servant and political activist Charles Perkins, to some of the communities around Mparntwe (Alice Springs), including Papunya. I saw the appalling conditions our people lived in, and still do today in many parts of Australia. Living in Canberra I also experienced first hand the many demonstrations and protests which were part of the political process towards achieving self-determination, such as the Aboriginal Tent Embassy erected on the lawns of Parliament House.

Through these actions our people sought to highlight the injustices we suffered and advance our status as Australians. Those of us born before 1967 had begun our lives in a statistical *terra nullius*, not eligible to be counted in the national census. For me, therefore, and for many of my colleagues and artists, art and politics are inextricably entwined. Obviously, much has changed since that time. One of the most significant changes is our profile within the Australian and international community, and this is largely a reflection of our contemporary cultural presence. This transformation in our status is not just the result of political agency; cultural activism has been a key partner in achieving this position. A few notable examples include the Yirrkala Bark Petition, which was presented to federal parliament in 1963 by the Yolngu people of northeast Arnhem Land; the Papunya School mural (1971) and the Yuendumu (School) Doors (1984); the 1988 Barunga statement written on bark; and the Aboriginal Memorial comprising two hundred hollow log coffins, also created in 1988 and now permanently on display at the National Gallery of Australia.

Our culture and its myriad contemporary expressions have their origins in an ancient and living tradition, but also operate in a world that fundamentally and irrevocably changed two hundred and twenty years ago when the

First Fleet, under instructions from Britain's King George, arrived under the captaincy of Arthur Phillip, the first Governor of New South Wales. They were not the first visitors to arrive at our shores from foreign lands, nor would they be the last. But they claimed it as theirs and named it in their language. The foreshores of the harbor they sailed into became Sydney; not Warran as the local Cadigal people knew it. For the Eora, Guringai, and Daruk people, this was not only a rich and bountiful natural environment; it was a vast and spectacular rock art gallery. For the strangers, it was a foothold to annex our country.

Art has always been a part of our world. Across this country there is written an artistic record of the peoples, lives, and cultures that predate the colonization of Australia in 1788 by thousands of years. Even before the English prison hulks disgorged their cargo of convicts on Australian soil, Aboriginal artists began to document this unexpected turn of events. Rock art paintings record sightings of strange watercraft and even stranger animals and oddly beardless men. In the late nineteenth century, Koori artists William Barak and Tommy McRae catalogued the changes they experienced in their lifetimes, offering a "before and after" narrative that revealed the increasing engagement of Aboriginal and non-Aboriginal people as the frontier spread throughout the country.

The cultural collision between the first Australians and the new arrivals could not have been greater. To their eyes, we were no more evolved than the bizarre flora and fauna they also encountered in this great southern land. And in their paintings, the early records of the colony, we became part of the flora and fauna—and were soon to literally disappear out of the picture. It was our artists who recorded our presence, our lives, country, and culture. However, up until the last decades of the twentieth century, the collection of our art was mostly sporadic and largely haphazard—and in fact was not even considered art by most. Only a very few individuals appreciated the aesthetic quality of the works, others were more interested in our work as either the artifacts of a dying race or the relics of primitivism.

Yet in a relatively few short years—by our standards—we have reclaimed and renamed our country. The art of our people has colonized the imagination of the colonizers. Intricately detailed and optically dazzling Western desert paintings that register the minutiae of country simultaneous to its vast sweeps and contours have relegated pastoral landscape paintings to the dusty realms of European nostalgia. The paintings that today are the hallmarks of Australian art have their origins in the early years of the 1970s, an era in Australia's history associated with tidal political and social change. Out of the desolation and squalor imposed on the desert people in the government settlement of Papunya emerged electrifying symbols of cultural affirmation, no less powerful for their inscription on the humble materials of white detritus: fruit cases, skirting boards, and discarded timber panels. From the context of "a general process of violent self-destruction nearing its completion" emerged a visual affirmation of cultural emancipation and self-determination.[1]

With the benefit of hindsight, the early works of the Papunya Tula Artists collective are often regarded as marking the entry point of Aboriginal culture to the world of art. Yet the works were then, and continue to be, more than commodified culture. As American artist Michael Rakowitz observed, these paintings bear an affinity with illuminated manuscripts.[2] For contemporary artists, the early paintings of their fathers, uncles and grandfathers have meaning and resonance beyond what meets the eye. In 2000, the Art Gallery of New South Wales, in Sydney, presented a major exhibition, *Papunya Tula: Genesis and Genius*. As the early paintings were unpacked from the safety of their traveling crates, the emergence of each one was greeted by the attendant artists with a ready familiarity and affection, and animated discussion. It is likely that the artists had never actually seen these works as they had disappeared almost three decades ago into collections far away from their point of "genesis."

In almost direct contradiction to the negligible market interest in the work of the Papunya Tula Artists in its fledgling years, the appearance of some of these paintings in the community caused considerable controversy at the time, due to their relationship to the sacrosanct world of the desert peoples. While all these paintings represent a direct link with the Tjukurrpa, the om-

nipotent force that permeates all aspects of life in the Western Desert, some are more clearly linked to an inner secret world. In regards to the latter genre, the elders of these communities made it clear that the consequences would be devastating for anyone unwittingly tapping into this formidable spiritual reservoir by viewing sanctified symbolism or depictions of sacred objects. The viewing of restricted paintings by the uninitiated is literally regarded as "dangerous."

Geoffrey Bardon was acutely aware of the serious consequences of infringing cultural protocols, urging his artist friends to only paint "safe" imagery, or preferably "children's stories." This suggestion reflected his role as a schoolteacher at Papunya and his interest in promoting the deployment of culturally appropriate rather than introduced Western symbolism in the classroom of primarily Aboriginal children. Critically, it also stemmed from his awareness that the paintings would eventually find their way into a wider world beyond the relative privacy of the painting studio.

The kinetic power of the early paintings is affirmed by the seriousness with which potential cultural transgressions are regarded and extreme punishments accorded to such offences. While the marvelous few hundred works of the early 1970s are now regarded as icons of Australian art and avidly collected, the cultural issues that surround them remain essentially unchanged. Yet the criterion of censorship for sacred images is a constantly shifting ground, much like the vast inland deserts of the artists' homelands.

Aboriginal culture, in all its plurality, is not a static entity, to be captured, prized, and prodded—or neatly categorized. As a living and dynamic entity, it resists easy definition, especially in the uncharted waters of the sacred. A few of the images that were sanctioned for exhibition and publication in *Genesis and Genius* may now not be shown, and any reprint would omit them. For *Icons of the Desert: Early Aboriginal Painting from Papunya* the collectors John and Barbara Wilkerson of New York, their curators, and advisors engaged in a process of careful consultation with communities in Central Australia. As a result of this discussion, all images have been cleared for exhibition abroad where it is unlikely that immediate family of the artists and related cultural custodians will find the showing of the images to be problematic. The format of the catalogue also respects the wishes of the artists by limiting the exposure of certain images and providing an opportunity for the sensitive works to be removed from the catalogue for Australian distribution.

Culture, in its many forms, is intrinsic to our lives, whether we live in Milikapiti or Melbourne, Perth or Papunya. Saltwater or freshwater, city or country, rainforest or desert. We live it and breathe it. It is our most precious heirloom to hand on to our descendants; and it has sustained us as a people throughout history. The authority over our heritage is solely invested in the senior custodians of our communities, who govern this infinitely complex cultural matrix.

HETTI PERKINS
Senior Curator, Aboriginal and Torres Strait Islander Art
Art Gallery of New South Wales

[1] Chip Morgan (Department of Aboriginal Affairs field officer at Papunya in 1975), quoted in Peter Read, *Charles Perkins: A Biography* (Australia: Penguin Books, 2001), 220.

[2] In conversation with the author, June 2007 during a site visit for the Biennale of Sydney, 2008.

THE MEN'S PAINTING ROOM
at **Papunya** winter 1972

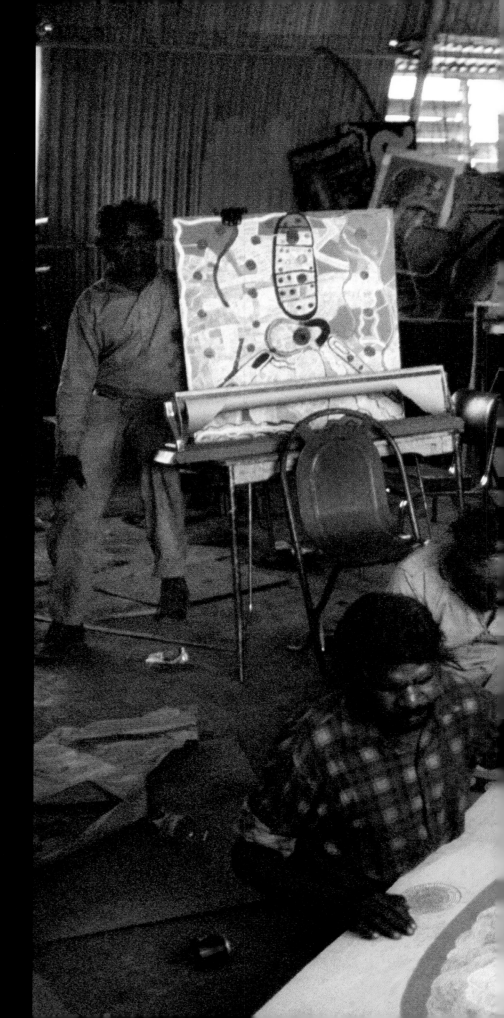

t was during a period of very wet weather that the landscape photographer and photojournalist Michael Jensen first visited Papunya. Trained in Denmark, Jensen had emigrated to Australia in 1966 and was based in Darwin from 1970 to 1974. He had visited the Warlpiri community of Yuendumu as a friend of Harry Tjakamarra, Michael Nelson's brother, and it was through Tjakamarra that he was invited to Papunya. Jensen recalls the extraordinary weather on his trip south from Darwin, with the Stuart Highway cut by floodwaters. At Alice Springs, the Todd River was in flood—an extremely rare event. Jensen drove to Papunya with a freelance journalist from Sydney, and they stayed overnight in a collapsible hut.

The suite of color photographs Jensen took are a precious record of the activity in the men's painting room in the former Town Hall—a vast corrugated iron hangar—which Geoffrey Bardon dubbed the "Great Painting Room." Bardon, who came from Sydney to Papunya in January 1971 to serve as the community's schoolteacher, and who first provided Aboriginal law-men there with painting materials, had already resigned his position by the time of Jensen's visit. The date of Jensen's suite is not yet sure, but black-and-white photographs by a photographer from Melbourne's *Sun Pictorial* (also published in this catalogue) date to July 14, 1972, when a parliamentary delegation visited Papunya. On the basis of the paintings and notice board items accumulating in the background, I suggest Jensen's photos were made several weeks later.

This moment is one of the high points in early Papunya art. Johnny Warangkula Tjupurrula, revealed as a man with a flashing smile and a flamboyant head of black hair, appears joyous as he paints his masterpiece, *Water Dreaming at Kalipinypa*. Old Walter Tjampitjinpa is also painting such a Water Dreaming story, as is Shorty Lungkarta Tjungurrayi. The link between these paintings and the concurrent rain and storms seems clear (it could indeed be argued the paintings were working to *bring about* the wet). By serendipity, all three works are now held in the Wilkerson collection.

In the photos the men work with concentration, or hold their boards like blazons of honor and religious belief. Warangkula's work is only partially covered with the stippling with which he disguised sensitive imagery; Clifford Possum Tjapaltjarri's is half laid out. Behind the men, a notice board bears the names of the principal artists. Photos of artists and family have been pinned up in large numbers. Several are by Allan Scott, the photographer commissioned by Bardon. A plethora of unsold paintings is visible, many still unidentified. Painted *coolamons* and a landscape watercolor in the Hermannsburg style (probably by Kaapa Tjampitjinpa) are also visible in this Aladdin's Cave of art.

—ROGER BENJAMIN

Group portrait, Men's Painting Room, Papunya, August 1972
(Back row, from left) Johnny Warangkula Tjupurrula with *Water Dreaming at Kalipinypa* (cat. 27), Tim Payungka Tjapangarti, Charlie Tarawa (Tjaruru) Tjungurrayi with decorated spears, Mick Namararri Tjapaltjarri *(Front row, from left)* Clifford Possum Tjapaltjarri with *Honey Ant Dreaming* (Collection of the Art Gallery of South Australia), unidentified artist (probably Yala Yala Gibbs Tjungurrayi), Shorty Lungkarta Tjungurrayi with *Classic Pintupi Water Dreaming* (cat. 25), unidentified artist, Kaapa Mbitjana Tjampitjinpa hidden by a version of *Budgerigar Dreaming* (his fingertips are visible at the top of the painting) *Photos © Michael Jensen*

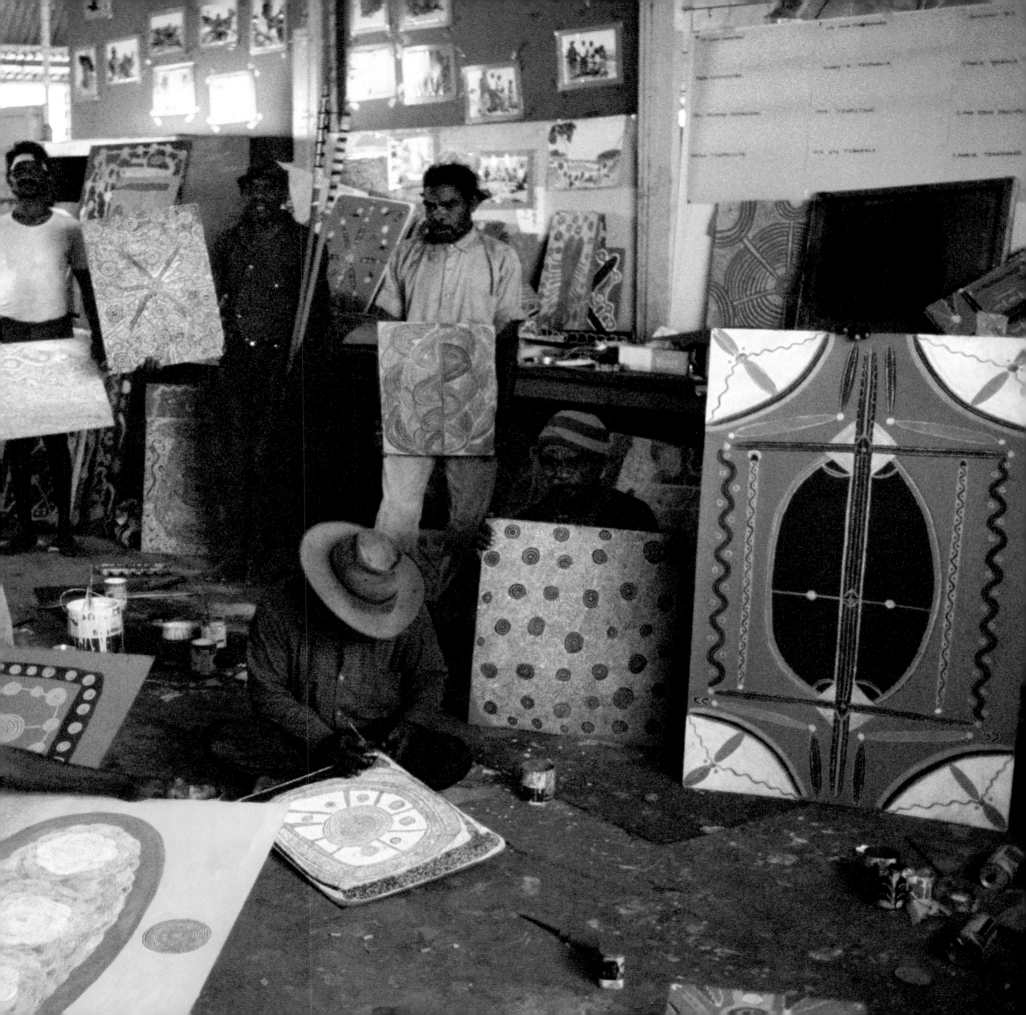

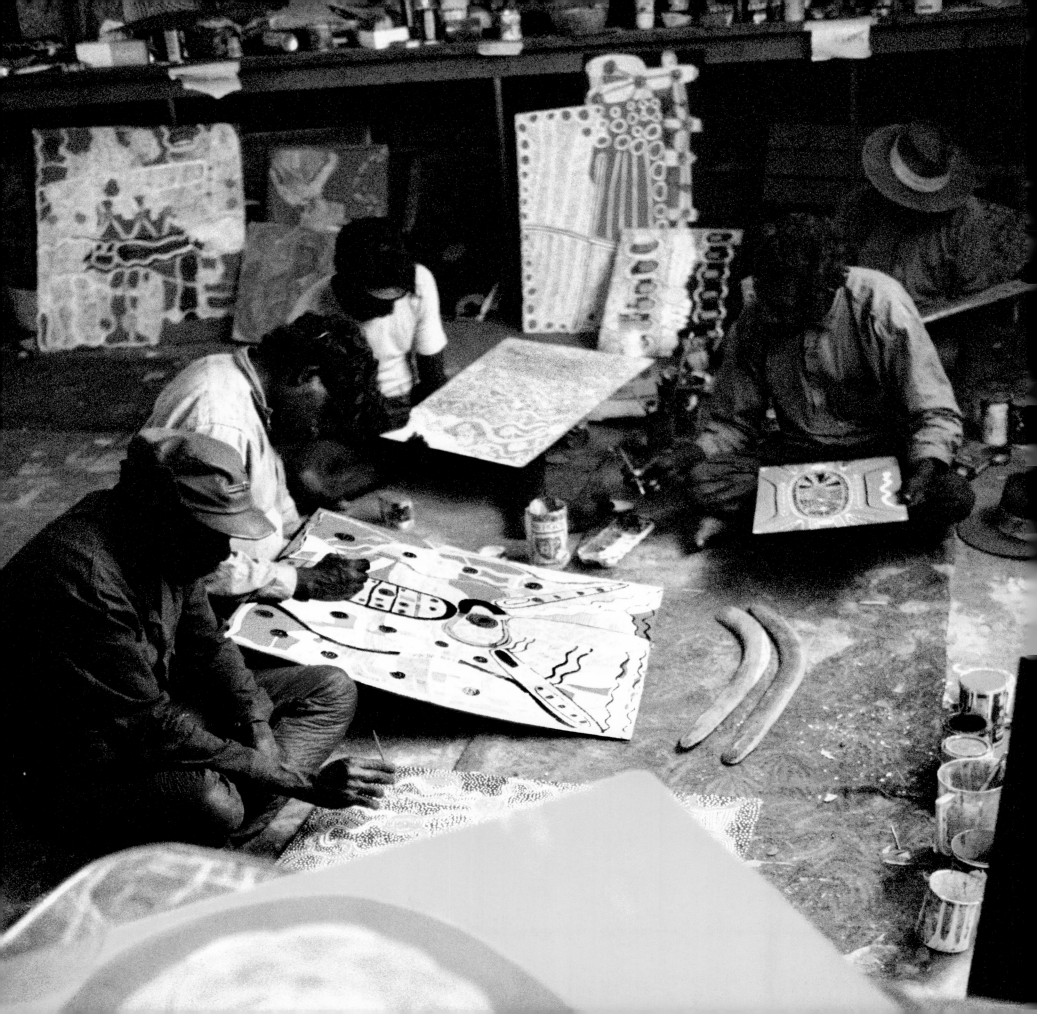

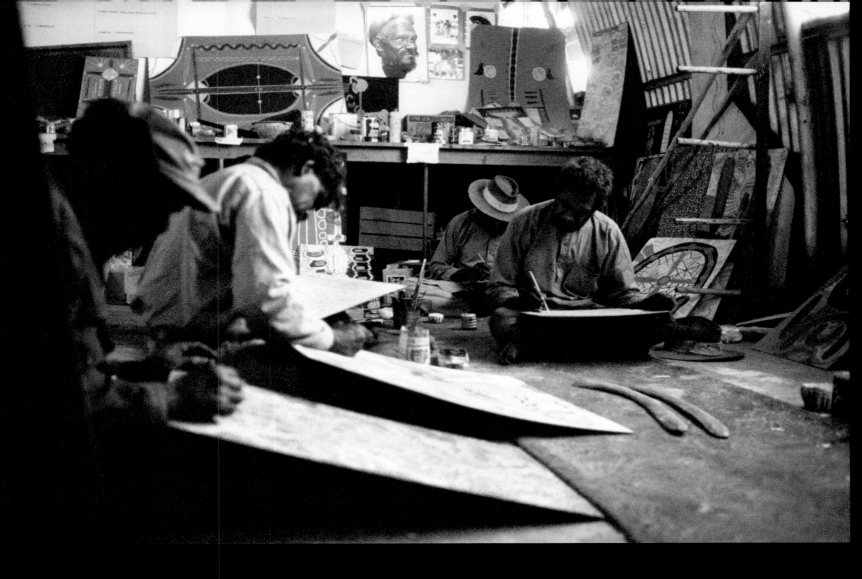

▲ *(From left)* Charlie Tarawa
(Tjaruru) Tjungurrayi,
Johnny Warangkula
Tjupurrula, Old Walter
Tjampitjinpa, Kaapa
Mbitjana Tjampitjinpa. Note
"number 7" boomerangs
(used as clapsticks), and
portrait photographs by
Allan Scott on rear wall.

From left) Charlie Tarawa
(ruru) Tjungurrayi,
nny Warangkula
purrula with *Water
aming at Kalipinypa
. 27)*, Tim Payungka
oangati, Kaapa
mpitjinpa with *Children's
y* (Sotheby's, October
2008, lot 97), Old Walter

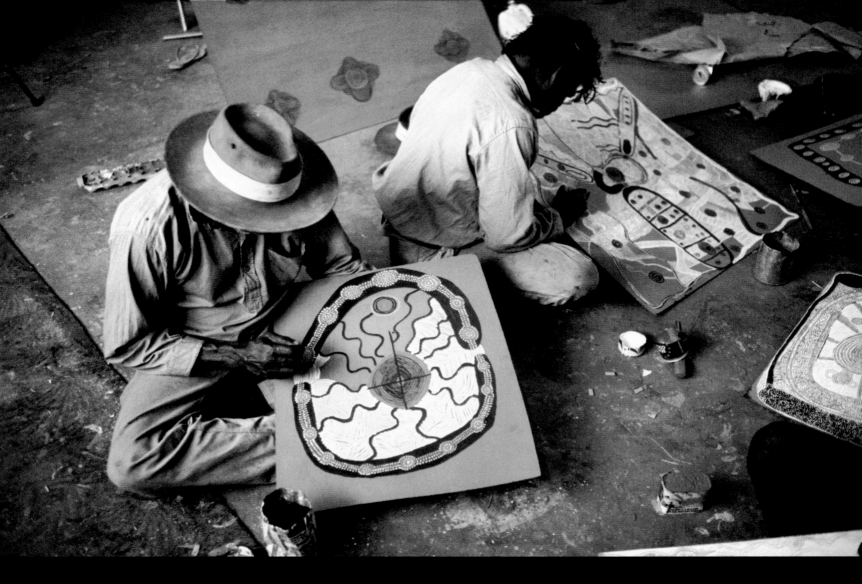

▲ *(From left)* Old Walter
Tjampitjinpa with
*Rainbow and Water
Story* (cat. 26), Johnny
Warangkula Tjupurrula
with *Water Dreaming at
Kalipinypa* (cat. 27)

**Inside our tin shed Town Hall, fire, earth, wind
and water were being re-created within a set
of ideas and signs and season cycles of the
black men. . . . Outside the rain made a glass-
like shimmer on the Belt Range. There would
be splashing of rain drops on the stale dust
and sand at the Outpost; then nodding, Old
Walter would briefly tell me that he was the
Water Man himself.**

—Geoffrey Bardon, "The Great Painting Room: Like Warriors of Old" (2004)

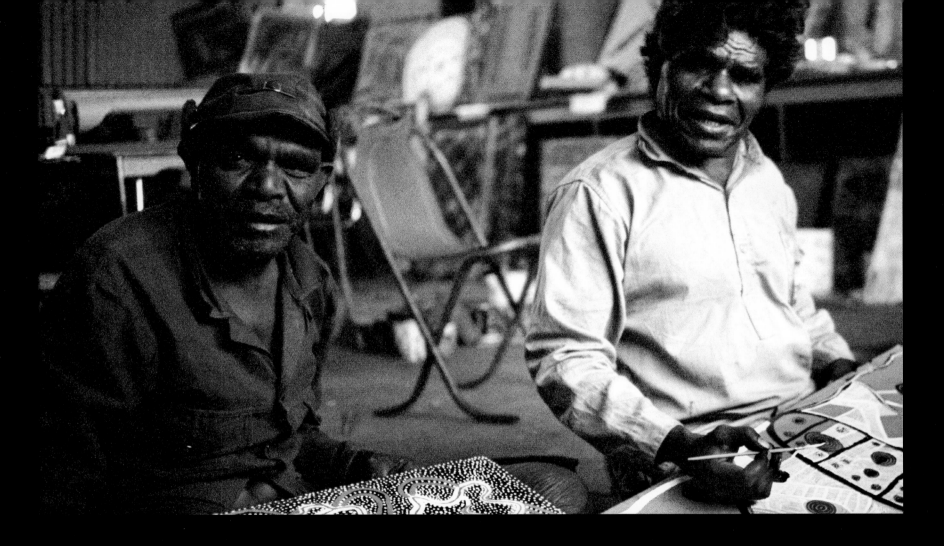

▲ Charlie Tarawa (Tjaruru)
Tjungurrayi and Johnny
Warangkula Tjupurrula

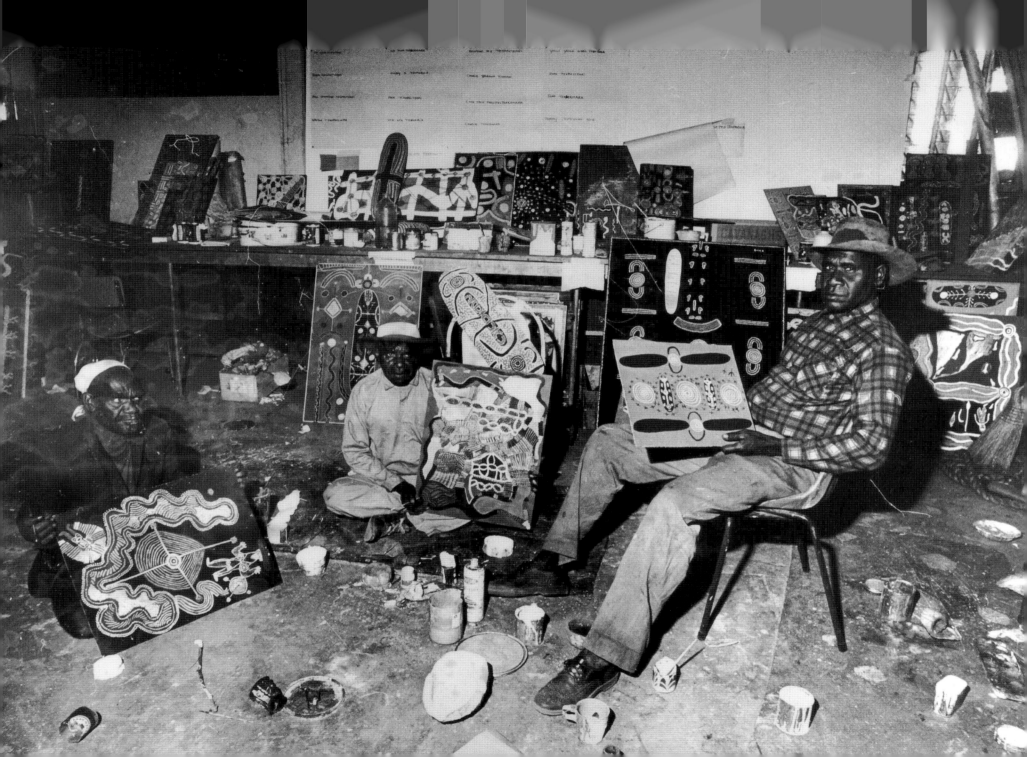

THE FETISH FOR
Papunya boards

ROGER BENJAMIN

In two or three generations' time—perhaps sooner—young aboriginal artists may begin to use again spirals, lines and circles in a new geometrical form of *abstract art*. 　　　　　　—T. G. H. Strehlow, 1956

I go to school every day, learn, and I saw old people down at camp painting. They start painting, you know, with little board. They put dot painting and they learn, you know, they're slowly learning, learning, bigger and bigger, it was 1974, 1975, yeah.
　　　　　　—Bobby West Tjupurrula, 2007

◀ Men's Painting Room, Papunya, ca. July 14, 1972 *(photographer unknown)*

(From left) Uta Uta Tjangala holding *Children's Story for Girls* (see Bardon and Bardon, page 499); Johnny Warangkula Tjupurrula holding a Water Dreaming painting; Long Jack Phillipus Tjakamarra holding an unidentified work

I. Introduction[1]

Beauty has many forms, but it is not every day that a new kind of beauty is born to the world. Such is the achievement of the painters of Papunya from Central Australia. Theirs was a strange beauty, unlike anything seen before by the white people who were among its first admirers. On small rectangles of cheap brown masonite, they wove intricate traceries of waving lines, circles, and dots. Their painted forms were not haphazard; instead, they had the inestimable advantage of drawing on millennia of culture and tradition.

It is hard to hold in the mind that, when looking at these small, abstract-looking pictures in earth colors, you have before you both a vital contribution to contemporary art and something with ancient sources. Early Papunya art had a continuity with mark-making, song cycles, and story-telling that goes back before the invention of cuneiform writing in the Fertile Crescent or the picture-writing of Egyptian hieroglyphics. Unlike those forms of writing, the concentric roundels, U-shapes, and regular waving lines like those one sees here were carved into the stone surfaces of rock engravings that have been carbon-dated back well over ten thousand years. The men who made the boards in 1971–72

are descendants of those original makers (fig. 1). By a miraculous strength of culture and a social organization of genius in a fragile desert ecology, they have adapted their way of life and the rich meaning of their image-making to changing conditions. Not for nothing is Aboriginal culture called the oldest continuous culture in the world.[2]

This survival is in the face of an assault that has been gradual yet relentless: the assault of a colonial incursion similar to that of white men impinging on the lands of Native Americans and Canadian First Peoples. Aboriginal people, numbering perhaps one million across a land mass as great as the continental U. S., with over two hundred and fifty distinct languages separating them, seldom had the numbers to oppose the settlers from Europe by anything other than local guerrilla wars using spears, shields, and fire. In the fertile southeast and southwest of Australia and on the great arc of the east coast, they were pushed aside, swept away: decimated by imported diseases, shot out in organized hunts and massacres, reduced to poverty, alcoholism and the madness of self-directed violence.[3] In the twentieth century, the life of the church mission and the government reservation, the bureaucracy of assimilation, the extinction of languages—the story is familiar to both continents. In Australia we have only recently seen government take responsibility

for the crimes of failed programs in which young Indigenous children were forcibly removed from their parents (a practice continuing into the 1970s). In the first official apology for the plight of the "Stolen Generations," in 2008, Prime Minister Kevin Rudd described the policies of removal as "a blight on the nation's soul."[4]

Strangely, however, the vastness and aridity of this land has also protected its original inhabitants. In an ethnically diverse nation of just twenty million, almost ninety percent cling to the coastal fringe of cities. The Northern Territory (in which Alice Springs and Papunya are situated) is a tract of land the size of Texas and California put together, yet it has only two hundred and fifteen thousand inhabitants. Unlike the general Australian population (three percent are of Indigenous descent), almost one third of the "Territorians" are Indigenous. In tropical Arnhem Land, home of the Yolngu, Kunwinjku, and dozens of other language-groups, Indigenous culture and law are strong indeed and art-making (in ochres on bark sheets) has been practiced at least since the start of the twentieth century. In the Central and Western deserts, in the country of the Warlpiri, Pintupi, Luritja, Anmatyerre, Arrernte, and other peoples, there are far-flung communities famous for an art-making that is an extension of traditional culture: Yuendumu, Balgo, Lajamanu, Kintore, Kiwirrkura, Papunya, Hermannsburg, Utopia, and the large town of Alice Springs. The words of the Aboriginal rock band No Fixed Address, "We have survived . . . the White Man's world," continue to ring true.

This great movement of painting culture began at Papunya, seemingly at a precise time—July and August of 1971—and with a specific work: the communal painting of a Honey Ant Dreaming on the whitewashed wall of the local school (fig. 2), that followed several smaller trial murals.[5]

Stories of "beginnings" often mask a complex truth. The advent of Papunya art is sometimes seen as a "genesis" of a Biblical kind, with a prophet-like figure, the white art teacher Geoffrey Bardon from distant Sydney, providing a divine spark to the Aboriginal men of Papunya. The earliest printed version of Bardon's story comes from an anonymous text printed on the labels of the Stuart Art Centre when he was still the inaugural art advisor at Papunya:

> Now, Geoff Bardon, a talented young artist at present teaching at Papunya has shown the Wailbri and Pintupi tribesmen how to reproduce this art form [sand mosaics] on boards using commercial paints. The result has been overpowering. Myths, legends, stories, conversations, invocations, medical lore, jokes, have all emerged from these peoples who, until now, with their very limited English vocabulary, lacked the means of communicating with us in any great depth.[6]

The need to recognize the agency of the Indigenous men at Papunya as weighed against the intervention of Bardon is already apparent in this text, and it remains a political as well as historical question today.[7] The author (presumably Bardon or Pat Hogan) realized that the early art of Papunya was a transfer of graphic and painterly practices from one cultural realm—that of ceremonial performance and narrative elaboration—to another.[8] She was most likely unaware that in the 1930s and '40s several people, including the amateur anthropologists Charles Mountford and Norman Tindale (working with Pintupi and Arrernte), Olive Pink (working in Alice Springs and with the Warlpiri), and teachers in Ernabella, had provided Central Desert people with

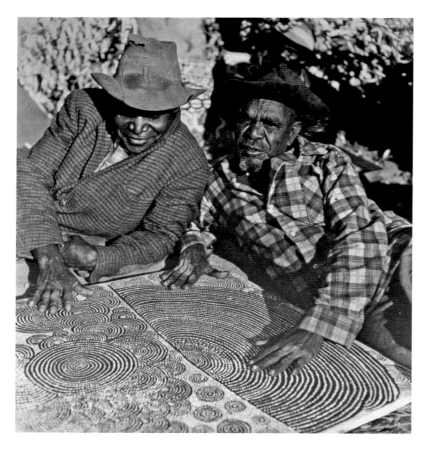

FIGURE 1.
Freddie West Tjakamarra and Charlie Tarawa Tjungurrayi touching and recounting Shorty Lungkarta Tjungurrayi's *Homeland Dreaming*, 1973.

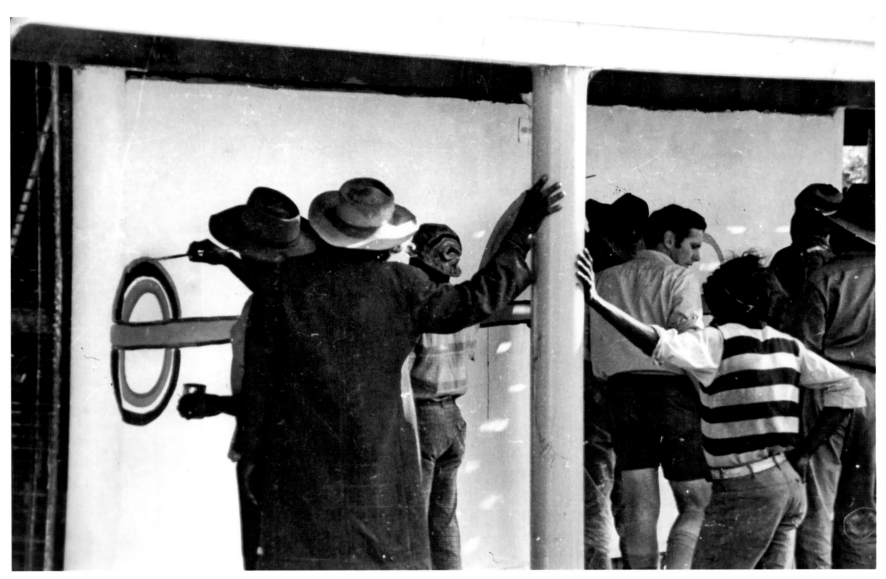

FIGURE 2.
Work in progress on the Honey Ant Mural, Papunya, June–August 1971. Painters visible include Billy Stockman Tjapaltjarri and Long Jack Phillipus Tjakamarra (wearing knit hats); Old Mick Tjakamarra (wearing an overcoat) and teacher John Redman (wearing shorts) observe.

drawing materials—usually colored chalk or pastels and paper—and had elicited drawings that presage almost exactly the kinds of designs seen in 1971.[9]

What was decisive was the new quality of robust permanence conferred on the painters' marks by acrylic paints applied to pieces of masonite board. Suddenly there was an object that could be sold to others, and carried, posted or shipped indefinite distances—in sum, a new commodity, with which the long-established yet antimaterialistic culture could communicate with the outside world. Another early observer of the art, the teacher, historian, and amateur ethnographer R. G. (Dick) Kimber, recognized the full social import of the new painting:

The Papunya Tula Artists' adapted paintings provide the same strengths and pleasures as do the ground mosaics which originally inspired them. They assist in maintaining social order and responsibility, give pleasure in their creation, act as supports for mythological tradition, bring to mind important food and water supplies, and focus attention on the importance of tribal lands. Furthermore, they provide practical financial help for the artists and, in their acknowledgment as works of art, promote pride and dignity.[10]

It is the Papunya boards themselves that are the focus of this exhibition.

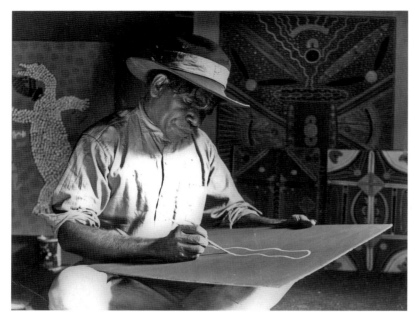

FIGURE 3.
Johnny Warangkula Tjupurrula at work in the Men's Painting Room, Papunya, 1972.

The collection proposes that, in effect, Papunya boards are a distinct aesthetic category. They are so in virtue of several attributes that distinguish them from the paintings on canvas that became standard from 1973. In that year, increasing sales and government funds enabled Papunya Tula's art advisor at the time, Peter Fannin, to purchase this canvas support, with its supposedly superior durability, ease of transport, and above all its likelihood of being understood *as art* by the White world.

First, the boards are a distinct *physical* category. They are a finite and relatively small group of works. Vivien Johnson, who is producing a digital database and a book on the subject, estimates that a maximum of one thousand works were produced on board before the introduction of canvases and stretchers in 1973.[11] Their rarity is closely linked to their value as collectibles. The boards also share the peculiarity that not all of them are perfectly rectangular, but may present eccentric four-sided, or even ovoid surfaces to the artist (see cat. 28). Chocolate-brown "masonite" (pressed from dyed wood pulp) was popular as a building material in Australia at the time, as was a yellowish composition board. Random materials like ceramic tiles, laminex scrap, and sawn-up tabletops were painted on at first. Masonite could even be found in the door panels of the Australian-made Holdens and Fords beloved of Aboriginal people for travel to visit country or relatives (to buy an old used car was often the priority when painters began selling boards).[12] All of these unorthodox, irregular painting supports give a homespun, provisional effect to the earliest works. This was opposed to the systematic, crisp look of the modern-day canvases painted on stretchers, later demounted and rolled up for transport to distant art galleries.

Second, the boards possess an *aesthetic* distinctiveness. Although they are small in scale, many are intricate in design. They exhibit such a startling

variety of designs that no two appear to be the same. This is no less a question of graphic inventiveness than theological and cultural expansiveness, as each of the two dozen painters set about interpreting the numerous stories he was entitled to use. There are two social roles at stake in ceremony or painting: *kirda*, or "owner" of a Dreaming, and *kurdungulu*, the "worker" or "manager" who gives guidance to or oversees *kirda* as they execute the ceremony or sand mosaic painting.[13] A system of permission, mutual obligation, and supervision ensures a certain commonality of design in Aboriginal art (whether it be executed by men, as in Papunya prior to the 1980s, or men and women). This system persists today in an era when women are as strong as men in the community of painters.[14]

There is however also a question of one-person languages or graphic idiolects at play in the distinctiveness of early boards. Whereas the ceremonial sand paintings are executed by teams of men or women, and body paint for ceremony is applied according to *kirda/kurdungulu* protocols of reciprocity (with a strict separation of gender), these small boards usually only admitted of one artist, one paintbrush. As a result you get the advent of "style"—in the classical sense of the word, as a graphic characteristic proper to one person. (In the West the term "style" had its origins in reference to orthography, as mark-making thought proper to a person's temperament.) As artists like Johnny Warangkula Tjupurrula (fig. 3), Tim Leura, or Kaapa Tjampitjinpa painted more and more, the more their work looked like their own alone, especially in these early years before the introduction of canvas.[15]

The quality of aesthetic distinctiveness within the corpus of Boards is less true of later Papunya works. Fred Myers's explanation is compelling: that a greater uniformity in pattern-making and motif in the canvases is due in part to the move away from divulging sacred visual information. After the grave dispute over painting at the Yuendumu Sports Weekend event of late 1972 (which Myers discusses in his essay on Shorty Lungkarta Tjungurrayi in this volume), there was a kind of recision, a communal consolidation around a more limited range of visual materials.[16] In my view, this censoring was not really a negative, but an adjustment of practice. Traditional compensation was offered to the aggrieved parties for harm done. Over the next few years the artists drew upon their license to interpret stories to elaborate a new set of visual premises. The situation also compelled a standardization of orthography and the identification of major Dreamings that asserted ownership of country: in short, a new communality of imagery arose. In conjunction with artists' access to ever-bigger canvases, this led to spectacular and unexampled results.

Third, the Boards are a very particular affective category: a *dangerous one.* This issue needs to be explained fully here, as it has had a direct impact on the organization of this exhibition. Dangerous for whom? The answer is, for Aboriginal people who may not have the right to know the details of certain stories. Indigenous religious knowledge in many Australian societies is based on a hierarchy of initiation into levels of information. Usually only fully initiated men or women with recognized competence earn the privilege of having the depth of meaning of certain Dreamings conveyed to them by the custodians of that Dreaming, meanings which they must hold in binding confidence.[17]

There are some stories that expose the inadvertent witness or viewer of an important ceremony to severe consequences. Space in Aboriginal communities is strictly controlled: for example, when certain men's ceremonies

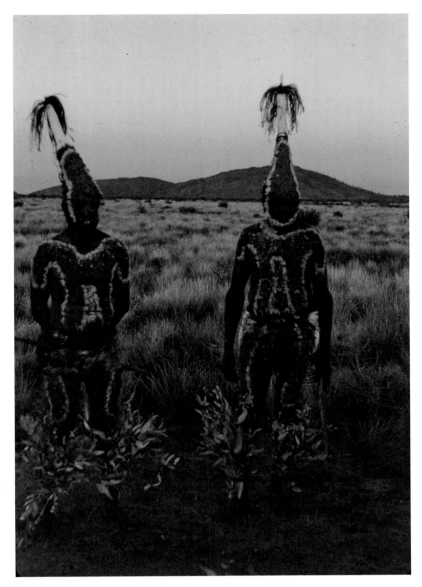

FIGURE 4.
Public Possum Ceremony, performed by Tim Leura Tjapaltjarri and Old Henry Tjugardi Tjungurrayi for purposes of filming, 1973.

are being held, women, small children, and uninitiated older children are not allowed to approach the ceremony ground, on pain of physical punishment. Certain transgressions can result in social repercussions, illness, ritual spearing, or even death. Equally, the wrong people seeing sacred objects (such as the ovoid stones or hardwood boards with incised patterns known in Central Australia as *tjurungas*) constitutes a similar offense.

By extension, to see painted representations of people performing secret ceremonies (fig. 4), or representations of powerful ritual objects (such as *tjurungas*, or the small boards swung in the air to call out to the Ancestors and warn of ceremony, or the other sacred display objects constructed to rise from the ground as part of a sand mosaic) is also taboo within the strict Indigenous context.[18] Only those familiar with the Law in relevant communities are able to judge when there is "cultural harm"—to use the current legal term—inherent in the image.[19]

The organizers of *Icons of the Desert* have, through the good offices of Dick Kimber of Alice Springs, recently consulted members of the Pintupi and Warlpiri community about the range of images proposed for view within the exhibition. The result was that a group of some nine paintings were considered to pose a threat to unwitting Indigenous viewers. They either show figures enacting ceremony or ceremonial objects in too explicit a fashion. These nine early boards were not recommended for display or reproduction within Australia; however they were approved for the United States, where the elders considered it very unlikely Central Australian Aborigines would see them. This policy is an extension of the practice used in state museums, of having a secure secret/sacred store for ritual objects in the collections. Usually only one curator has access to such a store, and carefully vets visitors in consultation with the community concerned.[20] In some exhibitions of Aboriginal art in the past, viewing rooms warning certain members of the community not to enter have been built as another way of handling this issue of cultural harm.

In sum, some of the paintings in this exhibition are once again understood by community elders to have breached desert protocols for divulging sacred information. By the non-Indigenous they should be considered with due respect for their ritual authority, although this can only be understood very schematically. It remains as a kind of aura, and I believe adds to the visual power that these small jewellike works project. A sense of the extra-aesthetic understanding that Central Desert people had of the boards is clear in Allan Scott's beautiful photograph of two artists retracing the designs with their fingers (see fig. 1). Such scenes, sometimes captured on film and still to be witnessed today (often when artists are alone with their pictures), make it clear that these objects are much more than "paintings" as the West understands them. It is as if, in such retracing, the artists are performing the ephemeral narrative accompaniment to story that is sand drawing. Origins in the sense of touch led Bardon to define this as the "haptic" quality of the art. At the same time there is a musical and oral performance, since there may be the singing of songs, use of hand signals or spoken retelling of stories that accompany the Dreaming at hand.[21]

Fourth, the nature of the boards in the teleology of art marks them out for special status. In Western culture there is a reverence for first things, for the forerunner in matters of invention. This is a function of hindsight, of course—only once a phenomenon has gained acceptance and prestige will its antecedents come to occupy such a place.

An awareness that the boards hold a special place in the history of the movement shows in the program for collecting agreed upon in 1996 by the Melbourne gallerist Irene Sutton and the Wilkersons (whom she began advising after meeting at the Gramercy Art Fair in New York City).[22] It confirmed a fact of criticism and curatorship already evident. Examples include the spatially separate display early Papunya works were given in the 1980s at the National Gallery of Victoria by the curators Ann-Marie Brody and her successor, Judith Ryan. A similar strategy was in place at Lauraine Diggins's installation at the Westpac Gallery Melbourne in 1989.[23] The greatest display to date was in the

first two rooms of the comprehensive survey *Papunya Tula: Genesis and Genius* at the Art Gallery of New South Wales in 2000, where curators Hetti Perkins and Ken Watson allocated some sixty boards to the first two rooms (fig. 5).

The separate display of boards remains a widespread curatorial practice today, for example in the stellar group of boards from the Papunya Community School Collection, now installed at the Araluen Arts Center, the main public museum in Alice Springs. Two small walls—the tip of the iceberg of the world's largest collection of almost two hundred and fifty early boards—are in place at the Museum and Art Galleries of the Northern Territory (MAGNT) in Darwin.

There is a developmental logic in the decision to collect and display a small number of later Papunya canvases of the 1980s and '90s. These works, where possible by artists already represented by early pieces in the exhibition, are meant to demonstrate something of the brilliant consequences of the initial paintings. The first group of large canvases was commissioned in 1974 by the Federal Government's Aboriginal Arts Board to provide funding support for the Papunya artists, and to procure artworks for display in Australian offices and embassies overseas.[24] This precedent for big pictures was compounded in 1976 with the commission of a big work for a television

documentary—the famous *Warlugulong* by the Tjapaltjarri brothers, Clifford Possum and Tim Leura (fig. 6).

Although they were at first reserved for important commissions, Papunya Tula began offering large canvases to the best artists as a commercial speculation under the impulse of the art advisors John Kean and Andrew Crocker at the end of the 1970s. From that time, Papunya Tula artists like Clifford Possum, Turkey Tolson Tjupurrula, and Anatjari Tjakamarra (by the early 1980s no longer living together in Papunya itself) had entered a new phase of formal experimentalism, clearly stimulated by the expanded surfaces of big pictures. Only the biggest of all Papunya canvases, Tim Leura's "truck-sized" *Napperby Death Spirit Dreaming* (National Gallery of Victoria, 1980), painted flat out over tarpaulins spread as protection over the red dust of Papunya, approximated the scale of the larger temporary ground paintings made for ceremonies.

Early Papunya Boards owe a fifth distinctive characteristic to the art auction. In the title of the essay I invoke the idea of the "fetish" in relation to the boards. The term is loosely suited on a number of grounds, first of all because of the etymology of the word, a Portuguese term that refers to a totemic or

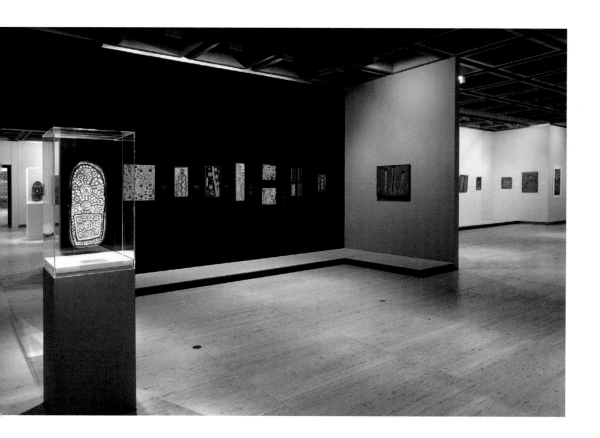

FIGURE 5.
Installation shot of room with boards in *Papunya Tula: Genesis and Genius*. Art Gallery of New South Wales, Sydney, 2000.

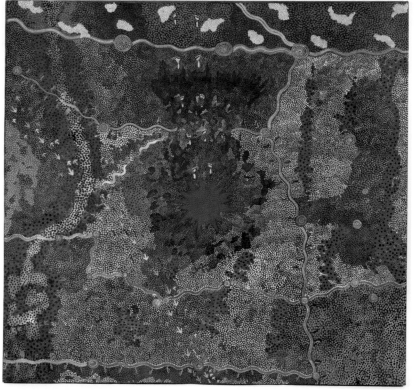

FIGURE 6.
Clifford Possum Tjapaltjarri, Tim Leura Tjapaltjarri, *Warlugulong*, 1976, synthetic polymer paint on canvas. Collection of the Art Gallery of New South Wales, purchased 1981.

religious endowment in small man-made objects (originally those from tribal Africa). The second sense is that of what Marxist tradition calls "commodity fetishism" (which partakes only marginally on the Freudian concept of the erotic fetish). Art auctions have a peculiar fiscal volatility that has raised the profile of Papunya Boards as collectibles par excellence. As Jean Baudrillard recognized long ago, in the scenario of the art auction, the standard categories of economic value—use value and exchange value—no longer apply. The auction instead becomes a kind of battle of wills between two or more desiring subjects generally endowed with considerable resources. Baudrillard coined the useful term "sumptuary value" to express the intangibles—such as the desire for social distinction, or the need to express an acquisitive impulse within a personal domain—that may contribute to the wild ride that can occur in the art auction. Sumptuary value is a domain of excess no longer tied to the humdrum of use values. A sort of gladiatorial dispute over the body of the artwork can sometimes take place in the peculiar theatrical environment of the live auction.[25]

Papunya Boards were the first category of Aboriginal art to shoot to prominence as the subject of art auction inflation. For almost a decade they held the record for prices paid, despite their small scale. Indeed the most famous painting exhibited here, Johnny Warangkula Tjupurrula's *Water Dreaming at Kalipinypa* (see cat. 27) was the specific painting that on two occasions took the world record for a price paid for an Aboriginal painting.

The first occasion was at Sotheby's in 1997, when a clever preauction campaign helped establish the exceptional nature of this picture. *Water Dreaming at Kalipinypa* is a work of unparalleled visual complexity, despite its modest scale: something like a page from the medieval *Book of Kells*. The buying price of AUD $202,000 more than doubled the previous record for an Aboriginal painting. The sale made front-page news in *The Age* newspaper.[26]

The pathos of the sale for journalists revolved around the fact that Johnny Warangkula had been located by the newspaper in Alice Springs, an elderly man who was destitute and sleeping rough with other Aborigines in the camps on the dry Todd riverbed. Tjupurrula had painted only sporadically since the mid–1980s, yet according to the story in the press, was proud that such a price had been paid for his picture. Although not mentioned in the article, high prices paid for works of remote Aboriginal art are often said by the artists to be an acknowledgment of the value and power of the Dreaming

Fame but no fortune for sweet dreaming artist

KATRINA STRICKLAND
MICHAEL REID

IT was a noisy old day at the Hetti Perkins Nursing Home in Alice Springs yesterday.

Resident Johnny Warangkula Tjupurrula, 83, had woken to the news that a painting he did in 1972 had set an indigenous art record when it sold on Monday night at a Sotheby's auction in Melbourne for $486,500. The man known as Johnny W was over the moon.

"I'm very famous, I'm very famous," he shouted to the nursing staff. "I'm number one, number one big-time artist."

His niece Pansy Nabanardi and her daughter Brenda Nungala had, upon hearing the news via *The Australian*, come to visit. His wife Gladys, they said, was back at Papunya.

"He's very excited," Ms Nungala said. "He deserves it, he's worked really hard all his life to support his family."

Acting nursing and care service manager, Toni Finan, said the news had been an enormous morale boost for Warangkula, who she said was regarded by most staff as a "delightful, cantankerous old man".

"He feels he's been recognised for who he is and what he does," she said.

Not that it was the first time for Warangkula. The same painting, Water Dreaming at Kalipinypa, set a record price for indigenous art in 1997 when Sotheby's sold it for $206,000. Back then, Warang-

‹ I'm number one, number one big-time artist ›

WARANGKULA TJUPURRULA

kula was destitute and sleeping in the Todd River, but his fortunes have improved. The attention surrounding the painting's 1997 sale inspired him to start painting again, which in turn led to a number of exhibitions in Alice Springs.

Earlier this year Warangkula moved into Hetti Perkins, a slick 40-bed nursing home for elderly indigenous people which opened last year. He no longer paints, largely due to his failing eyesight. Speaking through an interpreter yesterday, Warangkula said he would not mind a slice of the $486,000, having received only $150 for the work when he sold it decades ago to "get tucker".

Sotheby's indigenous art specialist Tim Klingender said records such as that set on Monday night did benefit artists even if they did not get a slice of the sale price.

"The painting sale places the artist firmly on the international map and highlights the western desert art movement as a whole ... (which will) raise the prices received by Aboriginal art centres for the artwork of their communities," he said.

Melbourne art dealer Irene Sutton, who bought the work, said yesterday she had done so on behalf of an American collector who had a significant Aboriginal art collection. He planned to hire an Australian curator to tour his collection in Australia and the US, she said.

The work will first be displayed at the Art Gallery of NSW's upcoming Papunya Tula exhibition, which opens mid-August.

FIGURE 7.
Newspaper article on Johnny Warangkula Tjupurrula, *The Australian*, June 28, 2000, page 3.

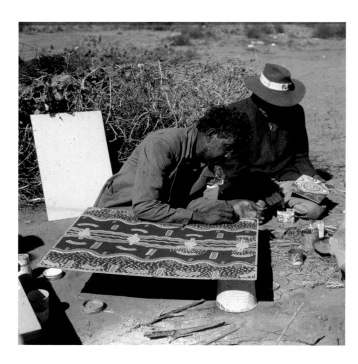

FIGURE 8.
Clifford Possum Tjapaltjarri, *Warlugulong,* 1977, synthetic polymer paint on canvas. National Gallery of Australia, Canberra. Purchased with the generous assistance of Roslynne Bracher and the Paspaley Family, David and Michelle Coe, Charles and Eva Curran 2007.

FIGURE 9.
Kaapa Tjampitjinpa (foreground) working on a painting for Allan Scott.

represented, and are thus considered entirely fitting.

Water Dreaming at Kalipinypa came onto the auction market again four years later, in 2000. On that occasion it again set a new record price of AUD $486,500. The discussion in the press (fig. 7) was more focused around the lack of any mechanism for profits on the resale of this and other Aboriginal works to go back to the artist or his community.[27] This debate on a resale royalty (or *droit de suite*) continues to be a topical issue in Australia, where such a law was recommended in the 2003 Myer Report on the visual arts industries. In 2005 legislation was proposed at the federal level by the Indigenous senator Aden Ridgeway, but rejected by the conservative government of John Howard and his attorney-general, Phillip Ruddock. This put Australia at odds with the European Union, which had imposed a resale royalty on art in 2001 (the United Kingdom did so in 2006). In 2008 the new Labor government has undertaken to introduce a resale royalty in Australia.

The 2000 record price for Warangkula has been easily exceeded, first by a canvas by Rover Thomas of Turkey Creek fame purchased by the National Gallery of Australia in 2001, then by a mural-sized Emily Kame Kngwarreye (which exceeded one million Australian dollars). Most recently, Clifford Possum's mural-sized "map-painting" *Warlugulong* (fig. 8) sold to the National Gallery of Australia for $2.4 million in 2007.

Thus Papunya Boards, including several in this collection, have the historic status of having led the development of a secondary market for Aboriginal art in Australia.[28] Despite the system's shortcomings, this market has, I believe, stimulated the spread of painting from remote community to remote community by providing a central index of value—a kind of art bank— that underwrites the public fascination with this new source of aesthetic and cultural experience, both in Australia and overseas.

2. The School of Kaapa

Kaapa Tjampitjinpa was painting before I arrived at Papunya [fig. 9]. He used scrap wood, fibro cement sheets and school slates, and had been dismissed as a school yardman for allegedly stealing brushes. The painting movement was built around this man's compulsive will and extraordinary ability to paint. . . . Kaapa consistently allowed the secular and the sacred to clash in his symbology.
—Geoffrey Bardon, *Papunya Tula: Art of the Western Desert,* 1991

One of the most interesting groups of pictures in this exhibition is one I would qualify as "transitional," in that they use representational schema one could call "whitefella" as well as "blackfella." These pictures are richly cross-cultural documents. In most of Geoffrey Bardon's publications, he considered it a point of importance that he encouraged the painters to be true to what he thought of as their own culture and its graphic systems: "When attempting to

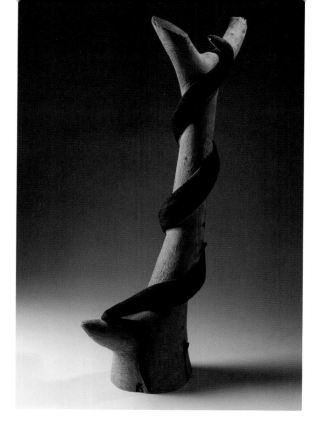

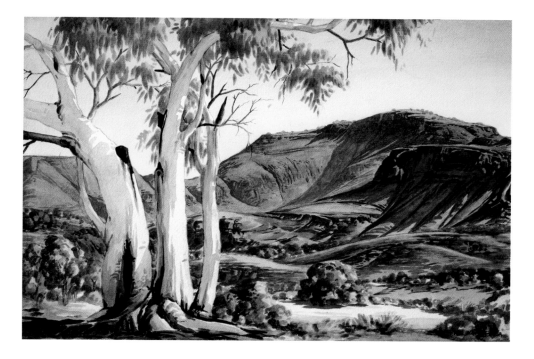

FIGURE 10.
Clifford Possum Tjapaltjarri, *Carved Snake*, 1973. Collection of
the National Museum of Australia.

FIGURE 11.
Albert Namatjira, *In the Ranges, Mount Hermannsburg*, ca. 1950, watercolor and pencil on paper.
Private collection. Courtesy of Legend Press.

lift the spirits of the Aboriginal painters I would ask for 'good paintings to beat
the white fellow painter'. . . . By my insisting on slow careful work with good
stories, the men developed an inspired concentration. They understood the
advice not to use any signs or colors that were 'whitefella.'"[29]

There is perhaps a certain idealism in his injunction, as the very fact of
encouraging pictures of this kind was already a major concession to "white-
fella" desires and materialistic collecting practices. A point of importance is
that three Papunya-based men, the Anmatyerre stockman Kaapa Tjampitinpa
and his cousins Clifford Possum Tjapaltjarri and Tim Leura Tjapaltjarri, had
considerable experience as artists before Bardon appeared on the scene.[30]
Wood carving was of course a major technology in traditional desert life for
the making of domestic implements and weapons. Hermannsburg Mission
(south of Papunya) had promoted plaque carving and the sculpting of small
native animals earlier in the century. At Mount Allan Station to the north, the
owner D. D. Smith had promoted plaques and naturalistic timber-carvings by
stockmen (fig. 10). Such carvings, made by a wide range of artists, were still
readily available in Alice Springs throughout the 1970s. (A wide variety of com-
mercial carving of native animals and weapons continues to this day at places
like Maruku Arts at Uluru.)[31]

Kaapa, Tim Leura, and Clifford Possum had all worked at Mount Allan
Station. As Johnson has emphasized, they understood the concept of the pro-
fessional artist from their acquaintance with the first Aboriginal man to be-

come famous as a painter, Albert Namatjira (fig. 11). Namatjira was an initiated
Arrernte man who had been raised further south on the Lutheran mission of
Hermannsburg early in the century, and had established a school of natural-
istic landscape painting in watercolors that became a popular feature of mid-
twentieth-century visual culture in Australia.[32] Namatjira's work was sold both
in Alice Springs and through outlets in the coastal cities, and his paintings and
those of his many relatives were widely reproduced. Indeed, the Hermannsburg
landscape style continues to this day. In the mid–1950s at Glen Helen Station,
Namatjira had recognized the talent of the young Clifford Possum and asked
him to join with him in painting the landscape. Possum refused, recalling:
"See—Namatjira asked me, 'You want learn watercolor painting, carry on my
work?' But I said, 'No, no. I do it my way. Carving—start from carving.'"[33]

Thus, when painting on permanent surfaces began at Papunya, first
with the School murals and then on small boards, there were experienced art-
ists on hand even if they did not initially come forward to engage with Geoffrey
Bardon. As Tim Leura later put it, he "was watching" Bardon for some months
before asking his cousin Kaapa (who had worked on the murals) to introduce
the two men; Leura then introduced Clifford Possum to Bardon. When Clifford
Possum first sat down in 1972 to make a picture in the "Great Painting Room"
(as Bardon ironically dubbed a disused military hangar), the art teacher was
astonished at the work that resulted. He writes of *Emu Corroboree Man*: "His
first painting, an Emu Dreaming with a realistic corroboree man dancing as

the centerpiece, was quite spectacular. The painting showed super-lative skill and some European influences in the realism of the man and the emus."[34]

In Vivien Johnson's estimate:

The extraordinarily accomplished Emu Corroboree man which Clifford Possum produced for Geoffrey Bardon that first day, is more than one of the seminal Papunya boards. . . . In Clifford Possum's own life as an artist . . . it was an artistic breakthrough, to a new medium in which his decades of experience as a carver and painter of wooden sculptures would all come together. The precision of line and the steadiness of hand, the conjuring with three-dimensional spatial effects, but most of all the ability to visualize the final form of the work even before he had picked up his brush: these were the legacies of Clifford Possum's days as a wood carver. [35]

Emu Corroboree Man is indeed extraordinarily interesting to look at (see cat. 18 in the supplement). The work could be called heraldic, in that a series of conventional symbols are laid out in strict symmetry around a central axis. The only significant variant on this symmetry is the subtle *contrapposto* of the Emu Man himself, with his right knee akimbo and his ankle raised to imply movement. The sign for the Emu Dreaming appears on all twelve of the ceremonial boards on view: it consists of two lozenges with a bifurcated pair of shorter lozenges at each end, with each pair separated by a dotted roundel of four or five rings. Only the single short board behind the dancer's back shows different motifs. Discreetly placed around the edges of boards and painting grounds, the footprint of the Emu appears. Clifford's brother Tim Leura painted a ceremony man of almost identical pose and decoration in a surround of a dozen *tjurungas* of different motif, presumably around the same time. Comparing the two works, one can see why Tim Leura said of his brother, "I can't beat him."

The dynamism of *Emu Corroboree Man* results from a clash of two distinct optics. The first is the perspectival view created by the silhouettes of the dancer, his ceremonial apparatus, and the two flanking emus (each with its little ringed ground and the vertical of the ceremony pole). The drawing of the dancer's body is subtle enough to include the four fingertips of each hand grasping the short board from below. He has sparing body paint and a "nose-peg"—a bone ornament that pierces the septum—emblazoned with a tuft of feathers for the occasion. The tall conical headdress is of a kind visible in old photographs of ceremony; constructed of mud and vegetable materials, it has a fringe of emu tail feathers as a top tassel.

The ceremony boards that accompany this figure can be read in at least two ways: as a kind of magical environment in a space that is pictorial only; or as seen from above, with the boards laid on the sand of the ceremony-ground. Setting off the black silhouette of the man is a rectangle formed of panels of white lines, masterful in its dexterous control. If it represents "body painting" (as stated by the artist), then it is transposed from the body to a pictorial element in a move reminiscent of the panels of chest painting seen in Arnhem Land, or the breast and shoulder motifs on which Utopia women have always based their art. Yellow ochre-accented dabs of paint fill every inch of the surface that is not taken up by the ceremonial paraphernalia.

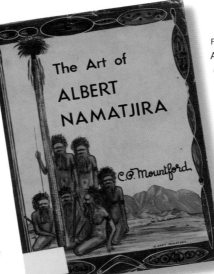

FIGURE 12.
Albert Namatjira, cover of C. P. Mountford, *The Art of Albert Namatjira* (Melbourne: Bread and Cheese Club), 1944. Courtesy of Legend Press.

The prime concept for this painting—a painted representation of the performance of a specific ceremony—was the form taken in a number of early boards from what Vivien Johnson calls the "School of Kaapa." This representational concept well and truly predates what Papunya artists themselves called "Bardon time."[36] A small number of Albert Namatjira's paintings and book illustrations of the late 1930s and early 1940s had something of this character, but he abandoned the practice presumably because it affronted issues of secrecy (fig. 12).

Yet this pictorial concept—the recording of a ceremony—resurfaced at Papunya. It is evident in the first of Kaapa Tjampitjinpa's paintings to win recognition from the professional art world: *Man's Ceremony for the Kangaroo "Gulgardi"* (not reproduced here because of its secret/sacred imagery). Jack Cooke, an assistant director of "the then equivalent to the federal department of Aboriginal Affairs," Dick Kimber recalled, "had been one of the few people highly impressed by the art and its potential for sales which would assist the Aboriginal people."[37] It was Cooke who entered Kaapa's painting in July 1971 for the Alice Springs Caltex Golden Jubilee Award. Kaapa became the first Aboriginal artist to share first prize with *"Gulgardi"*— an event which much encouraged his countrymen with the potential of the new art.

Well over a meter long and painted in watercolors on plywood, the work appears rather rudimentary by subsequent standards but sets out certain elements of the School of Kaapa: a monochrome background lacking any infill by dots or dashes, against which are set ceremonial objects in plan (here, short and long ceremonial poles), but with an implied vertical placement, and a realistically drawn human figure—the "special ceremonial man" painted up and wearing a headdress at the top of the picture.[38]

Following this success, some dozens of descriptive transitional works were painted between late 1971 and about mid–1972. Many were by Kaapa himself (especially if one includes his versions of the *Budgerigar Dreaming*, exemplified by cat. 19 in the supplement), several by Tim Leura (including his signature *Honey Ant Dreamings*) and a few by Clifford Possum and Long Jack Phillipus Tjakamarra of the Ngaliya/Warlpiri language groups. This proclivity reflects, according to Dick Kimber, such works' art-market appeal because they included "recognizable stylized-naturalistic animals or plants, and had a high degree of symmetry." Kimber explains this love of symmetry as partly a feature of Anmatyerre culture, and partly a proven taste developed earlier in previous decades with the carvings marketed successfully on Mount Allan Station.[39]

In addition to *Emu Corroboree Man*, the exhibition counts other works in this transitional manner (cats. 5, 17, and 19 in the supplement). All have been recently judged problematic by community elders for viewing by Aboriginal women and uninitiated men from Central Australia; in fact, an awareness of

the risky status of *Emu Corroboree Man* was made clear in its first American owner's recollections of Geoff Bardon's concerns when he bought it in 1972, and the later defensive view of the painting by Clifford Possum himself.[40]

Nevertheless, in the context of this American publication, we have community permission to exhibit and discuss these works within an artistic context. Painted several months after *Gulgardi* in 1971 is the large board *Mikanji* (formerly *Untitled*) by Kaapa (cat. 5 in the supplement), exhibited as catalogue number one in the historic *Dot and Circle* exhibition of 1985. Dick Kimber reports that it was one of the earliest group of six Papunya paintings offered for sale by Jack Cooke in Alice Springs in October 1971—"wonderful works with minutely detailed human figures and ceremonial regalia painted against black backgrounds." Although finding the works "extraordinarily beautiful" and himself purchasing this work now in the exhibited collection, Kimber also regarded them as "potentially dangerous."[41]

The group of works is, in my view, a clear aesthetic advance on "*Gulgardi*." *Mikanji* and a cognate work entitled *Kangaroo* owned by the Museums and Art Galleries of the Northern Territory (MAGNT) in Darwin share the same symmetrical schematization of a ceremonial scene, with "realistic" figures replaced by U-signs set around a central sand mosaic partitioned off by large ceremonial objects. Beyond this lie two large arrays of ground painting of an ampersandlike format. *Tjurungas*, bullroarers, and ceremonial poles topped with emu feathers are all in evidence. In catalogue 5, as Dick Kimber states, "the two snakes are the mythological snakes involved in creation of extensive shallow depression in the Napperby Country; after good rains these become part of the Napperby Lakes, which sometimes hold water for months." Kimber continues on the issue of secrecy:

> He [Kaapa] was adamant that certain aspects of these, were, in fact, enabled to be seen by both men and women in his country, and that he had only painted those which were acceptable to be seen by both. . . . Although Kaapa declined from including the majority of such aspects in his paintings after about [19]73, he was absolutely emphatic that this particular painting and a number of others of even more elaborate nature could be openly displayed.[42]

A series of three paintings by Kaapa's countryman Tim Leura Tjapaltjarri provide a useful gauge of the moves toward protecting the public from potentially dangerous images in the early Papunya boards. *A Joke Story* (cat. 17 in the supplement) is one of the clearest and most descriptive of all the paintings in the School of Kaapa style, yet Leura arrived at it *after* paintings in the more abstract planimetric style (like his first recorded *Honey Ant Story*, cat. 16).[43] The original annotated drawing of *A Joke Story* from the Stuart Art Centre that accompanied the painting when it was first sold there reads "One fella A [left figure] is laughing at fella B [right figure] for starting the party too soon. Third fella (tracks around center) is still away catching the kangaroo."[44]

These notes do little to explain the mythic "joke," which remains obscure. Tim Leura's work contains two of the most beautifully drawn figures of men in the whole Papunya repertoire, painted with an anatomical precision that separates him from others like Mick Namararri Tjapaltjarri or Johnny Warangkula Tjupurrula, who also painted figures in the early years (often in instructional pictures for children). The upright ceremony man on the left seems just to

have arrived at the sand mosaic site, and is still holding his spear and gesturing as if in speech to his colleague. This other, already seated cross-legged on the ground, is painted up with exactly the same designs and gesturing with his *woomera* (spear-thrower) as if in reproof or self-defense. The idea that the human tracks around the elaborately painted sand mosaic with its three great poles denote an absent third man shows an interesting temporality: he cannot be shown in the picture as he is not present at the site.

Tim Leura's shift to what Bardon calls a "tribal and cautionary context" is very plain in Leura's *Family Funny Story* (fig. 13), painted a few months later in June–July 1972—a story of a family man protecting his wife from the sexual enticements of "a rogue."

Here the black space that had made every object so salient in *A Joke Story* has been covered over with a dotted or black-speckled spatial environment on a mid-brown ground. Thus Leura's dancing, chasing, and fleeing figures are reduced to hectic silhouettes enlivened with white body paint. Bardon explains that the *coolamons* (concave wooden platters of varied domestic use, from cradling babies to gathering seeds to carrying hot coals for fire) framing the painting are "substitutes for the ceremonial objects." Indeed, they are much less specific in recording identifiable totemic designs than the ceremonial headpieces and *tjurungas* visible in *A Joke*.

We can thus deduce Tim Leura's phases of "cautionary" adjustment: (1) the introduction of dotting, which among other things creates a busy visual environment that distracts from the major objects and players; (2) the replacement of recognizable totemic designs on objects with generalized patterns;

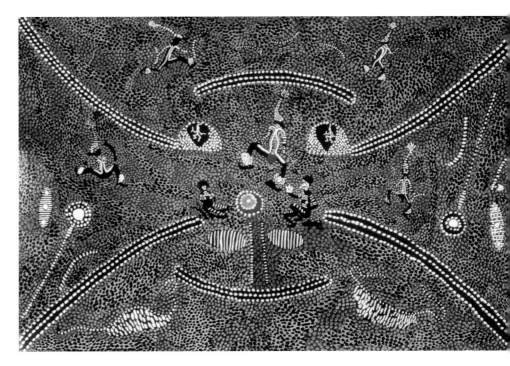

FIGURE 13.
Tim Leura Tjapaltjarri, *Family Funny Story*, 1972, synthetic polymer paint on composition board. Private collection.

FIGURE 14.
Tim Leura Tjapaltjarri, *Seven Sisters Dreaming*, 1973, synthetic polymer paint on composition board. Private collection.

and eventually (3), the replacement of complete human figures with the conventional sign for a man or woman. This is a well-known indexical track sign: the U-shape created by the posterior of a person sitting down in the sand or soft dirt.

A third Tim Leura picture, this time painted in August–September 1973, makes this final move to indexical sign rather than mimetic figure: the seven women of this *Seven Sisters Dreaming* (fig. 14) are present visually only as black U-shapes with their silhouetted digging-sticks, and with human footprints showing their passage.[45] Each of these modifications gives a greater level of abstraction to the concept and the appearance of the painting.

Clifford Possum pursued a similar trajectory, and by the time he came to paint *Women's Dreaming about Bush Tucker "Yarlga"* (cat. 37) in later 1972, he had completely transformed the appearance of his painting.

Women's Dreaming about Bush Tucker "Yarlga" is one of a short series of Clifford's paintings in which he developed "the superimposition and overlaying of Dreaming landscapes," an effect that became a signature feature thereafter.[46] In order to analyze this effect I will, following Nancy Munn, make use of the Warlpiri term *kuruwarri* (*walka* in Pintupi). The anthropologist Jennifer Biddle defines *kuruwarri* as "marks made by and/or traces left by Ancestors as they roamed country; the (same) marks, traces, made again by contemporary Warlpiri on body, board, canvas. Crucially, these marks retain the power, the 'presence' or 'essence' of Ancestors, even when dis-attached from them or

from country."[47] *Kuruwarri* are thus the "backbone" of most Papunya paintings, essential designs that mark the passage of an Ancestor through country. In Clifford Possum's *Yarlga*, they flicker in and out of view like a celestial object obscured and revealed by moving clouds. The "clouds" here are sections of dots in compartments: white dots on a black ground, black dots on a red ground, yellow dots on black ground. As Johnson points out, Clifford Possum has not simply overpainted the *kuruwarri* designs with the dots, but deliberately executed those forms in a partial or interrupted way. This is easily visible for example in the twinned serpentine forms at the top and bottom. Conceptually there is an interpenetration of zones that corresponds to the artist's stated concern to show the penetrability of the ground in Aboriginal belief, and the fact that Dreamings enter the ground and travel beneath the surface before emerging elsewhere in the creation of the landscape. Indeed, Christine Watson has argued (for the related Kutjungka nation) that the land itself is considered sentient, as is the very "skin" of the painting.[48]

Clifford Possum's is a painting for which two entirely different subjects have been suggested. Although it was auctioned in the 1990s as a *Bush Fire Dreaming*, Geoff Bardon's notes suggest otherwise (and this is supported by the absence of the human tracks of the people and the *lungkarta* [blue-tongue lizard] common to most of Clifford Possum's Bush Fire stories). For Bardon, "the central circle is a fire with firesticks radiating in formal order where women sit opposite each other at either end of long yams sticks;[49] the curving lines from the center of the design represent smoke from the fire and the stippled and ragged white shapes are the bush tucker the women have gathered called 'yarlga' [*yalka*, cyperus rotundus], which is white and like an onion." Elsewhere Bardon writes that the dotting represents "trees, grass, earth and atmosphere"—the kinds of concepts not usually ascribed to Aboriginal dot painting, but already tested in Possum's *Love (Sun) Dreaming*, in which the artist claimed to show "sunlight, clouds, shadow and earth"— an Anmatyerre atmospherics that may, among other things, show the legacy of Hermannsburg landscape art.[50]

3. New Pintupi, Old Pintupi

> *The country is, as Nancy Munn (1970) brilliantly explained, an objectification of ancestral subjectivity. Places where significant events took place, where power was left behind, or where the ancestors went into the ground and still remain—places where ancestral potency is near—are sacred sites (known in Pintupi as yarta yarta).*
>
> —Fred Myers, "Forms and Signs" in *Painting Culture*, 2002

Apart from the work of the leading Anmatyerre/Warlpiri artist Kaapa Tjampitjinpa, most of the initial boards painted at Papunya were done by men of Pintupi identity. The Pintupi were the people who had lived at the furthest remove from the encroachments of the "whitefellas," west into the Gibson Desert and beyond the West Australian border. Two other essays in this catalogue give a detailed account of the life stories of major Pintupi painters: Shorty Lungkarta Tjungurrayi in Fred Myers's account, and Charlie Tarawa Tjungurrayi in Vivien Johnson's. Such texts are a kind of essential new recounting of the lives of the painters, a sort of Vasari-in-progress for the Western

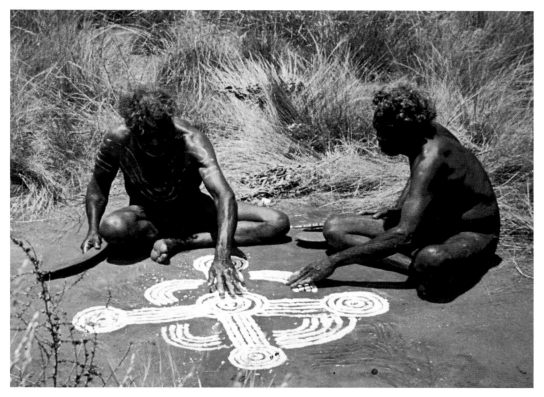

FIGURE 15.
Old Walter Tjampitjinpa and Old Mick Wallankarri Tjakamarra prepare a small sand mosaic for Geoff Bardon's film *A Calendar of Dreamings*.

FIGURE 16.
Old Walter Tjampitjinpa in the Men's Painting Room, June 1972.

Desert that was started by Geoff Bardon.[51] Bardon was always sure to paint a word portrait of, and thus to humanize, his artist friends (fig. 15). Bardon's words turned the men's very silence for reasons of protocol into an affective category, a term of esteem: they were "obscure" or "grave." Bardon well understood that the linguistic deficiency was that of the foreigner, the interloper, not of the Aboriginal countryman.

The ritual leaders who directed the painting of the major murals on the walls at Papunya School (fig. 16) were those who had responsibility, as *kirda* for the Honey Ant Dreaming—the Ngaliya men Old Mick Wallankarri Tjakamarra and Bert Tjakamarra. They were recognized as authorities across the porous divide of the major language-nations: Pintupi, Luritja, and Arrernte going roughly from west to east, and then north to Warlpiri and Anmatyerre. A significant majority of people at Papunya in the Bardon and Fannin times were Pintupi. Those known as Old Pintupi had had a much longer accommodation with the White world, typically working on cattle stations or living on missions. The "New Pintupi" were those who had walked in from the Western deserts or been encouraged to move in by Aboriginal Welfare officers led by Jeremy Long in response to drought and food shortages. The process of relocation was continuous: remarkably, the last known family group of desert-dwelling Pintupi, who had largely refused contact with Euro-Australians, walked into an area near Kiwirrkura (actually Mount Webb, or Winparrku) as late as 1984.

The paintings of most of the Pintupi exhibited far less affiliation with

Euro-Australian vision than the early School of Kaapa works. It was less a matter of expunging "whitefella" images and colors (as in Bardon's exhortation) than of adapting in a more unfettered way the imagery from the cultural compendium of sand mosaics, body painting, and the decoration of ritual objects. Charlie Tarawa's early work offers a good example: he was "the most experienced and world-wise Pintupi man of the Tjungurrayi-Tjapaltjarri skin brothers for the 'new' Pintupi painting group at Papunya and later at Kintore."[52]

Tarawa's *Moon Love Dreaming of Man and Woman—Medicine Story* (cat. 10) alone survives from a series of four *Medicine Stories* on the theme of love magic (*yilpinji* in Warlpiri) that Bardon documented in October–December 1971. At this early point in his time at Papunya, Bardon was greatly impressed by Tarawa's "use of ancient motifs of a convincing visual power," continuing "the simple forms shown have great interest because they were themes used in the earliest times before I encouraged the men to paint children's and family topics because of the perceived dangers in the work being shown."[53]

In this imagery traveling lines (the sets of parallel lines) connect up the "sit-down places" (concentric circles). Within the pictorial frame so formed against the black, in the privacy of a windbreak, two Old Men make love with two Moon Women. The U-shapes with a straight bar represent the sexually erect men, and the receptive U-shape the women, in Moon Spirit form. (That is, the U reads as a crescent moon as well as the shape of a sitting person. The latter is the indexical mark, the former the visual metaphor, gendered female

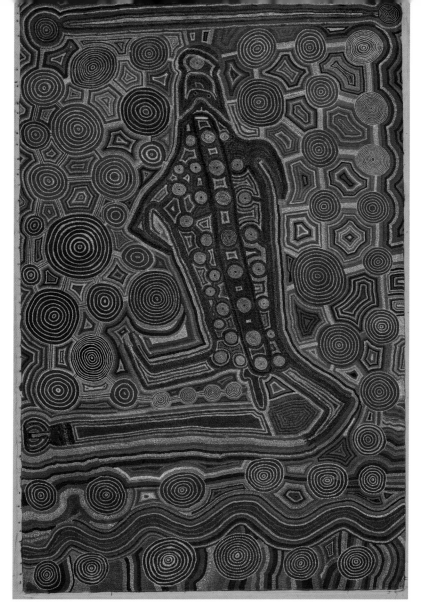

FIGURE 17.
Uta Uta Tjangala, *Yumari*, 1981, synthetic polymer paint on canvas. Collection of the National Museum of Australia.

FIGURE 18.
Uta Uta Tjangala (left) and Yala Yala Gibbs Tjungurrayi standing by the Yumari rockhole, 1990.

because of its enclosing, receptive form; Pat Hogan notes it as a "vulva.") According to Bardon, the white parallel lines on either side "are stylised boomerangs, or music sticks or body paint motifs for a ceremonial occasion."[54] Without descending to the level of more explicit imagery, the artist has found a way of showing an interaction between two bodies in a mode with plenty of gravitas.[55]

The same might be said of Uta Uta Tjangala, a man of great ritual authority and presence who is most famous for having directed a team of kinsmen in painting, a decade later, the monumental masterpiece in the National Museum of Australia, *Yumari* (fig. 17).

That Old Man Dreaming can be read at one level as a rather scabrous and amusing story, at another as a parable of love gone wrong that announces the dire consequences of flouting the Law, a Law developed over centuries to

preserve a functioning social structure (and an uncompromised gene pool) in the tiny populations of remote Australia.

Yumari is a sacred site in between the present-day communities of Kiwirrkura and Walungurru, or Kintore. It is a site for which Uta Uta Tjangala was boss. Many of his paintings relate to the stories of the Old Man Dreaming and that place.[56] A marvelous photograph by Jon Rhodes shows Tjangala and his taller countryman Yala Yala Gibbs Tjungurrayi standing near the Yumari rockhole in 1990 (fig. 18). Uta Uta is a hale and hearty older man, upright and filled, it seems, with intense pride in standing on his sacred ground. At Yumari is a rockhole with semipermanent water whose odd geological formation—a sort of X-shape in the ground with one longer and one shorter "arm"—is explained by the body of the ancestor and events that took place there. The shape of the rockhole is Uta Uta's own Dreaming, Tjuntamurtu. In the 1980 painting the Old Man is figured by his penis, the double line beneath the figure. Uta Uta told his good friend Fred Myers that the figure in the center of the painting is Tjuntamurtu, that is his ancestral conception dreaming—the short-legged figure who was frightened by the Old Man at Ngurrapalangu and left behind there. The Old Man (Yina) who goes on to Yumari is represented by a parallel line beneath this figure which is said to be his penis.[57]

In this early *Medicine Story* (cat. 8) Uta Uta, like Charlie Tarawa, produced an emphatic visual impact by laying a design in brown or dark red over a board prepared with matte black (probably blackboard paint). His *Medicine Story*, the earliest of two Uta Utas in the exhibition, lends this visual drama to the following Dreaming, recounted by Fred Myers:

> *This certainly is a painting that is part of the Old Man (Yina) Dreaming that Uta Uta frequently painted. The Old Man travelled from Kampurarrgna in the Henty Hills westward, through Sandy Blight Junction and Yumari and*

FIGURE 19.
Yumpululu Tjungurrayi using a mirror to inspect his body paint, with Paul Bruno Tjampitjinpa, 1976.

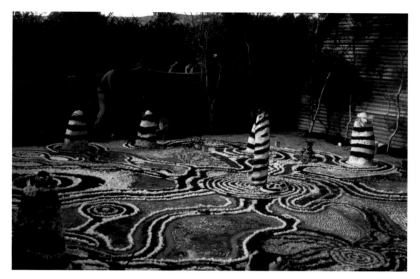

FIGURE 20.
Public sand mosaic or totem display, Alice Springs Show, 1964. South Australian Museum Archives, Leske Collection.

on westward. The Old Man . . . is often said to be "medicine one," by which the painter means that he carried a kind of sorcery with him—involving the capacity to ruin the nose of people. He was powerful and dangerous.

The Old Man has characteristics often found in myth, his penis sometimes has a life of its own and his testicles often travel separately from his body . . . so that he had to call to them when he was moving on.[58]

More specifically, at the Yumari rockhole the Old Man had, in Dick Kimber's words, "a sexual liaison with his strictly forbidden mother-in-law relation. His enormous penis led him astray. . . . Thereafter he suffered painful torment. The pain increased as he traveled west until eventually his testicles fell off and rolled away—or 'went walkabout.'" The notes taken down at the time of *Medicine Story*'s execution record that "the solid form at the base represents the Old Man lying down, the two central forms, his penis, and the concentric circles and connecting lines represent his testicles 'gone walkabout.'"[59]

Tjangala makes extensive use of white dots within the confines of the *kuruwarri* in *Medicine Story*. As an ever more important feature of Papunya art, the practice of dotting requires some explanation. It is a "traditional" Aboriginal mark-making, it being generally accepted that dots had at least two referents in ceremonial performance. The first is in the body-painting applied by men or women for ceremony (fig. 19). Strictly controlled designs embodying the Dreaming to be enacted are applied to the skin with ground-up ochre colors mixed with water or spittle. The skin was traditionally smeared first with emu fat, and the ochre applied with small daub sticks (made of bone or wood with a brush end of fiber) in a process that infused or impregnated the *kuruwarri* with ancestral potency. The painted dots around the *kuruwarri* lines "push" the *kuruwarri* in, and "draw" the ancestral presence out.[60]

The second and more poetically evocative precedent is the decoration of the bodies of dancers with pinches of whitish plant-down. This is made from the pulped flowers of particular plants that grow on the Spinifex sandplains, the most commonly used being *helipterum tietkensii* (plant-down is a substitute for bird-feather down, hard to obtain in quantity).[61] The balls of down are fixed onto the body of dancers painting up for ceremony. Portions of down can break off and gently fall as the dance progresses, speckling the earthen dance floor. In this way dotted areas such as that visible in the central zone of Uta Uta Tjangala's work could be viewed as a ceremony-ground seen from above, with the fallen fluff visible between the elements of *kuruwarri*. Thus there may be a representational element, rather than disguise or decorative infill, in this early example of dotting. But as we will see, both these roles became more prominent, and dotting the very integument and physical matter of Papunya painting.

One of the impressive features of Pintupi and Arrernte/Anmatyerre aesthetics at Papunya is the visual inventiveness of the artists, their capacity for making one-off images that have no apparent precedent, and that can exhibit wide variability from one work to the next (fig. 20). This is partly a function of the story at hand: senior painters at Papunya were recorded as interpreting many dozens of stories. Billy Stockman Tjapaltjarri, for example, painted versions of Tjukurrpa at different locations in their trajectories for the Carpet Snake, Kunia Snake, Spiders (Barking Spider, Trap Door Spider), Budgerigar, Kangaroo, Rock Wallaby, Eagle, Black Ant, Goanna, Bush Raisin, Water, Rain, Frog, Witchetty Grub, and Possum.[62]

It is the Pintupi artists Mick Namararri Tjapaltjarri and Charlie Tarawa who, for me, best exemplify this characteristic of inventiveness. Tarawa's *The Trial* (cat. 30) of 1972 is a work of remarkable finesse. It was annotated in mid to late 1972 by Pat Hogan, in the gap between Bardon's departure and

Papunya School teacher Peter Fannin's assumption of the position of art advisor. Pat Hogan recorded an exegesis of the subject, although Bardon has cast doubt upon any of her interpretations made after his departure.[63] Her text states that we are looking at a formal trial: the accused at the center, the Elders in judgment sitting in rows at the top and bottom edges, and the six executioners as half-roundels to the left and right, with black lines indicating the judges' fatal verdict and pink lines the spirits of the dead pointing to the accused.[64] However, Vivien Johnson (in her essay for this volume) suggests that Pintupi justice was may not have been meted out this way, and considers it more likely the subject of Tarawa's painting would be "the sentence of death that would be imposed on unlawful intruders to Wati Kuwala's sacred cave at Tjitururrnga" (the word Kuwala means "frost"). This was the fearful cave of the Ice Man, a place surrounded by white mist and chilly clouds, of which Tarawa was the custodian.

This hermeneutic dispute clearly demonstrates how knowledge of individual paintings' subject is always extremely limited in the case of early Papunya art. The artists were usually reticent to say more than a few phrases about any one work, and still more hesitant to discuss work that was not their own. Language and the need for translation was—and is—a constant problem in understanding Aboriginal art. Among the few "whitefellas" working with artists at Papunya in the early 1970s, only Fred Myers, a professional anthropologist, had fluency in an Aboriginal language (Pintupi). The need to protect secret knowledge was crucial, and as artists seldom had interlocutors with enough cultural competence to elicit detailed explanations.

The aesthetic interest in *The Trial* for me is twofold. The austere color scheme, with its combination of severe black, pink ochre, and the layering of irregular white dots over the raw masonite brown has an austere sonority. The spatial effects are of still greater interest: there is an expansiveness, an opulence of radiating lines bound in tightly by the edges of the board. More specifically, the sense created by the black inner circle is of an interior within an exterior, a containment or spatial shift that is symbolic as much as translating an experience of space. The imagery seems to chime well with Johnson's thesis about this image referring to the cave of the Ice Man.

4. Cave Stories

Indeed, images of caves have an important place in the works in this exhibition. Of all the sites depicted in Central Desert painting, they are the most remote to Euro-Australian knowledge. Caves were places where initiated men hid sacred objects—*tjurungas* in particular—to keep them from the eyes of women and children. A special surrounding perimeter in which weapons were banned, game protected, and intruders seen off was in the care of the cave's guardians.[65] Caves were also ancient sites of inscription: ceremonies were held inside, sand mosaics could be made on the floor, or wall paintings made and renewed (unlike the much more numerous rock shelters of Arnhem Land, many of which were sites for social gathering, education and entertainment during the Wet season; others however were strictly off limits).[66] As a result, such caves have rarely been seen by white men, although those closer to white settlement (for example, in the hills of the MacDonnell Ranges) were frequently desecrated in the late nineteenth and earlier twentieth centuries, their sa-

cred objects stolen. To the distress of elders, the objects were sometimes even sold by younger Aboriginal men into the lucrative market for such artifacts.[67]

The execution of Mick Namararri's *Big Cave Dreaming with Ceremonial Object* (cat. 32) was witnessed by the white Australian who bought it, a theater director visiting Papunya in order to "study comparisons between Aboriginal and Greek mythology as it is expressed in dance and ceremony."[68] According to this witness, the artist sang continually throughout the process—a regular occurrence that proves the embeddedness of all such images within an oral, musical, and danced religious culture. Geoff Bardon made notes on the painting (see page 137).

According to his ideas, the lower half of the picture represents the interior of a very large cave in which a row of ten men participate in a ceremony before a major *tjurunga* (made out in orange with white painted decoration). Viewed on the larger scale, this image is also reminiscent of a sexual conjunction (comparable for example to Charlie Tarawa's *Moon Dreaming*). However, nothing of that kind is mentioned in Bardon's notes.

In his conversation with Bardon, Mick Namararri revealed that much of the imagery denoted a specific local geology:

The simple patterned forms represent cliffs at the top of the design with a featured cave and ceremonial object inside that cave. Close study of the intricate patterning reveals at the top, small ceremonial objects known as tjurungas, linear water motifs and patterns representing bush tucker, grass, rock and the stratum of cliff geology of a specific place in the artist's homeland.

The bottom motif is similar but it includes many ceremonial men arranged in ritual order, a water mark in spiralling linear effects and a strong elongated and patterned oval form which is the principal ceremonial object in the cave itself. The simplicity of the black area could imply that the ceremony is at night which is the traditional situation.[69]

The thought of a ceremony taking place in the blackness of a nighttime interior, lit by firelight and perhaps in the awe-inspiring surrounds of red granite or sandstone cliffs and gorges (well-known from photographs of "tourist" sites in Central Australia) helps explain the dramatic impact of this painting. As one probes the detail of Namararri's image, the filigree infill of the caves, with its whorls, striations, and the most delicate of arabesques, one is struck again by the meticulous care of the painter, coupled with his self-abandonment to invention in pattern.

A second great *Cave Story*, this time by Tim Payungka Tjapangarti (cat. 9), so differs in conception from Mick Namararri's that the fundamental freedom of what the painters achieved is brought home forcefully. The painters were living in exile and permanent social crisis, yet here, when they retold their Dreamings, they were in the space of personal graphic invention even as they interpreted tradition. The scanty information recorded for this painting reads: "The bottom half of the picture represents successive views of a cave in the hills. The top section represents the interior of that same cave."[70]

The one thing Tim Payungka shares with Mick Namararri is the two-part concept for the painting, with one section seeing overall conceptual views of the cave, including both outside and inside, and the other half the interior

of that cave. In *Cave Story* no ceremonial objects or allusions to ceremony men are readily apparent, despite Payungka's painting having an early date of November 1971.[71] In the upper interior section one might see the two detached rectangles with honeycomb cells as alluding to decorated objects, but this is speculation. The abstraction is striking, as is the rectilinear shape of Payungka's cave-forms showing the massive, foursquare layers of rock.[72]

5. Water Dreamings

The Water (*Ngapa*) Dreaming is one of the great Dreamings of central Australia. One of its "songlines" runs from Adelaide on the Southern Ocean thousands of kilometers to Darwin in the tropical north; another moves from the west to the east, a great storm front passing through Kalipinypa. On these songlines great events occurred at different sites with the Dreaming crossing many different Aboriginal nations; it has interconnections with Rainbow, Hail, Wind, and other Dreamings. The Water Dreaming is a generative principle crucial to the life cycle of the desert country. The advent of rain transforms the landscape by germinating the plants, wildflowers, and new growth that makes the land spring into color. This new growth increases "bush-tucker" supplies and sustains the animals and the people that feed upon them. Thus the role of the Water men or women for any community is highly important: their task is to control and summon the water, to sing in the rains.[73]

The year 1971–72 was particularly wet (fig. 21), which helps explain why so many versions of the Water Dreaming were painted by Old Walter Tjampitjinpa (senior custodian of the Water Dreaming at Papunya), Johnny Warangkula Tjupurrula, and others. The Wilkerson collection is privileged in conserving a fine example of the Water Dreamings produced by Old Walter, who passed away in 1981, but who had vast knowledge of the water sources and associated ceremonies across much of the Western Desert.[74]

During the Bardon time, Water Dreamings probably outnumber any other individual story in the work of the painting men. Elements of this Dreaming were sufficiently public for senior members of the Papunya community to paint up and perform a Water Ceremony in 1974 for the cameras of Geoff Bardon and his colleagues, for the making of the documentary *A Calendar of Dreamings* (1977).

One of the great painters of the early years, the Luritja man Johnny Warangkula Tjupurrula, had special responsibility for the Water Dreaming and painted dozens of versions of the theme as a consequence.

The most celebrated painting in this exhibition is Warangkula's *Water Dreaming at Kalipinypa* (cat. 27). Its story is not so much an evocation of a rainstorm as an image of country being transformed by the ceremonial activity of the Water Man—the man whose song and words, reverberating in the chambers of his cave, brings forth the rain. As one of the artists averred, "The Water Man does not get wet—he is the rain itself. At night the people can see

FIGURE 21.
Haasts Bluff after heavy rain, 1972.

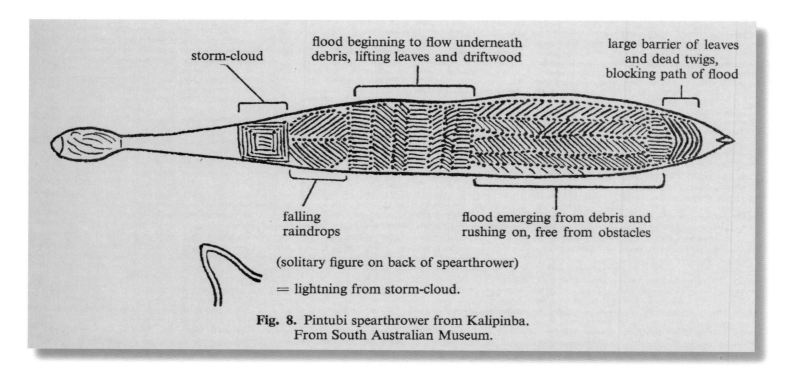

storm-cloud

flood beginning to flow underneath
debris, lifting leaves and driftwood

large barrier of leaves
and dead twigs,
blocking path of flood

falling
raindrops

flood emerging from debris and
rushing on, free from obstacles

(solitary figure on back of spearthrower)

= lightning from storm-cloud.

Fig. 8. Pintubi spearthrower from Kalipinba.
From South Australian Museum.

FIGURE 22.

T. G. H. Strehlow,
diagram of spear-
thrower with Water
Dreaming motifs at
Kalipinypa.

his fire in his cave on the mountains."[75] Details of the place to which the painting alludes have been recorded by Dick Kimber:

> *Kalipinypa, the key site over which the painter has authority, [is] a storm center, and Water or Rain Dreaming totemic site. It is located some 300–400 kilometres west of Alice Springs. . . . Kalipinypa . . . is a claypan which, until earthworks partly revealed and partly destroyed it, covered a gritty and gravely stony deposit. This evidently helped to trap water after heavy rains, and beside it there existed, until the earthworks modified it, a deep native well and other features.*
>
> *All features within a kilometre or so in the vicinity are interpreted as being associated with the creation time: certain sandhills are clouds; certain trees represent the stormbirds kalwa; certain outcrops are associated with lightning; other weathered conglomerates reveal hailstones, and so on. However in this painting . . . the plant growth of the locality has been emphasised . . . depicting prolific growth of locally occurring plants after good rains. As stated in the original notes accompanying the work, 'the small lines, dotting and change of colors denote growth of all the root growth under the soil of the bush food after rain.'*

Kimber goes on to explain that the principal local bush food is the wild raisin, *kampurarrpa*, for which Warangkula held major totemic rights; this important food source is visible in the black dotted overlay in sections on the right of the board. Other items, rendered almost invisible at first glance, include the *tjurungas*, "camouflaged and merging with the rest of the painting," of the "'water men' ancestors and the wild raisin totem, and other elements showing the location of soaks, together with running water and caves."[76] Geoffrey

Bardon praises this "haunting landscape," writing that it is "so intricate that the work is ghostlike, with a spectral or phantom Ceremonial man located in the center of the design in pale yellow, in hard-to-discern cliff, waterhole and bush tucker terrain." He also discerns the "classic Water Dreaming mark" of three roundels connected by waving lines, almost hidden on the far left side of the painting.[77]

Complex events at Kalipinypa the storm center were often portrayed by Old Walter and other Pintupi artists. To give a sense of Kalipinypa's power as a site, I reproduce the diagram of a *woomera*, or spear-thrower, from that place (fig. 22). Linear graphic motifs (including the concentric square and herringbone patterns) showing a Water Dreaming have been incised on it, probably using a possum-tooth point. Australian anthropologist Strehlow read this Pintupi spear-thrower as narrating a storm and the floods which resulted from it: starting at the hunter's hand-end: "storm-cloud; falling raindrops; flood beginning to flow underneath debris, lifting leaves and driftwood; flood emerging from debris and rushing on, free from obstacles"; and finally at the spear-end, "large barrier of leaves and dead twigs, blocking path of flood."[78]

The link between such fine clusters of markings and Warangkula's rendition of Water Dreaming events is clear, although the painter is far less systematic than the carver. The visual fascination of his picture lies in the delicacy of the artist's veiling of things, and the way the site is divided into dozens of small compartments, no two of which are the same. Often surrounding a roundel that might identify a waterhole or soak, Warangkula has filled each compartment with its own pattern: waving parallel lines, stippling, staccato dots, radiating curves, or cross-hatches. Each of these patterns is in a white, pink, or ochre yellow that covers another darker color, and denotes elements like running water and the "growth of all the root growth under the soil

of the bush food after rain." The result is like a great patchwork quilt but one not trammeled by regularity, so that the eye constantly shuffles over an immense filigree, a veil of lace that overlays and yet penetrates the land.

Two others of the several Water Dreamings in the collection demand to be singled out, those by the Pintupi master Shorty Lungkarta Tjungurrayi. There is a short series of Children's Stories, requested by Geoff Bardon from the leading artists between May and July 1972 as "part of the programme direction that men paint non-secret material, the work of this time excluding ceremonial objects almost entirely but achieving an interesting visuality."[79] *Children's Water Story (Version 2)* (cat. 24) is an image of multiple roundels in white dots laid over red ochre with black *kuruwarri* lines. The delicate roundels superimposed on one another give this painting a hypnotic aspect: they give rise to a kind of optical confusion or interference that, in the crosshatched works of bark-painters of Arnhem Land, was considered a manifestation of ancestral power; equally the "shimmering" of dots is so considered by Warlpiri.[80] This motif of overlapping whorls (this time said to represent water running in 'little creeks' toward a central waterhole)[81] became a specialty of Tjungurrayi, seen at its most electric in the exhibition's great *Tingarri ceremony at Ilingawurngawurrnga* of 1974 (cat. 40).[82] The optical vibration of overlapping roundels was developed in a more popular form by the Papunya painter William Sandy in the later 1980s.[83]

Shorty Tjungurrayi's second, slightly later *Water Dreaming* (cat. 25) is not dissimilar in structure, despite its firmer two-dimensional design and its atypical color scheme combining yellow and white over black. Here, a central waterhole is represented by the large roundel, with straight lines again showing "little creeks" flowing into it. The original annotations remark "little soaks," being the small yellow roundels between creeks (one more complex roundel with seated men is not singled out). The enclosing yellow lines indicate a "big creek," while the black and red dotted shapes at the periphery are given as "hills."

Dick Kimber offers a more developed estimate of Shorty Lungkarta's subject and its likely topographical aspect, based on his knowledge of the painter and his heritage. "The site depicted is most probably Lampinja (Lampintjanya), the artist's birthplace," he writes, "with the 'little' creek' and 'big creek' routes being formed by the movements of the ancestral snakes, and the hills . . . promoting rain storm run off into the claypan. The red overdotting in the dark areas at the top and bottom of the work may represent *mungilpa* seed, abundant after rains."[84]

Our conversation about the practice of dotting is continued by this reference to bush tucker. Despite what was said about the School of Kaapa above, even the earliest manifestation of the new painting at Papunya, the *Honey Ant Mural* painted on the school walls from June to August 1971, had dotted decoration of its central roundels in the third version (fig. 23).

In one of the very earliest pictures in the collection (cat. 2), the tiny board *Three Ceremonial Sticks* by Tommy Lowry Tjapaltjarri (surely one of the first paintings by the creator of *Two Men's Dreaming* a decade later), uneven white dots of paint are the sole material in which the spectral ceremonial poles are indicated. Johnny Warangkula is credited by Geoff Bardon with introducing the pictorial language of overall dotting that influenced so many other painters, using them not merely as "infill" between *kuruwarri* elements but

increasingly to constitute the story itself. However, between 1972 and 1974, Warangkula's technique was more than just circular dabs of paint applied with a fine paintbrush end, as he tended to make a myriad of discrete dashes or short, almost cubic strokes that give directional inflection to each patch of surface and imply, as it were, a three-dimensional grasp of space.

Clifford Possum took a different approach once "converted" to the use of overall dotting in his 1972 paintings *Bushfire I* and *Bushfire II*. With the discipline and balance critics consider typical of Anmatyerre culture, Possum's use of dots soon attained a systematic level of control with highly regular spacing and perfectly formed roundels. From 1977 he made use of a round

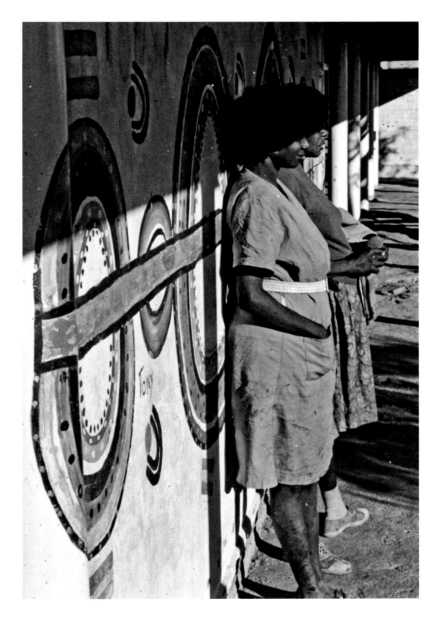

FIGURE 23.
Two women standing at the *Honey Ant Mural*, third version, Papunya, 1971.

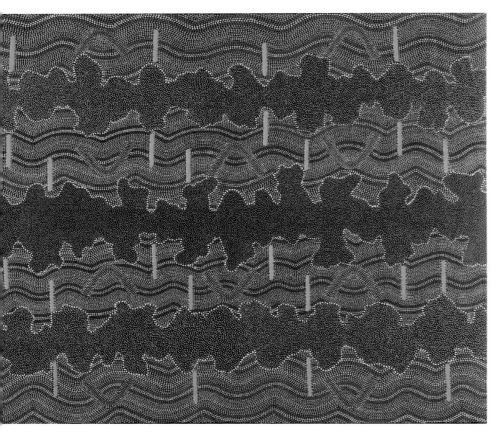

FIGURE 24.
Clifford Possum Tjapaltjarri, *Water Dreaming at Napperby Lakes*, 1983, synthetic polymer paint on canvas. Collection of Flinders University Art Museum, Adelaide, Australia, acc. 2028.

stick applied perfectly vertically to give the regularity he required for his five vast "Mapping" paintings that deal with multiple Dreamings: the two versions of *Warlugulong*, *Kerrinyarra*, *Mt. Denison Country*, and *Yuutjutiyungu*.[85] These paintings mark a late 1970s watershed in Papunya art, and indicate the direction to be taken by the Anmatyerre artists toward big canvases of encyclopedic narrative. A measure of how much Possum's practice changed is his famous "minimalist" *Water Dreaming* painting of 1983 (fig. 24), a canvas whose inventive symmetry and creation of pictorial space much impressed devotees of contemporary white Australian and international art on the many occasions it was exhibited and reproduced.

6. Tingarri Stories:
Later Men's Painting from Papunya Tula

Icons of the Desert does not focus exclusively on the early boards. Several large works dating from two to three decades later have been collected not only because of their visual splendor, but in order to give an idea of the rapid development of the painting movement, in particular after the move of Pintupi and other artists away from the benighted township of Papunya. Only the briefest indication of events over the eight years to 1980 can be sketched here. The main point is that economic and political conditions favored the efflorescence of painting by the Papunya Tula painting men. Key among the improved economic conditions was the support of the artists' cooperative (founded at Alice Springs in 1972) by a newly formed federal agency. This was the Aboriginal Arts Board (AAB) of the Australia Council of the Arts, established by Labor Prime Minister Gough Whitlam's reformist government of 1972–75. Directed by the key pro-Papunya anthropologist and museum man Bob Edwards, and guided by an all-Indigenous board, the AAB purchased significant quantities of Papunya painting, arranged commissions for large-scale work, and helped promote the new art through traveling exhibitions.[86] The slow process of creating a market for the new art included the initial (and, for over a decade, the only) sales of Papunya works to an art museum. Around early 1972 the Museum and Art Galleries of the Northern Territory (MAGNT) in Darwin bought seventy-eight boards, as proposed by Pat Hogan of the Stuart Art Centre to the director Colin Jack-Hinton.[87] However, staff at the Australian Museum in Sydney showed no interest in the Papunya paintings that Bardon proposed to them in the early 1970s.[88]

On the political front, there was a crucial new level of access and ownership of traditional land, which in itself stimulated art-making. An historic return of exiled tribal people to their traditional country, known as the Outstation Movement, began in earnest after the Aboriginal people of the Northern Territory were given control of over thirty percent of the Territory's land by the Aboriginal Land Right (NT) Act 1976, passed by the Federal Government in Canberra following a commission of enquiry initiated by the Whitlam government.[89]

However, already in 1973 the outstation impetus had begun with the movement of some two hundred Pintupi from the dysfunctional Papunya township (which Bardon called a "death camp") to settle at Yayayi Bore, 26 kilometers (16 miles) west of Papunya. As John Kean writes, "an increasing number of Pintupi artists began painting those places with which they yearned to be reunited. The now famous small boards, with spidery lines and cryptic iconographs, were some of the first rumblings of their intention to get back to country."[90]

In August 1973 Fred Myers, then a young doctoral student from Bryn Mawr College in Pennsylvania, arrived at Yayayi to live among the Pintupi for twenty months to pursue his anthropological fieldwork. As part of his research, and to assist the community at Yayayi, Myers documented two hundred and seventy paintings and recorded artists' stories following the practice initiated by the artists and their white advisors at Papunya. It is probably true to say that, at Yayayi, Pintupi artists came to a new prominence in the overall movement, giving certain visual forms a new canonical status. The "site-path complex" seen in the sand mosaics and on painted or incised boards gained new authority in their hands. An early example is *Ngunarrmanya* by Freddy West Tjakamarra (a work quite unlike his *Old Man's Corroboree*, cat. 13 in the supplement). Highly abstract in its conception, *Ngunarrmanya* (fig. 25) is dominated by one concentric roundel of massive proportions—well over two dozen concentric rings—signifying a sacred site. This central site is connected by broad bars (traveling lines) to some six or eight subsidiary roundels.

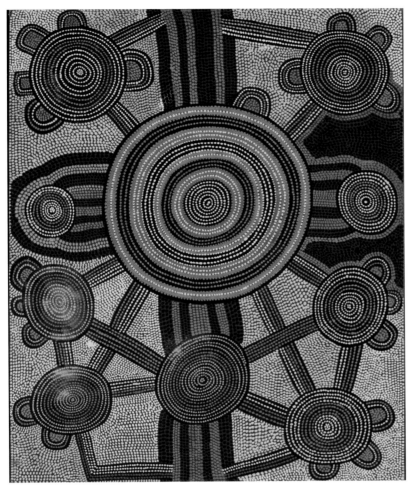

FIGURE 25.
Freddy West Tjakamarra, *Ngunarrmanya*, 1974, synthetic polymer paint on canvas board. Collection of the National Museum of Australia.

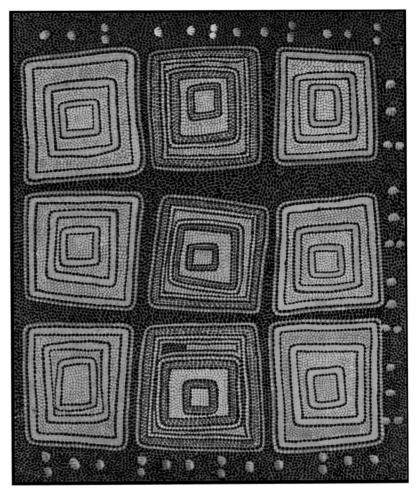

FIGURE 26.
Anatjari (Yanyatjarri) Tjakamarra, *Possum Men of Yirtjurunya (Yitjurunya)*, 1974, synthetic polymer paint on particle board. Collection of the National Museum of Australia.

This Freddy West painting deals with a subject of special significance to Pintupi artists, that is the Tingarri cycle of Dreamings. Papunya Tula Artists came to give the following "official" definition of this cycle on its certificates authenticating paintings of this subject:

> Generally, the Tingari are a group of mythical characters of the Dreaming who travelled over vast stretches of country, performing rituals and creating and shaping particular sites. The Tingari Men were usually followed by Tingari Women and accompanied by novices and their travels and adventures are enshrined in a number of song cycles. These mythologies form part of the teachings of the post initiatory youths today as well as providing explanations for contemporary customs.[91]

It is very often written of such stories, "since events associated with the Tingarri cycle are of a secret nature no further detail was given." However, because a major period of Tingarri initiations took place at Yayayi during his time there in the middle of 1974, Fred Myers has a better grasp of these narratives and their graphic structures than most commentators. In his analysis of a long series of Tingarri works by Anatjarri Tjakamarra (a prolific Pintupi artist with whom Myers worked closely), Myers isolates a "five-circle grid." This arrangement was so frequently used by Anatjarri the anthropologist calls it a "template" that is varied according to the requirements of different Tingarri stories. The theory holds good for the Freddy West work mentioned above. Myers also grasps the generative character of the imagery: "The five-circle grid contains the potential for extension. Links may be established through circles and lines to other places. These in turn become the focal points for other grids, so that eventually a wider network of relationships is created. . . . This process is reflected in the form of the larger canvases that were subsequently produced by the Pintupi painters."[92]

Willy Tjungurrayi's *Pulpayella* (cat. 43) is the sole early example of this kind of work in the exhibition. It uses the new materials of acrylic on canvas offered as an alternative to artists by Papunya's second art advisor, Peter Fannin,

and then his successors, Janet Wilson and Dick Kimber. *Pulpayella* is one of a set of canvases of narrow columnar form, many of which use variations on the five-circle grid.[93] Here again, very little of this Tingarri subject and the site of Pulpayella was revealed by the artist. A later version of this gridded design may be seen in Anatjari Tjakamarra's *Yarranyanga* (cat. 47). Judith Ryan has characterized the austere hermeticism (in the religious sense) of such works in the following insight: "Like cadences in a solemn Gregorian chant, a limited number of colors and motifs are ritually repeated. The universe of signs and symbols is an impenetrable and ordered construct which provides a window on to the secret world of the men."[94]

One dramatic variation of the Tingarri motif that appeared in the early 1970s should be mentioned, because of its seminal relation to Papunya art of the last fifteen years. Before and during the period of Tingarri initiations at Yayayi, Anatjari Tjakamarra produced paintings showing "concentric squares"—rectilinear compartments—in columns of three (fig. 26). As Myers writes, this kind of design "reflects the rectilinear incised patterns typically found on sacred boards of Western Desert people. It should be considered simply as a painting of such a board."[95]

The square rather than circular Tingarri pattern, which Anatjari was almost alone in producing in the early years, has prophetic qualities in that such geometric motifs can frequently be seen in the last decade as a leitmotif of Tingarri men's painting done at the Pintupi communities of Kintore and Kiwirrkura. These overall fields of geometric pattern relate back to Western Desert *wunda* shields, spear-throwers like the one illustrated previously, and engraved pearl shell pendants from the West Australian coast. The great figure in Arrernte ethnography, Ted Strehlow, related the variety of rectilinear patterns used on such objects to the parallel-line constructions of hair-string crosses, as well as the formerly popular desert entertainment of cat's-cradle games with hair or fur string. As Davidson wrote of traditional objects from Western Australia in 1937: "All bullroarers, churinga and 'dancing boards' in this tremendous area . . . are decorated in designs of varying character derived from a few basic motifs such as the longitudinal zigzag, herring-bone, concentric squares and rhomboids, and angular meanders."[96]

The major artists painting for Papunya Tula in this genre of rectilinear Tingarri paintings in recent years have been, among the older painters, the late Tim Payungka Tjapangati, George Tjungurrayi, and Ronnie Tjampitjinpa; and among the younger generation of men, Warlimpirrnga Tjapaltjarri, Kenny Williams, and Ray James Tjangala. Most recently, the Pintupi painter Doreen Reid Nakamarra has adapted the "herringbone" design to dramatic effect in paintings on subjects exclusive to women's Dreamings.[97]

Ronnie Tjampitjinpa, a Pintupi man born around 1943, was not one of the "first artists" at Papunya (to use Johnson's phrase, encompassing the original shareholders in the company)—only Long Jack Phillipus survives from their ranks. A young man of thirty when he began painting in 1971, Ronnie's early paintings are few in number and tentative in design. Ronnie was active at the time as a stockman and fence-builder who also assisted a Pintupi linguist in Papunya. One of the initial group to move with his family to the new Pintupi outstation at Kintore in 1981, it was only in the late 1980s that his career as an artist took off. Ronnie Tjampitjinpa then introduced a signature style of wide bands of paint in "traditional" colors, in a manner surely related to the unctuous lines painted on the fat-coated bodies of performers in ceremony.[98] Initially Tjampitjinpa painted in the roundel format, but moved soon to the concentric square and rhomboid designs which he stamped with great visual authority. His 2005 work *Untitled* (cat. 50) is rare in combining both the circular and rectilinear design elements. The painting is dominated by a massive roundel over one meter wide, while above and below it are the cellular compartments typical of his later work.

These developments help to provide an historical context for understanding Tommy Lowry Tjapaltjarri's monumental canvas *Two Men's Dreaming at Kuluntjarranya* (cat. 44), one of the pinnacles of Pintupi painting of the 1980s.[99] Rather like Warangkula's *Water Dreaming at Kalipinypa* (cat. 27), the work has a quality that resounds beyond its dimensions (4 x 6 feet). Indeed, in seeking to characterize the impact of this work on the Euro-Australian viewer, one might have recourse to the Russian Expressionist Wassily Kandinsky's theory of the *Klang*, or the resounding note that can be attained by great visual art. Kandinsky (fig. 27), who was a synaesthete, believed the auditory and spiritual qualities of an image could be perceived whether the work was abstract or not, as a kind of inner sound (*innere Klang*).[100]

In the case of the Tommy Lowry, there is for me a solemn, booming quality to his painting: the great glowing circles "sound," like naval cannon shots or heavy bells tolling, all set about with the filigree detail of a myriad little notes and lines of music. Obviously this reading has little to do with a

FIGURE 27.
Wassily Kandinsky, *Motif from Improvisation 25*, 1911, woodcut. Courtesy of Pasquale Fine Art, San Francisco.

Pintupi view of the world, but one can say instead that the painting has its own Indigenous sound: the sound of the chanted song for the place *Kuluntjarranya* that would have been sung during its painting, and might be again whenever an elder with that knowledge saw the work.[101] However, when Papunya artist Michael Tjakamarra Nelson famously said, "White people can't understand our painting, they just see a 'pretty picture,'" he was underestimating just how much the Western art lover can bring to the task of seeing: in this tradition the aesthetic can be a rich realm, a way of life unto itself.

The art critic would say there is much to separate *Two Men's Dreaming at Kuluntjarranya* from the site-path paintings of 1980s Pintupi convention. Tommy Lowry avoids the regular traveling-line connections between the sacred site elements. The six great, uneven objects in the picture are concentric roundels of a density and breadth seen almost nowhere else (unless it be in Uta Uta Tjangala's masterpiece of the previous year, *Old Man's Dreaming,* where vast shapes of inscribed boulders hover in an environment of site-path gridding). The story of *Two Men's Dreaming at Kuluntjarranya* reveals that these objects are in fact salt lakes formed by the urine of two great ancestral medicine men. Traveling in the area, they had taken ill and died after consuming bad "native tobacco" plant (*minkulpa*).[102] They returned to life for further adventures after the lakes were formed. The tobacco plant can be seen at the lower left with bars at its side, but very much in the rich imagery of this painting is unexplained. The infill dotting wedged between these off-form, eccentric lake shapes is formed of a kind of linear patterning like the bright bands of a cut agate geode. With this vermiculated form, Tommy Lowry seems to learn from a motif in the recent experimental works of Clifford Possum, just as his practice also draws from the example of Uta Uta Tjangala.[103]

I conclude this sketch history of later works by the original Papunya painting men with two final pairings of works, early and late. The first pair is on the theme of continuity and consistency in practice, while the second exemplifies change and innovation. Yala Yala Gibbs Tjungurrayi instances the former: one of the most long-lived of the first generation of painters, he continued painting (with some fallow periods in the 1980s) almost until his death in 1998. Yala Yala had spent the first four decades of his life largely beyond the white Australians, traveling with his family in remote homelands southwest of Lake MacDonald. This imposing Pintupi man was a ceremonial authority for the region of Kintore and further west. Dick Kimber recalled that when not traveling in his own country, "Yala Yala Gibbs preferred to use sign language in adherence to traditional Pintupi protocols."[104] Perhaps his respect for traditional knowledge and Law underpins the consistent and immediately recognizable style of painting he fashioned for himself.

Yala Yala's painting *Untitled 1998* shares the color scheme and even some of the forms of his earliest paintings, like *Wind Story* of late 1972 (cat. 38). In both works he uses his characteristic manner of close-knit, rather liquid white dots set over a black or dark brown ground, so that the *kuruwarri* lines are revealed underneath. *Wind Story* is a powerful centrifugal composition where, according to Bardon, we see a family group sheltering at a campsite, behind a series of curved windbreaks (the kind made by desert dwellers of massed branches and twigs). The related work *Wiltja Story* in Darwin tells the tale of an old man "left to die in a bush-shelter, *wiltja.* Suddenly a gusty wind came from the north-west and blew the shelter into the sky."[105]

Untitled (cat. 49), something of a last testament of the artist as it was painted in the final year of his life, is a more complex image showing the many comings and goings of the Tingarri men around Lake MacDonald. A dozen roundels are connected in asymmetrical, eccentric ways by traveling lines and motifs for running water. Tjungurrayi injects a startling note of brown color on the bodies of what appear to be reptiles to the left and the right. The scanty documentary information from Papunya Tula reads, "This painting depicts designs associated with the rockhole site of Kutulalinyi, west of Lake MacDonald. The Snake Dreaming is associated with this site. In mythological times a large group of Tingarri men camped at this site before continuing their travels to Lampintja."[106]

The second pairing, exemplifying change and innovation, is from the illustrious later career of Mick Namararri, the experimenter whose *Big Cave Dreaming with Ceremonial Object* we examined earlier in this essay. Namararri's late work is represented in the collection by his *Tjunginpa* (cat. 48): a work that looks nothing like earlier Papunya art given his use of striated or sedimentary layers over the canvas. Here, Fred Myers's perception about the value of a "local art history" of Central Desert art rings true: that is, examining clusters of works painted by related artists at around the same time often yields valuable congruencies. Namararri's horizontal and linear format for this painting has a strong family resemblance to the celebrated group of late works by Turkey Tolson Tjupurrula, his *Straightening Spears* series, also of 1990 (fig. 28). In

FIGURE 28.
Turkey Tolson Tjupurrula (1942–2001), *Straightening Spears at Ilyingaungau,* 1990, synthetic polymer paint on canvas. Gift of the Friends of the Art Gallery of South Australia 1990. Collection of the Art Gallery of South Australia, Adelaide.

Turkey Tolson's case there was a conceptual relation between the long thin vine-wood spears being adjusted for trueness in the flames of a fire and the format of the painting, with its dozens of handpainted sequences of straight lines running from end to end of the canvas.

In the Namararri, the horizontal bands are not continuous lines (as they appear to be in Turkey Tolson, where they are in fact composed of minute lines of dots). Namararri's "lines" are composed of small yellow rectangles set off against red or white dotted infill. These designs are associated with the Dreaming for the Bettong (a desert marsupial—the short-nosed rat-kangaroo) at the site of Tjunginpa. This place is a small hill to the northwest of the Kintore community, just over the West Australian border. Perhaps the annotation for other Tjunginpa paintings for different animals done by Namararri at that time also holds true here: "The overall dotting represents the footprints of the mouse and also *kampurarrpa* (bush raisins) and flowers, for which the mouse foraged in the area."[107] Several of these canvases, exhibited in the 2000 *Genesis and Genius* exhibition, contain fields of minute, variegated dots in an all-over pattern that anticipate the better-known work of the Anmatyerre/Alyawarre artists Emily Kame Kngwarreye and Dorothy Napangardi from Utopia. Namararri's *Tjunginpa* has a rhythmic and rectilinear structure that is rare in his work, and seemingly marks a moment of admiration for his Pintupi countryman Turkey Tolson.

Epilogue

It is hard to consider the history of the early Papunya boards without a deep sense of the future promise engendered by the activity of the painting men and their white emissaries. That promise can be tracked in several broad areas: the first is their insight in finding a way of translating ceremonial designs onto small permanent surfaces—making a high art that could leave the intimacy of their bodies and their lands. The second is in devising and instituting a viable structure for selling and disseminating their art—by founding the Papunya Tula cooperative, the model for dozens of Aboriginal-controlled art centers established from the 1980s on. A third is the development of a subject-matter that could outlast the controversy over the secret/sacred, and evince a visual language that could be adapted by Indigenous artists over much of Australia.

Tim Leura Tjapaltjarri's *Yam Spirit Dreaming* of March 1972 (cat. 21) is emblematic of this third innovation. It presents a subject matter devoid of the complication of literal ceremonial men and their sacred accoutrements. The Yam is a "bush tucker" story par excellence: it represents one of the great staple food sources of the desert, and thus symbolizes the daily round of digging in the hard ground for food, in particular by women using their yam-sticks (and often accompanied by children). The yam is a plant so important that it has "totemic" affiliations in the social world of the desert and thus an ancestral and religious dimension. Billy Stockman Tjapaltjarri, Tim Leura's cousin, painted a significant *Wild Potato (Yala) Dreaming*, with visible root networks and tubers on a bright yellow ground, as early as 1971.[108]

Tim Leura's version of the *Yam Spirit Dreaming* in this exhibition is the first in which he makes a unique invention: attaching human and animal figures to the root-and-tuber system of the yam.[109] As Europeans and Asians did with the Mandrake root, Leura anthropomorphizes the tuber and acknowl-

FIGURE 29.
Tim Leura Tjapaltjarri, detail with Yam Dreaming in *Napperby Death Spirit Dreaming*, acylic on canvas, 1980. Collection of the National Gallery of Victoria.

edges its special powers. Geoffrey Bardon wrote of the second and "definitive" version of this image that there are "many human figures seeming to emerge from the roots of the yam and doing their various work. The artist has depicted the figures in the same white ochre color as the plant, implying that they have the same spiritual substance. . . . The areas of light stippling are grass; dark stippling shows where the grass has been burnt away in search of the yam."[110] At least ten stick men and women are visible (see cat. 21), while the "definitive" version (painted three months later) includes just-discernible dingoes, a crow, children, women carrying *coolamons* on their heads, and warriors with spears and shields.[111] It is as if a whole community grows from the sustenance and generative force provided by the yam.

Then, Tim Leura Tjapaltjarri's *Yam Spirit* leaps forward into the future. In 1980 Clifford Possum was sent a twenty-three-foot roll of canvas by Geoffrey Bardon to paint for the making of a new film (which did not eventuate). Tim Leura came to inherit the commission and, assisted by Clifford Possum (who painted crucial Possum Spirit elements), he executed the masterful *Napperby Death Spirit Dreaming*, which Bardon later called a "deeply felt representation of his soul's journey." This work is unique as "an encyclopaedic representation of Tim's Aboriginal values" that, uniquely, contained paintings within the painting.[112] There are three graphically distinct pictures inserted into the composition: an *Old Man's Dreaming*, a *Sun and Moon Dreaming*, and the *Yam Spirit Dreaming* (fig. 29). Tim Leura painted a variant of his earlier "definitive"

Yam Spirit Dreaming (at the time the treasure of Geoff Bardon's collection in Sydney), which he had seen again in the color illustration Bardon had just published in his first book.[113]

One cannot but reflect on the crucial role the Yam Dreaming has also come to play in Indigenous women's art in the last two decades. It continues to be an occasional subject among the women who these days dominate the production of Papunya Tula, and is important to Warlpiri female painters at Yuendumu and Lajamanu. But the subject was given extraordinary power in the visions of Emily Kame Kngwarreye. Arguably the most famous Australian artist of the late twentieth century, Kngwarreye's Indigenous name—*Kame*—means "Yam."

Most of her paintings, and in particular the black-and-white series of 1995 culminating in her *Big Yam Dreaming* mural, encompass the yam plant. They do so both as a body painting motif proper to women's ceremony, and—at least to Western eyes—as the pattern made by the presence of its root network beneath the ground.[114] Yet for the idea of doing painting in itself, which Kngwarreye developed well beyond that of the Papunya artists, and for the practice of making the Yam Dreaming a proper subject for art, we have to thank the great artists like Tim Leura Tjapaltjarri and his countrymen who made the new art on little boards during those first years at Papunya.

ROGER BENJAMIN

Research Professor in Art History and
Actus Foundation Lecturer in Aboriginal Art

Power Institute Foundation for Art & Visual Culture,
University of Sydney

[1] Thanks for help in the preparation of this essay are due to Clare Lewis for her assiduous work as my research and curatorial assistant on this project. I have much benefited from the expertise of Fred Myers, Vivien Johnson, and Jennifer Biddle shared in conversation and in their comments on the text; Dorn Bardon also kindly provided written feedback. Djon Mundine, Judith Ryan, Howard Morphy, Steve Fox, and the late Gabriele Pizzi have taught me much about Central Desert art over the years. Thanks are due for the insights of Lynnette Napangardi Tasman of Lajamanu and Bryony Nicholson of Papunya Tula Artists, and to Sarah Tutton with the obtaining of illustrations. Finally, I thank Irene Sutton, Kate Sands, Andy Weislogel, and John and Barbara Wilkerson for their encouragement over a long period of time.

[2] For a discussion of the antiquity of Central Australian designs see Peter Sutton, Phillip Jones, and Steven Hemming, "Survival, Regeneration, and Impact," in Sutton, ed., *Dreamings: The Art of Aboriginal Australia,* 1988: 182–84; this book remains one of the finest introductions to Central Desert art, its history and meanings.

[3] The violent history of Indigenous-settler and debates about it are surveyed in Attwood, *Telling the Truth about Aboriginal History.*

[4] The official and ceremonial apology of Kevin Rudd at Parliament House, Canberra, on February 13, 2008, was a much-lauded event ending a decade of recalcitrance by the Liberal government of John Howard. For key accounts of the "Stolen Generations" see Read, *The Stolen Generations*, and his *A Rape of the Soul So Profound.*

[5] The only full account of the murals is the photo essay in Bardon and Bardon, *Papunya: A Place Made after the Story*, 12–19. See also the footage taken by Geoffrey Bardon in the superbly moving documentary film, *Mr. Patterns*, 2004.

[6] Printed labels "Wailbri & Pintupi Art" from the Stuart Art Centre, Alice Springs, 1971–72; this text may have been a collaboration between Bardon and Pat Hogan, the manager of the Stuart Art Centre and a significant figure in the early marketing of the boards.

[7] A key text detailing the underecognized role of Geoffrey Bardon is Ulli Beier, "Geoff Bardon and the Beginnings of Papunya Tula Art," in *Long Water: Aboriginal Art and Literature Annual* (Sydney: Aboriginal Artists' Agency), 1988: 83–100; recent assessments include Paul Carter, "The Enigma of a Homeland Place," in *Papunya Tula, Genesis and Genius,* 247–57, and the film *Mr. Patterns.*

[8] The Stuart Art Centre text begins: "Until a hundred years ago [sic], sand stories played a very important part in most Aboriginal ceremonies. This is most understandable when one realizes that bark, or any other suitable medium on which they could illustrate was not available. An area would be cleared and, sometimes for days, would be trampled and stamped until it became a hard flat surface. Upon this area, using ochres, charcoal, twigs, hair, blood (as an adhesive), feathers and the grass seeds that resemble flock, the painting would be built. Sometimes, if a small picture, by one member of the tribe, sometimes by as many

as thirty artists." (Hogan, "Wailbri & Pintupi Art"). Note that these days ceremony continues, and that grounds are often cleared using the community bulldozer.

9 See Phillip Jones, "South Australian anthropological history. The early expeditions of the Board for Anthropological Research," in *Records of the South Australian Museum*, vol. 20, 1987: 71–92, and Sutton, 80–81 and 159.

10 R.G. (Dick) Kimber (1977), quoted in Johnson, ed., *Papunya Painting: Out of the Desert*, 67.

11 See the forthcoming book by Vivien Johnson, *A Brief History of the Early Papunya Boards* (Sydney: University of New South Wales Press); it may be that Geoffrey Bardon provided canvas on rare occasions in 1972, as implied in Bardon and Bardon, 33; Bardon specifies the dates he was at Papunya on xxi.

12 See the one-hour panel discussion "Mutukayi: motor cars and Papunya painting," edited by Peter Thorley, December 2, 2007, National Museum of Australia, at www.nma.gov.au/audio/papunya_painting_series/mutukayi/.

13 For an exposition of *kirda/kurdungulu* relations in art practice see Peter Sutton, "The Morphology of Feeling," in *Dreamings: The Art of Aboriginal Australia*, 93–106.

14 The history of women as painters within Papunya Tula has yet to be written, although its origins date back to the early 1980s and husband-wife collaborations such as that between Tim Leura Tjapaltjarri and Daisy Leura Nakamarra; see the brief comments by Hetti Perkins (183–84) and Vivien Johnson (195–97) in *Genesis and Genius*. For sustained accounts of the leading role of women within Kukatja art and culture see Watson, *Piercing the Ground*; and for Warlpiri see Biddle, *Breasts, Bodies, Canvas*.

15 For an earlier version of this argument see Fred Myers, "Truth, Beauty and Pintupi Painting," in *Visual Anthropology*, no. 2, 1989: 163–95.

16 The classic account of this issue is Kimber's "The Politics of the Secret in Contemporary Western Desert Art," in *The Politics of the Secret*, 123–42.

17 The major accounts of how art relates to Aboriginal systems of knowledge are Munn, *Walbiri Iconography*; Myers, *Pintupi Country, Pintupi Self*; and Morphy, *Ancestral Connections*.

18 I deliberately avoid here the naming of such objects; for a detailed account of these artifacts that gives some idea of their religious function, see Strehlow, "The Art of Circle, Line and Square," in *Australian Aboriginal Art*: 44–59.

19 "Cultural harm" is the term accepted into white law during the copyright infringement cases of the later 1990s; see Terri Janke and Nathan Tyson, "The Carpet Case: Aboriginal Culture acknowledged in Landmark Decision. Introduction and Commentary," in *Periphery*, no. 22, February 1995: 4–6, and Vivien Johnson, ed., *Copyrites: Aboriginal Art in the Age of*

Reproductive Technologies (Sydney: National Indigenous Arts Advocacy Association and Macquarie University), 1996.

20 See Anderson, "Australian Aborigines and Museums: A New Relationship," in *Curator*.

21 The classic account of sand-drawing is Munn, *Walbiri Iconography*; Geoffrey Bardon's exegesis of "hapticity" is set out in detail in his "Theories of Papunya Tula Art" in *Papunya Tula: Art of the Western Desert*, 125-136; see also the analysis of Bardon's theories in Paul Carter, "Introduction: The Interpretation of Dreams," in Bardon and Bardon, xiv-xxi; ideas of hapticity are much developed in the books of Christine Watson and Jennifer Biddle.

22 Sutton Gallery of Fitzroy in Melbourne opened in 1992, initially in partnership with Peter Bellas Gallery of Brisbane. The gallery exhibits cutting-edge Australian contemporary art, including occasional exhibits of paintings from Central Australian Indigenous communities. Sutton has represented Gordon Bennett, Australia's most celebrated urban-based painter of Indigenous descent, since the early years of his career.

23 See Diggins, ed., *A Myriad of Dreamings: Twentieth Century Aboriginal Art*, and Brody, *The Face of the Center*.

24 See Johnson, "When Papunya paintings became art," in her *Papunya Painting: Out of the Desert*, 29–42.

25 See Baudrillard, "The Art Auction," in *For a Political Economy of the Sign*, 112–22.

26 Myers lists some five newspaper articles on this 1997 "scandal," in particular Martin Daly and Chris Ryan, "A painting by this struggling artist has just sold for $206,000 but he won't see a cent," in *The Age*, July 2, 1997, A1. See Myers, *Painting Culture*, 325.

27 A useful summary is Maslen, "Knocked down; still out," in *The Age*.

28 All such issues of the art market are subject to much more extensive enquiry in Myers's *Painting Culture*, especially chapters 6–8.

29 Bardon, *Papunya Tula: Art of the Western Desert*, 35.

30 See Johnson, *Clifford Possum Tjapaltjarri*, 52–53.

31 Thanks to Dick Kimber for his discussion of this issue.

32 See Hardy, Megaw, and Megaw, eds., *The Heritage of Namatjira*, and French, *Seeing the Centre: The Art of Albert Namatjira*.

33 Clifford Possum interview with CAAMA, late 1980s, quoted Johnson, *Clifford Possum Tjapaltjarri*, 42.

34 Bardon, *Papunya Tula: Art of the Western Desert*, 113.

35 Johnson, *Clifford Possum Tjapaltjarri*, 54.

36 Johnson explains this term: "When asked to recall the sequence of events over this decade, the painters' practice was to divide it up into the 'times' of the various Papunya Tula managers—none of whom stayed longer than a few years. Thus the painters could tell you whether they

had started painting in 'Chep [Geoffrey] Bardon time', 'Peter Fannin time', 'Dick Kimber time', 'John Kean time' or 'Andrew Crocker time.'" Johnson, *Papunya Painting: Out of the Desert*, 49.

[37] See Kimber, "Papunya Tula Art," in *Dot and Circle*, 44.

[38] *Gulgardi* is illustrated in Bardon and Bardon, page 135, painting 54. A close variant of this ceremonial layout by Kaapa, with two figures and a more pronounced perspectival space, is in the Museum and Art Gallery of the Northern Territory (it is possibly a Goanna Dreaming).

[39] Kimber, "Recollections of Papunya Tula 1971–1980," in *Genesis and Genius*, 210.

[40] The text of American naturalist Larry May is published in Johnson, *Clifford Possum Tjapaltjarri*, 219. Johnson writes, "Clifford Possum maintained that the corroboree portrayed in *Emu Corroboree Man*, though performed only by men, could be watched by the whole family" (64). Geoffrey Bardon made the following points: "These particular ceremonial objects at one time were of questionable secrecy and I was somewhat reluctant to publish this photograph. The detail shows the illustrative technique of the artist, closely derived from a photographic realism quite similar to the coat-of-arms on Australian paper currency" (Bardon and Bardon, 384).

[41] See Kimber, "Papunya Tula Art: Some Recollections," 44 and note 6.

[42] Kimber, quoted in *Important Aboriginal Art* (Sotheby's), June 29, 1998, cat. 21.

[43] *A Joke* was documented at the Stuart Art Centre as being painting number five in the eighth consignment (thus dated late February–March 1972); see Bardon and Bardon, 276. Although entitled *A Joke* by the Stuart Art Centre, I prefer Geoffrey Bardon's *A Joke Story* as it retains a mythic rather than quotidian implication.

[44] Other annotations mention the taboo objects visible as *tjurungas*, headbands, masks, and a pubic band. Two sketch diagrams of the work exist: one done in the field by Bardon, which is incomplete as it only details the right half of the picture, and the one by Pat Hogan, which varies the descriptions of objects (for example, Hogan's drawing mentions a "third fella"). It appears Hogan had more information about the picture, possibly from the artist Tim Leura, who often visited Alice Springs to make deliveries for the community.

[45] As Jennifer Biddle has pointed out in conversation, the terms "iconic" and "indexical" familiar from semantic theory tend to merge in Central Desert symbology, as the conventional signs like U-forms or track signs for animals (i.e. the "icons") are indexical in origin, being based on marks physically imprinted in the sand.

[46] Johnson, *Clifford Possum Tjapaltjarri*, 222.

[47] Pedagogical notes courtesy of Jennifer Biddle.

[48] See Watson, *Piercing the Ground*, 30: "The Kutjungka system of image making can be best described as a system of marking and penetrating

the skins of sentient entities or selves which are viewed by local people as conscious, rather than as one of embellishing or decorating the neutral surface of objects."

[49] Yam sticks are hardwood crowbars (these days steel is often used), used by women for digging vegetables and reptiles out of the ground; they can also be used by women for self-defense or fighting.

[50] Bardon and Bardon, 376 (classified under Women's Dreamings). Bardon's phrase is quoted in Johnson, *Clifford Possum Tjapaltjarri*, 221.

[51] As early as 1986, the first solo exhibition was accorded to one man, Charlie Tarawa Tjungurrayi, by Andrew Crocker while in the 1990s two great Papunya Tula artists, Clifford Possum and then Michael Tjakamarra Nelson, were given complete books written by Vivien Johnson and published in color by Craftsman House. Other portraits of individuals have appeared in obituaries of Dick Kimber and essays by Fred Myers and Philip Batty. Johnson's *Aboriginal Artists of the Western Desert: A Biographical Dictionary* (Sydney: Craftsman House), 1994, has been expanded in her *Lives of the Papunya Tula Artists* and the Dictionary of Australian Artists Online, (www.daao.org.au).

[52] See Bardon, extensive entry in *Fine Aboriginal Art* (Deutscher-Menzies), cat. 58.

[53] Bardon and Bardon, 300, 301.

[54] See entry in *Fine Aboriginal Art* (Deutscher-Menzies), cat. 58.

[55] For a remarkable study of love magic see Nicholls, *Yilpinji—Love, Art & Ceremony*, 2006.

[56] The best account of this work is Myers's "Aesthetics and Practice: a Local Art History of Pintupi Painting," in *From the Land: Dialogues with the Kluge-Ruhe Collection of Aboriginal Art*, 219–59.

[57] Fred Myers, personal communication, May 2008.

[58] Myers quoted in *Important Aboriginal Art* (Sotheby's), June 30, 1997, cat. 17.

[59] Kimber in ibid.

[60] See Biddle, *Breasts, Bodies, Canvas*, 61–66; 71–73.

[61] Peter Latz lists four such plants in his remarkable *Bushfires and Bushtucker: Aboriginal Plant Use in Central Australia*, 212–13.

[62] Typescript notes by Susan Congreve, Papunya file, Library of the Museum and Art Galleries of the Northern Territory, Darwin.

[63] See Bardon and Bardon, 39, on the rejection of Pat Hogan by the Papunya painting men after Bardon's resignation.

[64] Summary of Pat Hogan in *Aboriginal Art* (Sotheby's), July 26, 2004, cat. 96.

[65] See Strehlow, "The Art of Circle, Line and Square," 54.

[66] As Bardon writes, "It is very common for the Ceremonial men to be in a cave, often where there is a rockhole. Yet in reality there are very few

'caves' in this area, but there is an incredible knowledge retained by Aboriginal men of where a cave may be, since its Dreaming is part of their custodianship." Bardon and Bardon, 441.

[67] Strehlow, "The Art of Circle, Line and Square," 58–59. For a detailed account of how Europeans stole or traded sacred objects from the Arrernte people over half a century from the later nineteenth century—a cultural theft that accompanied the decimation of Arrernte populations—see Phillip Jones, "Namatjira: Traveller between two worlds," in *The Heritage of Namatjira,* 115–26.

[68] The theater director traveled there on the recommendation of the Canberra-based senior government advisor H. C. (Nugget) Coombs. See Sotheby's, June 28, 1999, cat. 102.

[69] Bardon in ibid.

[70] Label affixed to back of the plywood board. See also ibid., and Bardon and Bardon, painting 412.

[71] The work was apparently "given as payment to the [owner] for his professional services as a script writer on Geoff Bardon's first film on the Yuendumu Sports Carnival entitled *The Richer Hours,* produced in 1971–72." Ibid., cat. 25.

[72] As with most Western desert paintings, to talk of "top" and "bottom" is irrelevant, as the boards were often rotated in the artists' hands (and larger canvases are painted flat on the ground with multiple orientations).

[73] The Ngapa Tjukurrpa (Water Dreaming) belongs to Nampitjinpa and Tjampitjinpa (primary *kirda*), as well Tjangala and Nangala (secondary *kirda*). On the imagery see the fifty Water Dreamings compiled in Bardon and Bardon, 49 and 156–205.

[74] "Towards the end of his life, with failing eyesight, he commissioned some of the other Papunya Tula artists to paint his stories for him." *Genesis and Genius,* 300.

[75] Unattributed epigraph in Bardon and Bardon, 158.

[76] Notes provided by Dick Kimber in 1997, published in *Genesis and Genius,* 281. See also the voiceover in *A Calendar of Dreamings.*

[77] Bardon and Bardon, 168.

[78] Strehlow, "The Art of Circle, Line and Square," 59; this *woomera* is in the collection of the South Australian Museum.

[79] Bardon and Bardon, 487.

[80] See Howard Morphy's influential article, "From Dull to Brilliant: The Aesthetics of Spiritual Power among the Yolngu," in *Man.*

[81] See notes from the Stuart Art Centre, #14003 (i.e. consignment 14, no. 3), personal archive of John and Barbara Wilkerson.

[82] There is a closely comparable work by Shorty Lungkarta Tjungurrayi in the collection of the Araluen Art Center, Alice Springs.

[83] See John Weber Gallery's *Papunya Tula.*

[84] Kimber cited indirectly in Sotheby's, June 30, 1997, cat. 19 (Stuart Art Centre #17009).

[85] See Johnson, *Clifford Possum Tjapaltjarri,* 86–114.

[86] For more detail see Myers, "In sacred trust: Building the Papunya Tula market," in *Genesis and Genius,* 235–245, and for a comprehensive view, his *Painting Culture.*

[87] Hogan was a trustee of MAGNT at the time, according to Margie West of the Darwin museum. See Hogan, "Notes and Inventory for the Early Consignments of Pintupi Paintings," in *Dot and Circle,* 55; eventually some two hundred and fifty Papunya paintings of the 1970s entered the MAGNT collection.

[88] Information in letter by Dorn Bardon to the author, July 29, 2008.

[89] See Ken Watson, "Chronology," in *Genesis and Genius,* 307: "Implementing the main recommendations of the Woodward Royal Commission, 36 percent of the Territory's land area reverted to Aboriginal ownership under freehold title."

[90] John Kean, "A Big Canvas: Mobilising Pintupi Painting," in *Colliding Worlds: First Contact in the Western Desert 1932–1984,* 49.

[91] Text printed on the Papunya Tula Artists certificate dated October 15, 1998, for Yala Yala Gibbs Tjungurrayi, *Untitled,* 1998; personal archive of John and Barbara Wilkerson.

[92] Myers, *Painting Culture,* 95. An earlier attempt at a systematic analysis of the "site-path complex" may be found in Peter Sutton, "The Morphology of Feeling," in *Dreamings: The Art of Aboriginal Australia,* 81–86.

[93] Seven of these works in the National Museum of Australia's collection are illustrated in Johnson, *Papunya Painting: Out of the Desert,* 68–77.

[94] Ryan, 82.

[95] Myers, *Painting Culture,* 101.

[96] Davidson quoted in Strehlow, "The Art of Circle, Line and Square," 58.

[97] On Doreen Reid Nakamarra see Croft, ed., *Culture Warriors: the National Indigenous Art Triennial 07,* 132–33.

[98] The most sustained discussion of body painting as the basis for recent painting practice is Biddle, *Breasts, Body, Canvas.*

[99] This status was confirmed by its inclusion in the first definitive exhibition of the new art to travel overseas, *Dreamings: the Art of Aboriginal Australia,* initiated by Andrew Pekarik of the Asia Society in New York (this key date in the reception of Aboriginal art is analyzed in Myers, *Painting Culture,* 255–276).

[100] The main statement of these ideas is in Wassily Kandinsky, *Concerning the Spiritual in Art* (1912), trans. Michael Sadler (New York: George Wittenborn), 1947.

101 During the recent exhibition *Papunya Painting: Out of the Desert*, the curators arranged for Pintupi songs (recorded in 1974 by Fred Myers during the painting of works later given to the National Museum of Australia) to be played over speakers in the vicinity of those pictures.

102 The following account is given in *Genesis and Genius*, 285: "This painting depicts designs associated with the Two Men Dreaming at the site of Kuluntjarranya, south-west of the Kintore community. In mythological times these two men, *ngangkaris* (Aboriginal doctors) with very special powers, traveled in this area. They ate some very strong *mingkulpa* (native tobacco) which caused them to behave very strangely. They started to urinate but were unable to stop for a considerable time. The urine flowed across the surrounding country forming several salt lakes and making the sand very boggy. The shapes in the work represent the salt lakes." See also *Important Aboriginal Art* (Sotheby's), July 24, 2007, 66.

103 For Tjapaltjarri examples see Johnson, *Clifford Possum Tjapaltjarri*, 119 (*Two Men Fighting*, 1978) and 180 (*Yuelamu [Honey Ant Dreaming]*).

104 Kimber quoted in *Genesis and Genius*, 300. The desert hand-sign languages are so extensive that in the case of Warlpiri, over three thousand signs have been counted.

105 See West, ed., *The Inspired Dream—Life as Art in Aboriginal Australia*, 98.

106 *Genesis and Genius*, 289.

107 Ibid., 283.

108 Bardon and Bardon, 313. On this plant, *ipomoea costata*, see Latz, 214–15.

109 The work was first published in Patrick Corbally Stourton, *Songlines and Dreamings: Contemporary Australian Aboriginal Art* (London: Lund Humphries), 1996: 139, and described as "one of the most important paintings from the early days of Papunya Tula."

110 Bardon and Bardon, 324.

111 See Bardon, *Papunya Tula: Art of the Western Desert*, 120, also 138–39; in Bardon and Bardon, 324, he names this version five out of six in Tim Leura's Yam series.

112 The quotes are from Geoffrey Bardon in 1989; see the detailed discussion of this work in Johnson, *Clifford Possum Tjapaltjarri*, 238–39; see also Bardon and Bardon, 436.

113 Point made in conversation with Vivien Johnson.

114 The literature on Kngwarreye is extensive; for a start see *Emily Kame Kngwarreye: Alhalkere: Paintings from Utopia* (Melbourne: Queensland Art Gallery and MacMillan), 1998, and *Utopia: the Genius of Emily Kngawarreye* (Canberra: National Museum of Australia Press), 2008, both edited by Margo Neale.

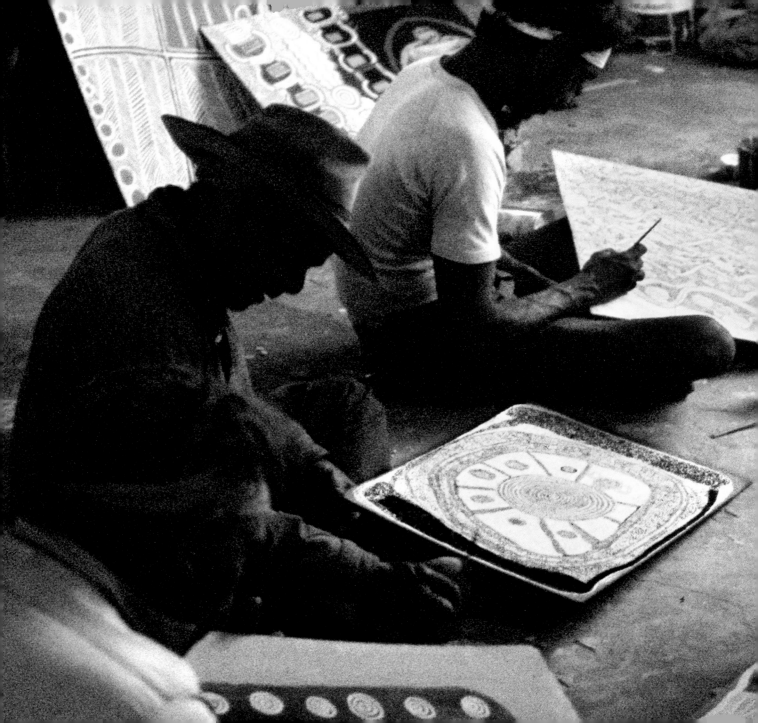

graceful transfigurations
OF PERSON, PLACE, AND STORY

**the stylistic
evolution of
Shorty Lungkarta Tjungurrayi**

FRED MYERS

I. Do You Have a Moon in Your Country?
A Personal Portrait of a Painter

In accepting the opportunity to write for this collection,[1] I decided I most wanted to provide a tribute to one of the Pintupi painters who changed my life. Shorty Lungkarta Tjungurrayi—conceived of the *Kanyala Tjukurrpa* (Hill Kangaroo Dreaming) at Tjulyurunya perhaps in 1912—was a man whose personality and art deserve to be represented in the extraordinary record of Papunya Tula artists. Shorty Lungkarta should be considered along with Uta Uta Tjangala and Yanyatjarri Tjakamarra, whom I previously analyzed in some detail,[2] as a painter of virtuosity. In this essay, I seek to gain some insight into the process of Shorty's imagination. My emphasis will be on the way his paintings relate to his experience of the land, to his experience as a living, active person enmeshed in social relations.

Often, we do not know very much about the kind of people the Papunya Tula painters were or the kind of lives they led while they made the works we admire. Shorty's personality was so striking that I want to offer a portrait of him before considering his work as an artist.

When I met him at the new Pintupi outstation of Yayayi in 1973, Shorty Lungkarta Tjungurrayi was a man of perhaps sixty-one years of age. Despite the fact that he had left the bush more than twenty-five years before that, coming from the Lake MacDonald region to the ration depot at Haasts Bluff in 1948, Shorty was still one of the more traditionally oriented people in the community, and it was interesting to see that very often his camp was set up between those who were known as "the New Pintupi" and those known as "the Old Pintupi," the earlier migrants from the Western Desert. He was,

Shorty Lungkarta Tjungurrayi *(center)* painting *Classic Pintupi Water Dreaming* (cat. 25) with Pintupi countrymen Yala Yala Gibbs Tjungurrayi and Tim Payungka in the Men's Painting Room, Papunya, August 1972

from almost the very first day I spent at Yayayi, a friend to me, and I always felt comfortable with him and his family. In many ways I think he fulfilled his role of *tjamu*, or "grandfather," to me.

I knew and remained friends with Shorty over a period of perhaps twelve years, living with or near him from 1973–75, in 1979, in 1981, and returned for brief visits in 1982, 1983, and 1984. The first painting I ever purchased—violating my own prescription of the time *against* buying—was a wooden dish he was painting as a *Kungka Kutjarra* (Two Women) Dreaming in late 1973 (fig. 1).

FIGURE 1.
Shorty Lungkarta Tjungurrayi, *Kungka Kutjarra Dreaming*, 1973, synthetic polymer paint on wood. Collection of the Museum of Contemporary Art, Sydney.

I was so drawn to it as an aesthetic expression of him—of his ritual knowledge and expressive genius—that I asked him if I could purchase it. I have since given it to the Museum of Contemporary Art in Sydney.

The travels of Shorty's life comprise the centerpiece of my first book, *Pintupi Country, Pintupi Self* (see chapter 3), as an example of how individuals managed their movements in time and place. I gave him the pseudonym Maantja (or "Moon"), deriving it from the name he bore as a young man. Later, too, Shorty attracted other followers. He became fast friends with Kevin Keeffe and Jeff Hulcomb, then outstation schoolteachers in the Papunya area. By the early 1980s, Shorty's waning concentration for painting and declining physical energy decreased his participation, and I may have purchased the last painting he did—which I loved—but this was a time of his final ritual ascendancy in new religious movements coming to the Papunya area. It was a great kindness that, before Shorty died in 1988, Kevin Keeffe read him the relevant portions of my book about him. At that time, having converted to Christianity, he had taken the name of Leon.

While I met Shorty on what I think was my second day at Yayayi, I had noticed him the previous day, with his white chin beard, holding his small grandson Thomas—a strikingly commanding man showing love and warmth to a child. On the morning of that second day, I woke up and stood not far from the water tap near the caravan in which the Summer Institute of Linguistics worker Ken Hansen lived with his family. I was uncertain of what to do or where to go, and it must have been obvious to anyone who saw me. From his camp nearby, Shorty motioned me over and proceeded to introduce the people in his camp and to tell me the names of all of his children. He had a few words of English, so I managed to comprehend what he was telling me. I remember Napulu, his wife, as being rather more harsh and commanding than Shorty, even in these first days when she stopped me and asked for tobacco. Shorty rarely asked me for anything and seemed genuinely to enjoy talking to me, often laughing and commenting on what a "funny bugger" I was, a suitable relationship with a *tjamu*. He often teased me about *ilypintji* (love magic songs), and I teased him in return. In the early parts of my stay, the men were singing an *ilypintji* cycle at night and performing some of its ritual acts in the day. Because I attended all of these, where possible, and because their content was sexual, Shorty assumed that was what I was interested in, although really he knew I was interested in ritual itself. He was mostly joking, although he did tell me it was effective anywhere and could get me a wife. "Do you have a moon in your country?" he asked. We do, I said. Then, "it will work, no worries." He had much authority in this particular cycle, which had been handed up by the Pitjanytjatjarra south of here.

Ceremonies provided conditions that were most favorable to him. He was without doubt the best actor/dancer among the men at Yayayi and perhaps in the immediate area. He did some clowning acts in his performance that were extraordinary examples of comic grace. After watching what I was told was a *Kurtaitja* (the general Central Desert word for what is sometimes called "the featherfoot killer") or *Warnapa* (revenge expedition) ceremony, I hardly knew how to describe the "beautifully stylized" way in which he knelt and rose halfway, thrusting his pelvis and then reaching between his legs and pretending to throw feces to the side. "Shorty is," I wrote, "the most superb of the dancers I've seen. A very sensitive man; you feel the art of it all so much." He sang also with a vigor and interest that were everything that a Western Desert Aboriginal man might be. The aesthetic sense and his courteous humanity attracted me to him, and I found them to be a well so deep as to never run dry. Even when inebriated and reeling under the influence, the man had qualities that transcended the everyday.

I don't know if other people at Yayayi felt this, but it was so for me. He was one of the few people who told me things that were going on and explained them to me freely because he *wanted* me to understand, because I was a friend. He did not begrudge the effort or feel it was ludicrous to try—and perhaps he was gratified that a white man could understand him, as Geoffrey Bardon hadn't been able. The best example of this was on his return from Balgo on a trip for ceremonial "business" in early 1975. At great length he told me what had happened there, telling me in a way that I felt was used for anyone who was not on the trip. These were important matters that he had seen. He told me how he had flown to Yayayi in a dream and walked around the camp looking for Napulu; how he had been "eating" his own flesh, how

1 I would like to thank Dick Kimber for many informative discussions about early paintings. I thank Faye Ginsburg for her comments on reading this essay, and Andrew Weislogel for his editorial interventions.

2 See Myers 1999 and 2002.

3 See Myers 1986 and 2004.

4 Bardon (1991), 99.

5 See Myers (1986), 62.

6 See Myers 2004.

7 See Myers 2002.

8 Myers 2004.

9 See Myers 1986.

10 Myers 1986.

11 See Myers 2004.

12 The "water stories" seem to be involved not with the well-known Rain Dreamings (also referred to as Water) painted by Johnny Warangkula or Walter Tjampitjinpa. I suspect that Shorty recognized or realized that Geoffrey Bardon had seen something important in Johnny's "Water Dreaming at Kalipinypa" and attempted to explain himself to Geoff in similar terms. Shorty's stories are a different mythological cycle, having to do with the claypans and salt lake at Lake MacDonald. These were very important in the yearly round in his country, filling up as claypans after the summer rains and becoming a resource for larger gatherings based on the presence of *mungilpa* seeds (see Myers 1986). Shorty was very familiar with these places, and I documented a number of paintings of them.

13 See Myers 1986.

14 Myers (1986), 63–64.

15 The word "tulurrutjunana" means "playing the stone game," where "tulurru" refers to a flat, round stone children throw and then try to hit it as it rolls.

16 *Important Aboriginal Art* (Sotheby's, June 30, 1997), 22.

17 *Important Aboriginal Art* (Sotheby's, June 29, 1998), 37.

18 Bardon (2004), 200.

19 See Myers 1999.

20 According to my notes and memory of this time, Shorty had prepared two larger than usual canvases of the same *Tingarri* Dreaming line a few days earlier, one of Tjukula and the other of Pirmalynga. Indeed, on June 4, 1974, Long Tom Tjapanangka told me he and Shorty had performed the Pirmalynga sequence of events at the ceremonial ground. (Shorty had told me he expected about $200 each, rather than the usual $80, and he said he wanted a "motorcar" from the government for four canvases.) [Author's field notes, June 12, 1974: 57.]

21 Author's field notes.

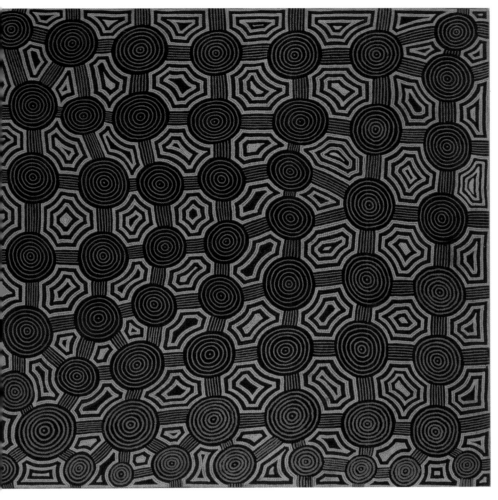

FIGURE 15.
Simon Tjakamarra, *Itterulnya*, 1988, synthetic polymer paint on linen.
Private collection.

men had with me about their paintings, in which they were explicit in placing these landscapes in the social and political context of a Pintupi exile or displacement from their traditional homelands. In that initial conversation, with two prominent painters—Uta Uta Tjangala and his brother-in-law Charlie Tarawa—they emphasized that the paintings were *turlku*, a word referring to ceremonies and that the paintings were from *their* country.

Indeed, the paintings were entangled in—and products of—a vexed history. The paintings have continued to have such values associated with them, as inseparable from the being and history of Indigenous identification with the landscape. When the paintings become less overtly representational of landscape itself, they continue to index place in manifesting the power invested in places and identified with their own being.

There were subsequent transformations of the paintings and their style, such as the op art innovations of Simon Tjakamarra (fig. 15), Joseph Tjaru, and Ronnie Tjampitjinpa developed in the late 1980s. Their paintings took on highly typified forms, of lines and circles on fields of dotting, very focused on the design and design effects with few or very less obvious references to landscape features specifically. Nonetheless, the paintings are regarded fundamentally as extensions of the places, even if the painters had become less likely to discuss these meanings for most interlocutors. Indeed, as the main art adviser of the time, Daphne Williams, was disinclined to ask or record these details, for fear of transgressing—*as* a woman—on men's business, the landscape associations were submerged—although distinctly present in the imaginations of the painters.

Shorty Lungkarta was one of a generation of painters who had lived closely, as foragers, on the land. While this generation is largely disappearing, paintings continue to index ideas and uses of place, now experienced presumably in differing ways. They continue to operate as loci of ancestral power, as sources of human identity—in ritual and painting, at least. And it is to artistic projection of this experience that our attention remains drawn.

FRED MYERS

Silver Professor and Chair, Department of Anthropology

New York University

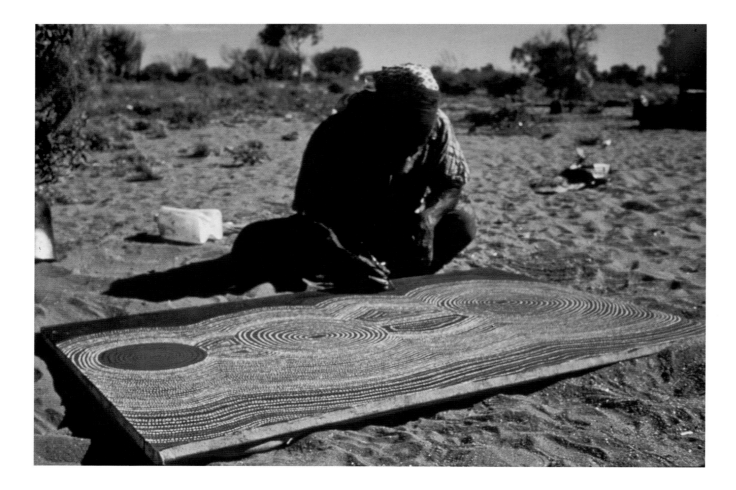

FIGURE 14.
Shorty Lungkarta Tjungurrayi
painting *Yitjiringinya*, 1981.
Photo by the author.

ground, at the novices' camp, singing this very song cycle! In the song cycle, the *Tingarri* men are scraping away the outer charred surface of their seed cakes—the seed cakes that are the ancestral version of the damper brought to the *Tingarri* ground to sustain the present-day novices.

These examples illustrate the stylistic evolution of Shorty's paintings, moving to relatively conventionalized forms, depicting more abstractly the features of the Dreaming events that he wanted to emphasize. His innovations within these forms were regarded, at the time, as particularly creative and compelling, powerful reductions of the complex phenomenon of Ancestral presence into two dimensions.

III. The Wider Context

Along with this stylistic evolution, Shorty's later paintings of the same places of the early "water stories" (not named as such once Geoff Bardon was gone) have a similar form. His late painting of the claypan site of Yiitjirringinya is very interesting in this light. It was completed April 15, 1981, at the location of New Bore, near Mount Liebig.

The design of this painting of the Two Boys at Yiitjirringinya (fig. 14),

near to Lampintjanya, looks rather like the outline of a ground painting. One emphasis of the painting of the two boys, sitting facing each other (and cursing) is the windbreak around them. This he paints as encompassing lines around the circles. As a matter of execution, the painting was initiated with three circles and then Shorty put lines between circles, then in yellow put a line around two of these, then a red line around the yellow.

"This design," he explained, "was done on antbed (*liintji*)—as a ground painting. It was done at same time as women do their ritual (*yawalyu*), then we would like the initiate down and do the ceremony. This was done for the Shield (*Kurtitji*) Ceremony when the young boy was sent away, involving body decorations (*yurtalpa*). This is a big initiatory ceremony, for older novices as well as boys."[21]

The sorcery songs of this story, he told me, will close the rectum (*kuna*) of a victim so the excrement comes out somewhere else. "It is a dangerous ceremony, Tricky. Danger lies there" (*Turlku miilmilpa, tickly. Danger ngarrin*). But there was a point to this information. I should tell whites, Shorty said, that they (Aborigines) "have dangerous things. Not to go anyway, you looking for gold, but different."

Shorty's comment here resonates closely with the very first discussions

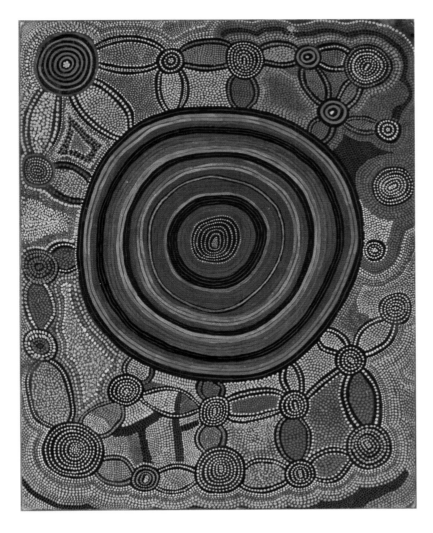

FIGURE 12.
Shorty Lungkarta Tjungurrayi, *Punyurrpungkunya*, 1974, synthetic polymer paint on linen. Private collection.

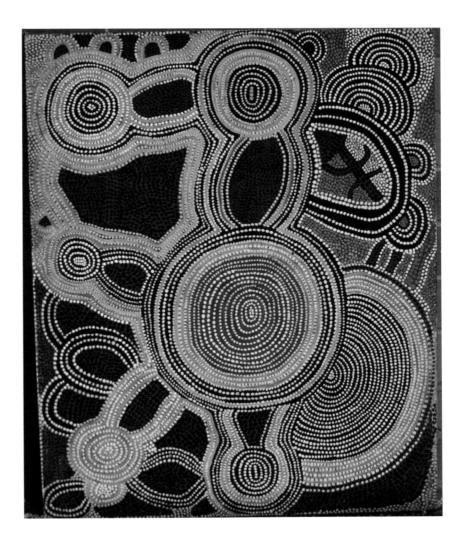

FIGURE 13.
Shorty Lungkarta Tjungurrayi, *Yintirinynga*, 1975, synthetic polymer paint on linen. Collection of Judith Wilson, Canberra.

of the paintings was becoming "displaced," as it were, that the connection between painting and landscape was reduced. But Shorty's paintings and those of other Pintupi men also remained closely tied to ritual presentations of place, and they remain under the authority of those with the right to depict them. Indeed, in June 12, 1974, several of Shorty's paintings were of the same events as those just being performed in the initiates' camp in the community. This grid is illustrated in two paintings from this period by Shorty himself (figs. 12 and 13), as well as one of the fine examples in the exhibition (cat. 40).

Shorty's painting was even more obviously than usual intertwined with ceremonial performances of sacred sites and the provisioning of the young men who were being initiated into the knowledge of these places. Indeed, sales scraped together for far-off museums were converted back at the ceremonial ground into bread and tea for the novices and to sustain their so-

cialization. Not only did the performance bolster confidence in the value of the paintings, the context of the Tingarri performance also generated a particularly rich assortment of paintings. The sale of paintings immediately and directly supported the performance, being turned into food provided for the initiates (known as *punyunyu*) at the ceremonial ground. This large oval (approximately 36.5 meters long x 23 meters wide), is a significant feature of a number of Shorty's paintings of the time, including this one. Actors decorated for Tingarri ceremonies could be seen with white *wamulu* (bush cotton) body decoration in concentric circles on their stomachs and backs, connected over the shoulders and sides, preparing to reenact their *Tjukurrpa*.[20]

From ritual camp to painters' camp, I watched Shorty Lungkarta putting the story of Ilingawurngawurrnga, another name for the Tingarri site of Mitukatjirri, on canvas. At night, the men were sleeping at the ceremonial

and identified through their conception as ancestral beings here. Their conception dreaming as the two boys is an artifact of their aging father's frequent and prolonged residence at nearby Walukirritjinya—with autumn movement to the claypans, as indicated in Shorty's life history. Feature 3 represents the two sons gathering the coals and wood of a fire. At feature 1, the two sons put up a windbreak around themselves, a feature also of a later painting. The two carpetsnake men were associated with sorcery ceremony, not *Tingarri*, and followed a different (if intersecting) story line. If one "puts this on a spear," Shorty told me, the victim is "one foot" ("one foot in the grave").

Let me turn, then, to the early paintings. *Snake Dreaming at Lampintjanya*, from 1972, visually emphasizes the snakes (fig. 9). The movements of the snakes, their home, and the bullroarer are all noted by Geoffrey Bardon's documents. As Dick Kimber noted, snakes are "associated with the formation of creek-lines that flow in a large clay pan. Not only is it a long-lasting claypan water, but also about its edge *mungilpa* grows in profusion after rains."[16] Visible in this painting, just above the center circle is an oblong with a cross design that, I believe, is a common form of a sacred object—the string cross—carried by the men and indicated by some other paintings.

Water Story (cat. 24) has some documentation available in the Sotheby's auction catalogue of 1998. It is thought to be "probably Lalpinga (Lampintjanya)," the artist's birthplace. In this painting, the central roundel represents a big waterhole with small creeks running into the central waterhole.[17] The underlying black motif could be a sacred object, but in a recent conversation I had with surviving Papunya Tula painters, the design was identified as "hairstring" (*puturru*)—perhaps a spinning of hair string on a stick as suggested by the circular shaping of the lines. This is a common way of disguising in public the presence of a sacred object by presenting its more mundane derivative.

Water Dreaming (cat. 25) was also part of a large collection, assembled by Tim Guthrie in 1972 and much later sold at auction by Sotheby's. In this small painting on masonite, the central roundel represents a waterhole, surrounded by soakages (small sets of concentric circles), with little creeks flowing into it from a larger watercourse that surrounds. The dark forms at each end represent hills. Again, this site is probably Lampintjanya, as suggested by the identification of a circle with two semicircles in the upper right as two men at the fire. My friend Dick Kimber, who has visited the site, identifies it as Shorty's birthplace, with the little creek and big creek routes formed by the movements of ancestral snakes, and the hills promoting rain storm run off into the claypan. Overdotting in dark areas at top and bottom may represent *mungilpa* seed, abundant after rains, blending Dreaming and present situations, but the dark areas were identified by Shorty as "hills" or "rocks."[18] I should also note that the painting is in the shape of a circular, constructed headdress worn in many men's rituals. Thus, the painting of the claypan is at once the physical place and also the ritual form of that story worn on the head of dancers.

Figure 10, which is untitled, is clearly another depiction of a water story. Painted in 1972, this painting indicates running water in a conventionalized iconography. Finally, the *Mystery Homeland* painting (fig. 11), I believe, is likely a big claypan—Lampintjanya. The numerous small white circles on the orange/red background probably refer to *mungilpa*, typically turned into seed

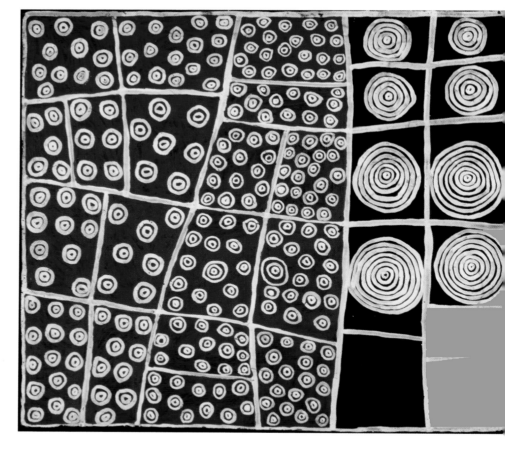

FIGURE 11.
Shorty Lungkarta Tjungurrayi, *Mystery Homeland*, 1972, synthetic polymer paint on composition board. Private collection.

cakes and able to feed temporary large gatherings of people. Commonly, claypans are comprised of many potholes, divided up, with high and low areas, such as those suggested by the rectilinear divisions in this field. The larger circles might be camps on a higher wooded area, represented by the black background, the hills that Shorty identified in the dark shapes surrounding the circle in *Water Dreaming*.

In these paintings, the "landscape" dimension is very tangible, and so also is the inseparability of person, places, and objects. Most of Shorty's later paintings are of *Tingarri* cycle themes, and space will not permit analysis. Here I just want to present a few images to indicate the stylistic evolution toward a more straightforward circle and grid form—a style evident in my drawings of *Kanamarapanytjinya* (see fig. 6) and *Lampintjanya* (see fig. 7) from the later period.

After the trouble with the early paintings, Shorty's paintings begin to drop out some details, also to move to more often the five-circle grid model and its variants,[19] which I found very common in this period—a model that may owe considerably to a body painting form common in *Tingarri* ceremonies.

One might imagine, then, that the immediacy and landscape intimacy

Because of the association of Shorty's brothers-in-law with the place, the story is elaborated. The two sons were throwing dirt at each other at Lampintjanya (they were two Tjangala brothers, Wirrili [George Tjangala] and Mungilnga [Left Hand Frank Tjangala]), digging for the carpetsnakes. They came here from another claypan at Yiitjirringinya, where their actions—as two boys—created the claypan there. After playing at a stone target game (*tulurrutjunuma*), the boys "sang" each other (sorcerized, *yinitjunungkupula*), angry over the *mungilpa* seed cakes. Wirrili was hiding the seed cakes (known as *nyuma*[15]) and giving only a little bit to Mungilnga so this Left Hand "sang" him. This is place where Shorty often got *mungilpa*, traveling from the water-hole at Walukirritjinya. The two boys continuously sat there in a windbreak (*yunta*). The songs of this sorcery ceremony are dangerous. It is powerful.

At Kanamarapanytjinya, as seen in my drawing (see fig. 6), the Native Cat's (*Kuninka*) same two sons are "working" here, gathering stones into piles. Hail (*kunarta*) came from these two sons, which is what killed the *Tingarri* men later. The center feature (1) is a rockhole. Creeks are indicated on the upper right and left. The small circles are hailstones, now visible as rocks and stones. Creeks are depicting running to the lake, the result of ancestral water snakes going along and having gone inside. Shorty's brothers-in-law, the men named Wirrili and Mungilnga, were noted by him as "bosses" of the place,

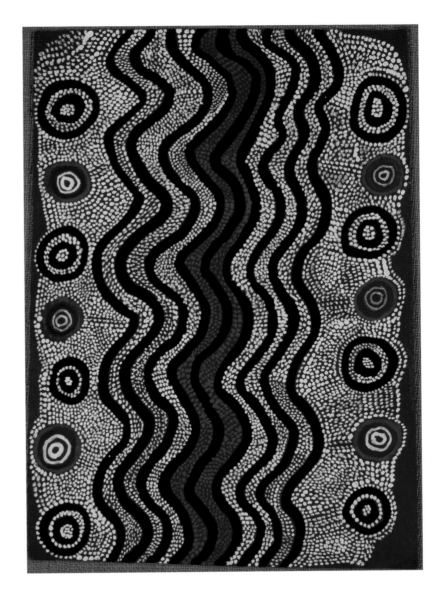

FIGURE 9.
Shorty Lungkarta Tjungurrayi, *Snake Dreaming at Lampintjanya*, 1972, synthetic polymer paint on composition board.

FIGURE 10.
Shorty Lungkarta Tjungurrayi, *Untitled (Water Dreaming)*, 1972, synthetic polymer paint on composition board. Private collection.

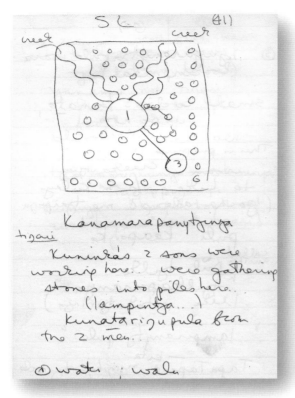

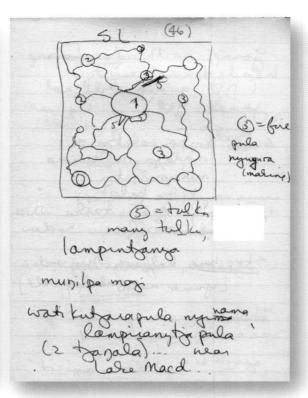

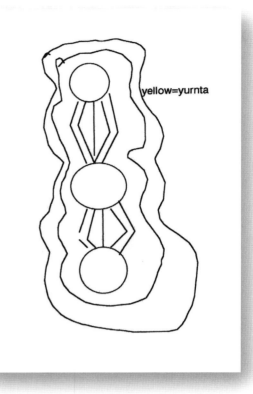

FIGURE 6.
Author's drawing of Shorty Lungkarta Tjungurrayi's *Kanamarapanytjinya*, 1974.

FIGURE 7.
Author's drawing of Shorty Lungkarta Tjungurrayi's *Lampintjanya*, 1974.

FIGURE 8.
Author's drawing of Shorty Lungkarta Tjungurrayi's *Yiitjirringinya*, 1981.

mance or set of ancestral stories known as *Tingarri*. His painting style evolves, following these constraints, towards one more abstracted. In this period, Shorty developed a characteristic style and acquired a degree of attention as a premier Papunya Tula artist—evidenced in the selection of a couple of his paintings, particularly, for the cover of *Art of the First Australians* (1976) and other collections. The two styles I associate with Shorty are the filigree dotting patterns of the paintings on masonite and later, after the switch to canvas board and canvas and especially with his focus on Tingarri stories; and an emphasis on overlapping circles and semicircles—giving a different effect of potency and multiplicity. The former pattern includes many of the paintings referred to as "Water" stories in documentation. I want to discuss the "Water" stories here, which are exquisitely represented in the exhibited collection.[12]

Among the paintings reproduced in important catalogues and gathered into collections, the so-called "Water Dreaming" stories stand out. Shorty's stories under this title have to do, not with Rain-identified ancestors, as is sometimes the case with other painters (as in Johnny Warangkula's "Water Dreaming" stories), but with the claypans and salt lake area around Lake MacDonald. These claypans were very important in the yearly round in his country, filling up with water after the summer rains and becoming a resource for larger gatherings based on the presence of *mungilpa* seeds.[13] The reference to water refers to watercourses in the claypans, the product of ancestral activi-

ties but not made by Water ancestral beings themselves.

Shorty was very familiar with these places. The paintings I personally documented of this cycle—*Kanamarapanytjinya* (fig. 6), *Lampintjanya* (fig. 7), and *Yiitjirringinya* (fig. 8)—are related, I believe, to a number of early paintings. I will discuss some of them as exemplary.

In many of Shorty's "water" stories, there is an emphasis on watercourses or water channels, and these are seen as the path of Ancestral snakes, a common mythological identification of sinuous channels as the "tracks" of Dreaming snakes. In the area of Lampintjanya and Kanamarapanytjinya, the broad mythological background involves the *Tingarri* story of the Ancestral Native Cat (*Kuninka*), whose two sons are around Lake MacDonald, waiting to punish a group of men he is sending to their death.[14] In the area of these claypans, there were also two Rock Python or Carpetsnake ancestors (*Kuniya*), and the two sons were pursuing these snakes in order to kill and eat them. At Lampintjanya, the two men were sitting at a fire, pulling a fire together. They put their (many) sacred objects down and began to dig. The creek in the swamp (claypan) of Lampintjanya is the result of their movements and digging, pursuing the snakes eventually to a hole (*pirti*) near a neighboring hill. The features of fire, the sacred objects, and the water pathways of the snakes are central to many of the images of this place. Lampintjanya, Shorty said, was full (wide) with the seed-bearing plant, *mungilpa*.

died there, and so on. These points of contact offer the listener the sense of a landscape redolent with histories of movement, histories of residence, histories of resource exploitation and other uses, of burials and initiations, of conceptions. Such are the activities that constitute his relationship to and experience of the places as well as his rights to represent them. First and foremost, in the paintings, one must recognize his right to show them; second, his knowledge of them.

There are numerous levels on which the features of the place operate. Shorty mapped his "main country" in the sand for me, roughly in the way I have reproduced it in my drawing (fig. 4). In his life or travel histories, he presented the story of articulation of the country in a pattern of activities that I can only summarize here (fig. 5). A fundamental feature of his discussions of movements involved the maintenance of a variety of activities with others around the landscape (from his and other countries) especially in the autumn. This is a time when the rains fall and allow people to travel along *pinangu* (small, temporary surface waters) in small groups. Many of these temporary waters were claypans and rockholes. It is also a time in which people would experience some relief from the tension of living in larger groups around the few permanent waters (*yinta*) during summer, at Walukirritjinya and Turpalnga in the Turner Hills or further south at Pirmalnga. In autumn, Shorty would likely be found moving at some distance from these main, permanent waters, often to areas with large claypans—such as Lampintjanya, Kanamarapanytjinya, and Yiitjirringinya. At these claypans, supplies of the seed plant *mungilpa* (*Tecticornia verrucosa*) were an attraction to gather together in relatively large groups including people from distant countries, especially as autumn makes way for colder time (*yalta*). In the cold winter months, the lizards were hunted in their burrows, largely by firing off the grass cover.

Yiitjirringinya, for example, is a claypan (*maluri*) in which *mungilpa* grew after the summer rains, becoming ripe and available in large quantities to support visitors. Large encampments for ceremonies increased sociality in the winter. This claypan is associated, therefore, with such experiences of sociality, intensification—marked by the visits and coresidence of kin and friends from distant countries. Such resource areas and times were anticipated and scheduled as the sites in which gatherings (for initiation or other ceremony) organized by the logic of social relations could be articulated with other dimensions of people's movements as bodies in the landscape. Mere mention of the place associates it with this time determined by the practicalities of food and water.

In this light, I can discuss several features of Shorty's painting as it evolved over time. First, like all the other Pintupi painters, Shorty painted his "own country" (*ngurra walytja*). The early paintings included the widest range of ancestral stories and drew on a range of imagery that was closely connected to actual ritual performance. The early paintings involved revelations of Dreaming-events of the ancestral Kangaroo and Hill Kangaroo in his country (Shorty's own conception dreaming). While indexing landscape of his own country, these myths are closely tied to the men's initiatory ceremonial cycle and the most restricted of ceremonial forms. It was precisely these kinds of paintings—connected to widely shared story-cycles—that Shorty, and other Papunya painters, were obliged to stop. While such places/stories/designs may be identified with an individual as "his" country, as in Shorty's case of the Hill Kangaroo, others share in the responsibility for and identification with these objectifications of ancestral activity.

A further dimension of Shorty's paintings, therefore, is that the range of subject matter in them is reduced, the reference to sacred objects disguised, and the focus of painting tends more towards a category of ceremonial perfor-

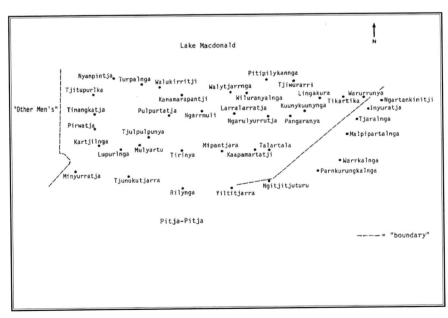

FIGURE 4.
Author's drawing, "Shorty's country."

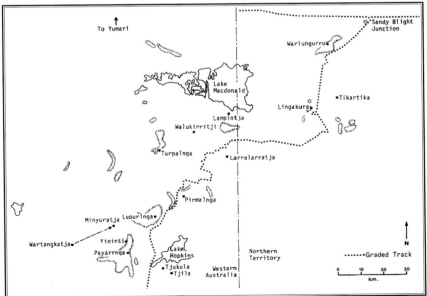

FIGURE 5.
Author's drawing, "Shorty's travels."

residence (use and association) at a place.[10] This is not simply an inheritance model, one that imagines human subjects "owning" land as property. Instead, it conceives of the relationship between persons and place as embedded in identity-forming (and embodied) exchange—relationships of feeding, nurturance, parenting, and labor.

Let us take, for example, Shorty Lungkarta's 1974 painting of the place Tjirinya, which, because of its secret/sacred imagery, I will discuss here using my original field diagram of the work (fig. 2). Shorty not only made reference to a waterhole directly perceivable in the present (feature 1) and a ceremonial ground and fire in the Dreaming story (feature 2), he also made reference to a man (deceased at the time) whom he called "father." Tiwilnga Tjapangarti, he told me, was from this place and he was identified in a feature (feature 3) in the painting that he described as "my grandfather, in the Dreaming, looking for his sacred objects. He lost them and is looking around for them." The man was walking around whirling a sacred object, a common activity of ceremonial life. Feature 4 is another ceremonial ground where the man walked around, surrounded by the rocks of the site Tjirinya. Feature 5 represents the circle designs worn on the backs of the men in the ceremonial enactment of the event—the same kind of circles one sees in paintings. The men revealed a small sacred object here, Shorty told me, "showed it halfway and then went to Pirmalynga." The small semicircles are the young men (novices) sitting and the bigger semicircles are the middle-aged men, the leaders and bosses of the ceremony.

In my more extensive analysis of the paintings of Shorty's adopted daughter Linda Syddick,[11] I was able to show how place is perceived even more intrinsically as constituting identities. Linda Syddick's inheritance of Shorty's right to paint certain places and their stories (fig. 3), she insisted, was central to her being, restoring what she had lost through the killing of her biological father. It is clear that anthropological and art historical interpretations have struggled to engage with the Indigenous imaginings of the land as not a simple object, but as having some sort of presence or sentience—or an articulated relationship beyond subject-object.

Someone's Story: Shorty Lungkarta and his paintings

One should bear in mind, therefore, that we are seeing in Shorty's paintings not just *any* Aboriginal person's perception of a landscape. Rather, a painting is (or should be) a particular, specified and identified person's perception of his/her places, showing what they are entitled to manage or give. Such a perspective transforms one's sense of the landscape from an undifferentiated scene for vision to a socially organized "patchwork."

The experience of the landscape is organized through the social relations and activities—a practical logic—in which people engage it. Shorty Lungkarta's paintings are useful to discuss in the light of other material I was able to learn about some of his engagement with the land that exposes these relations, and particularly around the sites of a set of his paintings—his "water story" paintings. The first point to recognize is that Shorty painted *his* country, which was most distinctively an area stretching south from Lake MacDonald. Second, one gets an idea of what his country evokes for him through knowledge of his life-story, particularly in how he relates the places he visits—including their economically useful qualities, whom he saw and lived with there, who

FIGURE 2.
Author's drawing of Shorty Lungkarta Tjungurrayi's *Tjirinya*, 1974.

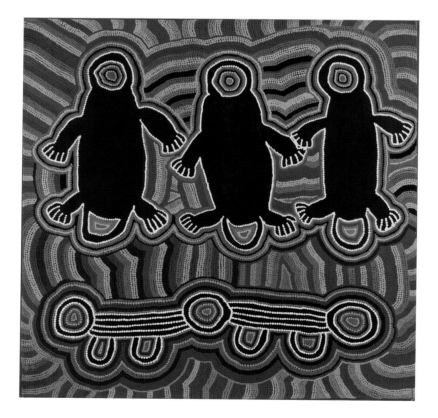

FIGURE 3.
Linda Syddick, *Et and His Friends*, 1993, acrylic on canvas. Collection of Margaret Levi and Robert Kaplan, Seattle.

Bardon admired Shorty's paintings, and he remarked, as I have, on Shorty's powerful appearance and dancing skills. But lacking language ability, he was unable to have much direct communication with Shorty.[4] Thus, for Shorty's beautiful early paintings, the "documentation" is meager or confusing. Some of his most spectacular paintings have no details recorded, leaving his paintings in the early period as something of a mystery. If the mythological background of the early paintings is also not always easy to discern, I can draw on our discussions of the country he regarded as his own to illuminate this work.

Despite the limited documentation, I cannot help recognizing again the sense of Shorty's performative vigor and the deep attachment to his country and stories. Shorty's paintings have a kind of compressed power—emanating sometimes from the slightly oblong center of the circles he drew. The source of this power is evident in his early work—in paintings that very directly referenced some of the most dangerous and powerful ancestral stories—and more indirectly expressed in later work.

By the time I first knew Shorty, therefore, he had reduced the range and variety of his paintings from those characteristic of the Geoffrey Bardon days (1971–72). At the Yuendumu Sports Weekend in 1972, where some Papunya paintings were exhibited, Shorty had found himself in trouble for painting designs that were regarded as too sacred—either too dangerous or too dear—to circulate. Some of his early paintings included images of ritual paraphernalia and reference to some of his ancestral Dreamings that are particularly restricted, such as the *Kanyala* (Hill Kangaroo or Euro); these appear only rarely in the period 1973 onward.

During 1973–75, in helping the Papunya Tula Artists cooperative while doing field research at Yayayi, I documented thirty-five paintings executed by Shorty. Since the corpus of his work has not been given much consideration, let me outline the subject matter—the "countries" (*ngurra*) and Dreaming stories—of the painting during this period. The main stories he painted involve largely *Tingarri* ancestral beings, and also the *Kungka Kutjarra* (Two Women) ancestors who are frequently involved with them. The principal Tingarri line is one that passes through Shorty's country, coming from Puyulkuru to Tjukulanya and on to Mitukatjirri and ultimately Pinarinya.[5]

Other paintings involve *Rumiya* (Goanna), the subject of some of his previously very successful paintings, and also Kangaroo (*Marlu*) and Two Men (*Wati Kutjarra*). Kangaroo Dreaming stories were generally avoided or presented rather obliquely, although it was an important Dreaming to Shorty, and I've always suspected it was perhaps the showing of these—as well as some overt depictions of sacred objects—that had brought on the criticism at Yuendumu in 1972. Among the paintings reproduced in important catalogues and gathered into collections, a few stand out: one labeled "Goanna Love Story," and a few so-called "Water Dreaming" stories. These last designations are confusing. Shorty did not have rights to Dreaming stories of the usual ancestral beings said to be "Water." Rather, the references recorded as "Water Dreaming" I suspect are remarks he made to an interlocutor about what was in the painting, like "*Kapi. Tjukurrpa*" ("Water. Dreaming.")—suggesting there was water there in the Dreaming. I didn't record a single case in my own documentation in which Shorty referred to his painting as an example of Ancestral figures identified as Water Beings. One such story, said to be of the Tawny Frogmouth owl (*Piwi*) is described at Walukirritjinya (Shorty's father's country) as "perishing, no *kalyu*." Many years later, I came to understand from Shorty's adopted daughter Linda Syddick that this must have referred to a story in which Tingarri men threw their spears up to the sky to make it rain,[6] bringing the "cleansing rain."

Icon and Index, Body and Country

Let me situate my discussion. Many Western Desert acrylic paintings have been understood, at least partly, as representations of place—or of mythologically inscribed place. I propose to explore Shorty Lungkarta's paintings along some lines of their association with place and the place-experience he mentioned to me frequently. I do not mean to view the paintings simply as "story-paintings" (emphasizing their mythological content)—as Geoff Bardon once called them and a genre of interpretation that has received considerable criticism from those emphasizing the paintings as "art."[7] I prefer instead to explore how they relate to the perception or experience of the landscape of living, acting bodies. Indeed, some of the elements of these paintings involve designs traditionally worn on the body.

In the early 1970s, the insistence of interpreters on the story—perhaps to the expense of the visual effects—attempted to draw attention not to ethnographic value, but to the fact that these paintings had meaning within Indigenous cosmology. Nancy Munn's delineation of an iconographic tradition in Central Desert ritual and sand stories drew attention to the complexity and meaningfulness of body and ritual decoration, but she hardly regarded the designs as simply an iconography. She also insisted on their indexical relationship to the ancestral beings from whose bodies the design forms had come. The paintings produced in recent years are, surely, also performances themselves—performances of the right to reveal these stories, of identification with the places, ancestral beings, and its people, and also of the power to evoke the Dreaming in the human perceptual realm.

The ancestral events commonly represented or indexed in the paintings are frequently themselves signified in the painting as activities that are (or were) primarily made available to human subjects through the medium of ritual, and ritual involving song and movement as well as some potential for narrative. In this respect, what is painted on a canvas may be a painting that invokes not only sensuous knowledge or experience of places, but also the rituals associated with those places.

Landscape Partitioning: My Country

While the capacity of the paintings to represent the Dreaming foundation of places long dominated the anthropological understanding of them, the continued role of representations of Ancestral events as part of a local revelatory regime of value[8] sustains other dimensions of the painting and image-making process—as embedded in a human process that I have called "identity-forming exchanges." Shorty's perception of the landscape draws on the protocols and relationships through which he reckons his identification with place[9]—what Pintupi call "my country" (*ngayuku ngurra*). This involves significant identifications through conception via an Ancestral being at a place, mother/father/close kinsman's conception at a place, parent's death or burial at a place, initiation at a place, birth at a place, or prolonged and regular

the young men there turned into bush bustards, etc., and traveled at night. And he told me what he had seen and how he had reasoned to come to these conclusions. In short, with Shorty, I always felt as if I was a whole person, not primarily a white person. He almost invariably referred to me by kin terms. He was a gracious man. In writing, I have tried to pass on some of the many things in which he instructed me.

Shorty's grace was equally visible in his relations to his own family. He showed great concern for his grandchildren, whom he loved. The constant picture I have of Shorty is of him sitting down and little Thomas running up to him, jumping into his lap and grabbing Shorty's neck and hanging on, pulling Shorty's hat down over his ears. Then Shorty would look over and break into a smile, purse his lips together in true Pintupi style, squint his nose and lift his chin (this is a kind of gesture people use). These were the habits and gestures that marked him as oriented to his traditions, but they flowed so fluidly that they filled him with life.

A few times when I sat with him and talked in his tent, Thomas came in, making a great annoyance of himself. Rising to his role of playful grandparent, Shorty would say to Thomas that he (referring to himself) was a "hard man . . . without pity," and would hit Thomas if he didn't pay attention. For Thomas, this provided the occasion to respond by attacking Shorty, who would just laugh. There were times when he was clearly angry that Thomas had no respect at all, but mostly these were transparently empty threats, a play with their relationship that also communicated what might be proper. Another frequent recourse was to tell Thomas that I was the boy's *marutju* ("brother-in-law"), and therefore he should be restrained. Thomas was very affectionate to me; I had known him since he was small and I was often at Shorty's camp; and since I was friendly with his father Jacky, I saw him there, too. He would run freely into my arms and hug me, with a devilish smile on his face, planning some trouble.

Shorty's grandchildren were around the camp, with Napulu or Shorty, who would sit and laugh at the antics of the children. By virtue of having several daughters who chose to live near him and their mother, and a number of others for whom they were acting as mother and father, Shorty had a rather large "following" and essentially cooperating kindred. The sons-in-law would often pool their resources with each other and/or with Shorty and buy large items like vehicles. None of Shorty's children were as tradition-oriented as he and Napulu; all of them were keen card players and let Napulu and Shorty do a lot of work for them, although they would all come to his aid instantly in trouble.

A mental/psychological vigor really characterized the man and his style. He was in extraordinary physical condition; there was no fat on his body and he retained the musculature and tone of a much younger man—still in possession of the vigor and virility of a middle-aged man. He was, in fact, still hopeful of getting a young wife. Despite his commitment to traditional activities, Shorty was also involved in drinking episodes, especially insofar as his son or his sons-in-law brought the alcohol out. Although the drinking was beginning to take its physical toll in the aging of his face, Shorty seemed to recover quickly his typical good spirits after drinking. His recovery from drinking bouts amazed me; he did not seem to drift into despair or lethargy on the "day after," but often would do some sort of work or painting. It was hard to

explain why Shorty drank, but the intense sociality of the drinking scene was exciting to many.

Shorty was not a man to step back from a fight, and he was proud of his ability to fight. He was, in any sense, a man who defended his own—with confidence and constraint, but unmoving certainty. And more than once, I benefited from his protection and acceptance.

Shorty and Napulu were very good at making sure there was always food. Unlike the more recent immigrants to the Papunya area who were known as the "new Pintupi," Shorty and the other people who had previously lived at Haasts Bluff always seemed to buy flour and keep some around in case they were unable to get to the store for food. There was almost always a bag of flour in the platform or in the fork of the tree; also they usually had tea and sugar, though these were the kinds of things he often asked me for. They were likely to have kangaroo meat; the son-in-law Ginger was a good hunter and often went out with the schoolteacher (his boss), as was the other son-in-law, Jacky. Shorty himself also went out frequently on the hunt.

Shorty's wife Napulu was his second wife; he had two wives for a while. According to their account, Shorty saw Napulu some time in the bush after her first husband had been killed by a revenge party and she fled with an infant child.[3] More than once he described at some length the events that finally resulted in him getting her and how various obstacles were placed in his way. Eventually, he did get her, as a result of determination on his part it would seem, because then they had to flee to avoid retaliation by her relatives and men who thought they had a prior right. Subsequently, things cooled down to the point where he allowed himself to be speared and thereby to put an end to the "trouble" that resulted. She was really a case of love at first sight and they were among the closest of married people I knew. Through him, she was always rather well informed on those aspects of men's ceremonial life that she was permitted to know. Among the women, I understood that Napulu was preeminent in women's ritual.

Shorty was a man who lived his life to the fullest as a participant. He was not alienated or despondent. He participated in life, its joys and disappointments. As a painter, he had no equal I think in the depth of feeling shown, nor as a dancer. He had a keen sense of humor. He loved his own country, hundreds of miles to the west of Yayayi at Walukirritjinya and Lupurlnga (in the Sir Frederick Range), and he remembered the life out there where his father was killed and his mother died. He swore revenge on his father's killers, and according to him, he got that revenge at Haasts Bluff. At age sixty-five he was alert and still extraordinarily vital. He was not one of the people for whom the change from the traditional life had dire consequences; it was almost as if these changes hadn't reached him, especially insofar as his imagination and character seemed to have been forged before he ever left his own country to come in to Haasts Bluff.

II. The Mysteries of a Man's Painting

When I knew him, Shorty spent most of his time, especially while painting, with Uta Uta Tjangala and Charlie Tarawa (Tjaruru) Tjungurrayi—men with whom he shared a good deal of experience, dating back to Haasts Bluff, as those from that era who had retained strong ties with traditional culture. Geoffrey

THE INTELLIGENCE OF
Pintupi painting

VIVIEN JOHNSON

◄ Charlie Tarawa
(Tjaruru) Tjungurrayi,
Men's Painting Room,
Papunya, August 1972

About seven hundred and fifty of the thousand or so small painted wooden panels or "boards" that were created in 1971–72 by a group of middle-aged and elderly Aboriginal men at the remote government settlement of Papunya survived a quarter of a century of neglect to emerge as the priceless, seminal works of one of the most remarkable art movements of the postcolonial era. Those twenty or thirty men went on to found the Papunya Tula Artists company, the acrylic painting enterprise which, a decade after the boards' creation, led to the first Aboriginal art ever taken seriously as contemporary art by Australian audiences. In addition to their sheer beauty and art-historical significance, the early Papunya boards are also key documents in the history of the painters' culture. For members of that society, they retain a paramount importance as the first and most detailed coded memorizations of ceremonial acts repeated by their ancestors over so many millennia. The documentation provided by the Papunya Tula annotators of these paintings, collected from the artists at the time of their production, is only a starting point in the quest to discover their meaning, including, but not confined to, their cultural significance to the men who created them. As we shall see, the epistemological issues are as tangled as the contemporary politics of their presentation today.

• • •

Throughout the 1970s, "Pintupi Painting" and "Papunya Painting" were used interchangeably to describe the work of the Papunya Tula artists, though neither was strictly accurate. For the eighteen months he was in Papunya in 1971–72, Geoffrey Bardon's "painting men" did all reside at the settlement,[1] although prior and subsequent to this the Pintupi members of the group lived on various "outstations" in the direction of their traditional homelands, to which they finally returned with the establishment of Kintore in 1981 and Kiwirrkura in 1984.

Nor were all the founding artists of Pintupi descent. In contrast to the cultural homogeneity of most other remote desert communities where painting started up decades later in the wake of Papunya Tula's eventual success, the Aboriginal population of Papunya and its outstations was heterogeneous to the point of dysfunctionality over the first two decades of its existence. Even its Pintupi residents divided themselves into opposing categories of "Old" and "New," based on how long ago they had come east from their heritage countries to pursue a modified traditional lifestyle on the fringes of European settlement. The so-called "New Pintupi," who arrived in Papunya from the desert in the early 1960s assisted by the Northern Territory Welfare Branch patrols, were frequently derided as "myalls"[2] for their lack of sophistication in European ways. In time, these tables were turned by art collectors who placed a higher value on a "bush" background. At the time of the early boards' production, however, the "New Pintupi" were eager for the opportunity to demonstrate the depth and sophistication of their knowledge of their own culture to their countrymen and to the worldly wise Anmatyerre, Luritja, Kukatja, Arrernte, and Warlpiri ex-stockmen who made up the rest of the original group of painters at Papunya.

One man who assisted them in this endeavor was Charlie Tarawa Tjungurrayi (ca. 1920–1999), who used his excellent grasp of English and translation skills derived from an experience of Europeans dating back to his boyhood to position himself as the spokesperson for the "New Pintupi" painters.

. . .

The life of Charlie Tarawa—or "Wadama," as he was universally known in Papunya and Kintore—was one that displayed as insatiable a curiosity about the world as one would expect from "one of the most intelligent human beings of any race whom I have ever met."[3] This was the judgment of Dr. Charles Duguid, to whom Tarawa introduced himself as a young boy at the missions of Haasts Bluff and Hermannsburg in the 1930s where Duguid labored as a valiant early advocate of Aboriginal land rights.[4] His father and older brothers had been some of the first Pintupi to venture into these settlements from their homelands far in the west. In his early teens, Tarawa's entire family migrated east, and he worked as a laborer on the building program for Haasts Bluff, and later, during World War II, for the military at Adelaide River south of Darwin. After the war, he returned to Central Australia and realized a dream of owning his own camels, which were still the major form of transportation in the Northern Territory. He became a dogger working out of Haasts Bluff, traveling west to kill the dingoes that preyed on ranchers' herds and returning east to exchange their scalps for rations. Many of his relatives and countrymen who were still living out in the desert later recalled his visits, with the tales of rations and wonders like matches, that he brought them from the missions in the east.

In 1956 Tarawa famously encouraged and guided a large group into Haasts Bluff that included Uta Uta Tjangala, Ronnie Tjampitjinpa, and Willy Tjungurrayi. Later he married, worked on the construction program of Papunya settlement, raised a large family, and returned in 1981 to live in Kintore close to his principal hereditary site and birthplace, Tjitururrnga. In 1982, he traveled to England with Andrew Crocker, whom he had befriended during Crocker's time as Papunya Tula manager (1980–81), and also to Hong Kong. The following year he returned to Amsterdam, where he was involved in a performance and film called "Nightsea Crossing" with performance artists Ulay and Marina Abramovic.

Charlie Tarawa had been part of the painting movement from its inception and among the most prolific and consistent of the founding artists over several decades, although never one of its "stars." Andrew Crocker, who organized a retrospective of his work that toured regional galleries around Australia in the late 1980s, cited his "middle-of-the-road" status as one of the reasons which made him a good choice for such an exhibition: that he was "representative of many of the painters."[5]

By the late 1980s, Wadama's fortunes were on the wane. Crocker's extraordinary death in a bomb blast in Namibia in 1987 had deprived him of his patron and exposed him to the ridicule of those who had been jealous of the favors this friendship had earned him. People would sidle up to him and, amid general hilarity, shout "Boom!" with expressive hand movements to indicate a bomb blast. A man in his late sixties, several of whose children had died prematurely and whose wife had left him, Wadama cut a sad and lonely figure. He enlisted my help to try to obtain copyright fees for the paintings reproduced in the catalogue of his retrospective, a copy of which he carried with him at all times in a "manbag" slung around his chest.

. . .

The line of men waiting their turn for Papunya Tula manager Daphne Williams to document their paintings and write out their checks snaked out the door of the old Kintore art shed into the dusty yard. The system Williams later devised, employing a roster of field officers maintaining a constant presence in Kintore and performing these operations as each artist finished each work, was not yet in place in 1989. Since the Pintupis' move back west, the Papunya Tula manager's role had involved a month-long round trip on rough tracks of dirt and sand to Papunya, Kintore, Kiwirrkura, and various smaller communities the painting company serviced in those days. Williams's regular visits were expected, and all the men would be ready for her with their finished canvases. As Wadama stepped forward for his turn, a ripple of mirth ran down the line at this oddly minimalist piece. But when he announced to Williams that it was a depiction of his audience with the Queen, a respectful silence descended.

An Audience with the Queen[6] (cat. 46) is typical of his work from this period. The gritty ochrelike white surfaces, often applied to the canvas with his fingers as in the ceremonial context, were at odds with the dominant style of Pintupi men's painting of the time, which favored neat grids of circles and connecting lines of travel. Nowadays, Wadama's works in this style are keenly sought after, and two of them, including *An Audience with the Queen,* earned a place in the *Papunya Tula: Genesis and Genius* retrospective at the Art Gallery of New South Wales in 2000.

Being presented to royalty is a huge status symbol in Western Desert society, signifying one's acceptability at the highest levels of "whitefella" society. For Clifford Possum Tjapaltjarri, his own introduction to the Queen, during his 1990 visit to London, was one of the most talked about experiences of his eventful life—his main inducement for undertaking the journey to England for the opening of his first solo exhibition. At the Annual Royal Garden Party at Buckingham Palace, sartorial in a grey morning suit, white top hat, and

sneakers painted with his Dreaming designs, Tjapaltjarri had been placed at the head of the queue of several hundred select guests out of the eight thousand in attendance who were accorded the special privilege of a personal moment with Her Majesty.[7]

If Wadama's equally eventful life had included such a moment, he rarely spoke of it, but as his eyes scanned the audience of his fellow painters that day in Kintore, everyone was keenly aware that the only person who could have challenged such a tale was the late Andrew Crocker himself. Was this the "real" story of the painting, or a shrewdly ironic invocation of the Papunya Tula "buy-back" ritual, over which Mrs. Williams was presiding with the line of dutiful subjects waiting to be granted a moment of Her Majesty's attention? The answer was immaterial. Bardon claimed Charlie Tarawa was "humourless,"[8] but maybe his deadpan humor was just too subtle to be appreciated by either side of the cross-cultural divide straddled by his remarkable life.

This anecdote sheds light on the complex character of an individual whose role as an intercultural negotiator—not only between Bardon and the New Pintupi, but also between them and the other non-Pintupi artists—was pivotal to the dynamic of the painting movement in its formative years. It also calls into question the received account of the "annotations," those short written descriptions of the sites and Dreaming stories represented, which have accompanied every painting sold by Papunya Tula Artists into the world. Supposedly, they enable the viewer to decipher their symbolism and thus respond to them as cultural statements of connection to land and ceremony, rather than pure visual experience devoid of signification. They are not supposed to be tales—real or imagined—of events in the artists' personal biographies. Or are they?

In the case of *An Audience with the Queen*, it is relatively easy to respond to this question with the observation that Wadama's play for the respect of his fellow artists can comfortably coexist with the multiple layers of meaning adhering to the classic Western Desert painting. That is, the painting can be taken to signify both an actual geographical place within the artist's heritage country, *and* the ancestral exploits at that site which underpin its Dreaming significance, *and* the ceremonies in which that place and those events are celebrated, *as well as* the idiosyncratic royal assignation of its title. Most likely the site is Tjiturrurrnga, a rockhole and craggy outcrop 40 kilometers due west of Sandy Blight Junction, just across the Western Australian border. Tjiturrurrnga is a cold, misty place associated with the haze and frost of the desert winter. Charlie Tarawa was fiercely proud of his authority over its story and associated ceremonies. Tjiturrurrnga is the dwelling place of the ancestral Ice Man Wati Kuwala, who, like the artist, was a Tjungurrayi. In a cave at the site (indicated here by the square border of the painting), Wati Kuwala sits armed and dangerous, guarding it from intruders.

This is not mere speculation. The Ice Man story was Charlie Tarawa's usual subject—though he also painted Emu, Wallaby, Water and Frog Dreamings, and Tingarri stories. And always, from his very first paintings in 1971, the unusual thick white paint represented the mist that hovers over Tjiturrurrnga's rockhole on cold winter mornings and the icy breaths of the wind that blows across it. Probably his earliest work in this style is the fourth painting of the third consignment to the Stuart Art Centre in 1971, a work variously titled *Fear* or *Medicine Story* (in its 1971 annotations by Hogan and Bardon,

respectively). According to Hogan and to Bardon's hand-drawn diagram on Papunya School letterhead, the thickly painted black and white lines across the painting represent the cold breath of "Kurumba" (presumably this should be "Kuwala") and the motif of a concentric circle surrounded by radiating lines represents the "spirit fingers" of this ancestor. The documentation also identifies a curious red cruciform figure at the base of the painting as "the fright a man feels when this spirit appears"—one of the only instances in Western Desert art where an emotional state is directly represented in this manner. In the annotation supplied by Bardon in his 2004 book for this painting[9] the "spirit fingers" have been relabeled as wild potato plants, based on the artist's explanation of this symbol in other paintings. However, Bardon also concedes, "An alternative interpretation for this painting is that these motifs and pattern could represent death and fear."[10]

These latter themes clearly relate to the annotation for Charlie Tarawa's 1972 painting in this exhibition (cat. 30), to which Hogan gave the title *The Trial*, suggesting that it depicts "the trial under traditional law of a man condemned to death."[11] The trouble with Hogan's reading is that her interpretations of the symbols are at odds with the normal processes of trial and punishment in the artist's society. The accused would certainly not be present but most likely hundreds of kilometers distant, and the identity of his executioner or executioners would not be made known to him. Far more likely what Wadama was talking about to the annotators of both *Fear* and *The Trial* was the sentence of death that would be imposed on unlawful intruders to Wati Kuwala's sacred cave at Tjitururrnga.

The purpose of such detailed discussion of the meanings of particular paintings in this exhibition is not to confuse the reader with their complexity. Rather, it serves to indicate the conceptual pleasures that become available if one delves beneath the dazzling surfaces of these works and explores the rich interpretive framework provided by the artists' Dreaming narratives. Only those who ignore Western artists' relation to the shared body of knowledge and cultural experience known as "Art History" respond to art works in the European tradition irrespective of their cultural context. Similarly, Western Desert audiences respond to these paintings by reading off them references to the artists' Dreamings. Such educated guesswork as this is also often necessary to "read" the early paintings, because documentation was often collected on the run, or from people who spoke very limited English and by people who understood very little Pintupi (or Anmatyerre, or Luritja, or Arrente, or Warlpiri, and so on) or misunderstood what they heard, or read into it their own imaginings or background reading about the artists' culture. Into the bargain, much documentation has simply been lost.[12] In the case of Charlie Tarawa Tjungurrayi, it has also provided an insight into the striking (post)modernity of this art, by which I mean:

> "[I]t has been the function of serious culture throughout the modern period to bear witness to a crisis of self."[13]

• • •

One area in which Charlie Tarawa Tjungurrayi was *not* "representative of many of the painters" is the comparative rarity in his paintings of explicit depictions of secret/sacred objects from the ceremonial world of the initiated

men. This, for me, was an especially good reason for making him the focus of this essay—that, and the way his character and life history represented a decisive break with the popular stereotype of the Pintupi painter as a mystic devoid of both conversation and guile whose paintings channel the mysterious spirituality of the land. This is not to say that Charlie Tarawa did not at times instantiate just this image, but that he of all people, with his irrepressible loquacity, his astute, calculating mind, and his love of travel and new experience, was so much more than this. Charlie Tarawa's "crisis of self" in his role as advisor to the "New Pintupi" and go-between with Geoffrey Bardon may have been that he was unable to persuade them to follow his example and avoid "restricted" content in their paintings. Their work routinely overstepped the boundaries imposed by the laws of their own culture about exposure of ceremonial knowledge in works destined for public display. Undoubtedly the "New Pintupi" were less sophisticated in their knowledge of the outside world and may not have fully understood the dangers. But perhaps, as Fred Myers has suggested, they were also deliberately flirting with taboo subjects—or too caught up in the excitement of rendering "the complex of ritual knowledge and experience onto a two-dimensional plane"[14] to worry about the consequences. Given his role of relaying Bardon's repeated requests for uncontroversial subject matter and his own more cautious practice, Wadama presumably did advise them against it, but their authority in such matters exceeded his own. For him to have admitted as much to Bardon, however, would have contradicted his pretensions to leadership.

These are complex issues, and meaningful discussion of them is made difficult or impossible by the contemporary cultural custodians' prohibitions on the display and reproduction of these works, particularly in Australia. But it is difficult, if not impossible, to understand the early Papunya boards and the dramatic changes of direction in the work of many of the painters, even in the small group of works displayed in this exhibition, without touching upon them. This is particularly the case with the work of the Anmatyerre painters Kaapa Tjampitjinpa and his cousins Tim Leura Tjapaltjarri and Clifford Possum Tjapaltjarri, whose work veers from one extreme to the other. Their earliest works are detailed layouts of ceremonial grounds complete with participants in full body decoration and explicit depictions of secret/sacred objects—almost as if they wished to prove to the "New Pintupi" that they were "true countrymen" who knew their stories and ceremonies despite having grown up in a world of matches and trousers. Then came works like *Ngalyilpi (a small snake)* (cat. 34) and *Bushfire Spirit Dreaming at Napperby* (cat. 33), which are almost completely devoid of traditional iconography of any kind (and in this years ahead of their fellow painters).

These men knew very well, from their extensive contact with Albert Namatjira and the Hermannsburg school of watercolor landscape painters who first introduced the vocation of artist to Aboriginal Central Australia, what it meant for them to be sending out representations of the ceremonial life to the outside world as art, though neither they nor anyone else anticipated the scenes that unfolded on the auction house sales floors a generation later. These artists resolved *their* crisis of self the same way Namatjira had: by making their role as artists central to their identity, and devising personal artistic vocabularies of symbolism to express the stories of their culture, like Clifford Possum's fire burst in *Fire Dreaming associated with the site at Warlugulong* (cat. 42) or

FIGURE 1.

Tim Leura's transcendently beautiful yam plant image *Yam Spirit Dreaming* (cat. 21). In this they returned to what had originally fascinated Bardon about the traditional visual language of the Western Desert: the way the symbols functioned as "brilliant simplifications of observed phenomena."[15] Before such works as these, like the natural forces they evoke, rapture and recognition are mutually reinforcing responses.

. . .

Looking through my files for images to illustrate this essay, I came upon a photograph of me and Charlie Tarawa (fig. 1) on the road outside his house in Kintore with the painting now known as *An Audience with the Queen*. He was on his way to present it to Daphne Williams for documentation and payment. On the back of the photograph I had written "Charlie Tarawa and V. Johnson with *Title*, Kintore 1989." I had forgotten that *Title* was the title he gave to this painting—although I now recall my astonishment when he told me so. I mention this not to muddy the waters, but as a further example of the peerless intellect of the man. To this day, his fellow painters seem almost universally oblivious to the Western convention of bestowing names on their paintings. Titles were given based on the annotations, until the supposedly neutral, but in fact highly charged, *Untitled* became common practice. Underlying the subtle hint of *Title*—that Her Majesty had not just met him but bestowed a rank (title) upon him—is the idea of his painting as a "deed of title" to the land, story, and ceremony it represents. The ancestral beings laid their claim to a site by leaving their marks upon it in the landforms, water sources, and the plant, insect, and animal life of the place.

So the members of Western Desert society legitimate their contempo-

rary land rights. They perform ceremonies in which they invoke the ancestral presence by producing graphic designs which are depictions of these ancestral marks on the landscape. The analogy with their paintings is obvious. The stories and designs of which the artists demonstrate their knowledge in the paintings are the basis of their custodial rights in the associated sites. Or as an anonymous Aboriginal painter quoted in *Charlie Tjaruru Tjungurrayi: a retrospective 1970–1986* put it, almost as succinctly as Wadama's title and painting:

> "If I don't paint this story some whitefella might come and steal my country."[16]

VIVIEN JOHNSON

New South Global Professor, Faculties of Arts and Social Sciences, Law and College of Arts

University of New South Wales, Sydney

[1] For further discussion, see *Papunya Painting: Out of the Desert* (2007), edited by the author. Nowadays, of course, Papunya Tula painting *is* predominantly Pintupi painting.

[2] Slang, a derogatory term meaning "wild ones."

[3] *Doctor and the Aborigines* (Rigby: Australia, 1972), quoted in Crocker, 15.

[4] It was Duguid who gave him the name "Charlie." When Duguid introduced himself in a thick Scottish brogue, the young Tarawa remarked that his name (i.e. Charlie) was "Like mine!" (ibid.)

[5] Crocker, 10. For further detail on the lives of Charlie Tarawa Tjungurrayi and other Papunya Tula painters see Johnson, *Lives of the Papunya Tula Artists*, 2008.

[6] "In this painting, the artist has described an audience with Her Majesty Queen Elizabeth II. The central roundel shows the meeting place. The four white shapes adjacent to the roundel show the Queen and the other people who were allowed in the room. The straight lines on the border of the work show the fence around the meeting place which is manned by guards." Papunya Tula Artists CT890660.

[7] For further discussion, see Johnson, *Clifford Possum Tjapaltjarri*, 169–71.

[8] Bardon and Bardon, 68.

[9] Painting 271, *Special Yam Dreaming*, in Bardon and Bardon, 329.

[10] Bardon and Bardon, 329. Curiously, the early work *The Trial* 1972 does not appear in this volume. This and other omissions are concealed by Bardon's new numbering system which overrides the chronology provided by the Stuart Art Centre consignment numbers.

[11] "A painting of a highly unusual subject, depicting the trial under traditional law of a man condemned to death. He is represented awaiting judgment as the set of concentric circles at the centre of the painting. Along the top and bottom edges of the painting, lines of mirrored double U-shapes indicate elders sitting in council. These are joined to the large central circle by black lines that indicate the decision of the council. The three double U-shapes on either side of the central black circle represent the executioners. The straight pink lines radiating towards the victim represent the fingers of spirits of the dead pointing to the accused, indicating to him that he is condemned to die." Sotheby's 2004, Lot 96. The number of this painting (#236 of the Nineteenth Consignment) indicates that it was annotated during the so-called "interregnum" period between Geoffrey Bardon's departure in mid–1972 and the commencement of Pater Fannin's time as Papunya Tula manager in late 1972.

[12] This despite Hogan's stern advice on each Stuart Art Centre documentation: "It is important that this label should never be destroyed. The evidence it bears of the registered stock number may, in future, prove to be of very great value for the purposes of identification and authenticity."

[13] Gray Watson, "Between Identity and Politics—A New Art," in *Artscribe* (April/May 1986): 67, quoted in Crocker, 25.

[14] Myers, *Painting Culture*, 119.

[15] Geoffrey Bardon, *Aboriginal Art of the Western Desert*, 18.

[16] Crocker, 11.

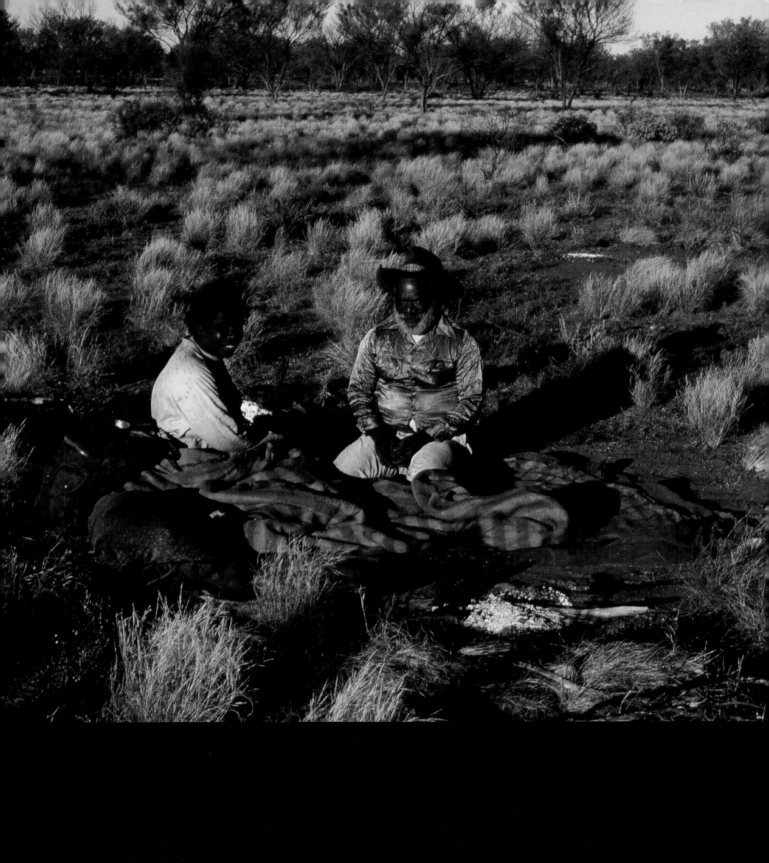

relatives of the artists
RESPOND TO THE PAINTINGS

R. G. KIMBER

On the suggestion of Professor Fred Myers, organizing curator Andrew Weislogel asked R. G. (Dick) Kimber to visit with descendants and relatives of the early painters living in and around Alice Springs. Kimber, a local historian and writer based in Alice Springs from January 1970 and a supporter of Papunya art from its inception, became the Northern Territory's first sacred sites officer in 1974. From May 1976 to May 1978 he was co-art advisor for Papunya Tula Artists (with Janet Wilson and then John Kean). He has been a person of high standing among the local Aboriginal communities ever since. On these visits, he carried a three-ring binder with reproductions of all of the exhibited paintings with him.

I was searching for Dinny Nolan when I found his nephew, Keith Kaapa Tjangala, son of Kaapa Mbitjana Tjampitjinpa, at Mpwetyerre in November 2007. Mpwetyerre—Abbott's Camp, as it is also universally known—is a formally designated Indigenous town camp, situated immediately up from the western bank of the Todd River in Alice Springs. Red gum trees and the white sand of the dry Todd riverbed lead to the vermilion and prickly spinifex of the nearby MacDonnell Ranges.

Keith is remarkably like his late father as I first knew him in the early 1970's, in physical build and appearance, bright intellect, and friendly willingness to help. Anmatyerre and Warlpiri are his first languages, and through living experiences he is also competent in English, Arrernte, Luritja, and Pitjantjatjarra. Most Aboriginal people whom I was to meet for discussions were similarly multilingual, with variations in their ability to speak English.

We agreed to meet the next week to discuss his father's paintings, but a death meant that he had to attend "sorry business,"[1] and also live elsewhere, for a considerable time. Although I intermittently dropped by Abbott's Camp over the next few months, it was March 2008 before he returned to live there. When next I saw him he was with Kevin Wirri, a renowned Pitjantjatjarra artist who paints in bright colors in a naturalistic style. We briefly looked at the

◄ Pantjiya Nungurrayi and her husband George Tjangala at their Tika Tika overnight camp, early morning of April 26, 1980 *(photo by the author).*

71

photographs of his father's and the other artists' paintings in the binder, and his immediate response was, "You must get my father's brother, Dinny, to look at them." I explained that this was intended, and went off in search of Dinny Nolan Tjampitjinpa, whom I had previously visited at Hoppy's Town Camp and Abbott's Camp, but who was now living a few kilometers out of town. His daughter Doreen had told me that a French entrepreneur had set up a large tent and had been encouraging him to paint a large canvas. I had known Dinny for over thirty years and had yarned with him about his life. My estimate—on the basis of events and people he knew and remembered from his childhood on Coniston cattle station, 250 kilometers northwest of the Alice in traditional Anmatyerre country—was that he was born around 1928. I had further discussed aspects of his life and the country's "Dreaming" associations during travel between Alice Springs and Papunya. The travels of the Emu ancestors was a favorite mythology that he liked to paint.

I pulled up outside the gate and, in looking toward the tent and house, saw that Dinny, who was seated cross-legged on the ground, had immediately recognized my red car. When I stood at the gate, awaiting an invitation to approach as is traditional protocol, he raised his right arm and, with a cupping of the fingers toward him, signaled me to approach. The French entrepreneur had left town, but two young white men and an Aboriginal woman were with him, and shortly afterward we were joined by Maria Nampitjinpa, the late George Tjangala's youngest daughter. They were cordial but all were about to leave to go shopping in the Alice, so I only had time to quickly show Dinny the photographs of the paintings, with one of the young white men fascinated to also be permitted by Dinny to see them, and Maria (who was married to him) intrigued to see the image of her father's painting.

Immediately upon seeing the photograph of the first painting (cat. 5 in the supplement), Dinny simply commented, "Kaapa, my brother! Mikanji." The notes indicated "Untitled," but Dinny was voice-certain in his reference to the site name, which had been his and Kaapa's grandfather's home country. He only commented, "My brother Kaapa again!" when he saw the next painting, *Budgerigar Dreaming* (cat. 19 in the supplement), and "My brother again!" when he saw the painting with the title, *Ngalyilpi* (cat. 34).

Although I knew that he had understandings through associations with all of the artists while they were living at Papunya, with but one exception he made no further voiced comment. Instead, as I read the name of the artist and caption while showing the further thirty-nine photographs of paintings, he acknowledged each artist and his Dreaming by his interested inspection and hand gesture. The exception was the first painting by the Pintupi artist Shorty Lungkarta Tjungurrayi, titled *Water Dreaming*. Before I had read the title he remarked, "I gave him a billy." We did not discuss this further at the time, but I was interested that Dinny remembered so clearly that he had given Tjungurrayi a billy can—implicitly, a full can of water. When next I met him I asked him about the incident, and he chuckled at my interest. "Billy can over there," he had told Shorty, who had walked in from the west, perishing of thirst. "You can have him water."

Maria made no comments about her father's painting (cat. 5 in the supplement), with its note "Untitled," other than that it made her happy to see it, and that she knew the location of his first homeland, close to the eastern flank of the Kintore Range. Unlike several of her older sisters and brothers, whom

along with their parents I had taken back to George's difficult-to-access sites east of the Kintore Range, she was too young to have known him during his early painting years, and had not had the opportunity to visit home country sites that were a long way off any roads and tracks. George Tjangala had always been a quietly serious yet friendly man, and although I had seen many of his paintings of the 1970s and '80s I could only guess at the meaning of the particular painting. I explained that though it may have been to do with the place of Dancing Lizards, I thought it more likely to be a Tingarri painting associated with *Kuninga* (Native Cat) sites along the southern shore of Lake MacDonald on the Northern Territory–Western Australia border. I had been privileged to have visited the sites twenty-six years ago with George and other Pintupi men during men-only travel. At Maria's request, I agreed to let her know if I saw other paintings that had been painted by her father, and which were depicted in books. It gave her pleasure to see them.

Because the group had to depart after this rushed inspection, I arranged to meet Dinny and the young man who was caring for him on May 6, 2008. On that morning, just as I was about to depart a shopping center in Alice Springs, a voice called my name. It was Doreen Nangala, Dinny Nolan's middle-aged daughter and Kaapa's niece. She agreed to look at the photographs of the paintings to assist me.

We sat in the shade of a red-gum tree on the edge of a town parking lot, and she guessed that one of her father's paintings would be of Mikanji. (Although we were looking at photographs of paintings, they were always referred to as paintings by the artists' family members who were asked about them. It is a natural thing for most people to do.)

I opened the binder, and immediately upon seeing the first Kaapa painting (cat. 5 in the supplement) she said "Mikanji," even as she turned her head away so that she was no longer viewing it. She remarked, on the basis of depicted items that she had never previously seen, that she believed the painting to be "men's business" and that therefore she should not look at it, or any of the others. I commented that this was entirely her decision, but also explained that Kaapa had clearly stated to me and a BBC camera crew that, from his perspective, all of his paintings were acceptable for public viewing. I had been surprised at this, as I had thought that many of his early ones had included paintings of sacred men's objects. However, to illustrate that they were innocuous, Kaapa had invited his wife to sit beside him while he discussed similar images to those in the present paintings. He explained that because no responsible Aboriginal men would ever discuss the nature of certain depictions, other people could "no more learn 'im"—in other words, the noninitiated could not come to know anything proprietary or harmful about the paintings. And if they did not understand, then they were, in Pintupi leader Nosepeg Tjupurrula's words, only looking at a "pretty picture." They could only comprehend the surface, not the country and the songs or ceremonies of association. While many men have taken Kaapa's view, others, such as Long Jack Phillipus Tjakamarra, have always taken a much more conservative one. However I can only recall Long Jack expressing direct reserve about his own early art, or that of deceased artists of his own Luritja-Pintupi associations, not those who speak Anmatyerre, Arrernte, or Alyawarre, and have rights to country that lies substantially east, north and southeast of Papunya.

As Nangala knew that I would never be other than honest in such a

statement, she tentatively agreed to view the three paintings by Kaapa.

She had been correct in stating that the first "Untitled" painting (cat. 5 in the supplement) was associated with the site Mikanji, and her first comment as she again only glanced at it was, "He's doing all these paintings, long time [ago].

"Men's business [is what I think they are]," she reiterated.

She deliberately (as I interpreted it) avoided close study of any of the central elements of the painting. Each outer pattern was interpreted as, "This must be all the men and women sitting down. Might be dancing for ceremony."

I asked her about the tall ceremonial poles.

"This is digging stick with white feathers," she said.

It was a logical answer for a woman to make, for women use decorated digging sticks or long straight clubs in their ceremonies, and conventionally they are topped with such as the white feathers of the Pink (Major Mitchell) Cockatoo, or these days white fowl feathers. I believe, however, that she knew that she was wrong. Although I knew that her eyesight was perfect, she was "blind" to all other elements of the painting. This was as it should be in strongly traditional culture. Men believe that the sighting of sacred men's objects by those forbidden to see them (women and children, and uninvited men who interrupt a ceremony) can cause blindness because of their power. By making a deliberate error Nangala was getting out of a predicament, for the person with authority could then emphatically correct her.

To avoid any further problems for Doreen I asked her how she felt about seeing—if only glimpsing—Kaapa's paintings.

"Happy!" she responded.

She reflected for a moment and added, a little regretfully, "I never been to that country much. I have never been in there."

As I had been to Mikanji, which is situated on Mount Doreen cattle station about 300 kilometers northwest of Alice Springs, I described the creek line, with its red gum trees, and the soakage water site.

Doreen whispered something I couldn't hear. She was being extremely cautious, clearly still thinking that the painting was "men's business," and that she should volunteer very little information.

She now glanced at Kaapa's *Budgerigar Dreaming* (cat. 19 in the supplement). The many tracks suggested to her "Emu!" which is a Dreaming that both Kaapa and his brother often painted. She also wondered aloud, "Mikanji?"

Although the term "budgerigar" is probably universally known to most other Australians, having been long adopted from a New South Wales Indigenous term, Doreen required my use of the Anmatyerre and Warlpiri word for the bird to recognize it. And although she had, as with everyone who has lived in Central Australia for more than a year or two, seen flights and immense flocks of budgerigars, being concerned at an element that she had glimpsed in the flick of her eyes at the photograph, she deflected any further possible suggestion of knowledge of it by saying, "Only Emu when Dad is singing story." That is, she only knew the Emu story, not that of the Budgerigars, which I'm sure that she knew that she should not know about, because of "men's business" associations. As with the Mikanji painting she was "blind" to other aspects.

"Real nice!" she added as a final comment on the painting.

When the next painting, *Ngalyilpi* (cat. 34) was revealed, with me reading out the name, she again barely glanced at it, and asked, "What that one Ngalyilpi? What they call him in English?" I knew that it (or otherwise a very similar word I had recorded as "ngalyibi") was the name of a vine that wound itself about a tree and traditionally was used as rope for a shoulder sling in which a baby-carrying bowl was balanced at a mother's hip. I stated this, but although she accepted what I said, I again thought that Doreen was being cautiously "incorrect." She suggested that perhaps the depiction of the clear, vine-like rope with its regular obscured sections represented a twining vine about the trunk of a tree which was covered here and there by hanging branches.

Although she had so briefly looked at it, I asked her what she thought if it as a painting. "*Palya*, a nice one!" she replied. "You can see it."

As she glanced at some of the other photographs of paintings, I asked two further questions of Doreen. "What do you think of all of the paintings? Do you feel anything in your heart or spirit about them?"

"That is good painting. That one [Kaapa] was the first one to start painting [at Papunya]. They—" she added, knowing by now that photographs of paintings by other early identified artists were in the binder, "—were the first ones to start painting."

My final question was, "Why did they use the colors that they did in the paintings, please?"

Her reply was much as I had expected of a person who knew that her parents had lived substantially traditional lives in their youth, and who herself had been painted up and danced the women's dances.

"Aboriginal, they use red ochre, white, yellow, black."

By this time some other kinfolk and people she had known from her years at Papunya had gathered, and she introduced me. I had known their parents, but had lost touch with them. Emma Nangala, Old Walter Tjampitjinpa's daughter, whom I had known when she was a little girl at Blackwater outstation, west of Papunya, when Old Walter lived there in the late 1970s, was one of them. I expressed my admiration for her father, who had been a friendly, generous-hearted senior man, and a teacher about the site Kalipinypa for Johnny Warangkula Tjupurrula, who became one of the greatest of the Papunya artists.

As I turned the pages of photographs in search of the image of her father's painting, Emma remarked, "I have always been looking [in books and films] to see some of my father's paintings."

I found the painting (cat. 26), reading its title, *Rainbow and Water Story*, and Doreen Nangala, who had encouraged Emma to join us, was as elated as was Emma at seeing it. Emma had visited Kalipinypa, a native well sunk into grit, and usually called a rockhole by the people of direct association. She knew that it was her father's main site, at and about which he had lived for some twenty years before the beginnings of major contact with white people in the 1930s.

As had Doreen of the Mikanji painting, Emma clearly avoided "seeing" anything specifically to do with men's ceremonies in Old Walter's painting: "There is waterhole. Kalipinypa. My father [lived there], early days. Talk all about soakage right there. I have been there. *Tjukurrpa* [the Dreaming] he been coming [the lightning of the story]."

She studied the painting, identifying certain aspects. The uppermost

circle was the rockhole, Kalipinypa—a feature independently suggested by Doreen, too, although she had not visited the Kalipinypa country.

"Lightning" was her identification of the golden hatched part of the painting, "coming in [from the west to Kalipinypa], every one." That is, each golden line coming in from the edge of the painting to the Rainbow (identified as the large arc at the top of the painting) represented the constant lightning strikes of the *tjukurrpa* storm, as it traveled west to east, with a focus in fierce intensity at Kalipinypa.

She put her finger on the central "circle" and ran her finger around. "Soakage there. Kalipinypa!"

She pointed at the yellow area again. "*Karpi*! Raining!" she said, associating heavy rain with the lightning. The sinuous lines running in from the rainbow on each side of the soakage indicated that running water from the storm was filling the soakage.

"Happy for seeing my father's painting. Good painting!"

Doreen, doing her best to assist me, asked Emma to comment on the colors used in Old Walter's painting. The reply was as might be expected from the way that the question was asked.

"You get that red, black, yellow, white. You get it from the gallery [to which the paintings are sold]. You been know. You been use it for canvas."

At this stage I bade farewell to the several Anmatyerre and Pintupi people now gathered, and after discovering that Dinny Nolan was not at the tent a few kilometers out of town, drove back to Abbott's camp. There I found Keith Kaapa, Kevin Wirri—and Dinny.

Keith and I joined Dinny, and Keith then called Kevin to join us. He did so because Kevin was a friend, and also because Keith knew that the Pintupi country sites in the photographed paintings were variously linked by Dreaming trails to Kevin's Pitjantjatjarra country to the south at Docker River. Although the area chosen for discussion was not ideal, being likely to attract the attention of others who had no right to the viewing or discussion, Keith accepted that Dinny needed to be comfortable.

Dinny, knowing that we were about to inspect the images of Kaapa's paintings, stated, "Kaapa is my brother. We two fellow first. One mother."

I opened the binder at the first image (cat. 5 in the supplement), which he had, in an instant, previously identified with the one word "Mikanji," the name of the site which had inspired his brother's art.

"Painting that one before," he said, meaning that it was a painting done by Kaapa a long time ago. "Painting [for Papunya Tula Artists in the early 1970s]."

He looked at the snakes of the painting. "That *wana* (snake) been traveling about. Big story. This one, big story. Mikanji. Rain, goanna, snake one." In other words, the Rain Dreaming, Goanna Dreaming and Snake Dreaming were all part of the important set of Dreamings associated with Mikanji, though only limited elements had been depicted by Kaapa.

"Big traveling, like this," he continued, moving his hand up the painting, and by doing so, taking into account how he was sitting, accurately indicating the south to north traveling of the mythological creator snake ancestors along the creek line at the site.

Dinny admired his brother's painting. "Nice one. Really flash one," he observed. "Really *tjukurrpa*.

"Snake, lot of track this way. This one here [he pointed to snake painted on the left hand ceremonial pole], him traveling.

"*Tjukurrpa* one. Mikanji. Country. Tjungurrayi–Tjapaltjarri [men of two subsections]. [They are] *Kutungurlu* ['managers'].

"Tjampitjinpa–Tjangala, been traveling." That is, the two snakes, with subsections equivalent to Kaapa Mbitjana Tjampitjinpa and his son Keith Kaapa Tjangala, were traveling the country in the Mikanji area in the *tjukurrpa* creation time.

"Nice one here. Tjangala–Tjampitjinpa, all here. All this story."

Having deferred to his father's brother for an appropriate time, Keith Kaapa now began speaking, with Kevin Wirri listening without interrupting, unless asked for comment, as he had when Dinny was talking. Keith was considering the painting of Mikanji as he spoke.

"We was looking at the *tjukurrpa*. Ngaba [Rain]. They were in the ceremony." His father and Dinny had taken part in ceremonies associated with Mikanji.

After referring to the painting of the men for the ceremonies, the observance of which is crucial if a site is not to lose its power, he commented:

"Still Water Dreaming there! Tjangala–Tjampitjinpa." That is, Tjangala–Tjampitjinpa are the "owners" of the Rain Dreaming at Mikanji, and through being responsible in their ceremonial actions, Kaapa and Dinny had maintained its goodness as a Rain Dreaming site.

I asked Keith if he liked the painting, and he responded "Yes!" Lifting his thumb as a sign of approval, he grinned and said, "Deadly!"

There was clear whispered acknowledgment of the Kangaroo tracks as representing the Kangaroo Dreaming, but this, as with much else, was not discussed so much as understood. It was obvious that they knew that the painting was of the "early days" of the Papunya Art development and, although Dinny had accepted the presence of the two Aboriginal women during his first brief inspection, they and children were not to be present during this present discussion. In fact, four young men who arrived unannounced were brusquely told to leave, and a middle-aged man was too.

I now turned to the *Budgerigar* painting (cat. 19 in the supplement), and Dinny allowed Keith to make the first comments.

"Before I can do the painting [of this nature], I have to go through the ceremony."

Although Keith knew that the painting was of the Budgerigar Dreaming, there was a similarity in the tracks (because of the lack of scale) to the Emu Dreaming, and he preferred to talk of that.

"Emu Dreaming. Dinny Tjampitjinpa *tjukurrpa*. All that one [the emus of the Dreaming], been traveling. Emu travel. Big mob.

"I'm thinking about the old people. I am like I'm [learning from my] school teacher [Dinny]. We do not want to lose it [the ancestral knowledge of sites]. We can teach our grandsons, granddaughters."

Keith then discussed all of his relations of a close kind who already had knowledge of the *tjukurrpa*, and the many young ones who still had to learn.

Looking at the painting again, but still recalling the Emu ceremonies, he stated, "That color is red in the ceremony. Emu color. It shows out real good in the ceremony."

It was now time to turn to the *Ngayilpi* painting (cat. 34). I instantly

discovered that my perception of a vine was incorrect for the particular painting, even though there was a ropelike nature to the story.

"Ngalyilpi. That one dangerous again. Like 'business' way," explained Keith.

Dinny made a special hand sign that enlightened me.

"Only man," said Keith, and referred to Men's Love Magic which, to be effective, the women must not know about. I imitated one of the love magic elements, saying "Lover boy" as I did so, and the men laughed. Keith then said that the women had their own love magic that the men did not know, but that he knew that a woman was attracting him by her powerful use of it.

Keith added that there were now only three senior men left who he considered still knew the *tjukurrpa* well. They were Long Jack Philipus Tjakamarra, Murphy Roberts Tjupurrula, and Dinny.

"I have seen my father's paintings," he concluded, "and I think I'll start painting again."

[1] "Sorry business" is the process of bereavement in Aboriginal communities. The mourning of a loved one often means that the family will move out of their home into an outdoor "sorry camp" for a period of time, during which the name of the deceased is not spoken but rather the name "Kwementyaye" is substituted. Mourning relatives may also cut off their hair or paint their faces with white pigment.

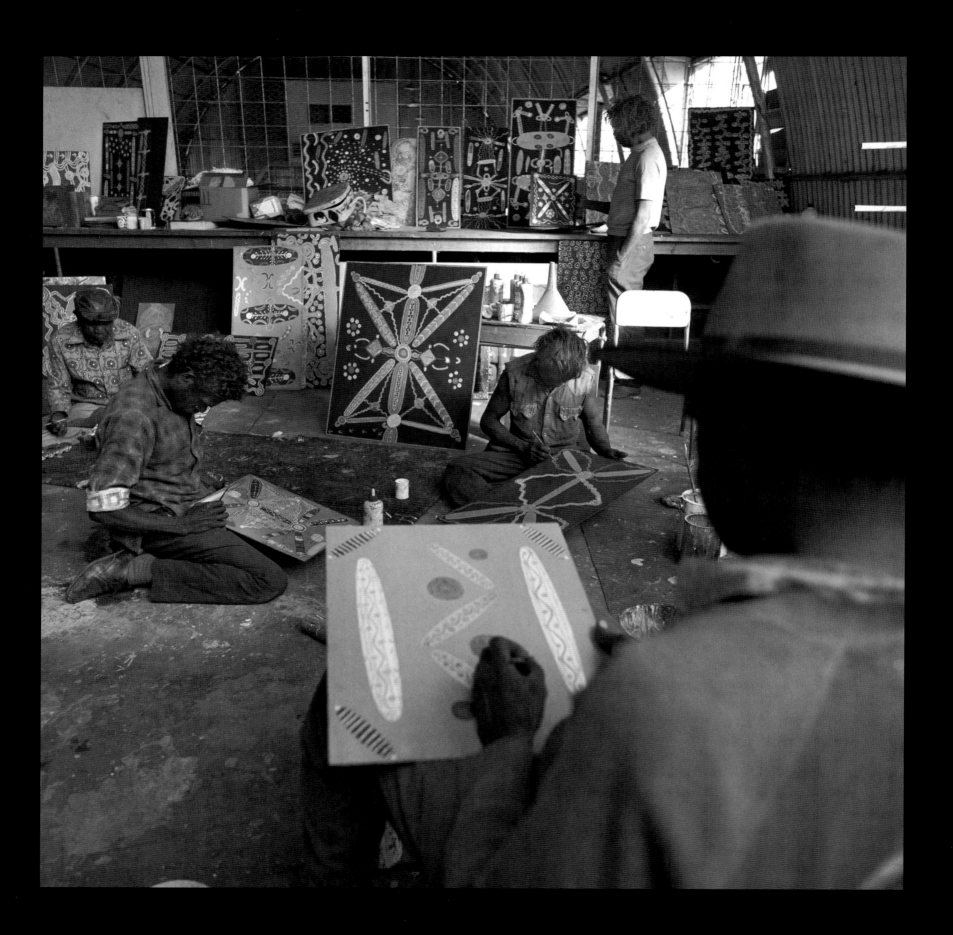

This catalogue is arranged chronologically. Annotations and explanations of works for the majority of works, of 1971 and 1972, were primarily written by Geoffrey Bardon in consultation with the artists. Geoffrey and James Bardon's monumental 2004 catalogue has been an invaluable aid; we have usually adopted the dates and titles Bardon uses. Earlier titles are given in square brackets. We thank Dorn Bardon for permission to quote extensively from the late Geoff Bardon's work.

Other notes on pictures were provided over the years by Pat Hogan, Peter Fannin, Dick Kimber, Fred Myers and Vivien Johnson. (Certificates and diagrams for the paintings are held in the Wilkerson collection.) The data from published sources were compiled by Clare Lewis.

One goal of this catalogue is to provide a critical chronology of a group of Papunya works according to art-historical method, which has not been attempted before. In some cases documentation is reliable. Bardon's dates and annotations for works painted prior to his departure in early August 1972 are assumed to be reasonably accurate, as he witnessed the execution of many of them. Papunya consignment numbers, given for bundles of works delivered by Bardon and others to the Stuart Art Centre in Alice Springs up to late 1972, are rough indications only, because the consignments have not yet been dated and earlier stock may have been consigned to Alice Springs with these bundles. Occasionally, stylistic and iconographic evidence has led me to contradict a published date (for example, Billy Stockman's *Possum Dreaming*, early 1972). Care has been taken to indicate the sources for differing readings of the stories in the paintings. —R. B.

In March 2007, Dick Kimber, a local historian and author based in Alice Springs, showed photographs of all paintings to be exhibited to Aboriginal community members. Those consulted commented that for reasons of secret/sacred imagery or depiction of ceremony, nine of the exhibition works could be harmful if seen by uninitiated members of their communities. Therefore, photographs of these paintings do not appear in the exhibition catalogue.

However, those consulted also granted permission for non-Aboriginal audiences to view these nine sensitive images, and so in copies of the book intended for U.S. distribution, they can be found in a supplement inserted in the back cover of the book. In copies intended for Australian distribution, this supplement has simply been omitted. Full catalogue entries for the nine works in question still appear in the book, as well as, in most cases, reproductions of original diagrams by Geoffrey Bardon and others from the collection of John and Barbara Wilkerson. —A. W.

1.

Stars, Rain, and Lightning at Night [formerly *Storm*], before or about May 1971
Kingsley Tjungurrayi
(ca. 1917–1977)
Luritja
Synthetic polymer and enamel paint on composition board
Bears consignment number "1 con 10" on reverse
27 13/16 x 9 1/8 inches (70.63 x 23.18 cm)

PROVENANCE

Stuart Art Centre, Alice Springs, consignment 1, painting 10
Private collection, Queensland
Sotheby's, *Important Aboriginal Art*, Melbourne, June 29, 1998, lot 22
Collection of John and Barbara Wilkerson, New York

BIBLIOGRAPHY

Sotheby's, *Important Aboriginal Art*, Melbourne, June 29, 1998: page 22
Bardon and Bardon, 2004: page 106, painting 15
Cf. Johnson, *Lives of the Papunya Tula Artists*: page 58 (ill.), for a related work

This historic painting, in the elemental colors of red and white over a black ground, is listed by Geoff Bardon as just the third Papunya work known to him on a solid support. It comes after two pre–1971 works by Old Walter Tjampitjinpa and Old Tutuma Tjapangati. All three depict stars at night, and Bardon (page 105) writes in explanation, "It was this work depicting stars at night that first interested me in the pensioners' work; to me it was a valid simplification of a perceived object, an image for a star, in fact, an observed twinkling star."

Stars, Rain, and Lightning at Night is the only surviving board from a trio of works dated to May 1971 or earlier (of the other two, only diagrams remain). Bardon writes (page 106):

> These three very early paintings, made perhaps before or about May 1971, by Kingsley Tjungurrayi, Don Ellis Tjapanangka and Toby Tjangala were for me statements of archetypes, stating no more than the elements and co-efficients of a story and requiring no ornamentation. The representations were on an unmarked and unincised background.
>
> After a short time Kingsley Tjungurrayi and Don Ellis Tjapanangka were no longer participants in the painting movement; Kingsley, a man of part-Afghan descent, was quite formidable in his business dealings, and later strongly enquired who was to be 'king' of any car we bought.

The 1998 sale catalogue states:

> The only recorded works by Kingsley Tjungurrayi appear in the records of consignment 1 to the Stuart Art Centre in Alice Springs, indicating that he was one of the original eight artists who painted for Geoff Bardon at Papunya in July 1971. His name does not appear in the Stuart Art Centre nor the Papunya Tula records after this date.

The rudimentary diagram for the first Papunya art consignment to the Stuart Art Centre, in Pat Hogan's hand, gives the little roundels as "stars at night" and the wavering connected lines as "lightning." It is inscribed "1 CON, No 10. Kingsley."

2.

Three Corroboree Poles [formerly *Untitled*], late 1971

Tommy Lowry (Tommy Tichiwan No. 4) Tjapaltjarri

(ca. 1940–1987)

Pintupi/Ngaatjatjarra

Synthetic polymer paint and natural earth pigments on composition board

8 7/8 x 2 7/8 inches (22.54 x 7.3 cm)

PROVENANCE

Purchased by Mr. and Mrs. W. L. Jackson, teachers at the Papunya School, in early 1972 "at an exhibition to raise money to buy more painting supplies" (Sotheby's, *Important Aboriginal Art*, Melbourne, June 28, 1999, lot 56)

Collection of John and Barbara Wilkerson, New York

BIBLIOGRAPHY

Sotheby's, *Important Aboriginal Art*, Melbourne, June 1999: pages 46, 48

Perkins and Fink, *Genesis and Genius*, 2000: pages 12 (ill.) and 288

Bardon and Bardon, 2004: page 115, painting 35

EXHIBITED

Papunya Tula: Genesis and Genius, Art Gallery of New South Wales, Sydney

August 18–November 12, 2000

This elemental image, apparently the first recorded work by Tommy Lowry (Tommy Tichiwan No. 4) Tjapaltjarri, shows three ceremony poles inserted into the ground; at the base of each are concentric rings or ground drawings. It thus indicates the centrality of ceremony in the cultural life of the Pintupi and the role of ceremony, with its traditions of body painting, dance, music, and story as the source of so much of the visual art that was to follow.

Bardon writes (page 115):

> Three ceremonial sticks as motifs were painted in my school art room at Papunya Special School, in the third term of 1971, by a then unknown Pintupi, on a very small piece of scrap wood salvaged from the Alice Springs timber yard. I found out later that the artist was Tommy Tichiwan [Tommy Lowry Tjapaltjarri]."

Nosepeg Tjupurrula's *Three Corroboree Sticks*, in the collection of the National Gallery of Australia, with its "simple, gently dotted image . . . predated this example by two months but revealed very similar imagery" (Bardon, page 115; see page 120 for the Nosepeg work).

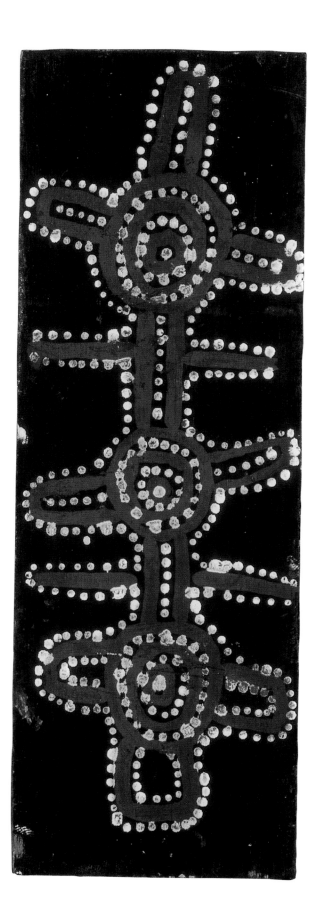

3.

Archetypal Pintupi Ceremonial Dreaming [formerly *Untitled*], September 1971

Unidentified artist

Pintupi

Synthetic polymer paint and natural earth pigments and polyvinyl acetate on composition board

8 15/16 x 2 7/8 inches (22.7 x 7.3 cm)

PROVENANCE

Purchased by Mr. and Mrs. W. L. Jackson, teachers at the Papunya School, in early 1972 "at an exhibition to raise money to buy more painting supplies" (Sotheby's, *Important Aboriginal Art*, Melbourne, June 28, 1999, lot 55)

Collection of John and Barbara Wilkerson, New York

BIBLIOGRAPHY

Sotheby's, *Important Aboriginal Art*, Melbourne, June 28, 1999: page 48

Perkins and Fink, *Genesis and Genius*, 2000: pages 12 (ill.) and 288

EXHIBITED

Papunya Tula: Genesis and Genius, Art Gallery of New South Wales, Sydney

August 18–November 12, 2000

Given the similarity in execution and materials, it seems likely this small board was also the work of Tommy Lowry Tjapaltjarri.

A diagram and annotation was provided by Geoffrey Bardon for the 1999 sale. On the diagram drawn by Frank Slip and signed by Bardon is the remark: "Painted on scrap wood—Geoff Bardon's Art Room, Papunya, Sept. 1971." On the verso of the diagram, Bardon notes: "The emerging design motifs for ceremonial men as a U shape, journey line and sitdown places are all apparent. It reveals the ceremonial positions for a dreaming map and is similar to ceremonial signs or motifs in actual images, on traditional objects here transposed to hardwood."

4.

Archetypal Homeland Journey Dreaming [formerly *Untitled*], ca. September 1971

Unidentified artist

Pintupi

Synthetic polymer paint and natural earth pigments on composition board

8 15/16 x 2 7/8 inches (22.7 x 7.3 cm)

PROVENANCE

Purchased by Mr. and Mrs. W. L. Jackson, teachers at the Papunya School, in early 1972 "at an exhibition to raise money to buy more painting supplies" (Sotheby's, *Important Aboriginal Art*, Melbourne, June 28, 1999, lot 54)

Collection of John and Barbara Wilkerson, New York

BIBLIOGRAPHY

Sotheby's, *Important Aboriginal Art*, Melbourne, June 28, 1999: page 48

Perkins and Fink, *Genesis and Genius*, 2000: pages 12 (ill.) and 288

EXHIBITED

Papunya Tula: Genesis and Genius, Art Gallery of New South Wales, Sydney

August 18–November 12, 2000

The fluency and bold design of this little work, as well as the regularity of the dotting, suggests that it was by a more experienced hand than cats. 2 and 3.

The Sotheby's catalogue entry notes: "At the time [the Jacksons] were informed by Geoffrey Bardon that this painting was 'special' as it was 'a very early example' and 'done in ochre.'" On the documentation provided by Geoffrey Bardon he wrote: "A sand painting pattern of linked concentric circles where vertical and straight lines represent a journey with horizontal bar sign, a motif in body decoration, and also a water mark for a ceremony."

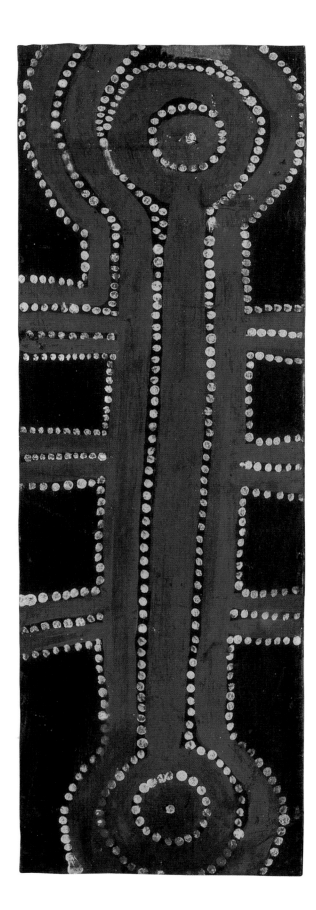

For reasons of its secret/sacred imagery, this image is reproduced in the supplement only

5.

Mikanji [formerly *Untitled*], October 1971

Kaapa Mbitjana Tjampitjinpa

(ca. 1926–1989)

Anmatyerre/Arrernte

Synthetic polymer/powder paint on composition board

36 x 35 7/8 inches (91.44 x 91.12 cm)

PROVENANCE

Acquired at the first exhibition of Papunya paintings in Alice Springs in October 1971 by R. G. (Dick) Kimber

Sotheby's, *Important Aboriginal Art*, Melbourne, June 29, 1998, lot 21

Collection of John and Barbara Wilkerson, New York

BIBLIOGRAPHY

Kimber, "Papunya Tula: Artists of the Central and Western Deserts of Australia," in *Australian Art Review*, ed. Leon Paroissien (Warner Associates), 1982: pages 122–25 (ill. detail page 123)

Dot and Circle: A Retrospective Survey of the Aboriginal Acrylic Paintings of Central Australia, eds. Zimmer and Maughan, 1986: cat. 1, page 59 (ill.)

Cf. Johnson, *Dreamings of the Desert*: page 19 for two similar works by Kaapa

Sotheby's, *Important Aboriginal Art*, Melbourne, June 29, 1998: page 21

Cf. Sotheby's, *Important Aboriginal Art*, Sydney, October 20, 2008: pages 101–2

EXHIBITED

Dot and Circle: A Retrospective Survey of the Aboriginal Acrylic Paintings of Central Australia, RMIT University Gallery, Melbourne

April 16–May 3, 1985 (cat. 1)

This is a crucial early work from Papunya, not only for its visual magnificence, but because it was purchased from the first exhibition of the new Papunya art, held in Alice Springs in October 1971. It represents an aesthetic advance on the July–August works by Kaapa Tjampitjinpa, who had won the Caltex Art Award with *Gulgardi* on August 27, 1971. In comparison with such works, Kaapa has avoided the use of perspective and literal figures of men participating in ceremony. In *Mikanji* Kaapa provides a symmetrical schematization of the ceremonial scene. "Realistic" figures are replaced by U-signs set around a central sand mosaic partitioned off by large ceremonial objects. Beyond this lie two large arrays of ground paintings, set out in an ampersandlike format. *Tjurungas*, bullroarers, and ceremonial poles topped with emu feathers are all in evidence—as presumably allowed by the artist's more liberal Anmatyerre view of issues of secrecy.

The work can be retitled *Mikanji* thanks to Dick Kimber's interview with relatives of the artist in this catalogue. "Kaapa had special responsibilities for Mikanji, a rain-making site near Mt. Denison on Napperby Station. . . . Kaapa was born on Napperby and later on lived at Mikanji outstation" (Sotheby's 2008, page 101).

The 1998 sale catalogue notes, "This unusually large and seminal painting is one of the first six paintings offered for sale in Alice Springs in October 1971." R. G. (Dick) Kimber in his personal correspondence in researching this painting for Sotheby's noted (page 21):

> It had been brought into Alice Springs from Papunya by a senior member of the Old Native Welfare Dept. (later Dept. of Aboriginal Affairs, and later still ATSIC). The painting was one of a small number offered for sale; most, if not all, had been painted by the artist Kaapa Mbitjana Tjampitjinpa . . . 1971 he (Kaapa) shared first prize in the Alice Springs Caltex Golden Jubilee Art Award, and this was the first public recognition of any Papunya Tula artist. This award sparked a great interest by Kaapa in painting, not only for the pleasure it gave in the recall and singing of sites for which he had responsibilities, but also because there were possibilities of monetary rewards. . . . This painting belongs to the earliest phase of the artist's work. As was normal with most of Kaapa's art, there was a strong sense of balance in the work. And, as was quite common in the earliest paintings by numbers of the first Papunya Tula artists, naturalistic depictions are a key feature.

> The two snakes are the mythological snakes involved in creation of extensive shallow depression in the Napperby Country; after good rains these become part of the Napperby Lakes, which sometimes hold water for months. (On such occasions, many water birds, not normally seen in the area, may migrate to the lakes, and in some instances, breed there.) The two ceremonial poles are complementary. At the base are tracks which are believed to represent a kangaroo ancestor, but the meanings of the other elements of the painting were not obtained.

In earlier descriptive notes regarding this work, Kimber writes (page 21):

> It has a black background and a red border, along the inner rim of which run fine white dots. An initial design, very largely obliterated when water was used to smear remove it, exists as a ghost outline in the background. Centrally placed is a set of concentric circles in orange, white and green. All other design elements are symmetrically arranged about these circles and towards the edge of the board, and a further colour, yellow is employed. The mirror-image designs are of two bullroarers and two ceremonial poles standing up from depictions of ground paintings, two snakes, two sets of geometrical designs and, across the base, a line of kangaroo tracks. Kaapa was relatively unusual in often painting ceremonial poles, ground paintings and bullroarers, and sometimes realistic portrayals of men in body paint and head dresses, in his early art for the Papunya Tula Company. He was adamant that certain aspects of these, were, in fact, enabled to be seen by both men and women in his country, and that he had only painted those which were acceptable to be seen by both. . . . Although Kaapa declined from including the majority of such aspects in his paintings after about [19]73, he was absolutely emphatic that this particular painting and a number of others of even more elaborate nature could be openly displayed.

6.

Big Family Kangaroo Ceremonial Dreaming [formerly *Kangaroo Story*], fourth quarter of 1971

Long Jack Phillipus Tjakamarra

(born 1932)

Pintupi, also recorded as Luritja/Ngaliya/Warlpiri

Synthetic polymer/powder paint on composition board

28 1/4 x 23 7/8 inches (71.75 x 60.64 cm)

PROVENANCE

Stuart Art Centre, Alice Springs, consignment 6, painting 21 (#6021)

Private collection, Northern Territory

Deutscher-Menzies, *19th and 20th Century Australian Painting, Sculpture and Works on Paper,* Melbourne, April 20, 1998, lot 2

Collection of John and Barbara Wilkerson, New York

BIBLIOGRAPHY

Deutscher-Menzies, *19th and 20th Century Australian Painting, Sculpture and Works on Paper,* Melbourne, April 20, 1998: page 16

Bardon and Bardon, 2004: page 220, painting 129

This remarkable painting, like a constellation of red stars and comets exploding from a distant center into an inky black sky, represents a Kangaroo ceremonial dreaming of great sanctity (as the notes below indicate). It is replete with a vivid sense of activity, and shows through the patterns of tracks the movements of the Kangaroo Ancestor, walking, sitting on its haunches, and lying down. The four radiating bars connote travel to four far-flung geographic locations, as opposed to the immediacy of the central ceremony, where *tjurungas* and ceremonial hats are in use.

Geoffrey Bardon writes in the 1998 sale catalogue:

> The central concentric circle painted as a sand mosaic, would represent a significant place, most likely a Wallaby Spirit waterhole location in the artist's Loritja/Luritja homeland. The radiating lines to all four corners of the design are major journey lines that are specific motifs for the traveling story itself. The shorter radiating straight lines are Wallaby tail marks accompanied by Wallaby tracks. The traditional "U" motif is for the four ceremonial figures grouped centrally in the design, accompanied by four shields or *tjurunga* oval forms. . . . The ceremonial hats created by concentric circles and crossed bars, that are linked to oval *tjurunga*, are ritual motifs of potentially secret/sacred consequence. The ceremonial hats are, from my experience, "pretend" ceremonial hats because of the extreme simplicity in vertical and horizontal division. This particular hat simplicity was usual with Long Jack's illustrations (see Bardon, *Papunya Tula: Art of the Western Desert,* page 62, *Children's Kadaitcha Dreaming*).

> The painting could be a Dreaming ritual of particular seriousness because of the ceremonial hats. Long Jack was an outstanding person and reliable workman, a baptized Christian who was to become a Lutheran pastor at Papunya and elsewhere for Central Australia. His tribal knowledge was formidable and always showed extreme caution very early in the painting movement when the traditional community at Papunya understood these designs would be widely seen.

The 1998 catalogue continues: "This painting was loaned by the vendor to the Araluen Arts Centre, Alice Springs. Whilst on loan in 1994 senior Papunya Tula artists, Paddy Carroll Tjungurrayi, William Sandy, Dinny Nolan Tjampitjimpa and Turkey Tolson Tjupurrula sighted the painting and indicated that this painting cannot be viewed by uninitiated male members and women of Central and Western Desert language groups."

Bardon published his original field note and drawing in 2004, in which he identified the four large U-shapes near the center as "kangaroos lying down," then within them four "kangaroo *tjurungas*" and at the center a "big corroboree stick." He wrote (page 220): "Long Jack uses a radiating configuration where modified ceremonial hat diamond forms, associated with story-telling tracks, are grouped symmetrically in elaborate Kangaroo Dreaming details; traveling and the hunting dance by the Spirit Being are integral to this ceremony."

For reasons of its secret/sacred imagery, this image is reproduced in the supplement only

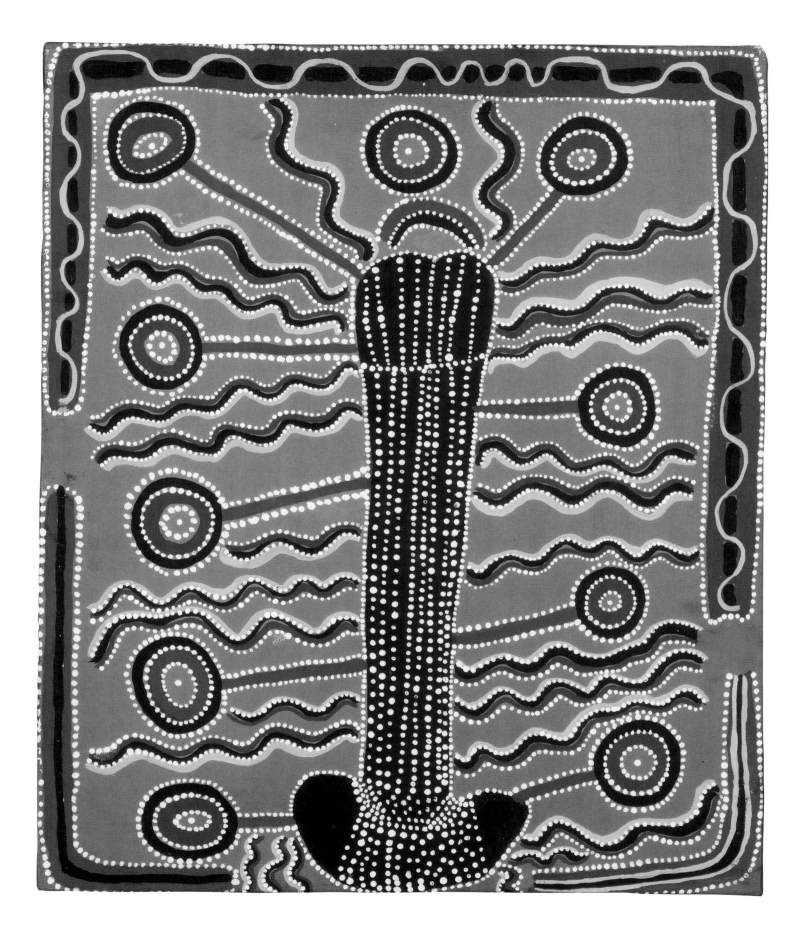

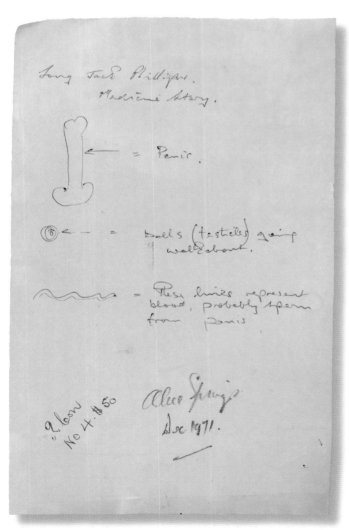

FIGURE 1.
Diagram by Geoffrey Bardon, collection of John and Barbara Wilkerson

7.

Medicine Story, December 1971

Long Jack Phillipus Tjakamarra

(born 1932)

Pintupi, also recorded as Luritja/Ngaliya/Warlpiri

Synthetic polymer paint on canvas

21 7/8 x 17 7/8 inches (55.56 x 45.4 cm)

PROVENANCE

Stuart Art Centre, Alice Springs, consignment 4

Purchased Alice Springs, December 1971

Private collection, Melbourne

Sotheby's, *Important Aboriginal Art*, Melbourne, June 29, 1998, lot 244

Private collection, Sydney

Sotheby's, *Aboriginal Art,* Melbourne, July 9, 2001, lot 130

Collection of John and Barbara Wilkerson, New York

BIBLIOGRAPHY

Sotheby's, *Important Aboriginal Art*, Melbourne, June 29, 1998: page 122

Sotheby's, *Aboriginal Art*, Melbourne, July 9, 2001: page 112

Cf. Bardon and Bardon, 2004: page 293 (comparative images only)

The annotated diagram in Geoffrey Bardon's hand (fig. 1) on the reverse of the work states: "2 Con No. 4. $50. Alice Springs Dec. 1971." It also gives the title and artist of the work, indicating the main motif as a penis and the roundels as "balls (testicles) going walkabout." The wavy lines are interpreted thus: "These lines represent blood, probably sperm from penis."

As the 2001 sale catalogue states: "This painting undoubtedly relates to the Old Man Dreaming often depicted by Uta Uta Tjangala and Charlie Tarawa." The entry for Uta Uta Tjangala's *Medicine Story* below gives details of the underlying story. Long Jack's imagery is quite different, however, with a much more recognizable phallic form dominating the entire composition. Uta Uta uses red ochre color for his *kuruwarri* laid over a black ground, which gives a more funereal effect. Long Jack inverts this, with the phallus a threatening black form over a visually buoyant ground of rust red. The visual energy and agitation of the symbolic ejaculate, shown as wavy lines in red, yellow, and black, is highlighted further with white dotting all the way up to the ten roundels of the Old Man's wayward testicles seen in different locations.

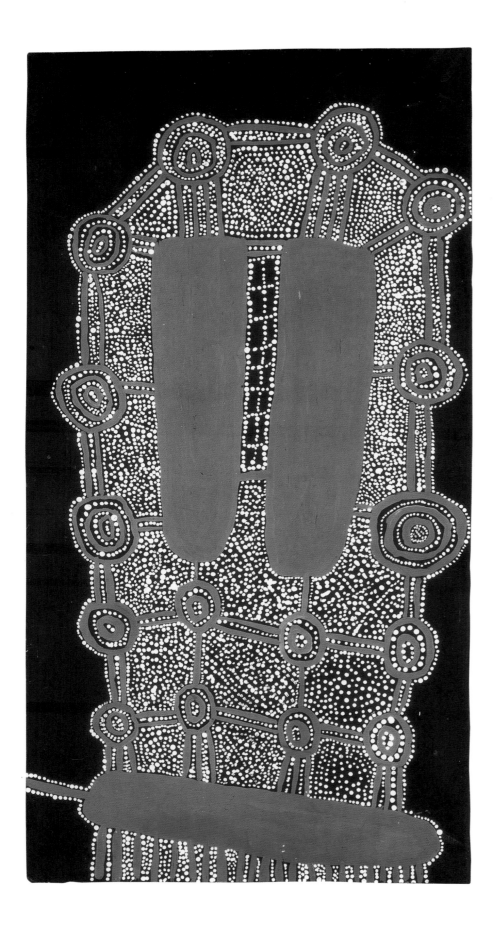

8.

Medicine Story, 1971

Uta Uta Tjangala

(ca. 1926–1990)

Pintupi

Synthetic polymer/powder paint on composition board

27 5/8 x 13 7/8 inches (70.17 x 35.24 cm)

PROVENANCE

Stuart Art Centre, Alice Springs, consignment 7, painting 5 (#7005)

Tim Guthrie Collection, Melbourne

Sotheby's, *Important Aboriginal Art*, Melbourne, June 30, 1997, lot 17

Collection of John and Barbara Wilkerson, New York

BIBLIOGRAPHY

Cf. *Dreamings: The Art of Aboriginal Australia*, ed. Sutton: pages 136–37; 178, 179 (ills.)

Sotheby's, *Important Aboriginal Art*, Melbourne, June 30, 1997: page 19

Cf. Myers, "Aesthetics and Practice: A Local Art History of Pintupi Painting," 1999: pages 219–59.

Bardon and Bardon, 2004: page 306, painting 248

In this early *Medicine Story*, Uta Uta Tjangala, like Long Jack Phillipus Tjakamarra and Charlie Tarawa (Tjaruru) Tjungurrayi, produced an emphatic visual impact by laying a design in brown or dark red over a board prepared with matte black (probably blackboard paint). The painting is also notable for the early, extensive use of white dots within the confines of the *kuruwarri*, or story lines, and seems to refer to a ceremonial ground. The theme of the Old Man at Yumari was developed by Uta Uta a decade later into some of the greatest large canvases in the history of Papunya Tula art (see Myers 1999).

Fred Myers provided the following notes on this story for the 1997 sale catalogue:

> This is certainly a painting that is part of the Old Man (Yina) Dreaming that Uta Uta frequently painted. The Old Man traveled from Kampurarrnga in the Henty Hills westward, through Sandy Blight Junction and Yumari and on westward. The Old Man is pictured in many of Uta Uta's paintings and often said to be a "medicine one," by which the painter means that he carried a kind of sorcery with him—involving the capacity to ruin the nose of people. He was powerful and dangerous.

> The Old Man has characteristics often found in myth, his penis sometimes has a life of its own and his testicles often travel separately from his body . . . so that he had to call to them when he was moving on. In other paintings of this Dreaming, by Charlie Tarawa, the Old Man is "lying down" and with his testicles separate from him as sandhills at Wiknya—a rockhole between the Ehrenburg Range and Sandy Blight Junction. At Tjurrpungkuntjanya, a rocky rise and rock-hole nearby, his testicles are said to be "racing along sideways"—to the side of his path. However, the features—the penis, the separate testicles and lying down—are part of the iconography of most places associated with the Old Man before he gets to Umari (page 19).

At the Yumari rockhole the Old Man had, in Dick Kimber's notes for the 1997 catalogue: "a sexual liaison with his strictly forbidden mother-in-law relation. His enormous penis led him astray. . . . Thereafter he suffered painful torment. The pain increased as he travelled west until eventually his testicles fell off and rolled away—or 'went walkabout.'"

Two old diagrams exist. One in Geoffrey Bardon's hand, on letterhead reading "Art promotions Papunya Incorporated, All copyright reserved," is the merest sketch with the words reading "Testicles of Old Man" and "Testicles gone Walkabout" (Bardon and Bardon, page 306). The second, in Pat Hogan's hand on Stuart Art Centre card (fig. 2), identifies the form at the bottom as the "old man lying down," the bifurcated central motif as the "penis of the old man," while roundels at the top indicate "testicles of old man gone walkabout."

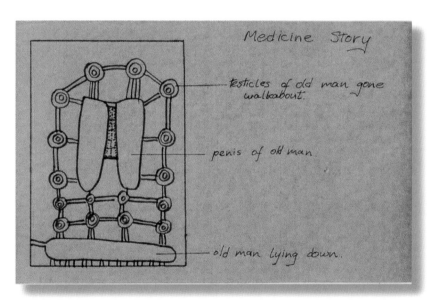

FIGURE 2.
Stuart Art Centre card, collection of John and Barbara Wilkerson

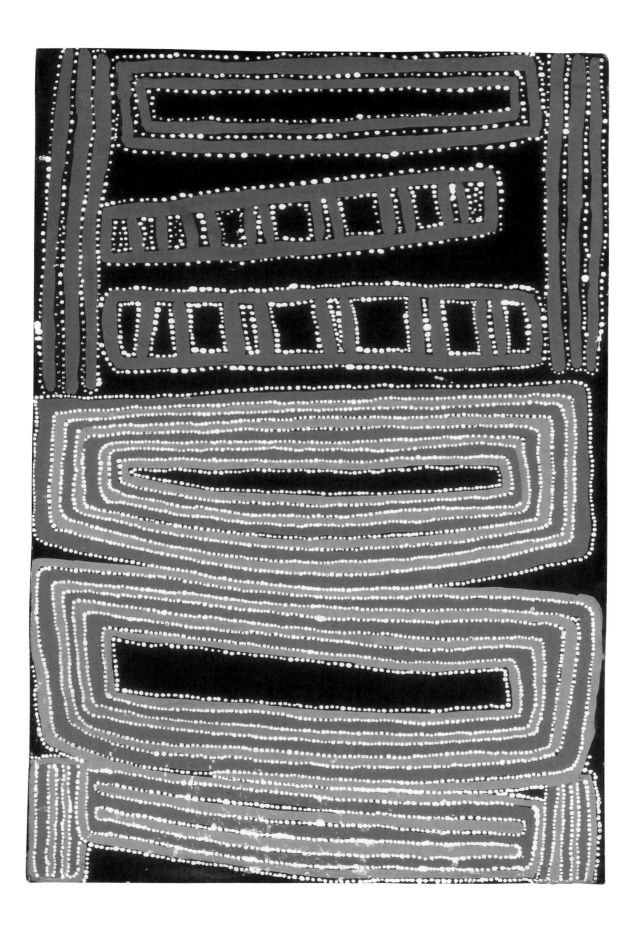

9.

Cave Story, November 1971

Tim Payungka Tjapangarti

(ca. 1942–2000)

Pintupi

Synthetic polymer paint on composition board

18 1/8 x 12 inches (46.04 x 30.48 cm)

PROVENANCE

Given as payment to the first owner for his professional services as a scriptwriter on Geoff Bardon's first film, on the Yuendumu Sports Carnival, *The Richer Hours* (1971–72)

Sotheby's, *Important Aboriginal Art*, Melbourne, June 28, 1999, lot 25

Collection of John and Barbara Wilkerson, New York

BIBLIOGRAPHY

Sotheby's, *Important Aboriginal Art*, Melbourne, June 28, 1999: page 23

Bardon and Bardon, 2004: page 441, painting 412

A label on the reverse with the artist's name and a description of the imagery reads: "The bottom half of the painting represents successive views of a cave in hills. The top section represents the interior of the same cave."

Tim Payungka Tjapangarti shares with Mick Namararri Tjapaltjarri and Yumpuluru Tjungurrayi a two-part concept for painting Cave Dreamings. One section gives overall conceptual views of the cave (including both the inside and the outside), and the other half the interior of that cave. In *Cave Story* no ceremonial objects or allusions to ceremony men are readily apparent, despite what one would expect given the early date of November 1971. In the upper interior section one might see the two detached rectangles with honeycomb cells as alluding to decorated objects, but this is speculation. The grave Pintupi abstraction of Tim Payungka's work is striking, as is the rectilinear shape of his cave-forms showing the massive, foursquare layers of rock—the "successive views of a cave in hills."

Bardon adds (page 441):

> Great importance is placed on various caves to which Dreaming ceremonies are connected; it is very common for the ceremonial men to be in a cave, often where there is a rockhole. Yet in reality there are very few "caves" in this area, but there is an incredible knowledge retained by Aboriginal men of where a cave may be, since its Dreaming is part of their custodianship.

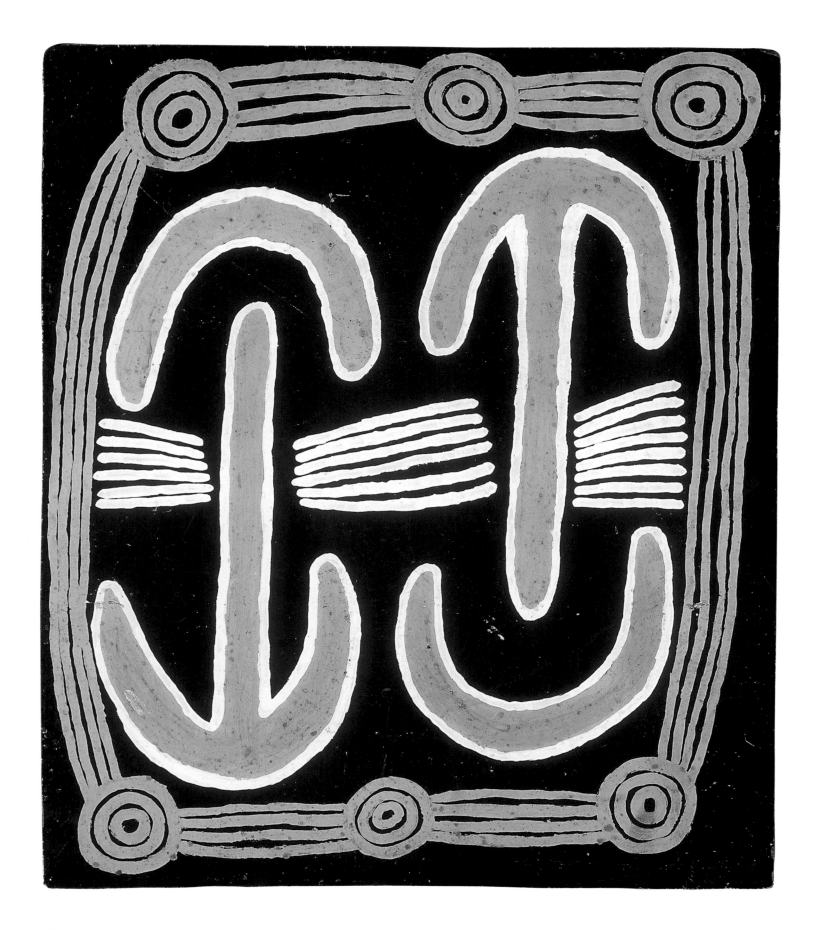

10.

Moon Love Dreaming of Man and Woman—Medicine Story, October–December 1971

Charlie Tarawa (Tjaruru) Tjungurrayi

(ca. 1925–1999)

Pintupi

Synthetic polymer paint on composition board

24 1/4 max. x 19 7/8 inches (61.6 max. x 50.48 cm)

PROVENANCE

Stuart Art Centre, Alice Springs, consignment 8, painting 35 (#8035)

Deutscher-Menzies, *Fine Aboriginal Art*, Melbourne, June 29, 1999, lot 58

Collection of John and Barbara Wilkerson, New York

BIBLIOGRAPHY

Deutscher-Menzies, *Fine Aboriginal Art*, Melbourne, June 29, 1999: page 49; cover (ill.)

Bardon and Bardon, 2004: page 300, painting 241

EXHIBITED

Art Gallery of New South Wales, date unknown (label attached to verso of painting)

Charlie Tarawa's *Moon Love Dreaming of Man and Woman—Medicine Story* alone survives from a series of four Medicine Stories on the theme of love magic that Bardon documented in October–December 1971. Bardon was greatly impressed by Tarawa's "use of ancient motifs of a convincing visual power" (Bardon and Bardon, page 300). Elemental traveling lines (brown parallel lines) connect up the "sit-down places" (concentric circles). Within the pictorial frame so formed against the black, in the privacy of a windbreak, two Old Men make love with two Moon Women. The U-shapes with a straight bar represent the sexually erect men, and the receptive U-shapes the women, in Moon Spirit form.

Geoffrey Bardon documented this painting with an original field note and drawing of the time. In his notes and certificate for this painting published in the 1999 sale catalogue, Bardon writes:

> The artist was a master of simple imagery that possessed great and ancient visual power. His motifs were derived from authentic perceptions of the desert world. This Moon Love Dreaming of Man and Woman, the woman representing the Moon Spirit, became an early theme as a medicine story beginning in mid–1971. The dominating configuration of repeated simple alternations, bottom to top, top to bottom, with the male "U" form includes a straight motif for an erect penis in sexuality. By simple imagery two Old Men after a long journey are copulating with women indicated by "U" shapes or the moon motif itself. The concentric circles represent sit down places in the journey adventure of these Old Men. They have been looking "everywhere for women" partners. The parallel straight lines that link the concentric circles or sit down places are journey lines. Windbreaks are implied for a camp. The parallel horizontal bars are stylised boomerangs, or music sticks or body paint motif for a ceremonial occasion. Visual form in desert mythology represents, man as the sun, and woman as the moon.

> The painting is a song and dance confrontation in sexuality. It is a brilliant design simplification of profound love rituals. This double version is distinguishable from an earlier single version of 1971 and subsequent 1975 version at the Art Gallery New South Wales. The design uses no secret/sacred ceremonial objects. It is a Pintupi image unique to this artist of love making in privacy behind windbreaks.

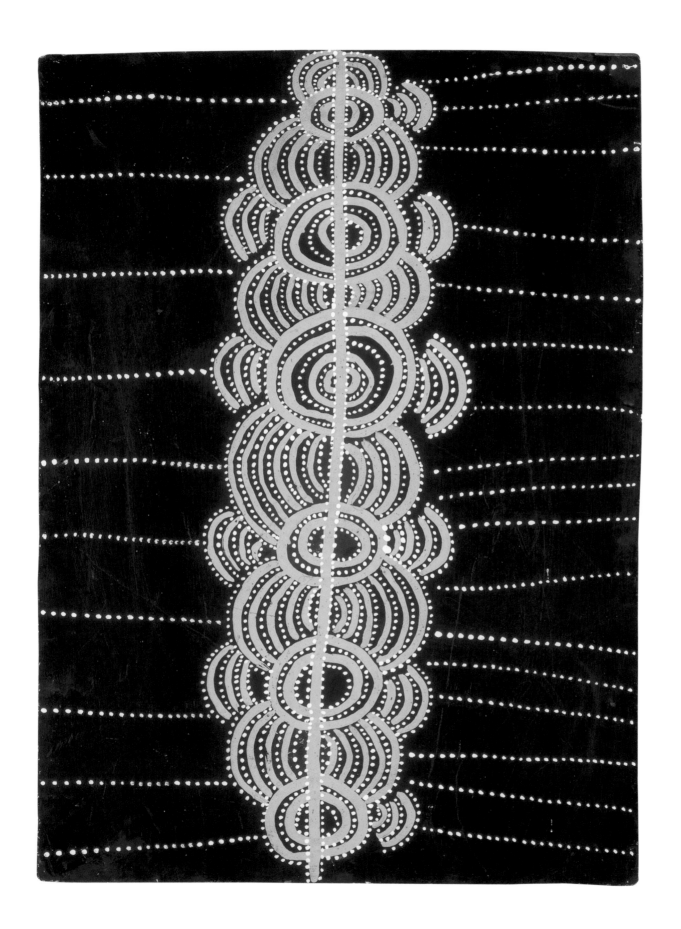

11.

Yam Traveling in the Sandhills (Version 2) [formerly *Bush Tucker Story*], late 1971
Mick Namararri Tjapaltjarri
(ca. 1926–1998)
Pintupi
Synthetic polymer/powder paint on composition board
20 1/4 x 14 1/8 inches (51.44 x 35.88 cm)

PROVENANCE
Stuart Art Centre, Alice Springs, consignment 10, painting 17 (#10017)
Private collection
Sotheby's, *Fine Aboriginal and Contemporary Art,* Melbourne, June 17, 1996, lot 38
Collection of John and Barbara Wilkerson, New York

BIBLIOGRAPHY
Sotheby's, *Fine Aboriginal and Contemporary Art,* Melbourne, June 17, 1996: page 19
Bardon and Bardon, 2004: page 232, painting 146

There is an agreeable spareness and simplicity about this work. With his minimal tracks of white dots, Namararri is able to activate the entire rectangle of the board, despite the visual focus being the bold red-ochre sandhill motif. Within a year, Mick Namararri had developed this elemental design into a magnificent richness of overlapping arcs forming arabesques and fish-scale patterns, rendered in minute white dots over a salmon ground (see "Bush Tucker Story," *Genesis and Genius*, page 38).

Although there is no original documentation for this painting other than the consignment number on the reverse, Bardon has written well about the image and another version of *Yam Traveling in the Sandhills*. Bardon writes (page 232):

> The sand pattern is the feature for the Yam Dreaming story. Wind-blown desert sands form corrugations and move imperceptibly across the landscape over time. . . . Dominated by a strong straight travelling line linking concentric circles as significant places, this design uses a simple arced ornamentation for the sandhill landscape; bush tucker is implied. Version 1 . . . is a more elaborate rendering of the motif with decoratively ornamented variations of sand forms.

In his diagram Bardon identifies the floating U-shapes on the edges of the closed-up sandhill motif as "women and children in bush tucker sandhill country." He considers the white dotted lines on the sides as a "pattern for earth."

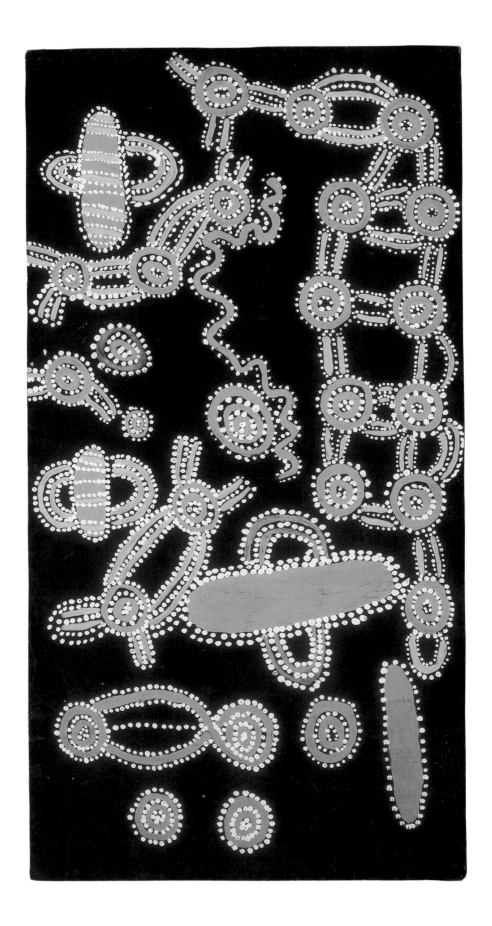

12.

Untitled, ca. November–December 1971

George Tjangala

(ca. 1925–1989)

Pintupi

Synthetic polymer paint on composition board

35 13/16 x 18 inches (90.96 x 45.72 cm)

PROVENANCE

Stuart Art Centre, Alice Springs, consignment 9, painting 38 (#9038)

Lauraine Diggins Fine Art, Melbourne

Private collection, Michigan

Sotheby's, *Important Aboriginal Art*, Melbourne, June 29, 1998, lot 102

Collection of John and Barbara Wilkerson, New York

BIBLIOGRAPHY

A Myriad of Dreaming: Twentieth Century Aboriginal Art, ed. Diggins, 1989: cat. 50, page 53 (ill.)

Sotheby's, *Important Aboriginal Art*, Melbourne, June 29, 1998: page 62

Cf. Bardon and Bardon, 2004: page 383

EXHIBITED

A Myriad of Dreaming, Twentieth Century Aboriginal Art, Lauraine Diggins Fine Art, Westpac Gallery, Melbourne

October 4–22, 1989 (cat. 50, page 53 [ill.])

This modest painting depicts a ceremony unfolding with a vital sense of social energy. The rare yellow paint, the ochre, and white stand out vividly against the black. The many U-shapes depict people, the ovals *coolamons* (food-carrying dishes) and the many roundels campfires or sacred sites. A grid of roundels connected by traveling lines at the top suggest a different dimension: that of long journeys.

The work is highly comparable in style and subject with the only other early George Tjangala known, *Men and Women at Snake Ceremony*, which Bardon documented at the time and has dated November–December 1971. They were numbers 28 and 38 in the same market consignment. Bardon commented (page 383): "George Tjangala at first took only casual interest in the painting movement as he was a young man with other pursuits at the time. Only one of many enthusiasts, he did not become a full working member of the painting group."

The 1998 sale catalogue reads:

> Of the six hundred and twenty recorded works produced at Papunya in Geoff Bardon's time there are only two works listed as being painted by George Tjangala. Both of these works are recorded in Pat Hogan's consignment notes to the Stuart Art Centre in consignment no. 9, indicating that this painting is either the first or the second work produced by the artist for the painting company. According to Papunya Tula artists records, George Tjangala did not return to paint for the company until 1976.

FIGURE 3.
Diagram, possibly by Geoffrey Bardon, collection of John and Barbara Wilkerson

13.

Old Man's Ceremony, late 1971–early 1972

Freddy West Tjakamarra

(ca. 1932–1994)

Pintupi

Synthetic polymer/powder paint on composition board

35 7/8 x 29 3/4 max. inches (91.12 x 75.57 max. cm)

PROVENANCE

Stuart Art Centre, Alice Springs, consignment 9, painting 42 (#9042)

Acquired by a private collector at the Stuart Art Centre, 1972

Sotheby's, *Important Aboriginal Art*, Melbourne, June 29, 1998, lot 15

Collection of John and Barbara Wilkerson, New York

BIBLIOGRAPHY

Sotheby's, *Important Aboriginal Art*, Melbourne, June 29, 1998: page 18

Bardon and Bardon, 2004: page 414, painting 378

There are some signs that this starkly impressive *Old Man's Ceremony* is incomplete, especially if one looks at the large ceremony board (or ground mosaic?) on the left. This displays fragmentary geometrical patterns of a kind seen on incised shields from the far west, and popular in Papunya Tula painting today as a visual metaphor for Tingarri rituals. Fragmentation and an uneven way of connecting sites—through water signs that meander strangely and occasional straight traveling lines—give a random character to the composition.

The diagram, almost certainly drawn by Geoffrey Bardon (fig. 3), indicates two Water Dreaming elements: the undulating sign for "running water" connecting the roundels at the far left edge, and a "water sign" on the red *tjurunga* depicted at the top right. Two "corroboree men"[1] are indicated by the U-shapes adjacent to roundels on this board and the large ceremonial object on the left.

Bardon writes (page 414): "Using spirals for journeying and a geometry of roundel and angular patterning, the artist depicts ceremonial objects for an Old Man's ceremony in an irregular design order."

[1] "Corroboree" is the term often used in nineteenth- and twentieth-century Australia for public indigenous ceremonies, seldom used today.

FIGURE 4.
Diagram by Geoffrey Bardon, collection of John and Barbara Wilkerson

14.

Bush Tucker Story, 1971–72

Anatjari (Yanyatjarri) Tjakamarra

(ca. 1938–1992)

Pintupi

Synthetic polymer/powder paint on composition board

28 max. x 11 5/8 inches (71.12 max. x 29.53 cm)

PROVENANCE

Acquired by a resident worker in Papunya in 1971–72 directly from Geoffrey Bardon

Sotheby's, *Important Aboriginal Art*, Melbourne, June 30, 1997, lot 72a

Collection of John and Barbara Wilkerson, New York

BIBLIOGRAPHY

Sotheby's, *Important Aboriginal Art*, Melbourne, June 30, 1997: page 54

A rigorous use of space controls this complex Pintupi work. In it some eight compartments are separated by arrays of *tjurungas*, or bullroarers, that indicate the ceremonial context. Many of the early boards are "bush tucker" stories like this: that is, they deal with plants and animals which have both a totemic status, and are used as food sources. In this case the seed-bearing "kulberri" plant dominates the work: it is present as a plant with green leaves, as black seeds that are the food source, and as damper, simple loaves that result from the seed being crushed and cooked. As such, Anatjari Tjakamarra's board is an image of plenty, of bush tucker increase produced by ceremony properly enacted.

Geoffrey Bardon produced an unusually detailed drawing of *Bush Tucker Story* on an A4 page (fig. 4). He identifies the oval shapes along the central and crossing axis of the painting as "tjuringas," the bottom left diamond shape as a "corroboree hat," and some of the surrounding oval forms painted with red and yellow lines and a grid as "waterholes." The black on white dotting in the background represents "black seeds" with the hatching around the edges and along the main axis representing "Kulberri"—described in the diagram as "green leaf with black seed" [this plant has not been further identified]. The four grouped ovoid forms on the top left, and three at the top right are designated as "damper from bush tucker."

For reasons of its secret/sacred imagery, this image
is reproduced in the supplement only

FIGURE 5.
Papunya Tula Art certificate, collection of John and Barbara Wilkerson

15.

Possum Dreaming [formerly *Totemic Possum Dreaming*], here dated early 1972

Billy Stockman Tjapaltjarri

(born ca. 1927)

Anmatyerre

Synthetic polymer/powder paint on composition board

36 max. x 25 1/4 inches (91.44 max. x 64.14 cm)

PROVENANCE

Papunya Tula Art, Alice Springs, consignment 17, painting 33 (#17033—stamp at top of certificate)

Purchased from Argyle Arts Centre, Sydney, 1974

Private collection, Sydney

Deutscher-Menzies, *19th and 20th Century Australian Painting, Sculpture and Works on Paper,* Melbourne, April 20, 1998, lot 4

Collection of John and Barbara Wilkerson, New York

BIBLIOGRAPHY

Deutscher-Menzies, *19th and 20th Century Australian Painting, Sculpture and Works on Paper,* Melbourne, April 20, 1998: page 18

Bardon and Bardon, 2004: page 222, painting 132

EXHIBITED

Aboriginal Art from Papunya Central Australia, Argyle Arts Centre, Sydney

May 23–June 16, 1974 (cat. 1 of 12, code no. 17033, price $100)

On stylistic, technical and documentary grounds, I believe the date of 1973 given to this painting by Fannin (1974 certificate), Deutscher-Menzies (1998 catalogue), and Bardon (2004 book) is in error. By 1973 no experienced Papunya painter was painting decorated *tjurungas* with the frank display seen here. Neither were the backgrounds behind ceremonial objects being left stark, blank and undotted. I believe *Possum Dreaming* belongs with works like Anatjari Tjakamarra's *Bush Tucker Dreaming* of 1971–72 and above all works from Consignment 17 like Uta Uta Tjangala's *Ceremonial Story* (#17041, see cat. 23), and Old Walter Tjampitjinpa's directly comparable *Snake and Bush Tucker* (Sotheby's, July 9, 2001, lot 93, #17036). Both Fannin and Bardon seemed to have missed that the 1974 certificate has a sketch in Pat Hogan's hand, and that it is stamped #17033 (that is, to consignment 17, which contained works from early-mid–1972), a number repeated in the catalogue of the Argyle Art Centre.

The June 1974 certificate from Papunya Tula Art, signed by Peter Fannin (fig. 5), has a glued-in diagram of the painting in Hogan's hand and a statement of significance in Fannin's hand reading: "This painting tells the story of the Totemic Possum Dreaming in Billy Stockman Tjapaltjarri's home country south of Papunya." Hogan's diagram indicates the little black "Possum Tracks" with their tiny digits, and the four great "Churungas" that dominate the composition. The roundel at the confluence of vertical and lateral traveling lines is "Home of the Possum Men," while the major yellow, black, and red traveling line is the "Tail Track of the Possum."

Geoff Bardon composed the following elegant reading of the picture:

> The artist here tells a possum traveling story. The central undulating line is the traveling itself, in sandhill country; the concentric circles are possum tree homes with possum tracks completing a myth of a mischievous Possum Spirit Being looking for bush tucker. The ceremonial objects carry markings for a ritual.

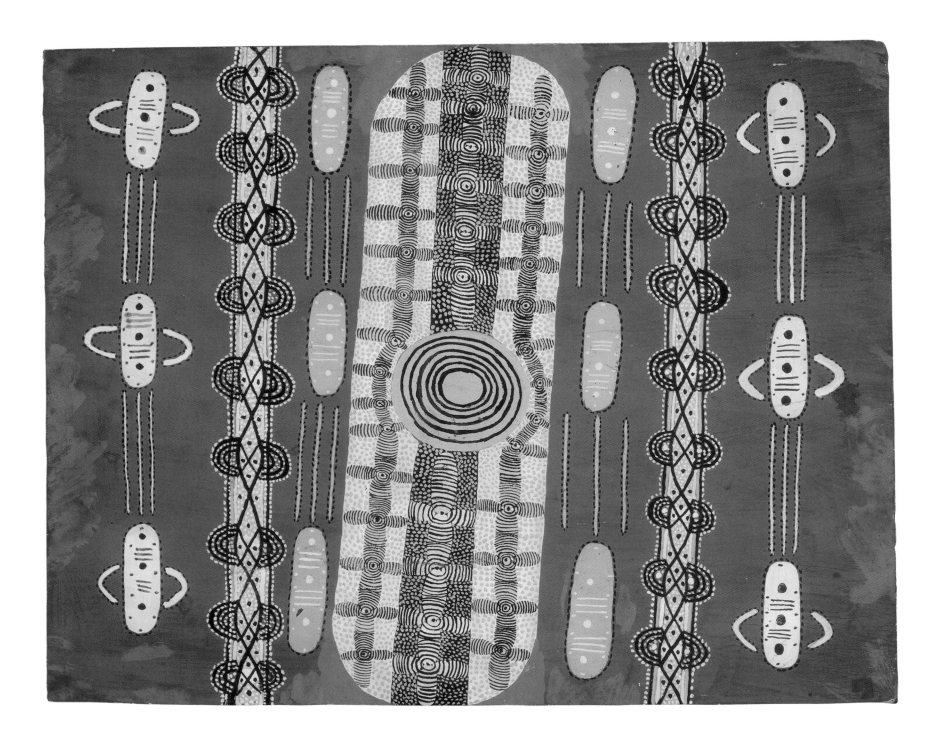

16.

The Honey Ant Story, February 1972

Tim Leura Tjapaltjarri

(ca. 1934–1984)

Anmatyerre

Synthetic polymer/powder paint on composition board

30 3/8 x 23 3/4 inches (77.15 x 60.33 cm)

PROVENANCE

Stuart Art Center, Alice Springs, consignment 6, painting 6 (#6006)

Private collection, Northern Territory

Deutscher-Menzies, *19th and 20th Century Australian Painting, Sculpture and Works on Paper,* Melbourne, April 20, 1998, lot 1

Collection of John and Barbara Wilkerson, New York

BIBLIOGRAPHY

Deutscher-Menzies, *19th and 20th Century Australian Painting, Sculpture and Works on Paper,* Melbourne, April 20, 1998: page 15

Bardon and Bardon, 2004: page 334, painting 276; also pages 331–37

The Honey Ant Dreaming is the central story for the locale of Papunya, and thus had been selected as the motif for the mural painted on the Papunya School at the outset of the art movement in mid–1971. In his magisterial study, Geoffrey Bardon places the above work first in a series of eight versions of the Honey Ant Dreaming painted by Tim Leura between February and April 1972. He classifies them under "Bush Tucker stories," as the honey ant is a great delicacy to desert peoples. In its nests a meter or two underground, sweet nectar gathered by worker ants is transferred to the grape-sized, golden abdomens of the storage ants, which are collected by women. Bardon implies the ant symbolizes the activity of certain ancestors (page 332): "The honey ant still does what the Ancestor Beings did in the Dreamtime: it comes out of the ground, makes a journey and returns to the ground."

In each of Tim Leura's eight strictly symmetrical works, a great oval motif representative of the honey ant nest is bounded by the accoutrements of ceremony. In the exhibited version the nest has the shape of a giant shield dotted with an ant pattern, hemmed in on each side by two arrays of spears and shields decorated with honey ant designs. According to Bardon, ceremonial men dancing the Honey Ant Dreaming are visible in the "two opposed filigree-patterned verticals, with many men, [which] represent a very high point in the honey ant dancing ceremonies."

An earlier date of 1971 and a quite different reading of the picture was given by Pat Hogan, former director of the Stuart Art Centre, in a letter of 1991 to Vivien Anderson (Deutscher-Menzies, lot 1): "Depicted are Tjuringas, the central roundel represents the caves where the artist and his people stored their Tjuringas, a place called 'Luga'. However 'Luga' was destroyed by fire and they moved the Tjuringas to 'Popinjaye,' North West of Haast's Bluff. The Tjuringas are placed in the caves at 'Popinjaye' for safe keeping, all ceremonies take place in the proximity of those caves. The Honey Ant creation myth shown here tells of the original ancestors who came up onto the earth as Honey Ants and later turned into men."

STUART ART CENTRE
BOX 870, ALICE SPRINGS, N.T. 5750

It is important that this label should never be destroyed. The evidence it bears of the registered stock number may, in future, prove to be of very great value for purposes of identification and authenticity.

ARTIST ___Timmy Leura___

TITLE ___A Joke___

Registered Number	Size	Price
8005	36" x 18"	

Myths, legends, stories, conversations, invocations, medical lore, jokes, have all emerged from these peoples who, until now, with their very limited English vocabulary, lacked the means of communicating with us to any great depth.

Footsteps. Churungas Headband.

Masks Masks. Rubberband.

Footsteps.

One fella A. is laughing at fella B. for starting Party too soon. THIRD fella (tracks around centre) is still away catching the kangaroo.

For reasons of its secret/sacred imagery, this image is reproduced in the supplement only

FIGURE 6.
Stuart Art Centre card, collection of John and Barbara Wilkerson

17.

A Joke Story [formerly *A Joke*], early 1972

Tim Leura Tjapaltjarri

(ca. 1936–1984)

Anmatyerre

Synthetic polymer paint on composition board

18 1/8 x 35 7/8 inches (46.04 x 91.12 cm)

PROVENANCE

Stuart Art Center, Alice Springs, consignment 8, painting 5 (#8005)

Acquired by a Canadian doctor who worked at Papunya in 1972

Private collection, Vancouver

Sotheby's, *Aboriginal Art,* Melbourne, July 9, 2001, lot 87

Collection of John and Barbara Wilkerson, New York

BIBLIOGRAPHY

Sotheby's, *Aboriginal Art,* Melbourne, July 9, 2001: page 86

Bardon and Bardon, 2004: page 284, painting 224

This is a fine example of the "School of Kaapa" style painting in which the Anmatyerre Arrernte artist has made a literal and perspectival depiction of a ceremony, supplemented by numerous ceremonial objects seen in plan against a background of blackboard paint. It was a style that was discontinued after Elders demanded restraint in the depiction of sacred or ceremonial material from mid–1972.

The early diagrams do little to explain the meaning of the mythic "joke" of the title. Tim Leura's work contains two of the most beautifully drawn figures of men in the whole Papunya repertoire. The upright ceremony man on the left seems just to have arrived at the sand mosaic site after hunting kangaroo, and is still holding his spear and gesturing as if in speech to his colleague. This other, already seated cross-legged on the ground, is painted up with exactly the same designs and is gesturing to the other with his spear-thrower as if in reproof or self-defense. *Tjurungas*, ceremonial masks, corroboree headbands, and ceremony poles are all depicted.

Two diagrams of this work survive, one a field note by Geoffrey Bardon done at Papunya (Bardon and Bardon, 2004: page 284) and a later one by Pat Hogan in Alice Springs (Stuart Art Centre label, fig. 6). The latter has a text that reads: "One fella A is laughing at fella B for starting party too soon. Third fella (tracks around centre) is still away catching the kangaroo."

For reasons of its secret/sacred imagery, this image is reproduced in the supplement only

FIGURE 7.
Diagram by Geoffrey Bardon (recto and verso), collection of John and Barbara Wilkerson

18.

Emu Corroboree Man, February 1972

Clifford Possum Tjapaltjarri

(ca. 1932–2002)

Anmatyerre

Synthetic polymer paint on composition board

18 1/16 x 24 1/8 inches (45.88 x 61.28 cm)

PROVENANCE

Purchased by Larry May from Geoffrey Bardon at Papunya, May–June 1972

Larry and Susan May, Arizona

Sotheby's, *Aboriginal Art*, Melbourne, July 25, 2005, lot 72

Collection of John and Barbara Wilkerson, New York

BIBLIOGRAPHY

Bardon, *Papunya Tula: Art of the Western Desert*, 1991: page 113

Johnson, *The Art of Clifford Possum Tjapaltjarri*, 1994: page 34

Johnson, *Clifford Possum Tjapaltjarri*, 2004: pages 60 and 218–19

Sotheby's, *Aboriginal Art*, Melbourne, July 25, 2005: pages 60–61

Maslen, "Dot painting sets a record," *Sydney Morning Herald*, July 26, 2005: page 3

Maslen, "Lost: bid to keep key work at home," *Sydney Morning Herald*, July 27, 2005: page 14

Strickland, Katrina, "Clifford Possum buyer uncovered," *The Australian*, July 27, 2005: page 3

Hossack, Rebecca, "Collectors' Focus," *Apollo*, vol. CLXII, no. 524, October 2005: pages 86–87

Genocchio, Benjamin, *Dollar Dreaming: Inside the Aboriginal Art World* (Melbourne: Hardie Grant), 2008: pages 15–16, 21–26, page 23

Emu Corroboree Man is of historic importance as it is the first painting that Clifford Possum Tjapaltjarri, the most celebrated of all Papunya painters, made for Geoffrey Bardon. Set aside by Bardon, who was anxious about its sensitive imagery, the board was purchased from him by a visiting American naturalist, Larry May, who recounted these events much later (Johnson 2004, page 219). Bardon recalled of Clifford Possum (1991, page 113): "His first painting, an Emu Dreaming with a realistic corroboree man dancing as the center piece, was quite spectacular. The painting showed superlative skill and some European influences in the realism of the man and the emus."

Emu Corroboree Man is indeed extraordinarily interesting to look at. It exemplifies the "School of Kaapa" style in which Anmatyerre painters represented the ceremonial activity (or "corroborees," as they used to be called) in a few dozen works between 1971 and mid–1972. At the center of a heraldic design laid out in strict symmetry is the decorated Emu Man himself, with his ankle raised to imply movement. The sign for the Emu Dreaming—a row of lozenge shapes separated by dotted roundels—appears on the dozen ceremonial boards arrayed about him. Around the edges of boards and painting grounds, the footprints of the Emu appear. Bardon's original diagram (fig. 7) specifies the roundels at left and right as "special Emu good places—Ngalicolong," and indicates the smaller objects on the margins as bullroarers, and those with tassels at the bottom as "special corroboree strings [worn] round waist."

The dynamism of *Emu Corroboree Man* results from a clash of two optics. The first is the perspectival view created by the silhouettes of the dancer, his ceremonial apparatus and the two flanking emus (each with its little ringed ground and vertical of the ceremony pole). The drawing of the dancer's body is subtle enough to include the fingertips of each hand grasping the short board from below. He has sparing body-paint and a "nose-peg." The tall conical headdress is of a kind visible in old photographs of ceremony. Constructed of mud and vegetable materials, it has a fringe of emu tail-feathers as a top tassel. The ceremony boards that accompany this figure can be read at least two ways: as a kind of magical environment in a space that is pictorial only, or as seen from above, with the boards laid on the sand of the ceremony-ground.

Bardon was the first to point out the relation between Clifford Possum's "realistic" emus and the appearance of the great bird on the Australian coat of arms, as seen here on an Australian one dollar note from 1969 (fig. 8).

FIGURE 8.

FIGURE 9.
Diagram by Geoffrey Bardon, collection of John and Barbara Wilkerson

19.

Budgerigar Dreaming (Version 1) [formerly *Budgerigar Dreaming*], early 1972

Kaapa Mbitjana Tjampitjinpa

(ca. 1920–1989)

Anmatyerre/Arrernte

Synthetic polymer/powder paint on composition board

18 3/8 x 12 1/2 inches (46.67 x 31.75 cm)

PROVENANCE

Acquired from the artist by Geoffrey Bardon at Papunya

Private collection, New South Wales

Deutscher-Menzies, *19th and 20th Century Australian and International Painting, Sculpture and Works on Paper,* Melbourne, August 10, 1998, lot 14

Collection of John and Barbara Wilkerson, New York

BIBLIOGRAPHY

Deutscher-Menzies, *19th and 20th Century Australian and International Painting, Sculpture and Works on Paper,* Melbourne, August 10, 1998: page 25

Bardon and Bardon, 2004: page 278, painting 211; also pages 64–65

This work is considered by Geoffrey Bardon as the first in a ten-work series on the Budgerigar Spirit Dreaming painted in early 1972 at Papunya by the preeminent artist Kaapa Mbitjana Tjampitjinpa. The story of this bird, "the symbol of wisdom and knowledge," was "ritualistically introduced to young Aboriginal people in early teaching-ceremonies" (Bardon and Bardon, page 277). Bardon considered the series as belonging to the set of Children's Stories which he commissioned from Papunya artists from mid–1971 into 1972, as part of his own work as a teacher and to elicit exceptionally clear stories of a public character. However over half of Kaapa's Budgerigar Dreaming works are of secret/sacred character because they display ceremonial hats like the Wilkerson version. Bardon called the series "the most accomplished painting record in existence of the perceived sacredness of ceremony itself," and noted Kaapa's "heedlessness, prepared as he was to show the forms, however dangerous to himself in a tribal context" (page 65).

Bardon owned this painting, made an early detailed diagram of it in 1972 (fig. 9), and for the 1998 sale catalogue wrote the following:

> There are significant variations in the depiction and conceptualisation of the Budgerigar Dreaming ritual. The design of this work continues an extraordinary painting record by this artist of the stages of initiation from youth to manhood in Amatjira Aranda tribal tradition. The Budgerigar theme was and is an instructional opportunity specifically connected to a boy's initiation. The senior men identify the Budgerigar, a tiny green bird that will arrive in vast numbers after the desert rains to feed on the new grass and refilled waterholes. This design has a strict symmetry and uses an almost heraldic order of a diamond shaped ceremonial hat with attributions of ornamented ritual objects depicted in a strong double-cross configuration. The work shows a technical skill and design mastery consistent with this artist's traditional Amatjira Aranda symmetry. It sets forth a ritual event at a particular place in the homeland regions of the family and language group (north of the MacDonnell Ranges, Central Australia). The identical corner motifs are variations on body painting, representing blood from the initiation ritual. The radiating budgerigar "spirit" bird tracks dominate both central areas of the design. The concentric circles are ground drawings and the two strong yellow diamond motifs are of considerable ritual importance. The opposing black arced forms elegantly delineated by a white border represent an unknown ceremonial feature.

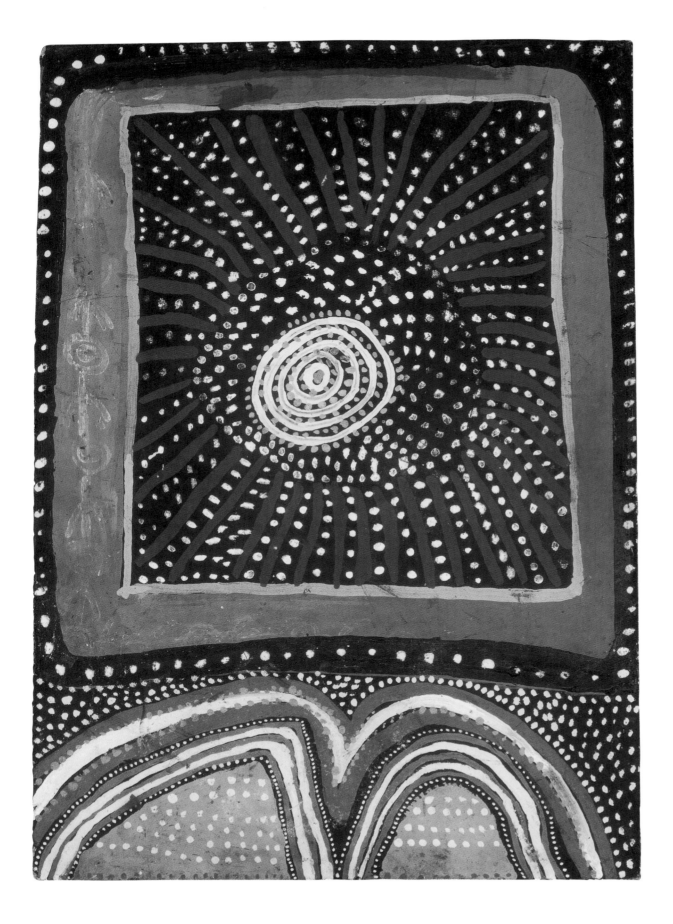

20.

Cave Story, early 1972

Yumpuluru Tjungurrayi

(ca. 1930–1998)

Pintupi

Synthetic polymer/powder paint on composition board

18 x 12 1/4 inches (45.72 x 31.12 cm)

PROVENANCE

Stuart Art Centre, Alice Springs, consignment 19, painting 61 (#19061)

Tim Guthrie Collection, Melbourne

Sotheby's, *Important Aboriginal Art*, Melbourne, June 30, 1997, lot 14

Collection of John and Barbara Wilkerson, New York

BIBLIOGRAPHY

Sotheby's, *Important Aboriginal Art*, Melbourne, June 30, 1997: page 15

Perkins and Fink, *Genesis and Genius*, 2000: pages 34 (ill.) and 289

Bardon and Bardon, 2004: page 449, painting 419

Johnson, *Out of the Desert*, 2007: page 142

Johnson, *Lives*, 2008: pages 152–55

EXHIBITED

Papunya Tula: Genesis and Genius, Art Gallery of New South Wales, Sydney

August 18–November 12, 2000

Yumpuluru Tjungurrayi's *Cave Story,* associated with the Tingarri initiation rituals, is a powerful work in which simple shapes take on emphatic force through the dramatic use of color. The resounding orange square bounds a sacred sink-hole indicated by a whirlpool of red stripes laid over black. This square balances on two half-circles that indicate the geology of the cave below. A longtime Papunya resident, Tjungurrayi seldom engaged in painting, making just "a few small boards in the 1970s, often distinctive for their quirky designs," before becoming a frequent painter after 1980 (Johnson 2007, page 142).

The 1997 sale catalogue indicates "this painting is the first recorded work by the artist and the only work by the artist in the Stuart Art Centre Records." In his notes for that catalogue Dick Kimber writes: "The cave is likely to be an extremely sacred-secret, men-only site situated in the midst of sandhill country westerly from Lake MacDonald (WA). The site is almost certainly an unusual sink-hole feature and is a Tingari site of immense significance to all Pintupi people. Women and children are not permitted to approach even the vicinity of the site, let alone see it, and it is considered so powerful in living mythological essence that only initiated men can survive the power of the locality. . . . Yumpululu was recognised as having a special senior role in custodianship of the site."

Geoffrey Bardon, drawing on his notes of the time, writes (page 449): "The rectangular area and its interior patterns represent a rockhole and draining water mark across the sand. The two half-circles are the external shape and stratum of the desert cave itself in a bird's-eye perspective understanding of the surface of the landscape, the dotting representing the sand and earth. The design shows a unique visualization of the perceived world of the desert."

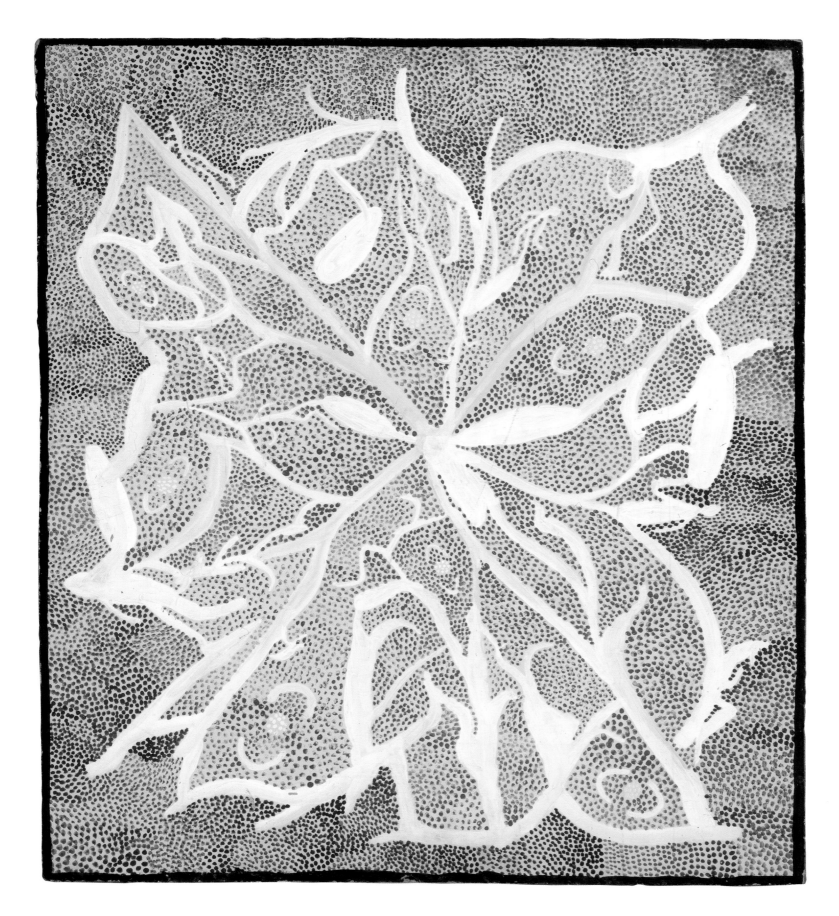

21.

Yam Spirit Dreaming, March 1972

Tim Leura Tjapaltjarri

(ca. 1934–1984)

Anmatyerre

Synthetic polymer paint on composition board

26 3/4 x 23 3/16 inches (67.95 x 58.9 cm)

PROVENANCE

Unknown private collection

Corbally Stourton Fine Art, London

Collection of John and Barbara Wilkerson, New York

BIBLIOGRAPHY

Cf. Bardon, *Papunya Tula: Art of the Western Desert*, 1991: pages 120, 138–39

Corbally Stourton, Patrick, *Songlines and Dreamings: Contemporary Australian Aboriginal Painting* (London: Lund Humphries), 1996: page 139

Bardon and Bardon, 2004: page 322, painting 262; also page 321

Bardon places this version of the Yam Spirit Dreaming third in a series of six, and it is the first in which Tim Leura Tjapaltjarri makes a unique invention: he attaches human and animal figures to the root and tuber system of the yam. As with the Mandrake root in Asian traditions, Leura anthropomorphizes the tuber and acknowledges its special powers. The Yam is also a "bush tucker" story par excellence: it represents one of the great staple food sources of the desert. It thus symbolizes the daily round by women using their yam-sticks and judgment of the condition of the ground to find and dig up the deeply buried tubers.

At least ten stick men and women are visible here, while the "definitive" version (painted three months later) includes dingos, a crow, children, women carrying *coolamons*, and warriors with spears and shields. In this version the artist distinguishes the Yam spirits (human figures attached to the root system) from the Yam Ceremonial Men (pairs of U-shapes seated around a fire). The radiating form of the yam's root and tuber system dominates the design, rendered in chalky white against the sand-colored, dotted background. Branches and leaves of the low-lying shrub above ground are also implied by Leura's mercurial brushstrokes.

"The consistent features of the yam image by this artist are elongated spirit images of noble warriors, women foraging, birds and animals, elegantly formulated with soft and delicate brush strokes in a very personal style and using an emphatic whiteness as the artist's response to the Yam Spirit. Leura had custody of this story from his father, Old Barney Turner Tjungurrayi of the Napperby homelands north of the MacDonnell Ranges" (Bardon and Bardon, page 321).

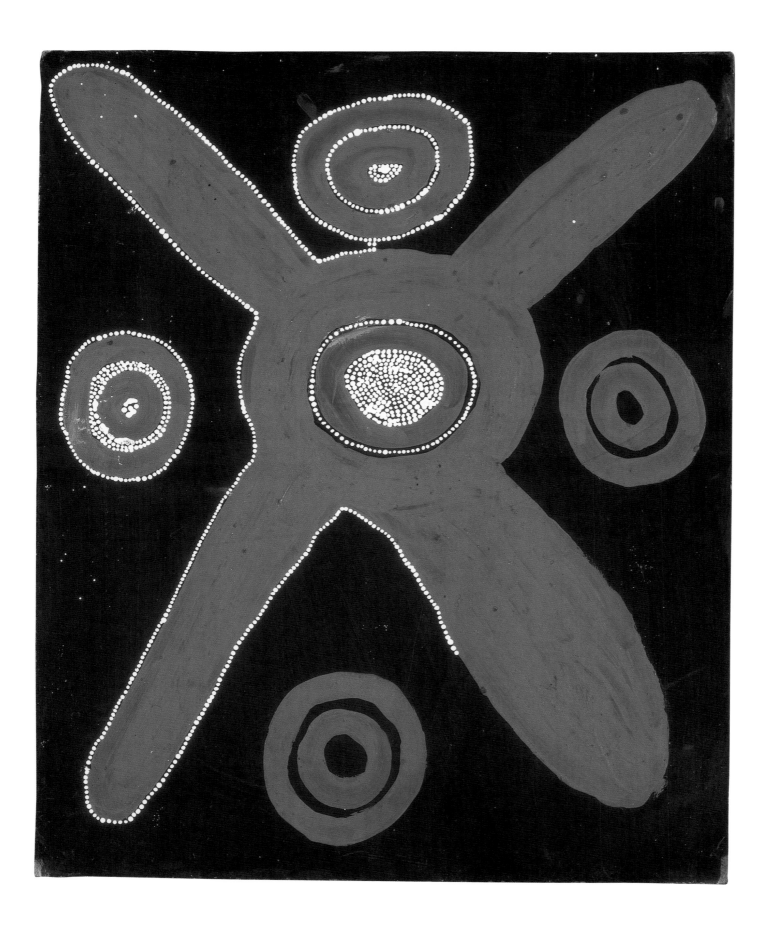

22.

Pintupi Medicine Dreaming [formerly *Medicine Story*], 1972
Tommy Lowry (Tommy Tichiwan No. 4) Tjapaltjarri
(ca. 1940–1987)
Pintupi
Synthetic polymer paint on composition board
19 15/16 x 16 1/16 inches (50.64 x 40.8 cm)

PROVENANCE
Stuart Art Centre, consignment 19, painting 59 (#19059)
Tim Guthrie Collection, Melbourne
Sotheby's, *Important Aboriginal Art*, Melbourne, June 30, 1997, lot 33
Collection of John and Barbara Wilkerson, New York

BIBLIOGRAPHY
Sotheby's, *Important Aboriginal Art*, Melbourne, June 30, 1997: page 34
Bardon and Bardon, 2004: page 302, painting 244

The certificate from the Stuart Art Centre in Pat Hogan's hand has a diagram (fig. 10) that identifies the central cross formation to be a "penis" and the surrounding concentric circles as "woman." The note in Hogan's hand states: "At a certain stage of the initiation ceremony, visiting men are allowed to lie with the women belonging to their hosts." However, Geoffrey Bardon's own account of this *Medicine Story* in his 2004 study is more circumspect. He writes: "Radiating arms arranged around a central concentric circle enclose four other concentric circles which could be testicles or women. The design is unfinished; it has phallic overtones."

The advanced consignment number suggests the late 1972 date; however on stylistic grounds the work looks closer to the Medicine Stories in the group around late 1971– early 1972 by artists like Long Jack Tjakamarra and Uta Uta Tjangala. The "unfinished" character of the work is due to the fact that the dotted edging of these elemental motifs only appears on the left half of the work.

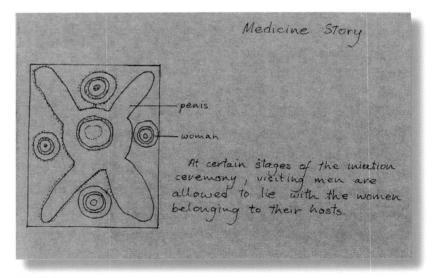

FIGURE 10.
Stuart Art Centre certificate, collection of John and Barbara Wilkerson

23.

Ceremonial Story [formerly *Untitled*], second quarter of 1972

Uta Uta Tjangala

(ca. 1926–1990)

Pintupi

Synthetic polymer paint on composition board

30 3/4 x 11 3/4 inches (78.11 x 29.85 cm)

PROVENANCE

Stuart Art Centre, Alice Springs, consignment 17, painting 41 (#17041)

Acquired by a Canadian doctor who worked at Papunya in 1972

Private collection, Vancouver

Sotheby's, *Aboriginal Art,* Melbourne, July 9, 2001, lot 91

Collection of John and Barbara Wilkerson, New York

BIBLIOGRAPHY

Sotheby's, *Aboriginal Art,* Melbourne, July 9, 2001: page 91

Cf. Perkins and Fink, *Genesis and Genius*, 2000: pages 27–9 for related works

Bardon and Bardon, 2004: page 412, painting 375

In a series of paintings treating ritual Dance Dreamings seemingly made in the first half of 1972, Uta Uta Tjangala preferred a format in which he accumulated connected rows of patterned objects. These might be *tjurungas*, panels of body paint, or ground drawings (Bardon and Bardon, paintings 341, 343, 373–75). *Ceremonial Story* is the most straightforward expression of this compositional idea, which is adapted to Uta Uta's long narrow panel. In it, six objects are connected by lucid strands of dotted stripes in black, red, or white. Three of the objects are left unmarked, while three bear design. The bounding objects at the top and bottom curve inward to enclose those in the interior, of a more classic *tjurunga* shape.

Although there is a diagram of this painting on the label from Stuart Art Centre, no items are identified. The note by Pat Hogan reads: "This story is not authenticated. I feel it tells of the death after being left in the bush of one of the elders of the water totem." Bardon writes (page 412): "This ceremonial story shows ceremonial objects and a consistently repeated striation of dotted lines that are sometimes used to depict body paint, particularly breast patterning on women or on the sand." In his 2004 analytic drawing, he names the design on the central *tjurunga* as a "sandhill pattern," while that on the second *tjurunga* from the bottom he gives as "snake travelling."

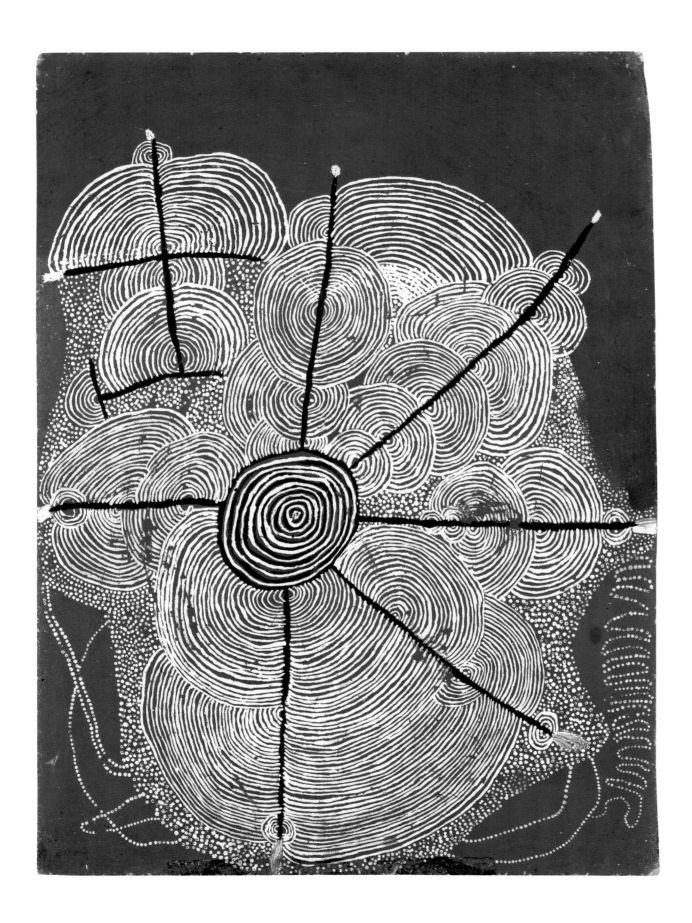

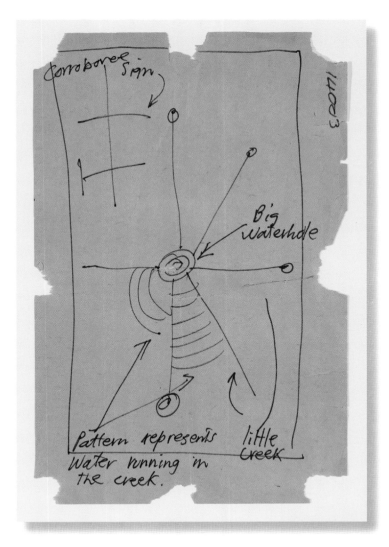

FIGURE 11.
Stuart Art Centre label, collection of John and Barbara Wilkerson

24.

Children's Water Dreaming (Version 2) [formerly *Water Story*], May–July 1972

Shorty Lungkarta Tjungurrayi

(1920–1987)

Pintupi

Synthetic polymer paint on composition board

24 1/4 x 17 1/2 max. inches (61.6 x 44.45 max. cm)

PROVENANCE

Stuart Art Centre, Alice Springs, consignment 14, painting 3 (#14003)

Tim Guthrie Collection, Melbourne

Private collection, Melbourne

Sotheby's, *Important Aboriginal Art*, Melbourne, June 29, 1998, lot 46

Collection of John and Barbara Wilkerson, New York

BIBLIOGRAPHY

Sotheby's, *Important Aboriginal Art*, Melbourne, June 29, 1998: page 37

Perkins and Fink, *Genesis and Genius*, 2000: pages 46 (ill.) and 285

Bardon and Bardon, 2004: page 487, painting 469

EXHIBITED

Papunya Tula: Genesis and Genius, Art Gallery of New South Wales, Sydney

August 18–November 12, 2000

In this delicate composition, Shorty Lungkarta Tjungurrayi makes the first of several works that respond to the unusually wet winter of mid–1972. The diagram on the Stuart Art Centre label (which copies Bardon's original field note in a different hand, fig. 11) notes a "corroboree sign" in the cross at the upper left, a "big waterhole" at the center, a "little creek" for the black radial lines, and for the curved concentric lines of white paint, "pattern [that] represents water running in the creek." Most of the roundels, so fine they appear like filigree or cobweb, center on the black bars of the creeks; their pattern could be compared to the radiating waves when a stone is dropped in a waterhole.

In addition the 1998 catalogue notes: "The site depicted is most probably Lalpinga (Lampintjanya), the artist's birth place, for which he was custodian."

Bardon's comments on the first of two very similar versions of this image by Shorty Lungkarta are equally applicable to the second:

> The central motif of concentric circles is the main waterhole and the surrounding radiating patterns represent water running after rain. The straight lines Shorty insisted were part of the creek but were possibly ceremonial sticks. The work is a beautiful example of Pintupi simplicity. . . . The patterned whorls in rhythmic variations of size, direction and overlap seem an advanced development of the visual intensities used in Shorty Lungkarta's earlier *Goanna Love Story*; he later painted far more elaborate pictorial compositions using similar overlapping whorl patterns of immense intricacy in only two or three colours (paintings 400, 423, 424; Bardon and Bardon, page 486).

> [Of *Children's Water Dreaming (Version 2)*]: The spectral dotting at the bottom left of the design could suggest the children as part of the story. . . . Great visual strength is achieved by an elemental use of a red ochre with black and white patterned dotting.

> These works by Shorty Lungkarta were part of the programme direction that the men paint nonsecret material, the work of this time excluding ceremonial objects almost entirely but achieving an interesting visuality. Spatial constraints and the use of high quality art materials with confidence by the painters were very important (Bardon and Bardon, page 487).

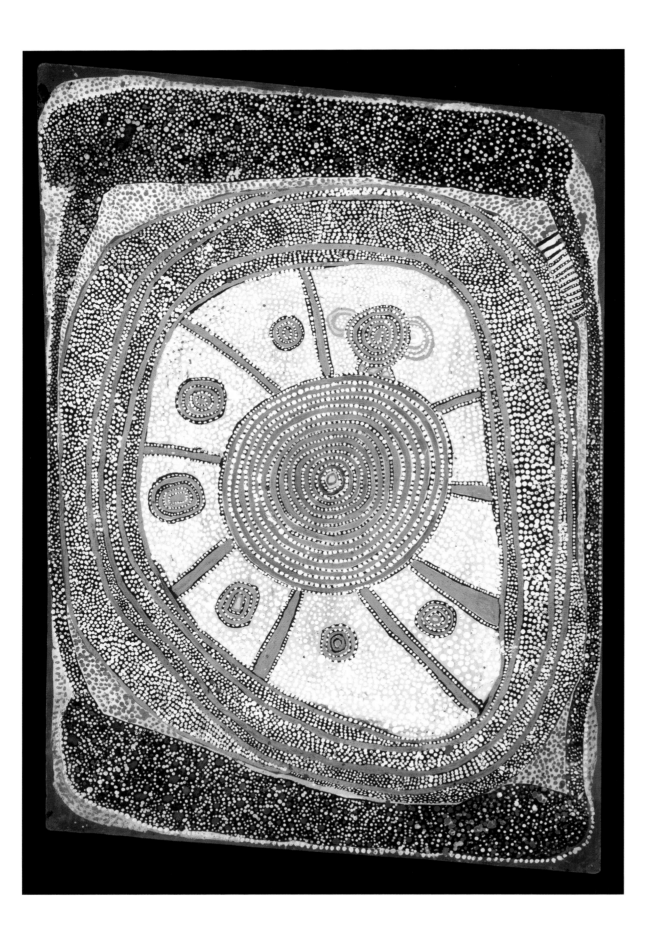

25.

Classic Pintupi Water Dreaming [formerly *Water Dreaming*], ca. August 1972

Shorty Lungkarta Tjungurrayi

(1920–1987)

Pintupi

Synthetic polymer/powder paint on composition board

24 1/2 max. x 16 3/8 inches (62.23 max. x 41.59 cm)

PROVENANCE

Stuart Art Centre, Alice Springs, consignment number 17, painting 9 (#17009)

Tim Guthrie Collection, Melbourne

Sotheby's, *Important Aboriginal Art*, Melbourne, June 30, 1997, lot 19

Collection of John and Barbara Wilkerson, New York

BIBLIOGRAPHY

Sotheby's, *Important Aboriginal Art*, Melbourne, June 30, 1997: page 21

Perkins and Fink, *Genesis and Genius*, 2000: pages 45 (ill.) and 285

Bardon and Bardon, 2004: page 200, painting 105

EXHIBITED

Papunya Tula: Genesis and Genius, Art Gallery of New South Wales, Sydney

August 18–November 12, 2000

This is one of three *Water Dreaming* paintings that were completed around August 1972, at a time of flooding rains in the Papunya area. The artist is visible working on his almost-complete *Water Dreaming* in two photographs of the painting room by Michael Jensen (fig. 12, see also pages 14–19). With his paintbrush, Shorty Lungkarta appears to be adding the final layer of red dots to the framing area in black, which represents the hills from which storm water runs off. The artist's use of a bright yellow acrylic paint gives this work a unique quality when combined with the fine white dotting that attenuates the underlay of black paint. While the great central motif is almost a perfect circle, the outer elements in this concentric design slowly conform, more and more, to the straight edges of the board, which is an unusual parallelogram in shape.

Documentation includes a certificate from the Stuart Art Centre, with a diagram and brief annotations by Pat Hogan. The 1997 sale catalogue records: "According to the original documentation the central roundel represents a waterhole, surrounded by soaks (represented by small sets of concentric circles) with little creeks flowing into it from a larger watercourse that surrounds. The darker forms at each end represent hills." Importantly, in his 2004 book Bardon identifies the special yellow roundel at the top right as Water Men sitting at a fire place (Bardon and Bardon, page 200).

"R. G. (Dick) Kimber has postulated that the site depicted is most probably Lampinja (Lampintjanya), the artist's birthplace, with the 'little creek' and 'big creek' routes being formed by the movements of ancestral snakes, and the hills (represented by the forms surrounding the central image) promoting rain storm run off into the claypan. The red overdotting in the dark areas at the top and bottom of the work may represent mungulpa seed, abundant after rains" (Sotheby's, page 21).

FIGURE 12.
Shorty Lungkarta Tjungurrayi, detail of group portrait, Men's Painting Room, Papunya, August 1972 (see pages 14–19)

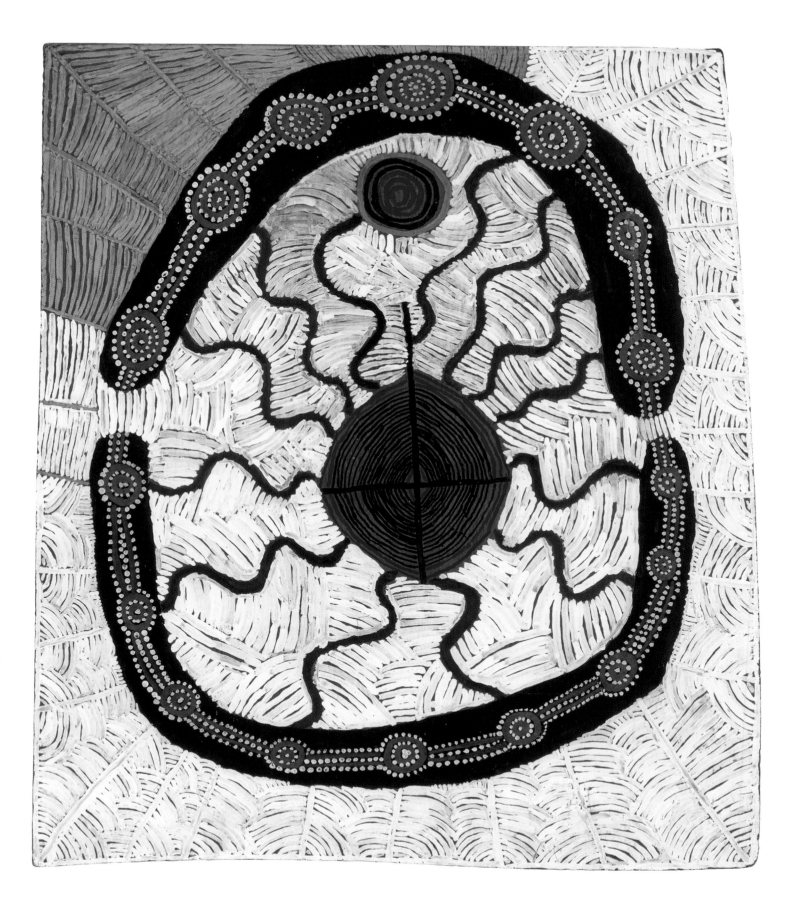

26.

Rainbow and Water Story, ca. August 1972

Old Walter Tjampitjinpa

(ca. 1912–1981)

Pintupi

Synthetic polymer paint on composition board

24 1/4 x 20 1/2 inches (61.6 x 52.07 cm)

PROVENANCE

Stuart Art Centre, Alice Springs, consignment 17, painting 35 (#17035)

Acquired by a Canadian doctor who worked at Papunya in 1972

Private collection, Vancouver

Sotheby's, *Aboriginal Art,* Melbourne, July 9, 2001, lot 88

Collection of John and Barbara Wilkerson, New York

BIBLIOGRAPHY

Sotheby's, *Aboriginal Art,* Melbourne, July 9, 2001, pages 86–87

Bardon and Bardon, 2004, page 188, painting 97

This is one of three *Water Dreaming* paintings that were completed around August 1972, at a time of flooding rains in the Papunya area. Old Walter Tjampitjinpa, a Pintupi man, was the senior custodian of the Water Dreaming at Papunya and had vast knowledge of the water sources and associated ceremonies across much of the Western Desert. Over a red ground he has laid in two great decorated half-circles, which seem simultaneously to refer to rainbows and to two Water Men painted up for ceremony. In photographs by Michael Jensen (fig. 13, see also pages 14–19), Old Walter is seen completing this picture; the white linework has not yet been applied to the zone beyond the rainbow shapes.

Based on the comments of the artist's daughter Emma Nangala (see pages 73–74), the site of this work can now be identified as Kalipinypa, with its soakage shown as the roundel in red and black. Nangala reads the yellow hatched lines as repeated lightning strikes abutting up against the rainbow, as the great *Tjukurrpa* storm came from west to east to Kalipinypa. The sinuous lines are running water, as the soakage slowly filled up.

Documentation includes a label from the Stuart Art Centre with an annotated diagram. According to it the fine lines in the painting "denote the movement of growth under the soil after rain." The red roundel indicates a "waterhole overflowing," and the arc at the top of the painting is a rainbow, with running water symbols moving to the center. Geoffrey Bardon writes: "The centerpiece is a hair-string ceremonial object and a soakage is marked as a mysterious roundel. Concurrent with the water theme are two men (and a rainbow) decorated with ceremonial traveling markings; the opposed half-circles, or men, face each other. The patterning in white and yellow depicts bush tucker, sand and landscape of the region" (Bardon and Bardon 2004, page 188).

FIGURE 13.
Old Walter Tjampitjinpa at work on *Rainbow and Water Story*, Men's Painting Room, Papunya, August 1972 (see also pages 14–19)

27.

Water Dreaming at Kalipinypa, ca. August 1972

Johnny Warangkula Tjupurrula

(ca. 1918–2001)

Luritja

Synthetic polymer paint on composition board

31 3/4 x 29 3/4 inches (80.65 x 75.57 cm)

PROVENANCE

Stuart Art Centre, Alice Springs

Tim Guthrie Collection, Melbourne

Sotheby's, *Important Aboriginal Art*, Melbourne, June 30, 1997, lot 15

Private collection

Sotheby's, *Aboriginal Art*, Melbourne, 26 and 27 June 2000, lot 70

Collection of John and Barbara Wilkerson, New York

BIBLIOGRAPHY

Sotheby's, *Important Aboriginal Art*, Melbourne, June 30, 1997, pages 16–17

Sotheby's, *Aboriginal Art*, Melbourne, June 26, 2000, pages 58–59

Perkins and Fink, *Genesis and Genius*, page 63 (ill.), page 281

Kleinert and Neale, fig. 37 (col.), page 730

Bardon and Bardon, page 168, painting 76

Genocchio, Benjamin, *Dollar Dreaming: Inside the Aboriginal Art World* (Melbourne: Hardie Grant), 2008: page 15 (ill.), pages 112–16

EXHIBITED

Papunya Tula: Genesis and Genius, Art Gallery of New South Wales, Sydney

August 18–November 12, 2000

This is one of three *Water Dreaming* paintings that were completed around August 1972, at a time of flooding rains in the Papunya area. The visual fascination of this, the greatest picture in the exhibition, lies in the delicacy of the artist's veiling of things, and the way the site at Kalipinypa is divided into dozens of small compartments, no two of which are the same. Often surrounding a roundel that might identify a water-hole or soak, Warangkula has filled each compartment with its own pattern: waving parallel lines, stippling, staccato dots, radiating curves, or cross-hatches. Each of these patternings is in a white, pink, or ochre yellow that covers another darker color, and denotes elements like running water and the "growth of all the root growth under the soil of the bush food after rain" (see Kimber's notes below). The result is like a great patchwork quilt, but one not trammeled by regularity, so that the eye constantly shuffles over an immense filigree, a veil of lace that overlays and yet penetrates the land.

The historic photographic portraits of Warangkula at work on his masterpiece by Michael Jensen (see pages 14–19) reveal many things—first, that the artist achieved his meticulous effects by sitting on the floor and resting his large board on his lap, in the enclosed environment of the large Nissen hut Bardon called the "Great Painting Room." The artist is carefully dressed and uses a very fine European-style paintbrush. Seemingly the masonite board is unprimed, and the artist makes use of its mahogany red surface to indicate the earth that lies underneath his painted motifs. Gradually he filled in the many shapes he had limned in white, buff or yellow acrylic paint, but in such a way that the "earth," rendered chalky pink by the overlay, still continues to breathe as a presence in the picture. As Old Walter Tjampitjinpa was doing in his own Water Dreaming nearby, Warangkula had begun near the center of the image, and gradually worked outwards, one by one filling the graphic compartments and bounding lines of objects to be disguised.

Dick Kimber, formerly a Sacred Sites officer for the NT government, wrote the following notes for the 1997 sale catalogue (text reprinted in 2000). Kimber drew on the complex diagram accompanying the certificate from the Stuart Art Centre (not seen by the author):

The site depicted in the painting is Kalipinypa, the key site over which the artist has authority, a storm centre and "Water or Rain Dreaming" totemic site. It is located some 300–400 km west of Alice Springs, east-north-east of Sandy Blight Junction, which is towards the Kintore Range from the Ehrenberg Range and is now marked on major maps of the area.

Kalipinypa is the location most often painted by the artist, with innumerable variations, and is a claypan which, until earthworks partly revealed and partly destroyed it, covered a gritty and gravelly stony deposit. This evidently helped to trap water after heavy rains, and beside it there existed, until the earthworks modified it, a deep native well and other features.

All features within a kilometer or so in the vicinity are interpreted as associated with the creation time—certain sandhills are clouds; certain trees represent the stormbirds *kalwa* (egrets, perceived as struck by lightning); certain outcrops are associated with lightning; other weathered conglomerate outcrops reveal hailstones; and so on. However, in this painting, whilst certain aspects of the landforms are alluded to, the plant life of the locality has been stressed. This is a common feature in many of the artist's early paintings of the site, depicting prolific growth of locally occurring plants after good rains. As stated in the original notes accompanying the work, "the small lines, dotting and change of colours denote growth of all the root growth under the soil of the bush food after rain."

One of the key "bush foods" depicted in the painting is the "wild raisin," and can be identified as the areas where black "dots" are overlaid above the small white lines. The artist holds major rights of the "bush raisin totem." The key specific site locality for this is the sizable mount immediately north of the Ehrenberg Range. The Aboriginal name for this mount is Kampurrarpa (or similar variant). The Aboriginal name for this mountain derives from the sweet-tasting Kampurrarpa "wild raisin," Solanum Centrale. This low plant, with blue-green (almost grey-green) leaves and purple flowers, grows prolifically in certain areas of sand-plain country, especially if, as was common in Aboriginal practice, the area has been fired some time prior to the rains. The fruit could be eaten as a snack travelling between waters; gathered as a plant-food staple during maximum time of harvest, pulped and formed into balls for storage; or even collected dry in the hard times and, by the addition of water and pounding, made into an edible paste.

Other elements depicted in the work include the *tjurungas* (sacred objects), camouflaged and merging with the rest of the painting, of the "water-men" ancestors and the wild raisin totem, and another showing the location of soaks, together with running water, caves, all reflecting the artist's deep ceremonial knowledge of the site.

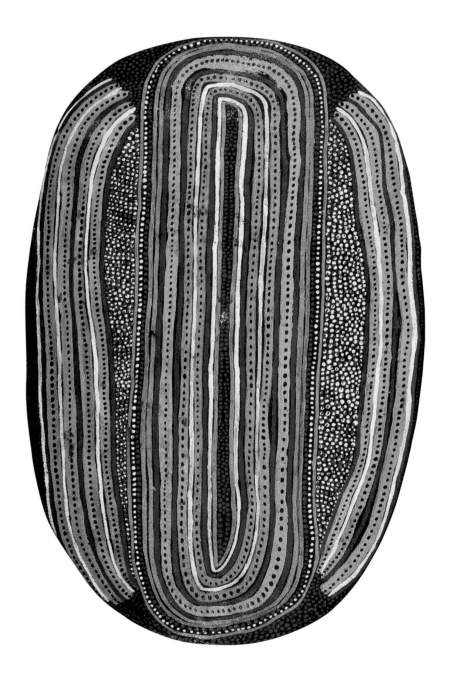
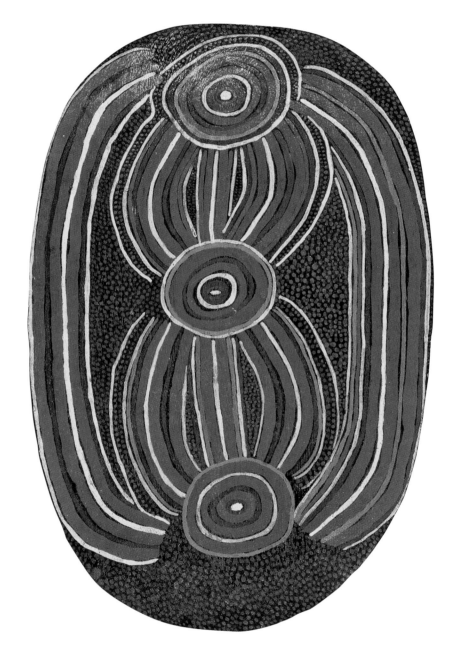

28.

Old Man's Dreamings, ca. 1972

Mick Namararri Tjapaltjarri

(ca. 1927–1998)

Pintupi

Synthetic polymer paint on carved beanwood plaque

17 11/16 x 11 1/8 x 1 1/4 inches (44.93 x 28.26 x 3.18 cm)

PROVENANCE

Acquired from Stuart Art Centre, Alice Springs, early 1973

Sotheby's, *Important Aboriginal Art*, Melbourne, June 30, 1997, lot 250

Collection of John and Barbara Wilkerson, New York

BIBLIOGRAPHY

Sotheby's, *Important Aboriginal Art*, Melbourne, June 30, 1997, page 120

This modest object takes a form that predates Papunya boards by thousands of years: the incised or painted oval of stone or hardwood of a kind used for ceremony; like them, it is decorated on both sides. Old Tutuma Tjapangati made a few such boards, as did Kaapa Mbitjana Tjampitjinpa in a schist material *(Genesis and Genius*, pages 11, 67). Mick Namararri's subject, as relayed by the art advisor, is grave, indeed profound in import: the last dreams and thoughts of an old man left to die by his kinsmen. This was indeed the practice of old, in times when a debilitated elder member of the nomadic group became unable to move on. Memories of procreation and sex from the past dominate this final, long meditation.

A hand-drawn diagram in an unfamiliar but firm hand (perhaps Peter Fannin's, fig. 14) identifies the painted object's two sides, with an inscription under each: "Old Man left to die near mountain range," and under the right hand side, "his dreamings of sexual experience." The annotations for the right indicate "breasts," "vagina," and "nipples."

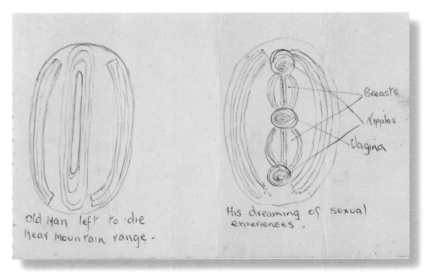

FIGURE 14.
Diagram, possibly by Peter Fannin, collection of John and Barbara Wilkerson

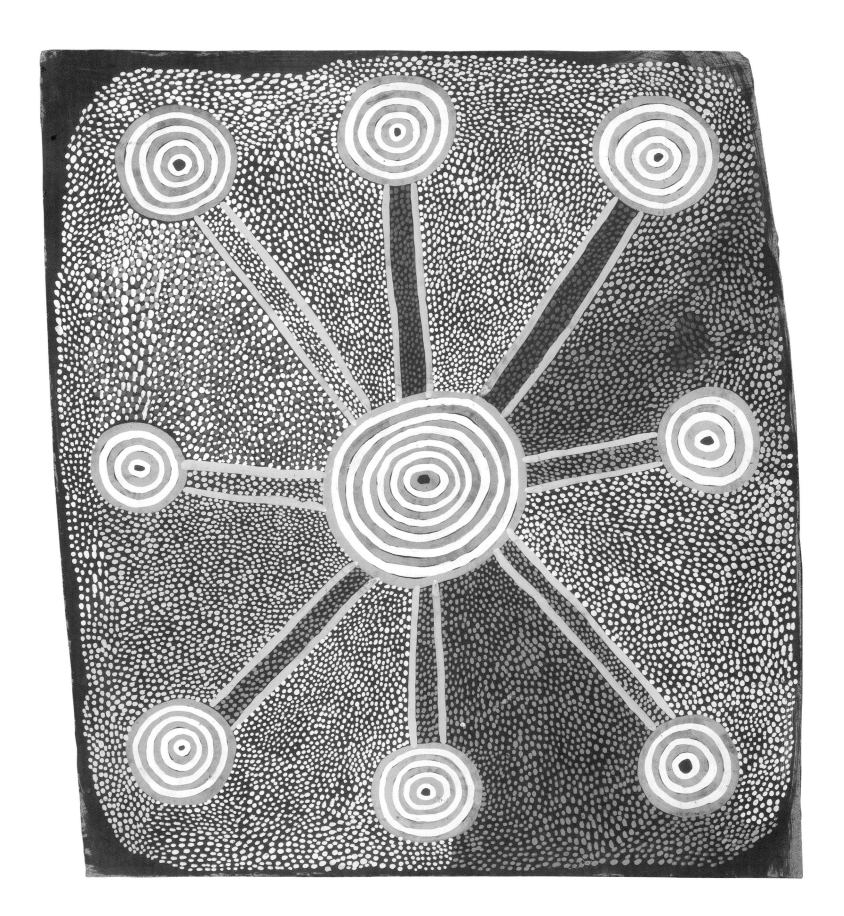

29.

Old Man's Story, 1972

John Kipara Tjakamarra

(ca. 1937–2002)

Pintupi

Synthetic polymer paint on composition board

21 3/4 max. x 18 7/8 max. inches (55.25 max. x 47.94 max. cm)

PROVENANCE

Stuart Art Centre, Alice Springs, consignment 19, painting 45 (#19045)

Purchased at Papunya in 1972

Sotheby's, *Important Aboriginal Art*, Melbourne, June 28, 1999, lot 41

Collection of John and Barbara Wilkerson, New York

BIBLIOGRAPHY

Sotheby's, *Important Aboriginal Art*, Melbourne, June 28, 1999, page 40

Cf. Perkins and Fink, *Genesis and Genius,* 2000, page 36–37

Johnson, *Lives*, 2008, pages 11–12

John Kipara Tjakamarra was one of the first Pintupi men at Papunya to take up painting. His output was limited but it displayed a formal diversity that bespoke detailed knowledge of country and ceremony. Bardon recounted of this "ascetic" Pintupi personage: "As with Yala Yala Gibbs Tjungurrayi, Anatjari No. III Tjakamarra and Shorty Lungkarta Tjungurrayi, John Tjakamarra never spoke at all, even when spoken to or approached by me on art themes either topical or of interest to the group" (Bardon and Bardon, page 209).

It is thus not suprising that no information survives on this work, other than a subsequent diagram in Pat Hogan's hand that indicates the central roundel as "Man" and the roundel to the right as "Testicle." If this note is correct, the exhibited painting may be an interpretation, in austere form, of the Old Man Dreaming so often painted by Uta Uta Tjangala. The targetlike motif is brilliantly clear in its symmetrical organization. The "background" of the image, primarily in white dabs of paint brush onto the board, contains areas where the color pink subtly diversifies the image, although the meaning of the forms thus created remains secret.

Vivien Johnson describes John Kipara Tjakamarra as "one of the inventors and most consistent exponents" of the "classic Pintupi grid-style Tingari paintings." She continues, "He leaves behind a body of work singular in the intensity of its devotion to the original themes of the painting movement and sublime in its indifference to the blandishments of fame and fashion" (*Lives*, page 12).

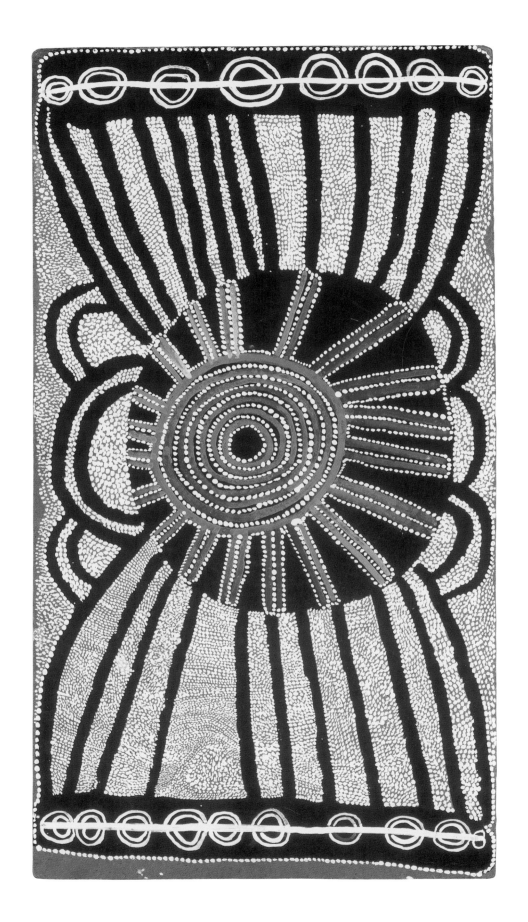

30.

The Trial, 1972

Charlie Tarawa (Tjaruru) Tjungurrayi

(ca. 1925–1999)

Pintupi

Synthetic polymer paint on composition board

29 15/16 x 15 7/8 inches (76.04 x 40.32 cm)

PROVENANCE

Stuart Art Centre, Alice Springs, consignment 19, painting 236 (#19236)

Private collection, France

Sotheby's, *Aboriginal Art*, Melbourne, July 26, 2004, lot 96

Collection of John and Barbara Wilkerson, New York

BIBLIOGRAPHY

Cf. Crocker, Andrew, *Charlie Tjaruru Tjungurrayi: a retrospective 1970–86*, 1987

Sotheby's, *Aboriginal Art*, Melbourne, July 26, 2004, page 78

Tarawa's *The Trial* of 1972 is a work of remarkable finesse. It was annotated in mid to late 1972 by Pat Hogan, in the gap between Bardon's departure and Papunya schoolteacher Peter Fannin's assumption of the position of art advisor. On her Stuart Art Centre card (not seen by the author), Pat Hogan recorded an exegesis of the subject, although Geoffrey Bardon has cast doubt upon any of her interpretations made after his departure.[1] Her text is glossed in the 2004 sale catalogue thus:

> A painting of a highly unusual subject, depicting the trial under traditional law of a man condemned to death. He is represented awaiting judgment as the set of concentric circles at the centre of the painting. Along the top and bottom edges of the painting, lines of mirrored double U-shapes indicate elders sitting in council. These are joined to the large central circle by black lines that denote the decision of the council. The three double U-shapes on either side of the central black circle, represent the executioners. The straight pink lines radiating towards the victim represent the fingers of spirits of the dead pointing to the accused, indicating to him that he is condemned to die.

However, in her essay for this catalogue, Vivien Johnson suggests that Pintupi justice may not have been meted out this way, and considers it more likely the subject of Tarawa's painting would be "the sentence of death that would be imposed on unlawful intruders to Wati Kuwala's sacred cave at Tjitururrnga."

The austere color scheme of *The Trial*, with its combination of severe black, pink ochre, and the layering of irregular white dots over raw masonite, has a grave sonority. In spatial terms the work displays an expansiveness of radiating lines bound in tightly by the edges of the board. The sense created by the black inner circle is of an interior within an exterior, a containment or spatial shift that is symbolic of, as much as translating, an experience of space. Thus the imagery seems to chime well with Johnson's thesis about the cave of the Ice Man.

[1] See Bardon and Bardon, 2004, page 39, on the rejection of Pat Hogan by the Papunya painting men after Bardon's resignation.

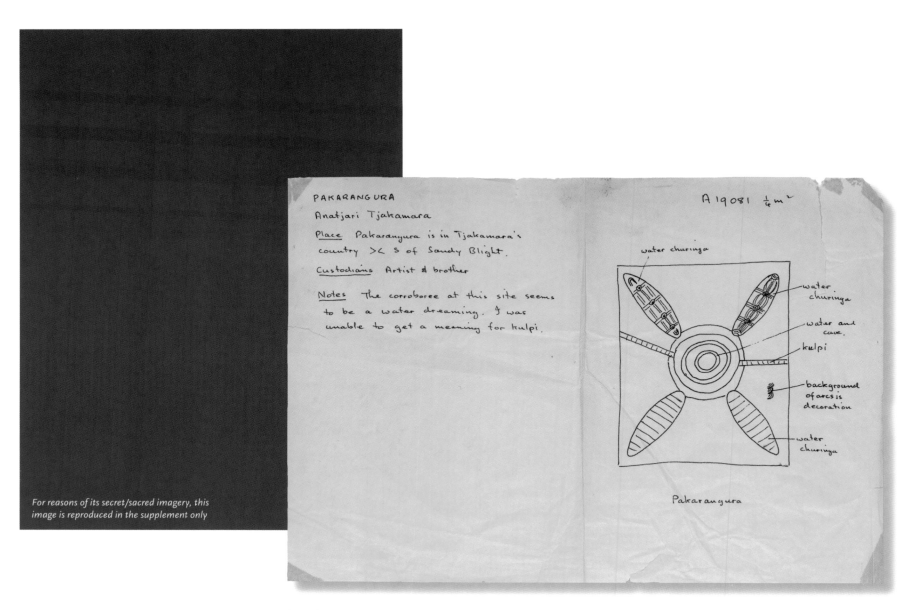

FIGURE 15.
Diagram by Peter Fannin, collection of John and Barbara Wilkerson

31.

Pakarangura, after August 1972

Anatjari (Yanyatjarri) Tjakamarra

(ca. 1938–1992)

Pintupi

Synthetic polymer/powder paint on composition board

23 15/16 x 17 7/8 inches (60.8 x 45.4 cm)

PROVENANCE

Painted at Papunya, with documentation by Peter Fannin, consignment #A19081

Private collection, Canberra

Sotheby's, *Important Aboriginal Art*, Melbourne, June 29, 1998, cat. 233

Collection of John and Barbara Wilkerson, New York

BIBLIOGRAPHY

Sotheby's, *Important Aboriginal Art*, Melbourne, June 29, 1998, page 115

Cf. Bardon and Bardon, 2004, page 190

Peter Fannin's certificate titles the work *Pakarangura*, which he notes "is in Tjakamarra's country S. of Sandy Blight." His diagram (fig. 15) interprets the central roundel as "water and cave," the four large oval forms as "water *tjuringas*," and "the background of arcs" as "decoration." The striped line entering the picture from the sides and traveling to the roundel identified as "*kulpi*." Fannin writes, "The corroboree at this site seems to be a water dreaming. I was unable to get the meaning for *kulpi*."

Bardon reproduces his diagram for a related (but lost) Water Dreaming by Anatjari (page 190); presumably earlier in date, it includes images of ceremonial hats, men sitting, and bullroarers, which in the present work have been replaced by the overlapping arc or "fish-scale" motif in white. This fine design, executed with great skill and bringing with it an intimation of spatial depth, might allude to water ripples on sand. However the overall design of four large objects running from the center to the four corners is retained by both pictures.

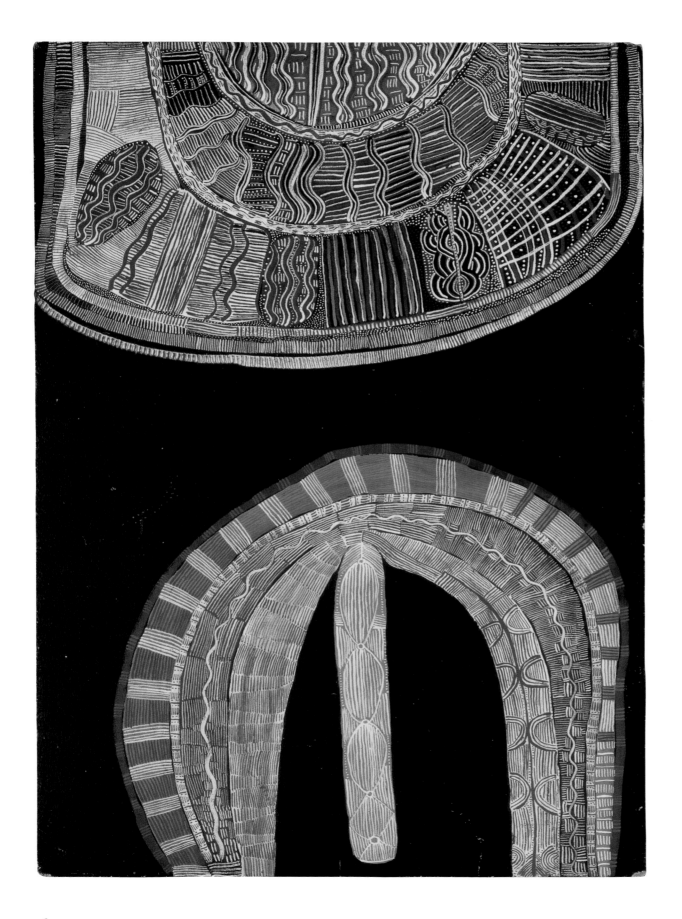

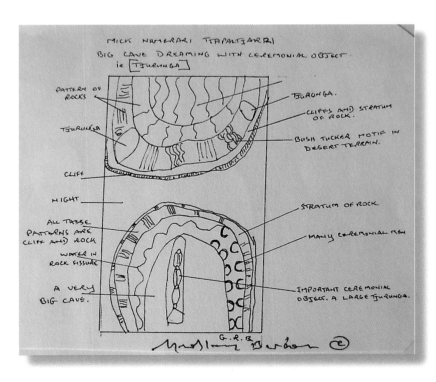

FIGURE 16.
Diagram by Geoffrey Bardon, collection of John and Barbara Wilkerson

32.

Big Cave Dreaming with Ceremonial Object [formerly *Untitled*], late 1972

Mick Namararri Tjapaltjarri

(ca. 1927–1998)

Pintupi

Synthetic polymer powder paint on composition board

35 7/8 x 25 1/8 inches (91.12 x 63.82 cm)

PROVENANCE

Purchased from the artist at Papunya by a visiting Adelaide theater director, late 1972

Sotheby's, *Important Aboriginal Art*, Melbourne, June 28, 1999, lot 102

Collection of John and Barbara Wilkerson, New York

BIBLIOGRAPHY

Sotheby's, *Important Aboriginal Art*, Melbourne, June 28, 1999, page 80

Perkins and Fink, *Genesis and Genius*, 2000, page 39 (ill.), page 283; also page 38 for a related image

Benjamin, Roger, review of *Papunya Tula: Genius and Genesis*, in *Humanities Research* no. 1, 2000 (cover ill.)

Bardon and Bardon, 2004, page 444, painting 415

EXHIBITED

Papunya Tula: Genesis and Genius, Art Gallery of New South Wales, Sydney

August 18–November 12, 2000

One of Mick Namararri's greatest paintings, *Big Cave Dreaming with Ceremonial Object* has an emphatic impact at both the macrocosmic and microcosmic levels. As an overall image, "this powerful painting probably depicts imagery of a highly secret/sacred nature that is possibly sexual" (Sotheby's 1999, page 80). Yet as one probes the details of the work—the filigree infill of the caves, with their whorls, striations, concealed objects, and arabesques denoting water and bush tucker—one is struck by the meticulous care of the painter and his remarkable gift for invention in pattern.

According to Bardon's notes and diagram (fig. 16), the lower half of the picture represents the interior of a very large cave in which a row of ten men participate in a ceremony before a major *tjurunga* (made out in orange with white painted decoration). In his conversation with Bardon, Mick Namararri revealed that much of the imagery denoted a specific local geology:

> The simple patterned forms represent cliffs at the top of the design with a featured cave and ceremonial object inside that cave. Close study of the intricate patterning reveals at the top, small ceremonial objects known as *tjurungas*, linear water motifs and patterns representing bush tucker, grass, rock and the stratum of cliff geology of a specific place in the artist's homeland. The bottom motif is similar but it includes many ceremonial men arranged in ritual order, a water mark in spiralling linear effects and a strong elongated and patterned oval form which is the principal ceremonial object in the cave itself. The simplicity of the black area could imply that the ceremony is at night which is the traditional situation (Bardon in Sotheby's 1999; also Bardon and Bardon, page 444).

The 1999 sale catalogue notes: "Purchased directly from the artist at Papunya in late 1972. The vendor, a theater director, traveled to Papunya following the recommendation of H. C. (Nugget) Coombs to study comparisons between Aboriginal and Greek mythology, expressed in dance and ceremony. He observed the entire process of the painting's creation, and recalls the artist continually sang throughout its execution."

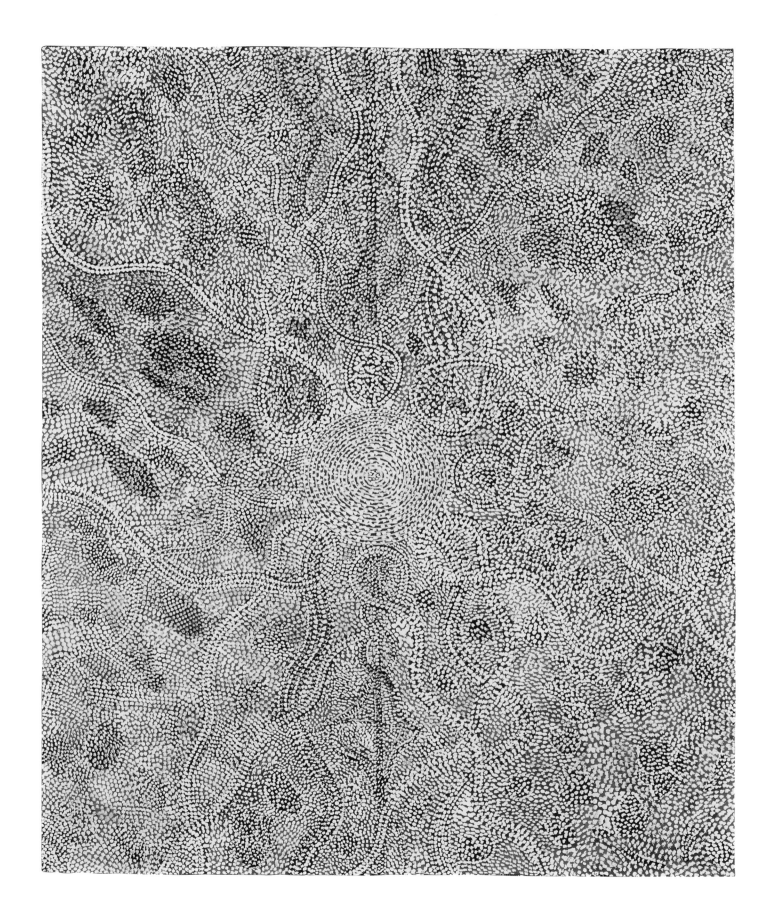

33.

Bushfire Spirit Dreaming at Napperby [formerly *Untitled*], late 1972

Tim Leura Tjapaltjarri

(ca. 1934–1984)

Anmatyerre

Synthetic polymer paint on composition board

23 7/8 x 18 7/8 inches (60.64 x 47.94 cm)

PROVENANCE

Purchased by a mission worker in the Alice Springs area in late 1972

Stuart Art Centre, Alice Springs, consignment 19, painting 225 (#19225)

Sotheby's, *Important Aboriginal Art*, June 29, 1998, lot 47

Collection of John and Barbara Wilkerson, New York

BIBLIOGRAPHY

Sotheby's, *Important Aboriginal Art*, June 29, 1998, page 38

Bardon and Bardon, 2004, page 227, painting 138

Johnson, *Lives,* 2008, pages 44–46

The work of the key innovator Tim Leura had changed remarkably since his object-laden works *A Joke Story* and *Honey Ant Dreaming* of a year earlier. In *Bushfire Spirit Dreaming at Napperby* he adopts a subtle allover composition with multitudes of white stipples over a pale brown and black ground. This was partly motivated, one presumes, as a way of obscuring sensitive details in his stories and was indebted to Johnny Warangkula's practice. As Vivien Johnson recently wrote, Leura developed "a soft delicate touch and used washovers and other techniques like dotting into wet grounds to obtain atmospheric effects of smoke, cloud and light which suggested his prior acquaintance with watercolour as a medium." The present work is an early example of his emerging signature style. For more detail on the Bushfire Dreaming see the entry on Clifford Possum's *Dreaming Story at Warlugulong* of 1976 (cat. 42).

Bardon writes:

> This late, stylized Traveling Dreaming, disguised with hidden forms where the landscape features are almost unseen, has a straight line as the journey motif, myriad curvilinear forms associated with dark patches and a hint of some mysterious map-like location. . . . The gentle left-handed brushtrokes of Tim Leura render the bitter earth, grass stubble after fire, in a subtle and brilliant colour mixing. . . . The story sings of the journey line amongst the burnt grass and seemingly meditates on the Bushfire Dreaming as a natural phenomenon. . . . Although the color is elegiac, the burning of country shown presupposes the country's rebirth (Bardon and Bardon, pages 227–28).

The 1998 sale catalogue notes:

> The consignment number of this work indicates it being painted in the transitional period from when Geoff Bardon left the position of art coordinator at Papunya and Peter Fannin assuming the role in late 1972. The painting bears striking stylistic resemblance to a work by Tim Leura Tjapaltjarri in the Holmes à Court collection . . . see *Cross Roads: Towards a New Reality, Aboriginal Art from Australia* (Kyoto: The National Museum of Modern Art, 1992), cat. 56, page 86 (ill.).

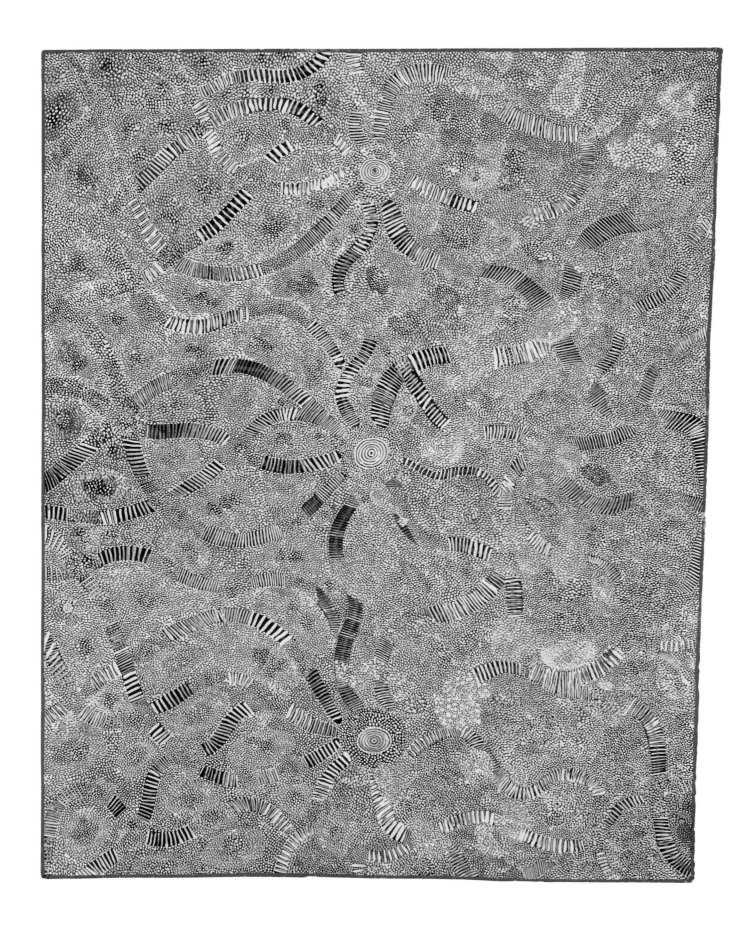

34.

Ngalyilpi (A Small Snake), signed "KaoAA" and dated 12/72
(December 1972) on the board

Kaapa Mbitjana Tjampitjinpa

(ca. 1926–1989)

Anmatyerre/Arrernte

probably assisted by Tim Leura Tjapaltjarri

(ca. 1934–1984)

Anmatyerre

Synthetic polymer powder paint on composition board

48 x 37 1/2 max. inches (121.92 x 95.25 max. cm)

PROVENANCE

Stuart Art Centre, Alice Springs, consignment 20, painting 59 (#20059)

Purchased at Papunya by a visiting Adelaide theater director, late 1972

Sotheby's, *Important Aboriginal Art*, Melbourne, June 28, 1999, lot 103

Collection of John and Barbara Wilkerson, New York

BIBLIOGRAPHY

Perkins and Fink, *Papunya Tula: Genesis and Genius*, page 69 (ill.) and 282

Sotheby's, *Important Aboriginal Art*, Melbourne, June 28, 1999, page 83

Cf. Bardon and Bardon, 2004, page 338 on Snake Dreamings

EXHIBITED

Papunya Tula: Genesis and Genius, Art Gallery of New South Wales, Sydney

August 18–November 12, 2000

This work marks a new departure by Kaapa Mbitjana Tjampitjinpa, working collaboratively with his kinsman Tim Leura. He has adapted the smoky grey-brown palette of Leura, and the discretion and reticence in iconography seen in the previous work. Note that in this beautifully controlled composition of snakes approaching their dens, they disappear here and there under the sand of the spinifex country, which implies both their quotidian and Ancestral modes of action. This pictorial device, attributed by Johnson to Tim Leura, is also seen in Clifford Possum's contemporaneous *Women's Dreaming about Bush Tucker "Yarlga"* (cat. 37).

Ngalyilpi (A Small Snake) is richly documented by an annotated diagram of the time by Peter Fannin, and an audio tape recorded by him of "the artist singing a ceremonial song related to the painting, and the artist with Johnny Warangkula, Old Mick Wallankari and Tim Leura singing another ceremonial song." The recording "reveals that Peter Fannin endeavoured at great length to encourage the artist to disseminate further information, often having difficulties understanding much of the artist's explanation" (Sotheby's 1999, page 83). In addition, Geoffrey Bardon prepared a separate diagram and brief text for the 1999 sale, in which he proposes a reading of the painting as a "bush tucker dreaming of the yam plant growing in the dotted earth," not a Snake Dreaming as Fannin's documentation convincingly proposes (Bardon, unpublished note).

Peter Fannin's notes read:

> Karpa Tjampatjinpa
>
> Ngalyilpi (small snake) story
>
> <u>Place</u> In the Spinifex (tjanpi) country well north of Yuendumu. Apparently <u>not</u> sandhill (tali) country.
>
> <u>Ownership</u> Tjampatjinpa (& presumably Tjangala) story.
>
> <u>Notes</u> Karpa was unwontedly reluctant to talk about this painting. Further enquiry from Bill Stockman reveals that it is a maku dreaming—very "dangerous." This maku is <u>not</u> the witchetty grub. About 7 cm long, winged. Bill promises to show me in due course.

In his diagram Fannin indicates the three central roundels as "snake holes (piti)," and the dominant meandering motifs as "snake (ngalyilpi—or maku) tracks leading to holes." The myriad minuscule dots making up the background are differentiated and grouped to indicate plants: "various plants other than spinifex", and as for the pale ovoid clumps, "spinifex (Triodia, sp.) (tjanpi) clump."

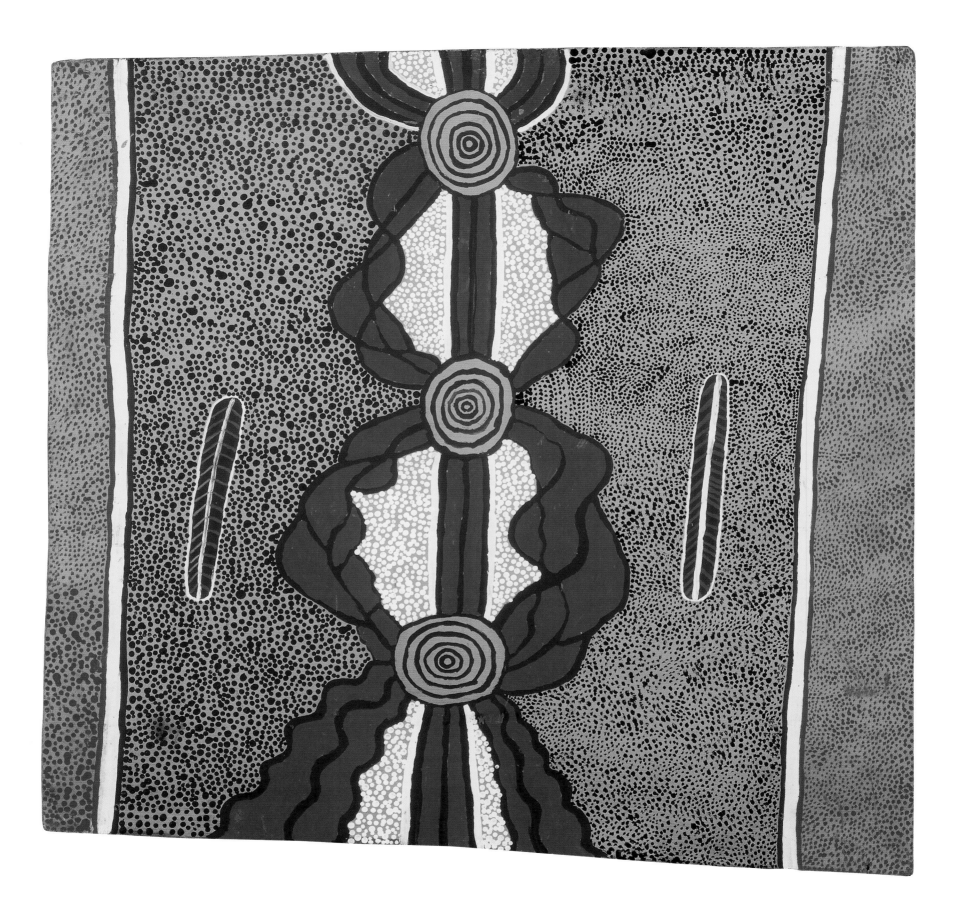

35.

Pintupi Women's Bush Tucker Dreaming, ca. late 1972

Johnny Scobie Tjapanangka

(ca. 1938–2000)

Pintupi

Synthetic polymer powder paint on composition board

Inscribed on verso "Freddie Tjagamarra/or/John Scobie"

23 1/8 max. x 23 1/4 inches (58.74 max. x 59.06 cm)

PROVENANCE

Stuart Art Centre, Alice Springs, consignment 15, painting 10 (#15010)

Deutscher-Menzies, *Fine Aboriginal Art*, Melbourne, June 27, 2000, lot 143

Collection of John and Barbara Wilkerson, New York

BIBLIOGRAPHY

Cf. Sotheby's, *Important Aboriginal Art*, Melbourne, June 30, 1997, page 28

Deutscher-Menzies, *Fine Aboriginal Art*, Melbourne, June 27, 2000, page 88

Cf. Bardon and Bardon, 2004, pages 79 and 372, painting 324

Cf. Johnson, *Lives*, 2008, page 121 (ill.)

Johnny Scobie Tjapanangka made very few paintings in the early years. This is one of two that show women's stories. The earlier, more elaborately orthodox painting of a women's ceremony was documented by Bardon for June–July 1972. *Pintupi Women's Bush Tucker Dreaming* is a much more stripped-back, minimal version of such a theme. However, both have in common a unique feature: interlocking meandering lines that in Bardon's notes for the earlier picture are said to represent "dancing." This dance meander in brilliant red and black dominates the present work, also rendered unusual by the broad fields of black and red dotting. (The same motif is also visible in his *Parrot Pea at Kilalgna* of 1972; Johnson, *Lives*, 2008, page 121). Johnny Scobie, who had spent much more time in Alice Springs than most Pintupi, is revealed as a bold experimenter.

Geoffrey Bardon wrote the following for the 2000 sale catalogue:

> The concentric circles are significant places where women and girls have been foraging for bush tucker in a journey across a landscape, with the central line, red and black pattern, as a journey line for traveling.

> The twisting and curving red pattern on either side of the journey line is possibly a woman's motif for a dancing ceremony. . . . Further, there is a clear rendering of three dimensions by the brushstrokes here which would place this work as Johnny Scobie Tjapanangka. At this time the artist was one of the few Pintupi men familiar with magazines, comics and photographs.

> The dotting is a ceremonial area for the occasion. The straight line verticals are the perimeter for a ceremonial area. The two vertical bars, symmetrically opposed are music or digging sticks.

> Johnny Scobie and Freddy (West) Tjakamarra may have had shared ownership of the story or part of the workload. Both men were of similar age, of the same Pintupi language group, associated then and now by unknown tribal connections.

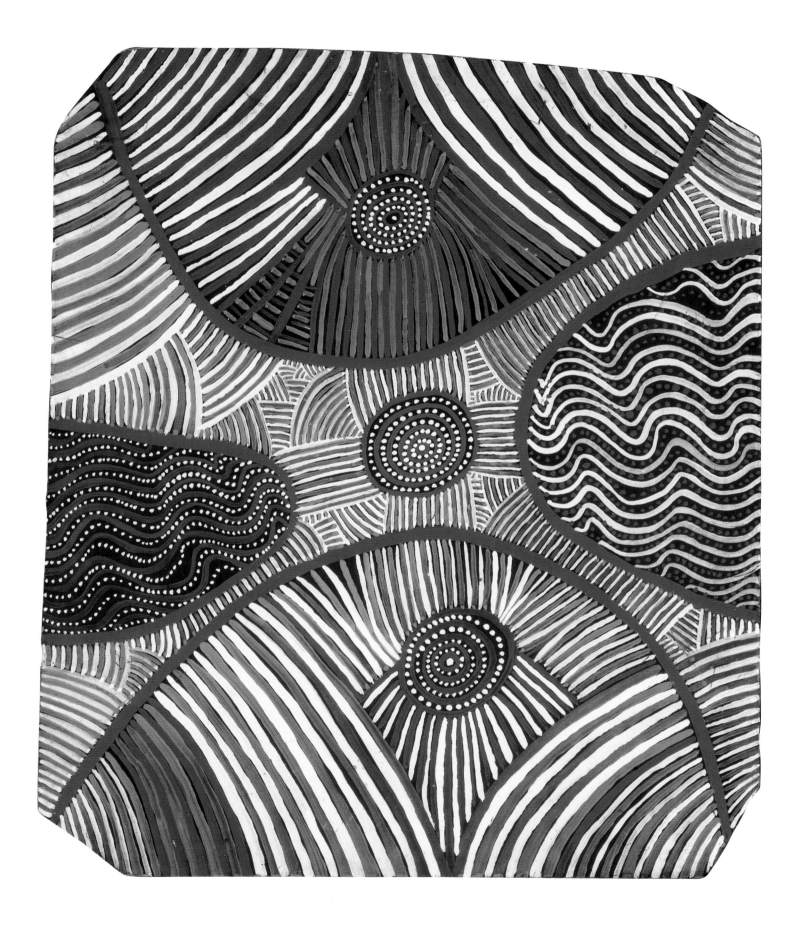

36.

Water Dreaming, late 1972

Mick Namararri Tjapaltjarri

(ca. 1927–1998)

Pintupi

Synthetic polymer powder paint on composition board

27 3/8 max. x 22 1/4 inches (69.53 max. x 56.52 cm)

PROVENANCE

Papunya Tula, Alice Springs, stock no. PT30 (1972)

Deutscher-Menzies, *Fine Aboriginal Art*, Melbourne, June 27, 2000, lot 32

Collection of John and Barbara Wilkerson, New York

BIBLIOGRAPHY

Deutscher-Menzies, *Fine Aboriginal Art*, Melbourne, June 27, 2000, page 25
(also back cover ill.)

Since it was painted at a moment when not all Papunya paintings were documented, there is little information about this impressive composition by Mick Namararri. Extrapolating from his familiarity with other works by the artist (whom he knew particularly well, as is shown by his 1978 documentary film *Mick and the Moon*), Geoffrey Bardon was able to provide the following reading in the 2000 sale catalogue:

> The centre concentric circle is a waterhole in a chasm-gully surrounded by patterned curved forms representing stylized cliffs and caves of a mountainous area. The top and bottom of the curved shapes (concave) are both cave forms with interior waterholes as circles. The linear patterns are the watermarks on the sand and rock stratum of these caves and cliffs. There are Water Dreaming patterns on opposing concave ceremonial objects. These forms are patterned in water motifs in a balanced spatial design to complete four opposing concave arcs. There is very little color, but rich pattern variations by hatching and repetition. The cut-off corners date this work from late 1972.

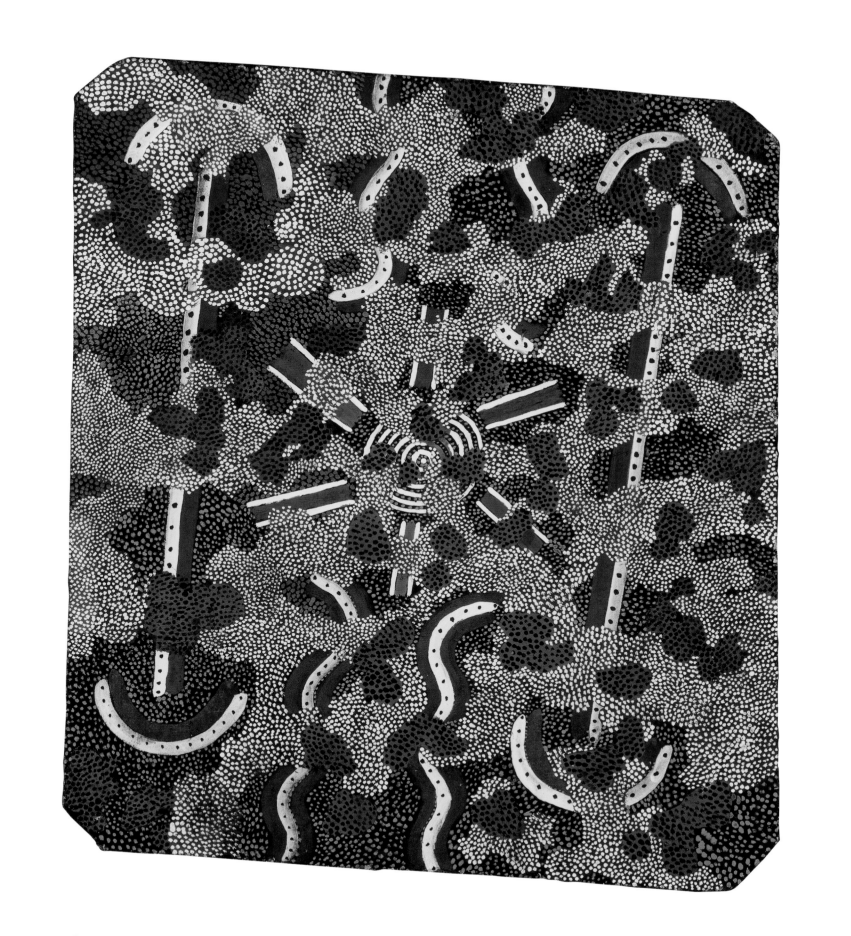

37.

Women's Dreaming about Bush Tucker "Yarlga" [formerly *Bush Fire Dreaming*], late 1972

Clifford Possum Tjapaltjarri

(ca. 1932–2002)

Anmatyerre

Synthetic polymer/powder paint on composition board

25 3/8 x 21 7/8 inches (64.45 x 55.56 cm)

PROVENANCE

Acquired at an exhibition at the house of Papunya art advisor Peter Fannin in 1973

Sotheby's, *Important Aboriginal Art*, Melbourne, June 30, 1997, lot 72

Collection of John and Barbara Wilkerson, New York

BIBLIOGRAPHY

Johnson, *The Art of Clifford Possum Tjapaltjarri*, 1994, page 50
(see pages 42–43 for illustrations of similar works from this period)

Sotheby's, *Important Aboriginal Art*, Melbourne, June 30, 1997, page 53

Bardon and Bardon, 2004, page 376, painting 330

Although it was auctioned at Sotheby's in 1997 as a *Bush Fire Dreaming*, Geoffrey Bardon's notes suggest this work is a *Women's Dreaming*. His reading is supported by the absence of the tracks of humans and the blue-tongue lizard common to most of Clifford Possum's Bush Fire stories. For Bardon, "the central circle is a fire with firesticks radiating in formal order where women sit opposite each other at either end of long yams sticks; the curving lines from the center of the design represent smoke from the fire and the stippled and ragged white shapes are the bush tucker the women have gathered called 'yarlga' [yalka, *cyperus rotundus*], which is white and like an onion. The dotting otherwise represents the earth and bushes" (Bardon and Bardon, page 376). The cut-off corners of the board date the painting to late 1972 (when Peter Fannin became the art advisor after Bardon's resignation).

Women's Dreaming about Bush Tucker "Yarlga" is one of a short series of Clifford Possum's paintings in which he developed "the superimposition and overlaying of Dreaming landscapes" (Johnson, page 74), an effect that became a signature feature thereafter. In this work the *kurruwarri* motifs flicker in and out of view like celestial objects obscured and revealed by moving clouds. Clifford Possum has deliberately executed those forms in a partial or interrupted way. This interpenetration of zones corresponds to the artist's stated concern to show the penetrability of the ground in Aboriginal belief, and the fact that Dreamings enter the ground and travel beneath the surface before emerging elsewhere in the creation of the landscape.

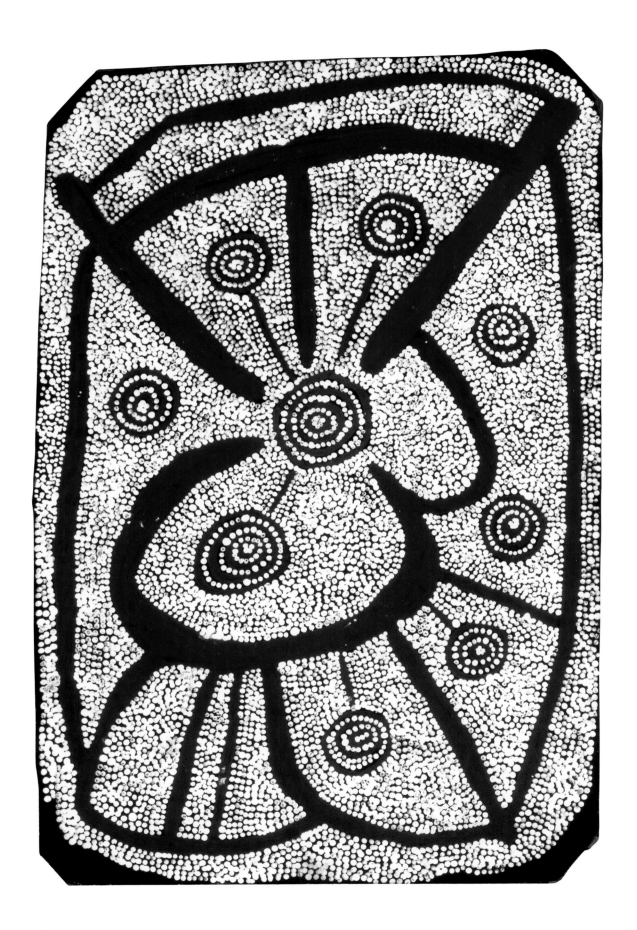

38.

Wind Story, late 1972

Yala Yala Gibbs Tjungurrayi

(ca. 1924–1998)

Pintupi

Synthetic polymer/powder paint on composition board

21 3/4 max. x 13 1/2 inches (55.25 max. x 34.29 cm)

PROVENANCE

Sotheby's, *Important Aboriginal Art*, Melbourne, June 30, 1997, lot 213

Collection of John and Barbara Wilkerson, New York

BIBLIOGRAPHY

Sotheby's, *Important Aboriginal Art*, Melbourne, June 30, 1997, page 105

Bardon and Bardon, 2004, page 470, painting 448

EXHIBITED

Exhibition of Pintupi Tribal Art,

Cask Gallery, McLarenvale Bushing Festival, South Australia

October 26, 1973, cat. 25

"A centralised linear design of roundels, half-circles and strong radials subdivide with a powerful simplicity a family group protected by windbreaks from the wind." So Bardon (page 470) writes of this emphatic centrifugal composition. The painting exemplifies Yala Yala Gibbs's characteristic manner of close-knit, rather liquid white dots set over a black or dark brown ground, so that the *kuruwarri* lines are revealed underneath.

Wind-storms and dust-storms can be a scourge of life in the open desert, and Aboriginal people make curved windbreaks of massed branches and twigs called *wiltja* to protect themselves. One may assume a mythic content for this image, although it was not recorded. A few sentences however elucidate a comparable work by Yala Yala entitled *Wiltja Story* (1972), now at the Museums and Art Galleries of the Northern Territory: "This relates to a myth concerning an old man who is left to die in a bush-shelter, 'Wiltja.' Suddenly a gust of wind came from the north-west and blew the shelter into the sky. The lines in the painting represent pieces of the shelter" (Margie West, ed., *The Inspired Dream* [Brisbane: Queensland Art Gallery, 1988] pages 98–99, pl. 81).

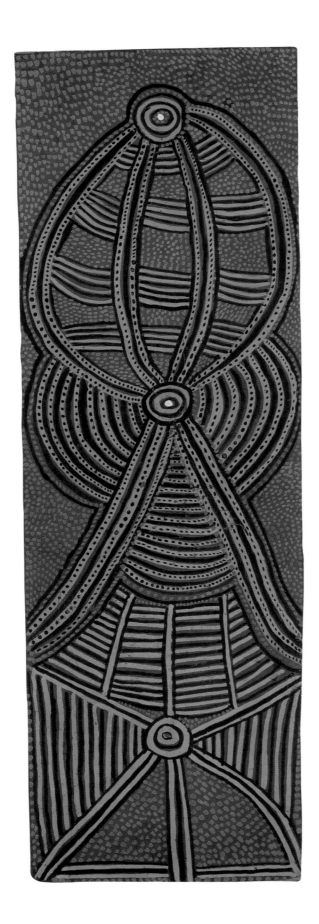

1973–1975

39.
Untitled, 1973
Turkey Tolson Tjupurrula
(ca. 1943–2001)
Pintupi
Synthetic polymer/powder paint on composition board
Bears artist's name and date on the reverse
17 3/4 x 5 3/4 max. inches (45.09 x 14.61 max. cm)

PROVENANCE
Acquired by a resident worker at Papunya in 1973
Sotheby's, *Fine Aboriginal and Contemporary Art, Melbourne,* June 17, 1996, lot 198
Collection of John and Barbara Wilkerson, New York

BIBLIOGRAPHY
Sotheby's, *Fine Aboriginal and Contemporary Art, Melbourne,* June 17, 1996, page 65
Johnson, *Lives,* 2008, pages 163–68

Despite becoming one of the pre-eminent Papunya Tula artists from the later 1970s until his death, Turkey Tolson was a late starter whose work, with one exception, dates from 1973 on. This explains the somewhat uneven formulation of this work. The level of abstraction in the strong bars of color (like body painting) and the pecked dotting accord with the art of the post-secret/sacred debates of 1972. Fred Myers remarks that it "looks a little as if it might be a painting of a place known as *Putjanya, Two Women Dreaming,* very close on to Kintore Range" that was quite frequently painted by Turkey Tolson and his brother Riley Rowe (e-mail to author, November 8, 2008).

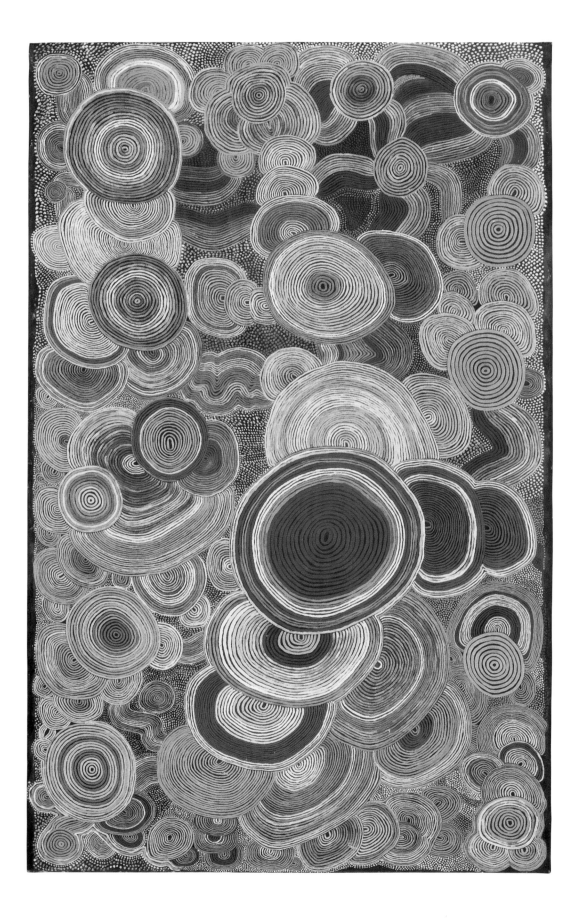

FIGURE 17.
Sale certificate, collection of John and Barbara Wilkerson

40.

Tingarri Ceremony at Ilingawurngawurrnga, June 1974

Shorty Lungkarta Tjungurrayi

(1920–1987)

Pintupi

Synthetic polymer paint on canvas

66 3/8 x 40 1/8 inches (168.59 x 101.92 cm)

PROVENANCE

Painted at Yayayi Bore

Papunya Tula Art, Alice Springs, cert. #SL74625, dated July 10, 1974

Private collection, Melbourne

Sotheby's, *Aboriginal Art*, Melbourne, June 26, 2000, lot 36

Collection of John and Barbara Wilkerson, New York

BIBLIOGRAPHY

Sotheby's, *Aboriginal Art*, Melbourne, June 26, 2000, pages 32–33

With this, the earliest work on canvas (as opposed to board) in the exhibition, the expanded scale made possible by the lightweight material is immediately felt. Shorty Lungkarta has filled an entire work, to the very corners, with what Bardon calls "overlapping whorl patterns of immense intricacy." Passages of dotting fill any visible gaps created by the intersecting roundels. Shorty's use of three or four colors in each roundel also marks an advance in sophistication over his related *Water Dreaming* of over a year earlier. It gives a spatial and coloristic richness to the whole: varied colors mean each roundel pulses in and out, while their massing by the dozen gives a symphonic aspect to this remarkable canvas.

This work was initially documented by Fred Myers at Yayayi Bore. Peter Fannin's annotations on the sale certificate (fig. 17) make clear that the overlapping roundels are used to depict ceremony related to the Tingarri cycle, not water. His notations (to a photo, not the usual pen sketch, affixed to the certificate) use the word "design" to indicate most of the picture, except in the central zone. For the center left he indicates "men sitting around painting" (this would be the novices mentioned in the notes as having their backs decorated) and on the right "older men—big U," and a "well," "hill," and "ceremony ground" (the older men leading the rites near the "deep well in a hill a few miles west of Mitukatjirinya").

Fannin's certificate reads:

> This represents the Tingari Men of the Dreaming at Ilingawurngawurng [Ilyingaugau] where they traveled after Pirmalyga and Mitukatjirinya. This is a deep well in a hill, a few miles west of Mitukatjirinya. Shown is the men's ceremonial camp where sacred designs were painted on the novices' backs. After this the men went a mile north, and copulated with 2 women who had followed the men from near Docker River. Because the women saw these designs and objects, the men grew angry and chased the women, trying to kill them by throwing sacred objects.

The 2000 sale catalogue adds: "This painting probably represents the site of Ilyingaugau to the south-east of the Kintore Community." A closely resembling work by Shorty Lungkarta is in the collection of the Araluen Art Centre, Alice Springs.

153

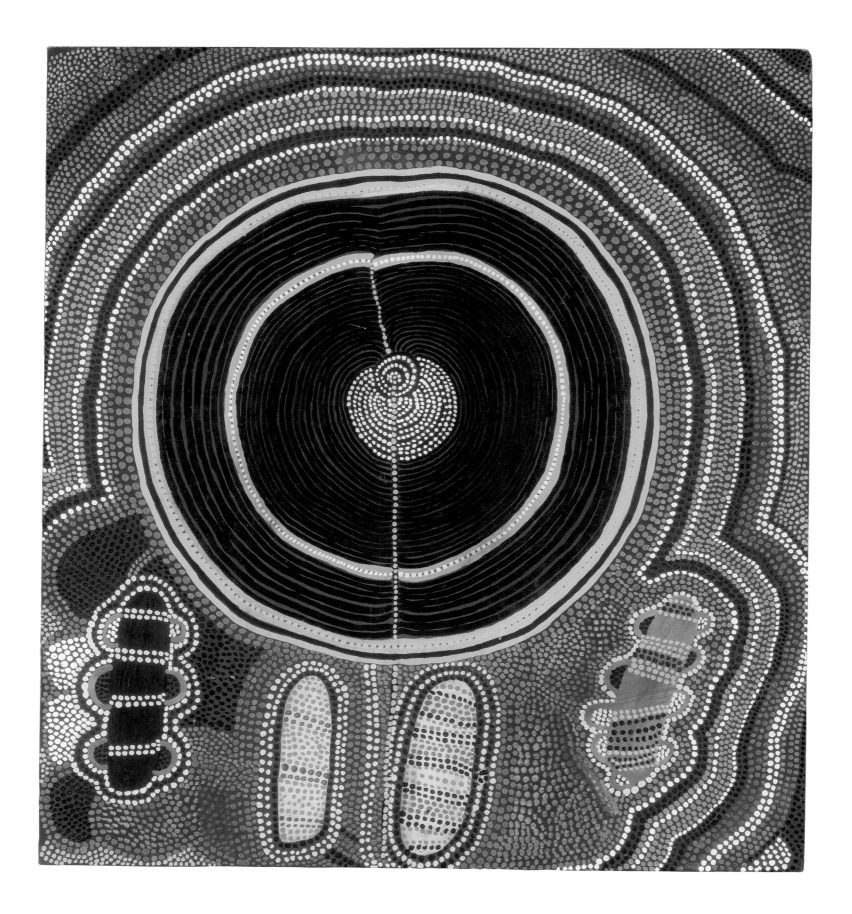

41.

Mystery Sand Mosaic, November 1974

Shorty Lungkarta Tjungurrayi

(1920–1987)

Pintupi

Synthetic polymer paint on canvas board

19 15/16 x 17 3/4 inches (50.64 x 45.09 cm)

PROVENANCE

Collection of Bill Copland

Sotheby's, *Fine Aboriginal and Contemporary Art*, Melbourne, June 17, 1996, lot 271

Collection of John and Barbara Wilkerson, New York

BIBLIOGRAPHY

Sotheby's, *Fine Aboriginal and Contemporary Art*, Melbourne, June 17, 1996, page 83

Bardon and Bardon, 2004, page 420, painting 386

Geoffrey Bardon produced a certificate, headed "To Whom it May Concern" and dated October 24, 1995, to authenticate and recommend the work for sale at the 1996 Sotheby's auction. A diagram by Frank Slip is attached. The text reads in full:

> This Mystery Sand Mosaic at Yei Tei [*sic*] Bore (1974) by Shorty Lunkgata Tjungurrayi, now deceased, was painted for Mr. Bill Copland under my direction and friendship in November 1974. In doing so I reminded Shorty of his earlier work done when I was art advisor at Papunya Outpost 1971–72. Shorty was a most responsive man of solid build, approximately 5' 6", a leader of his community, a wonderful dancer and a fine family man much loved by his community and he was most reliable in applying himself to conscientious work.
>
> He worked independently of close supervision in a dry creek bed at Yei Yei Bore using western acrylic paints and brushes and he personally enjoyed doing good work for me who had been his first white artistic friend.
>
> I can recommend this Mystery Sand Mosaic at Yei Tei Bore owned by Mr. Bill Copland as a fine example of the best Papunya Art achieved in the Western desert at any time and should be accorded considerable significance. My intention is to reproduce this work in my next book discussing Western Desert painting.
>
> This beautiful painting shows intensive workmanship and largely unknown content in that the artist was a man of no English and was painting a traditional circular and anonymous theme so common with the Western Desert art. The central circular motif can be subjectively understood by Shorty alone and without his explaining his full meaning the topic remains a mystery. My judgement is that the central motif depicts a corroboree hat with the straight lines representing sticks that are part of that hat. The four oval shapes at the bottom of the picture are *tjurungas* or sacred sticks used in ceremonies. They are brilliantly indicated and the work is superior in execution to most similar work. The acrylic colors are controlled and the story has ancient derivation.

Bardon made good his intention to reproduce the work, writing for his 2004 book: "The design uses flat patterning and shapes not previously recorded, and the density of its dotting linear quality is very powerful and vital. The four oval shapes at the bottom of the painting are ceremonial objects or sacred sticks used in ceremonies" (Bardon and Bardon, page 420).

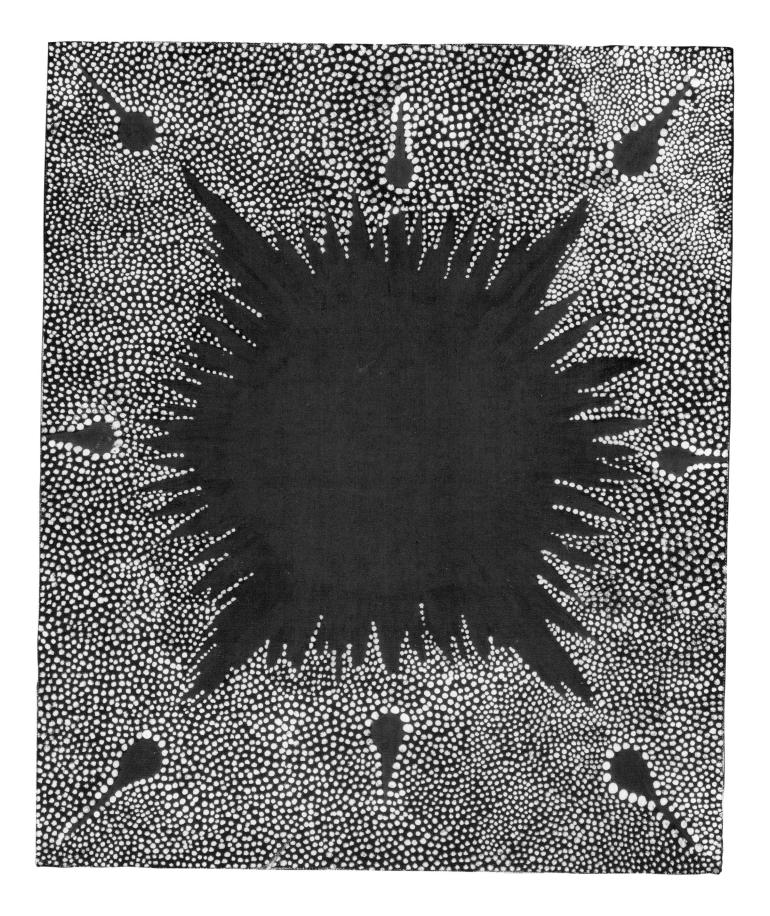

42.

Dreaming Story at Warlugulong
[formerly *Fire Dreaming associated with the site at Warlugulong*], October 1976

Clifford Possum Tjapaltjarri

(ca. 1932–2002)

Anmatyerre

Synthetic polymer paint on canvas board

19 3/4 x 15 3/4 inches (50.17 x 40.01 cm)

PROVENANCE

Papunya Tula Artists, Alice Springs, #CP761025

Acquired in Alice Springs in 1976

Sotheby's, *Fine Aboriginal and Contemporary Art*, Melbourne, June 17, 1996, lot 1

Collection of John and Barbara Wilkerson, New York

BIBLIOGRAPHY

Johnson, *The Art of Clifford Possum Tjapaltjarri*, 1994, pages 49–59, 154–55, plates 9 and 16

Sotheby's, *Fine Aboriginal and Contemporary Art*, Melbourne, June 17, 1996, page 9

Perkins, Hetti and Vivien Johnson, *Warlugulong 1976*. Australian Collection Focus Series no. 4 (Sydney: Art Gallery of New South Wales, 1999).

Johnson, *Clifford Possum Tjapaltjarri*, 2004, pages 86–99, 223

Vivien Johnson has described a near-identical painting by Clifford Possum as "the image of a bushfire as an explosion of red flame surrounded by tear-shaped sparks and white dots representing swirling ash against the blackened countryside." Both are parts of a small group of canvases made by Clifford Possum and Tim Leura Tjapaljarri on the Warlugulong or Bushfire Dreaming theme; these works presaged their complex joint masterpiece *Warlugulong* (1976) now at the Art Gallery of New South Wales. The first version of the above motif, in the National Museum of Australia in Canberra, was painted in Alice Springs in September 1976, and the exhibition version in October. We reproduce the exceptionally rich retelling of the story for the Canberra version by Dick Kimber for Papunya Tula Artists in 1976:

> The site of Warlugulong, approximately 300 kilometers north-west of Alice Springs, inspired this painting. It is owned by men of the Tjangala and Tjampitjinpa sub-sections of the Warlpiri tribe, but the Anmatyerre have strong links.
>
> In the Tjukurrpa—the Dreaming, a Tjangala traveled through the country carrying a fire stick. Actually, he was a man. His two sons followed behind and, although they had enjoyed a meal of kangaroo the previous day, they were now hungry again.
>
> Lungkata decided to light a fire. He touched the fire-stick to a bush and it exploded into flame. The flames licked out, flicking as the tongue of the Blue-Tongue, and indeed of all lizards and snakes, still does today, and soon clumps of grass and bushes were ablaze in every direction. The two sons broke branches from trees and beat at the flames, but the tongues of fire licked past them. Still the sons fought on, giving ground, beating away at the Bushfire, and then being forced to retreat again.
>
> The fire licked through the grass, exploded from bush to bush in crown fire, and drove them further and further south. Eventually the exhausted sons, having been pushed some 150 kilometers to the south, saw the fire lose its explosive nature, and die.
>
> Lungkata still resides at the place where the fire began (concentric circles). The movement of red indicates the explosive nature of the fire, and the charcoal areas indicate the burnt out country, the white dots being ash (Johnson 1994, page 54–55).

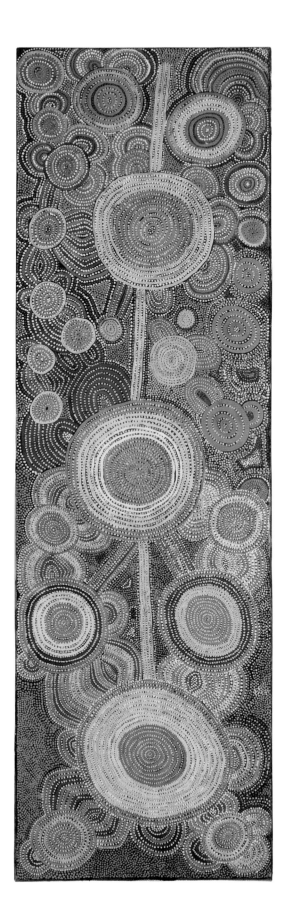

43.

Pulpayella, December 1976

Willy Tjungurrayi

(born ca. 1932)

Pintupi

Synthetic polymer paint on canvas

64 5/8 x 19 1/8 inches (164.15 x 48.48 cm)

PROVENANCE

Painted at Warra Wea [Waruwiya] for Papunya Tula Artists

Papunya Tula Artists, Alice Springs, #WJ761258

Private collection, Melbourne

Sotheby's, *Aboriginal Art,* Melbourne, July 9, 2001, lot 71

Collection of John and Barbara Wilkerson, New York

BIBLIOGRAPHY

Cf. Perkins and Fink, *Genesis and Genius*, 2000, pages 96–97 (ill.)

Sotheby's, *Aboriginal Art,* Melbourne, July 9, 2001, page 68

Johnson, *Lives*, 2008, pages 150–52

Pulpayella is one of many canvases of narrow columnar form offered to the artists by art advisors Janet Wilson and Dick Kimber. In their proportions, these columnar works resemble ceremonial objects, and many of them use variations on the classic Pintupi five-circle grid. Visually this work is not unlike Shorty Lungkarta's *Tingarri Ceremony at Ilingawurngawurrnga* (cat. 40), but is dominated by three great connected roundels or sites marching down the canvas. In more conventional Pintupi style, the sense of three-dimensional space is limited in Willy Tjungurrayi's work by comparison to Lungkarta.

Willy Tjungurrayi, a Pintupi/Winapa man born in the desert, was a resident of Papunya and then the outstations Yayayi, Waruwiya, and Inyilingi before moving to Kintore in the early 1980s. As he began painting in May 1976, *Pulpayella* must be an early example of his work. Until 2000, when he began working on linear compositions,"his style of delicately painted classic Pintupi grids of circles and connecting lines had changed little" (Johnson, page 152).

The Papunya Tula Artists certificate signed and dated by Janet Wilson, December 15, 1976, reads:

> The site depicted on this canvas is PULPA, or more fully PULPAYELLA, far to the west of Alice Springs, approaching the old, long disused, Canning Stock Route, over the W.A. border.

> The mythological rites and re-enactment are so secret/sacred that no details can be given about this place. All that is known is that large groups of men gathered (concentric circles) in the mythological time. These men were a group of Tingari men.

> It is known that the Tingari men travelled the country establishing the songcycles, ritual procedures and ceremonies that are still known as Tingari. No details can be given of the ceremonies themselves, because of the secret/sacred nature of these details. The Tingari cycles are virtually universal throughout the Western Desert peoples, but appear to be celebrated by several very extensive mythological lines of travel rather than just one vast linked route.

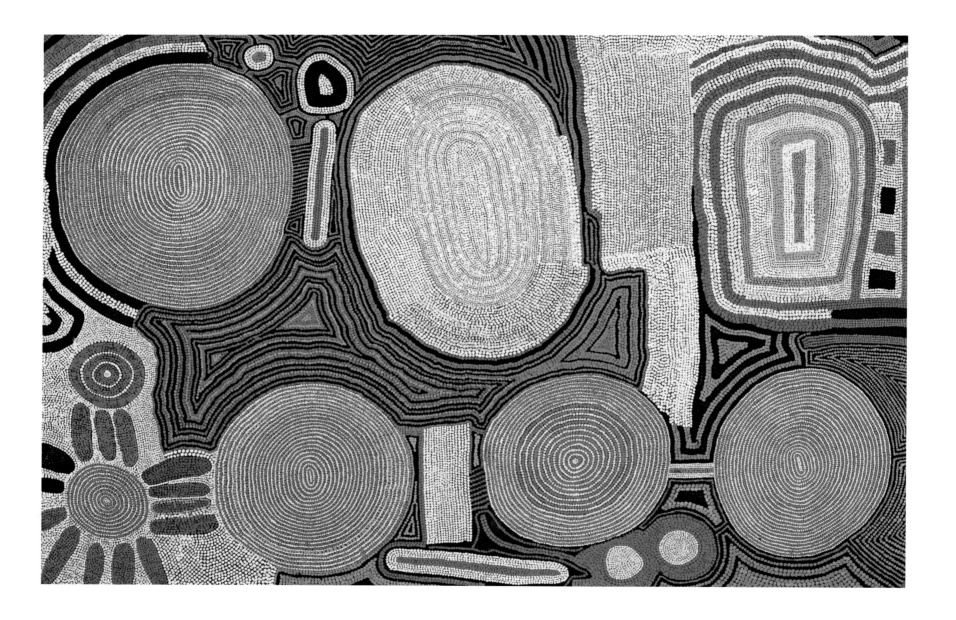

1980–1989

44.

Two Men's Dreaming at Kuluntjarranya, 1984

Tommy Lowry (Tommy Tichiwan No. 4) Tjapaltjarri

(ca. 1940–1987)

Pintupi

Synthetic polymer paint on canvas

47 7/8 x 72 inches (121.6 x 182.88 cm)

PROVENANCE

Painted at Kintore

Papunya Tula Artists, Alice Springs; artist's name, title, and date on back, #64

Collection of Duncan Kentish, Adelaide

Sotheby's, *Important Aboriginal Art*, Melbourne, July 24, 2007, lot 51

Collection of John and Barbara Wilkerson, New York

BIBLIOGRAPHY

Sutton, ed., *Dreamings: The Art of Aboriginal Australia*, 1988, pages 63 and 227

Perkins and Fink, *Genesis and Genius*, 2000, pages 105 (ill.) and 278

Sotheby's, *Important Aboriginal Art*, Melbourne, July 24, 2007, pages 66–68 (foldout)

Johnson, *Lives*, 2008, page 115

EXHIBITED

Dreamings: The Art of Aboriginal Australia, Asia Society, New York

October–December 1988

(traveled to Chicago, Los Angeles, Adelaide, and Melbourne)

Papunya Tula: Genesis and Genius, Art Gallery of New South Wales, Sydney

August 18–November 12, 2000

This monumental canvas is one of the pinnacles of Pintupi painting of the 1980s. The work has a quality that resounds beyond its dimensions. Unlike the site-path paintings of 1980s Pintupi convention, Tommy Lowry avoids the regular traveling-line connections between the sacred site elements. The six great, uneven objects in the picture are concentric roundels of a density and breadth seen almost nowhere else. The story of *Two Men's Dreaming at Kuluntjarranya* (as explained below) reveals that these objects are in fact salt lakes formed by the urine of two great ancestral medicine men. A native tobacco plant can be seen at the lower left with bars at its side. However, much in the rich imagery of this painting is unexplained. The infill dotting wedged between the eccentric lake shapes is formed of a kind of linear patterning like the bright bands of a cut agate geode. With this vermiculated form, Tommy Lowry seems to learn from a motif in the recent experimental works of Clifford Possum, just as his practice also draws from the example of Uta Uta Tjangala's great canvases of 1980–81.

The certificate from Papunya Tula Artists reads:

> The country depicted here is southwest of Kintore. Two ancestral Watijujarra (two men) who were *nangkaris*, or traditional Aboriginal doctors, were travelling in the area. The found some *minykulpa* (very strong native tobacco) and sat down on some sandhills to eat it. It was so strong that they died, sprawled out on their backs with their legs wide apart in the sand. Their bodies began to urinate. The urine flow was so great that the ground became saturated and a great salt lake was formed. The lake exists today and is called Kumpukurru (bad urine). After the lake was formed the two men came to life and traveled over this area, having further adventures. The large roundels are the lakes; the circles at the bottom left with the surrounding oblong lines is the tobacco plant (*Dreamings*, page 227).

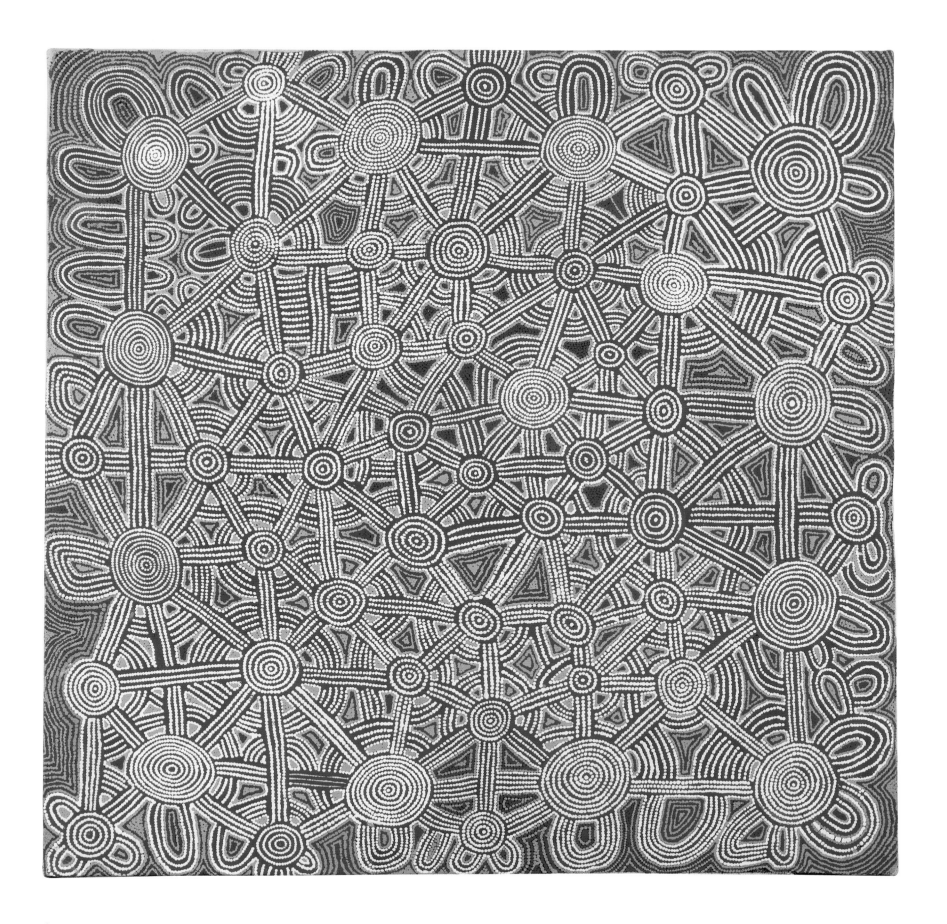

45.

Ngalyukuntinya, 1985

Tommy Lowry (Tommy Tichiwan No. 4) Tjapaltjarri

(ca. 1940–1987)

Pintupi

Synthetic polymer paint on canvas

48 x 48 inches (121.92 x 121.92 cm)

PROVENANCE

Papunya Tula Artists, Alice Springs, #TL850848

Private collection, Adelaide

Sotheby's, *Important Aboriginal Art*, Melbourne, June 30, 1998, lot 236

Collection of John and Barbara Wilkerson, New York

BIBLIOGRAPHY

Sotheby's, *Important Aboriginal Art*, Melbourne, June 30, 1998, page 117

Cf. Latz, *Bushfires and Bushtucker: Aboriginal Plant Use in Central Australia*, 1995, pages 102–04

EXHIBITED

Gallery Gabrielle Pizzi at Roar Studios, Melbourne, 1986

Although the vastness of the golden site-path complex here suggests the cycle of Tingarri Dreamings over some great expanse of country, Tommy Lowry's comments to the Papunya art advisor indicate he used the motif to tell a very local story (see below). This is a place where the artist's mother passed away, and at which witchetty grubs proliferate in the roots of trees. The famous witchetty grub (*maku*) is an important source of nutrition in the desert: it is the larva of a large grey moth, and grows to 11 grams in weight. The grubs grow inside the woody roots of a mulgalike acacia bush, *acacia kempeana*. In a good season as many as fifty grubs can be found in one witchetty bush (Latz, page 103). As in all bush tucker Dreamings from the Western Desert, the motif simultaneously evokes the animal in its zoological and its Ancestral guise.

The certificate from Papunya Tula Artists (probably written by Daphne Williams) reads:

> This painting is a depiction of the site of Ngalyukuntinya, south of the Kintore Ranges and the significant meanings this place has for the artist. At Ngalyukuntinya, the artist's mother died. Ngalyukuntinya is also the name of a tree from the roots of which maku or witchetty grubs are gathered. The roundels depict where the trees stand at the site and the numerous lines show the travels of the Maku ancestors and of Aboriginal men around the site.

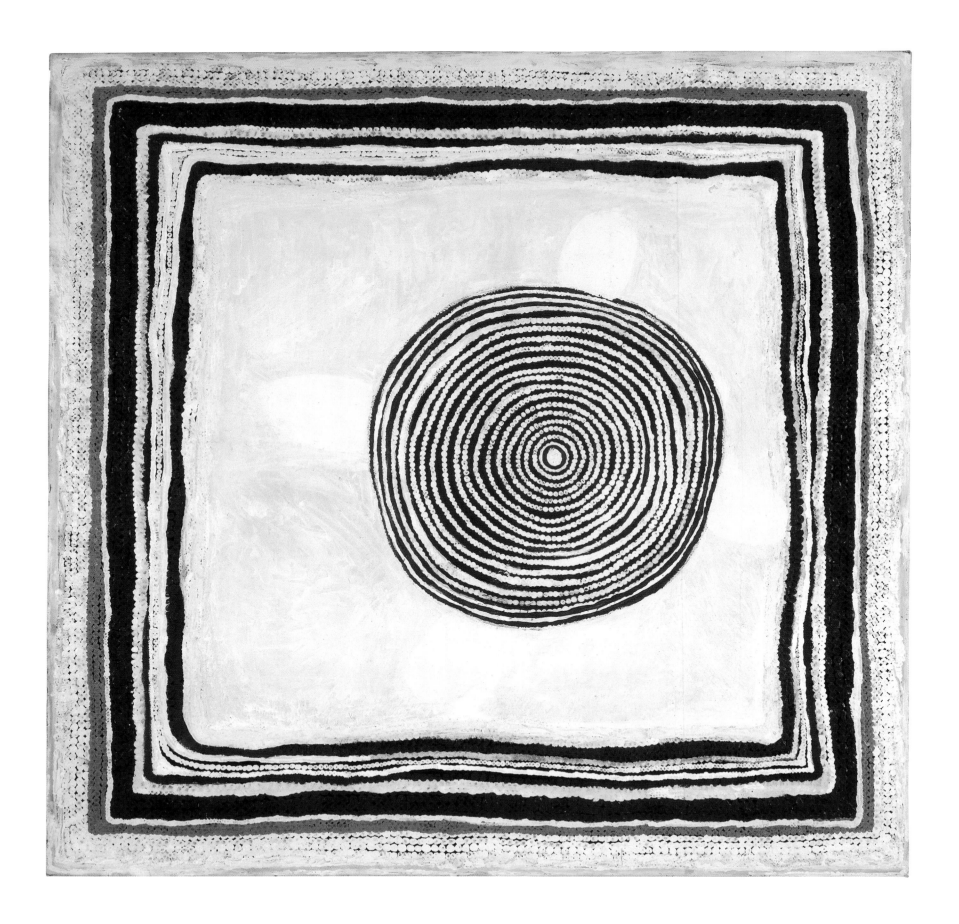

46.

An Audience with the Queen, 1989

Charlie Tarawa (Tjararu) Tjungurrayi

(ca. 1921–1999)

Pintupi

Synthetic polymer paint on linen

47 1/4 x 47 3/8 inches (120.02 x 120.33 cm)

PROVENANCE

Painted at Kintore

Papunya Tula Artists, Alice Springs, cat. no. CT890660

Alcaston Gallery, Melbourne

Private collection, Melbourne

Sotheby's, *Aboriginal Art*, Melbourne, July 9, 2001, lot 49

Collection of John and Barbara Wilkerson, New York

BIBLIOGRAPHY

Perkins and Fink, *Genesis and Genius*, 2000, pages 105 (ill.) and 278

Sotheby's, *Aboriginal Art*, Melbourne, July 9, 2001, page 49

EXHIBITED

Papunya Tula: Genesis and Genius, Art Gallery of New South Wales, Sydney

August 18–November 12, 2000

The visual impact of this, one of Charlie Tarawa (Tjararu) Tjungurrayi's most important late works, is due to its unique composition. The giant site motif with twenty concentric roundels, white on dark brown, is seen against a white ground within a square perimeter. Alternating white and dark brown borders lead to the main note of color—the brown bands that frame the image before it peters off into a fringe of white dots. The whole functions like a picture within a picture. Malevich's *White Square* compositions teach one to look for meaningful variations in the surface and opacity of abstract painting, and Tjungurrayi's canvas seems more nuanced the more one looks at it. Its textures are uneven, and four ghostlike lozenges emerge from the mist like the petals of a frost-rimmed flower. As Vivien Johnson argues, the artist's given "story" of an audience with the Queen of England may be but one level of reading for a work which may also be yet another embodiment of the artist's sacred country, the home of the redoubtable Ice Man in his freezing cave, Wati Kuwala.

The certificate from Papunya Tula Artists, signed by Daphne Williams on October 26, 1989, reads:

> In this painting the artist has described an audience with Her Majesty, Queen Elizabeth II. The central roundel shows the meeting place. The four white shapes adjacent to the roundel show the Queen and the other people who were allowed in the room. The straight lines on the border of the work show the fence around the meeting place which is manned by guards.

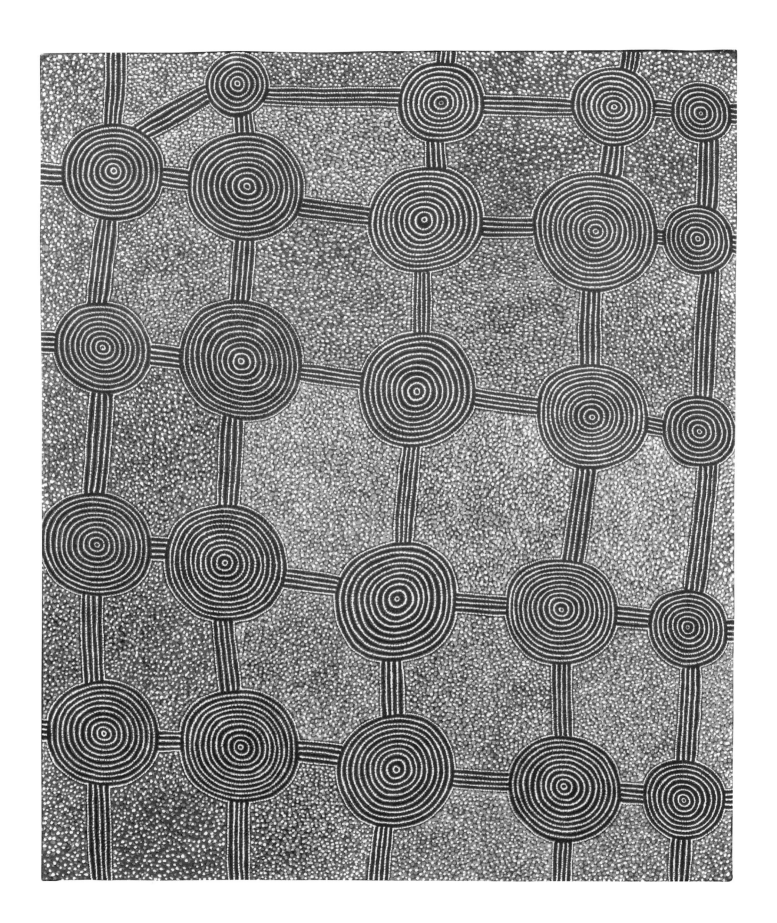

47.

Yarranyanga, 1989

Anatjari (Yanyatjarri) Tjakamarra

(ca. 1938–1992)

Pintupi

Synthetic polymer paint on linen

59 3/4 x 48 inches (151.77 x 121.92 cm)

PROVENANCE

Painted at Kiwirrkurra

Papunya Tula Artists, Alice Springs, #AT890465

Gallery Gabrielle Pizzi, Melbourne

Private collection, Melbourne

Sotheby's, *Aboriginal Art*, Melbourne, July 26, 2004, lot 108

Collection of John and Barbara Wilkerson, New York

BIBLIOGRAPHY

Sotheby's, *Aboriginal Art*, Melbourne, July 26, 2004, pages 92–93

The Papunya Tula Artists certificate reads:

> The site of Yarranyanga, a claypan with a number of small rockholes in sandhill country to the south of Kintore, near Tjukula is depicted in this work. In ancestral times a group of Tingari Men traveled through this area before continuing east.

> Because of the secret/sacred nature of events associated with the Tingari Cycle, no further detail was given. Generally, the Tingari are a group of ancestors who traveled over vast stretches of the country, performing rituals and creating and shaping particular sites. The Tingari men were usually followed by Tingari women and accompanied by novices and their travels and adventures are enshrined in a number of song-cycles. These mythologies form part of the teachings of the post-initiate youths today as well as providing explanations for contemporary events.

As the 2004 sale catalogue notes, this work is "closely related to many of the works in [Anatjari Tjakamarra's] solo exhibition, 1989 at the John Weber Gallery, New York, from which Metropolitan Museum of Art acquired 'Tingari Cycle Dreaming'; the first contemporary work of Aboriginal art to enter the Museum's collection."

48.

Tjunginpa, 1991

Mick Namararri Tjapaltjarri

(ca. 1927–1998)

Pintupi

Synthetic polymer paint on linen

48 1/4 x 71 7/8 inches (122.5 x 182.5 cm)

PROVENANCE

Painted at Kintore

Papunya Tula Artists, Alice Springs, #MN900517

Private collection, Los Angeles

Sotheby's, *Important Aboriginal Art*, Melbourne, June 28, 1999, lot 29

Collection of John and Barbara Wilkerson, New York

BIBLIOGRAPHY

Sotheby's, *Important Aboriginal Art*, Melbourne, June 28, 1999, page 27

Perkins and Fink, *Genesis and Genius*, 2000, pages 105 (ill.) and 278

Johnson, *Lives*, 2008, page 167

EXHIBITED

Papunya Tula: Genesis and Genius, Art Gallery of New South Wales, Sydney

August 18–November 12, 2000

Namararri's late work *Tjunginpa* of 1990 looks quite unlike earlier Papunya art, with its striated or sedimentary layers. Namararri's horizontal and linear format for this painting has a strong family resemblance to the celebrated group of late works by Turkey Tolson Tjupurrula, his *Straightening Spears* series, also begun in 1990. The two men were very close, with Namararri being "*kurdungulu*[1] for many of [Turkey Tolson's] Dreamings, and there are striking similiarities between the two artists' work, especially in their later years" (Johnson, page 167). In Turkey Tolson's case there was an apparent link between the long, thin vine-wood spears being adjusted for trueness in the flames of a fire, and the format of his painting with its dozens of parallel straight lines (although, as Johnson points out, "a striking vertical rock formation at this site may have been in the artist's mind when he created the original," page 167).

In the Namararri the horizontal bands are not continuous lines (neither are they in Turkey Tolson, where they are in fact made of minute lines of dots). Namararri's "lines" are composed of small yellow rectangles set off against red or white-dotted infill. These designs are associated with the Dreaming for the Bettong (a desert marsupial—the short-nosed rat-kangaroo) at the site of Tjunginpa. Perhaps the annotation for other Tjunginpa paintings for different animals done by Namararri at that time also holds true here: "The overall dotting represents the footprints of the mouse and also kampurarrpa (bush raisins) and flowers, for which the mouse foraged in the area" (*Genesis and Genius*, page 283).

The certificate from Papunya Tula Artists reads:

> This painting depicts designs associated with the Bettong Dreaming at the site of Tjunginpa. This is a small hill to the west of the Kintore community just over the W[est]A[ustralian] border. This small marsupial makes its home under spinifex clumps, its diet being berries, seeds and grass. In mythological times the Bettong traveled from the west to Tjunginpa.

[1] A witness empowered to authorize and ensure the correct telling of a Dreaming.

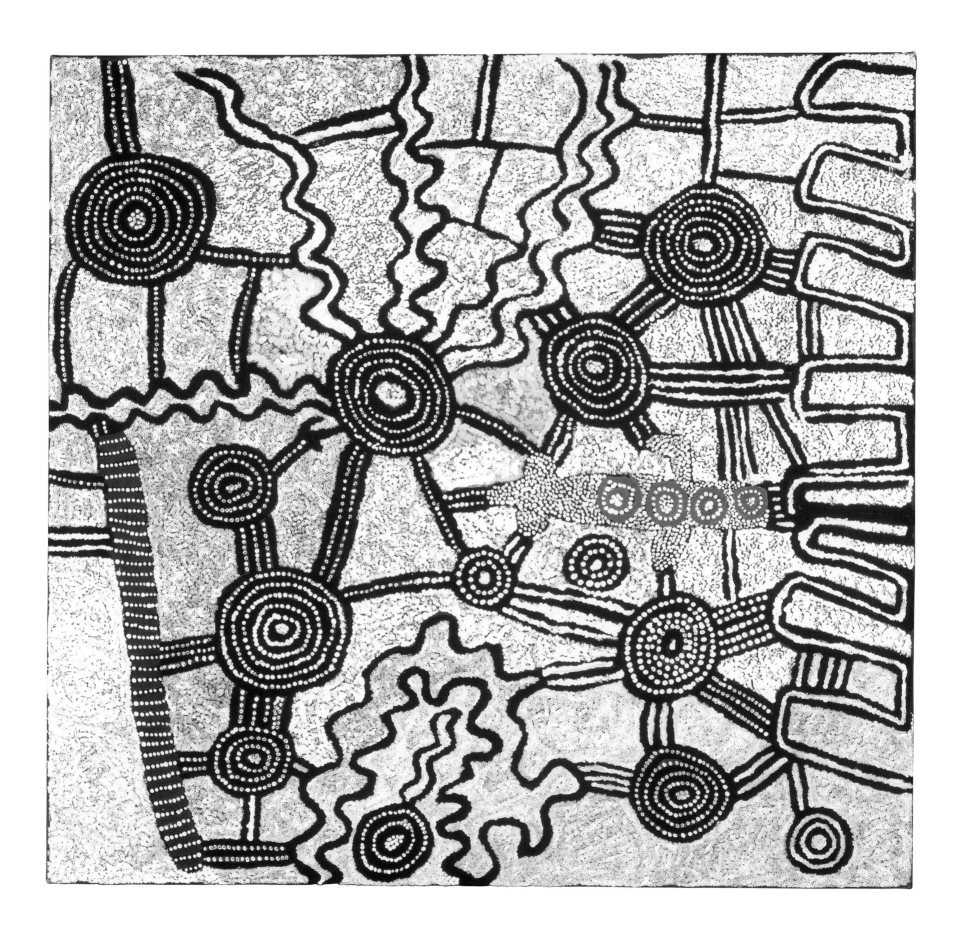

49.

Untitled, September 1998

Yala Yala Gibbs Tjungurrayi

(ca. 1924–1998)

Pintupi

Synthetic polymer paint on linen

35 15/16 x 35 3/4 inches (91.28 x 90.81 cm)

PROVENANCE

Painted at Alice Springs

Papunya Tula Artists, Alice Springs, #YY9809102

Private collection, Alice Springs

Sotheby's, *Aboriginal Art,* Melbourne, July 9, 2001, lot 53

Collection of John and Barbara Wilkerson, New York

BIBLIOGRAPHY

Perkins and Fink, *Genesis and Genius*, 2000, pages 129 (ill.) and 289

Sotheby's, *Aboriginal Art,* Melbourne, July 9, 2001, page 53

EXHIBITED

Papunya Tula: Genesis and Genius, Art Gallery of New South Wales, Sydney

August 18–November 12, 2000

The 2001 sale catalogue observes: "This painting was executed just three months before the artist died at Alice Springs Hospital in December 1998. It is an example of the artist's striking and acclaimed black over white works that he returned to at the very end of his painting career. These paintings bore a strong resemblance to his earlier works painted in 1971–72 at Papunya."

Indeed, Yala Yala Gibbs's *Untitled*, something of a last testament of the artist, shares the color scheme and even some of the forms of early paintings like *Wind Story* of late 1972. In both works he uses his characteristic manner of close-knit, rather liquid white dots set over a black or dark brown ground, so that the *kuruwarri*, or story lines, are revealed underneath. *Untitled* is a starkly impressive, complex image showing the many comings and goings of the Tingarri men around Lake MacDonald. A dozen roundels are connected in asymmetrical, eccentric ways by traveling lines and motifs for running water. A row of eight rectangular presences—possibly rocks or ceremonial objects—is on the right hand margin. Yala Yala Gibbs injects a startling note of brown color on the bodies of what appear to be a snake on the left, and a large lizard on the right. It is the very unpredictability of the structure and placement of elements that makes this work unique. Gibbs achieves a balance despite this disorder: what Mondrian called "dynamic equilibrium."

The Papunya Tula Artists certificate, signed "D. Williams for J. Stanton" on October 15, 1998, reads: "This painting depicts designs associated with the rockhole site of Kutulalinyi, west of Lake MacDonald. The Snake Dreaming is associated with this site. In mythological times a large group of Tingarri men camped at this site before continuing their travels to Lampintja. Since events associated with the Tingarri Cycle are of a secret nature no further information was given."

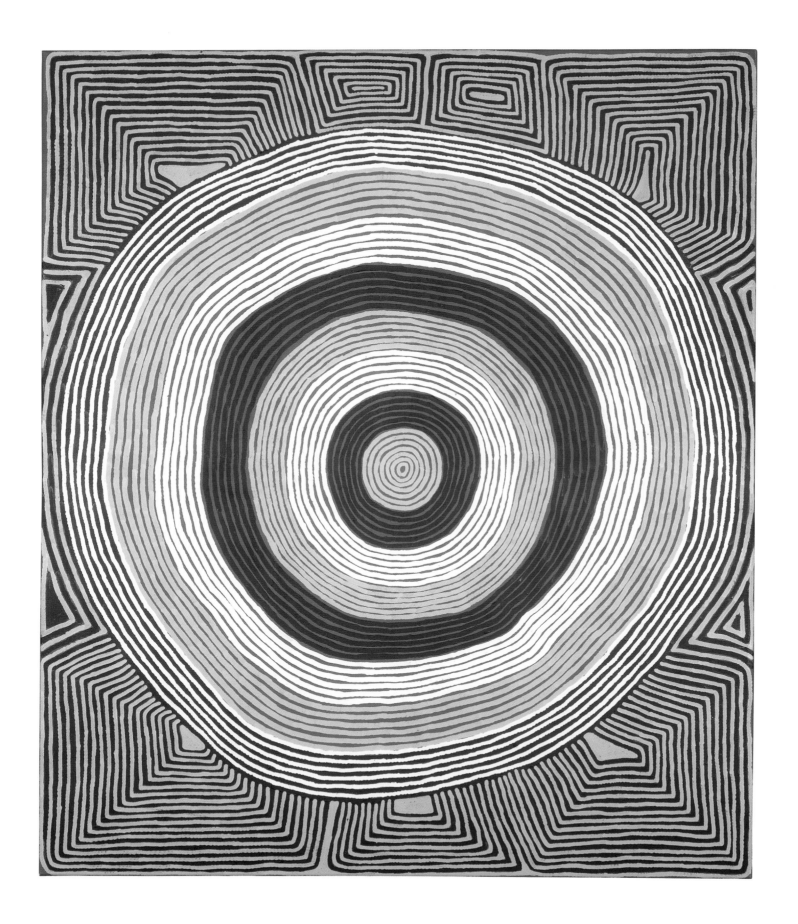

50.

Untitled, 2003

Ronnie Tjampitjinpa

(born 1943)

Pintupi

Acrylic on Belgian linen

59 3/4 x 72 1/4 inches (151.77 x 183.52 cm)

PROVENANCE

Painted at Kintore

Papunya Tula Artists, Certificate #RT030503

Private collection, Melbourne

Collection of John and Barbara Wilkerson, New York

BIBLIOGRAPHY

Cf. Perkins and Fink, *Genesis and Genius*, pages 87, 124, 126, 127, and 285

Johnson, *Lives*, 2008, pages 96–98

A young man of thirty when he began painting in 1971, Ronnie's early paintings are few in number and tentative in design. Ronnie was active at the time as a stockman and fence builder who also assisted a Pintupi linguist in Papunya. One of the initial group to move with his family to the new Pintupi outstation at Kintore in 1981, it was only in the late 1980s that his career as an artist took off. Ronnie Tjampitjinpa then introduced a signature style of wide bands of paint in "traditional" colors, in a manner surely related to the unctuous lines painted on the fat-coated bodies of performers in ceremony. Initially Tjampitjinpa painted thus in the roundel format, but moved soon to concentric square and rhomboid designs, which he stamped with great visual authority. His 2003 work *Untitled* in the exhibition is rare in combining both the circular and rectilinear design elements. The painting is dominated by a massive roundel over one meter wide, while above and below it are the cellular compartments typical of his later work.

The Papunya Tula Artists certificate reads:

> This painting depicts designs relating to the site of Tjintjintjin, west of the Kintore Community. In mythological times an old lady traveled to this site. She traveled from Malparingya, north-west of Kintore Community and visited the site of Tjintjintjin where there is an underground cave, also the soakage water sites of Ngatanga and Yaranga which are all west of Mantati Outstation, approximately seventy kilometers west of the Kintore Community. She then traveled further east to Muruntji, southwest of Mt. Leibig.

bibliography

Aboriginal art auction catalogues (various titles). Melbourne: Deutscher-Menzies, April 20, 1998; August 10, 1998; June 29, 1999; June 27, 2000.

Anderson, Christopher. "Australian Aborigines and Museums: A New Relationship" in *Curator*, vol. 33, no. 3 (1990): 165–179.

Attwood, Bain. *Telling the Truth about Aboriginal History.* Crow's Nest, NSW: Allen & Unwin, 2005.

Bardon, Geoffrey. *Aboriginal Art of the Western Desert.* Sydney: Rigby, 1979.

———. *Papunya Tula: Art of the Western Desert.* Melbourne: McPhee Gribble/Penguin, 1991.

——— and James Bardon. *Papunya: A Place Made After the Story,* Melbourne: Miegunyah Press, 2004.

Batty, Philip, ed. *Colliding Worlds: First Contact in the Western Desert 1932–1984.* Melbourne: Museum of Victoria, 2006.

Baudrillard, Jean. "The Art Auction," in *For a Political Economy of the Sign.* St. Louis: Telos Press, 1981.

Benjamin, Roger, review of *Papunya Tula, Genesis and Genius* in *Humanities Research* no. 1 (2000): 97–100.

Biddle, Jennifer Louriede. *Breasts, Bodies, Canvas.* Sydney: University of New South Wales Press, 2007.

Brody, Annemarie. *The Face of the Centre: Papunya Tula Paintings 1971–1984.* Melbourne: National Gallery of Victoria, 1985.

Corbally Stourton, Patrick. *Songlines and Dreamings: Contemporary Australian Aboriginal Painting.* London: Lund Humphries, 1996.

Crocker, Andrew. *Charlie Tjaruru Tjungurrayi: a retrospective 1970–86.* Orange, NSW: Orange City Council, 1987.

Croft, Brenda L., ed. *Culture Warriors: the National Indigenous Art Triennial 07.* Canberra: National Gallery of Australia, 2007.

Diggins, Lauraine, ed. *A Myriad of Dreamings: Twentieth Century Aboriginal Art,* Melbourne: Malakoff Fine Art Press, 1989.

French, Alison. *Seeing the Centre: The Art of Albert Namatjira 1902–1959.* Canberra: National Gallery of Australia, 2002.

Hardy, Jane, J. V. S. Megaw, and M. Ruth Megaw, eds. *The Heritage of Namatjira: The Watercolourists of Central Australia.* Melbourne: William Heinemann Australia, 1992.

Johnson, Vivien. *The Art of Clifford Possum Tjapaltjarri.* Sydney: Craftsman House, Gordon & Breach, 1994.

———. *Dreamings of the Desert.* Adelaide: Art Gallery of South Australia, 1994.

———. *Michael Jagamarra Nelson.* Sydney: Craftsman House, 1997.

———. *Clifford Possum Tjapaltjarri,* Adelaide: Art Gallery of South Australia, 2003.

———, ed. *Papunya Painting: Out of the Desert.* Canberra: National Museum of Australia, 2007.

———. *Lives of the Papunya Tula Artists.* Alice Springs: IAD Press, 2008.

Kimber, R. G. "Papunya Tula Art: Some Recollections August 1971–October 1972," in *Dot and Circle: A Retrospective Survey of the Aboriginal Acrylic Paintings of Central Australia,* eds. Janet Maughan and Jenny Zimmer. Melbourne: Royal Melbourne Institute of Technology, 1984.

———. "The Politics of the Secret in Contemporary Western Desert Art," in *The Politics of the Secret*, Oceania Monograph 45, ed. Christopher Anderson. Sydney: University of Sydney, 1995.

Kleinert, Sylvia and Margo Neale, eds. *The Oxford Companion to Aboriginal Art and Culture.* Melbourne: Oxford University Press, 2000.

Klingender, Tim, ed. Aboriginal art auction catalogues (various titles). Sydney: Sotheby's Australia, November 28, 1995; June 17, 1996; June 30, 1997; June 29, 1998; June 28, 1999; June 26, 2000; July 9, 2001; June 24, 2002; July 26, 2004; July 24, 2007; October 10, 2008.

Langton, Marcia, et. al., eds. *Honour Among Nations? Treaties and Agreements with Indigenous People.* Melbourne: Melbourne University Publishing, 2004.

Latz, Peter. *Bushfires and Bushtucker: Aboriginal Plant Use in Central Australia.* Alice Springs: IAD Press, 2004.

Maslen, Geoff. "Knocked down; still out," in *The Age* (29 September 2003), Fairfax Digital online.

Maughan, Janet and Jenny Zimmer, eds. *Dot and Circle: A Retrospective Survey of the Aboriginal acrylic paintings of Central Australia.* Melbourne: Royal Melbourne Institute of Technology, 1986.

Megaw, J. V. S. "Western Desert Acrylic Painting—Artefact or Art?" in *Art History*, vol. 5, June 1982: 205–218.

Mellor, Doreen and Terri Janke. *Valuing Art, Respecting Culture: Protocols for Working with the Australian Visual Arts and Crafts Sector.* Sydney: National Association for the Visual Arts, 2001.

Morphy, Howard. "From Dull to Brilliant: The Aesthetics of Spiritual Power among the Yolngu," in *Man*, vol. 24, no. 1 (1989): 21–40.

———. *Ancestral Connections: Art and an Aboriginal System of Knowledge*, Chicago: University of Chicago Press, 1991.

Munn, Nancy. "Visual Categories: An Approach to the Study of Representational Systems," in *American Anthropologist*, vol. 66 (1966): 939–50.

———. *Walbiri Iconography: Graphic Representation and Cultural Symbolism in a Central Australian Society.* Ithaca: Cornell University Press, 1973.

Myers, Fred, *Pintupi Country, Pintupi Self: Sentiment, Place, and Politics among Western Desert Aborigines.* Canberra, ACT, and Washington, DC: Australian Institute of Aboriginal Studies and Smithsonian Institution, 1986.

———. "Aesthetics and Practice: A Local Art History of Pintupi Painting," in *From the Land: Dialogues with the Kluge-Ruhe Collection of Aboriginal Art*, Howard Morphy and Margo Smith-Bowles, eds. Seattle: University of Washington Press, 1999.

———. "Ways of Placemaking," in *Culture, Landscape, and the Environment*, Howard Morphy and Katherine Flynt, eds. Oxford: Oxford University Press, 2000.

———. *Painting Culture: The Making of an Aboriginal High Art*, Durham: Duke University Press, 2002.

———. "Unsettled Business: Acrylic Painting, Tradition, and Indigenous Being," in *Visual Anthropology*, vol. 17 (3–4), July–December 2004: 247–72.

Nicholls, Christine. *Yilpinji—Love, Art & Ceremony.* Fishermans Bend, Victoria.: Craftsman House, 2006.

Papunya Tula. New York: John Weber Gallery, 1989.

Perkins, Hetti and Hannah Fink, eds., *Papunya Tula, Genesis and Genius*, Sydney: Art Gallery of New South Wales, 2000.

Perkins, Hetti. "Bobby West Tjupurrula in Conversation," in *One Sun One Moon: Aboriginal Art in Australia.* Sydney: Art Gallery of New South Wales, 2007.

Read, Peter. *The Stolen Generations: The Removal of Aboriginal Children in New South Wales 1883 to 1969.* Surry Hills: NSW Department of Aboriginal Affairs, 1981.

———. *A Rape of the Soul So Profound: The Return of the Stolen Generations.* Sydney: Allen & Unwin, 1999.

Rothwell, Nicholas. "Pintupi—An Introduction," in *PINTUPI—20 Contemporary Paintings from the Pintupi Homelands.* London: Hamilton's Gallery, 2006.

———. *Another Country.* Melbourne: Black Inc., 2007.

Ryan, Judith. *Mythscapes: Aboriginal Art of the Desert.* Melbourne: National Gallery of Victoria, 1989.

Strehlow, T. G. H. *Rex Battarbee: Artist and Founder of the Aboriginal Art Movement in Central Australia.* Sydney: Legend Press, 1956.

———. "The Art of Circle, Line and Square," in *Australian Aboriginal Art*, Ronald M. Berndt, ed. Sydney: Ure Smith, 1964.

Sutton, Peter, ed. *Dreamings: The Art of Aboriginal Australia.* Melbourne: Viking Penguin Books, 1988.

"Wailbri & Pintupi Art" (exhibition brochure for traveling exhibition). Museums and Art Galleries of the Northern Territory, Darwin.

Watson, Christine. *Piercing the Ground: Balgo women's image making and relationship to country.* Fremantle: Fremantle Arts Centre Press, 2003.

West, Margie, ed. *The Inspired Dream—Life as Art in Aboriginal Australia.* Brisbane: Queensland Art Gallery, 1988.

filmography

A Calendar of Dreamings, directed and edited by Geoffrey Bardon, 1977 [based on footage shot in 1974].

Mick and the Moon, produced by James Bardon, directed and edited by Geoffrey Bardon, 1978.

Benny and the Dreamers, directed and produced by Ivo Burum and Phillip Batty. CAAMA productions, ca. 1992.

Mr. Patterns, directed by Catriona McKenzie. Film Australia and Reel Films, 2004.

credits

Every effort has been made to locate the artists whose work is reproduced, or establish and locate their representatives, in order to obtain permission to reproduce the works.

All images remain the copyright of the artist, their estate, or appropriate authorities. In some cases copyright permission has been gained from the artist with the help of others, as indicated below. In other cases where copyright has not actually been obtained from the artist, permission has been granted through the courtesy of the individuals or organizations listed below.

The artist, by permission of Papunya Tula Artists through the Aboriginal Artists Agency
Billy Stockman Tjapaltjarri, Linda Syddick, Long Jack Phillipus Tjakamarra, Ronnie Tjampitjinpa, Willy Tjungurrayi

The estate of the artist, by permission of Papunya Tula Artists through the Aboriginal Artists Agency
Anatjari (Yanyatjurri) Tjakamarra, Charlie Tarawa (Tjaruru) Tjungarrayi, Clifford Possum Tjapaltjarri, Freddy West Tjakamarra, George Tjangala, John Kipara Tjakamarra, Johnny Scobie Tjapanangka, Johnny Warangkula Tjupurrula, Kaapa Mbitjana Tjampitjinpa, Kingsley Tjungurrayi, Mick Namararri Tjapaltjarri, Old Walter Tjampitjinpa, Simon Tjakamarra, Shorty Lungkarta Tjungurrayi, Tim Leura Tjapaltjarri, Tim Payungka Tjapangarti, Tommy Lowry (Tommy Tichiwan No. 4) Tjapaltjarri, Turkey Tolson Tjupurrula, Uta Uta Tjangala, Yala Yala Gibbs Tjungurrayi, Yumpuluru Tjungurrayi

License permission obtained and agreed to by Sarah Tutton for the Herbert F. Johnson Museum, Cornell University, New York, for 3,500 copies only.

Catalogue numbers 1–48, cat. 50
 Tony De Camillo

Catalogue number 44
 Graham Baring, courtesy of Sotheby's

Pages 10, 20
 Courtesy of The Herald & Weekly Times Ltd.

Pages 14–19, 50, 64, 76, 123, 125, and front endpapers
 © Michael Jensen

Pages 38, 87, 89, 98, 100, 102, 108, 110, 117, 121, 129, 134, 153
 Julie Magura, Herbert F. Johnson Museum of Art

Pages 22, 24, 25, 28 (right), 37
 Alan Scott, courtesy of Dorn Bardon from the photography collection of Geoffrey Bardon

Pages 23, 39
 Geoffrey Bardon, courtesy of Dorn Bardon from the photography collection of Geoffrey Bardon

Page 26 (left)
 Jenni Carter, © Art Gallery of New South Wales

Page 26 (right)
 Christopher Snee

Page 29 (left)
 Lannon Harley

Pages 29 (right), 30
 Courtesy of Legend Press (August 21, 2008)

Pages 31, 32
 Courtesy of Dorn Bardon from the photography collection of Geoffrey Bardon

Page 33 (left)
 Jack Doyle, 1974, courtesy of Dorn Bardon from the photography collection of Geoffrey Bardon

Page 33 (right)
 Rosalie Bayetto, courtesy of Dorn Bardon from the photography collection of Geoffrey Bardon

Page 34 (left)
 Dean McNicoll

Page 34 (right)
 Jon Rhodes

Page 35 (left)
 Penny Tweedie

Page 42
 © 2009 Artists Rights Society (ARS), New York/ADAGP, Paris

Page 52
 Courtesy of Fred Myers

Page 55 (bottom)
 Photo © Spike Mafford 2008

Pages 58, 59, 60, 62
 Graham Baring

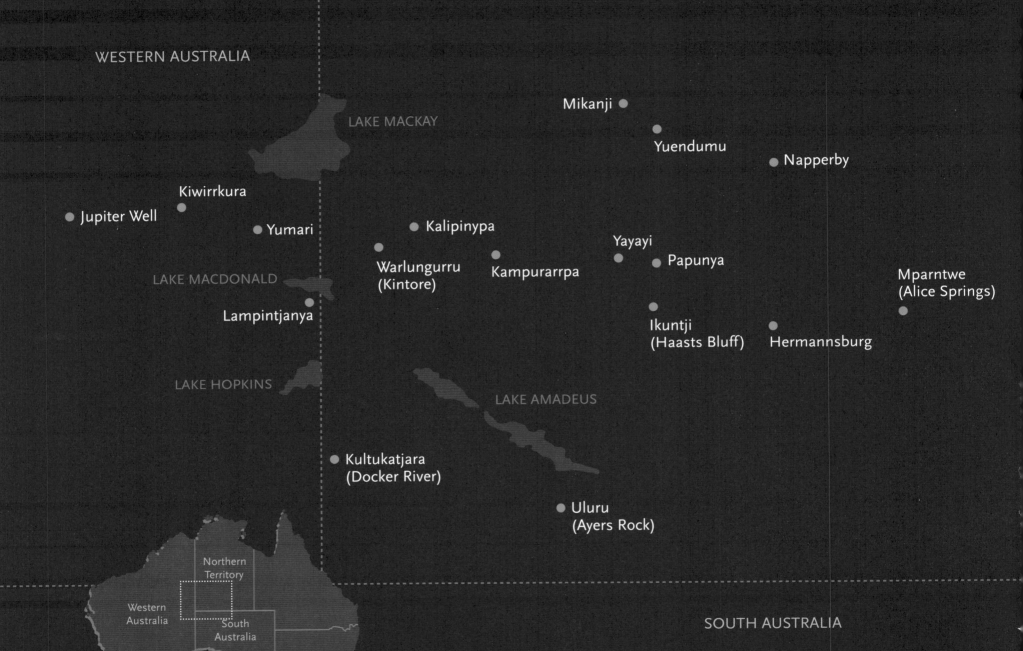

NORTHERN TERRITORY

WESTERN AUSTRALIA

LAKE MACKAY

Mikanji

Yuendumu

Napperby

Kiwirrkura

Jupiter Well

Yumari

Kalipinypa

Yayayi

LAKE MACDONALD

Warlungurru
(Kintore)

Kampurarrpa

Papunya

Mparntwe
(Alice Springs)

Lampintjanya

Ikuntji
(Haasts Bluff)

Hermannsburg

LAKE HOPKINS

LAKE AMADEUS

Kultukatjara
(Docker River)

Uluru
(Ayers Rock)

Northern
Territory

Western
Australia

South
Australia

SOUTH AUSTRALIA

100 km